New York Sights

'A masterful and original account of New York and the modern visual imagination. Douglas Tallack again proves himself a deeply insightful critic of American art and culture.'

James E. Hoopes, *Distinguished Professor of History, Babson College, Babson Park, MA*

'A wonderfully knowledgeable book – historically detailed, theoretically versatile and highly perceptive in its skilful reading of a wide variety of visual texts (paintings, photographs, films). Tallack is able to render the history of New York's "visual imagination" as a dialogue between its constantly changing material appearance and the various changes in its visual representation. Although the book is focused on the transformation of late-19th-century Old New York into the 20th-century metropolis of visual excess, it traces the impact of history on the very conditions of seeing (as well as on the ways and instruments of perception) until that catastrophic moment of 9/11 that changed New York (as object and as image) forever.'

Dr. Heinz Ickstadt, *Prof. em., John F. Kennedy-Institut, Freie Universitaet Berlin*

New York Sights

Visualizing Old and New New York

Douglas Tallack

Oxford • New York

English edition
First published in 2005 by
Berg
Editorial offices:
1st Floor, Angel Court, 81 St Clements Street, Oxford OX4 1AW, UK
175 Fifth Avenue, New York, NY 10010, USA

Berg is the imprint of Oxford International Publishers Ltd.

Library of Congress Cataloging-in-Publication data
Tallack, Douglas.
New York sights : visualizing old and new New York / Douglas Tallack.— English ed.
p. cm.
Includes bibliographical references and index.
ISBN-13: 978-1-84520-170-8 (pbk.)
ISBN-10: 1-84520-170-1 (pbk.)
ISBN-13: 978-1-84520-169-2 (cloth)
ISBN-10: 1-84520-169-8 (cloth)
1. New York (N.Y.)—History—1898-1951. 2. New York (N.Y.)—Intellectual life. 3. Visual
communication—New York (State)—New York—History. 4. New York (N.Y.)—In
art. 5. Arts, American—New York (State)—New York. 6. City and town life—New York
(State)—New York—History. 7. New York (N.Y.)—Buildings, structures, etc. 8. Landscape—
Social aspects—New York (State)—New York—History. I. Title.

F128.47.T144 2005
974.7'1—dc22

2005021077

British Library Cataloguing-in-Publication data
A catalogue record for this book is available from the British Library.

ISBN-13 978 1 84520 169 2 (Cloth)
 978 1 84520 170 8 (Paper)

ISBN-10 1 84520 169 8 (Cloth)
 1 84520 170 1 (Paper)

Typeset by JS Typesetting Ltd, Porthcawl, Mid Glamorgan
Printed in the United Kingdom by Biddles Ltd, King's Lynn

www.bergpublishers.com

Contents

List of Illustrations

Cover

Robert Bracklow, *Photographing The Flatiron*, ca. 1902.
Photo Collection: Alexander Alland Sr./Corbis. The FLATIRON BUILDING
DESIGN is a trademark of Newmark & Company Real Estate, Inc. as agent for the
owners of the Flatiron Building. All rights reserved. Used with permission.

Color Plates

Figures

Preface

Well into the writing of this work, it took a mention in William R. Taylor's fine book, *In Pursuit of Gotham*, to remind me that I live a few miles away from another Gotham, a village in Nottinghamshire, England, with a reputation, dating from the sixteenth century, for bizarre behavior. From the outset, however, I have been acutely aware that I have taken "New York" to mean not simply New York City but Manhattan and the more obvious parts of that island. Mine is a very partial book and, whatever its strengths, they do not lie in comprehensive coverage. Admittedly, it was part way through the period covered that the five boroughs were incorporated into Greater New York, but my chief justification for Manhattan-centrism is that of an outsider: I hope to comment, but in detailed rather than impressionistic ways, on the visual dimension of what Taylor calls "Gotham" and others simply call "New York" or "New York, New York," to cite an exaggerated version. At least it can be said that, over the years, such narrowness has provoked studies of the boroughs and their neighborhoods. Brooklyn's claim on New York City, for example, is much less interesting than its persistence as Brooklyn after 1898. Reminders of the more neglected histories of the boroughs and their neighborhoods have become stronger as the iconicity of New York has become more clichéd, to the point that New York, New York is also a sight in Las Vegas. Accordingly, this book maintains its narrow focus with less confidence in the concluding chapter. On the other hand, the counterpart to a decentralized focus is that when the World Trade Center was attacked on September 11, 2001, the Brooklyn Promenade became a favored place where people gathered to be part of New York City, and a place to which they still return to leave wreaths and signs of remembrance of a lost city sight.

If coverage is lacking, the book seeks to compensate with close analyses of a large number of images. My assistant, Carol Spencer, tracked down the illustrations with determination and expertise, and I acknowledge the courtesies extended by museums and galleries. However, when key images have not been included I have, whenever possible, given accessible published sources for good-quality reproductions in parentheses in the text, immediately after the title. I wish to thank staff at the Avery and Butler libraries at Columbia University; the Collection of Reba and Dave Williams (with the particular assistance of Bob Siciliano, the Registrar of Prints); the Museum of the City of New York; the New York Historical Society; the New York Public Library; the Whitney Museum of American Art; and the Library of Congress, notably those responsible for its splendid online collections. Robert A.M. Stern and his coauthors have done students of New York City a lasting service

in their series on New York's architecture and urbanism. I am also in the debt of the curators of small and large exhibitions that have brought together important sources over the past few years. I would single out Barbara Weinberg and colleagues, for *American Impressionism and Realism* (1994); Rebecca Zurier and colleagues, for *Metropolitan Lives* (1995); Barbara Haskell, for the first half of *The American Century* (1999); and Michael Shulan and colleagues for *Here is New York* (2001).

I have benefitted from the funding and support in kind provided by the University of Nottingham, the British Academy and the Arts and Humanities Research Board, the last of these on three occasions for related projects. Although the *3Cities* parent project, funded by the Arts and Humanities Research Board, slowed the completion of this monograph, I learned a lot from directing that research and from colleagues who, in different capacities, came together around it: Ben Andrews, Maria Balshaw, Iain Borden, Bill Boelhower, Peter Brooker, Mark Brown, Bart Eeckhout, Richard Ings, Steven Jacobs, Liam Kennedy, Mario Maffi, Glyn Marshall, Anna Notaro, Max Page, Luca Prono, Mark Rawlinson, Eric Sandeen, Carl Smith, Maren Stange, Kristiaan Versluys, John Walsh and Rebecca Zurier. The book was also improved by being aired as lectures at conferences and institutions across the world, and I have been more than ready to accept the suggestions of editors of those publications that have accepted versions of certain chapters and given permission for reuse of material: Maria Balshaw, Peter Brooker, Robbie Goh, Liam Kennedy, Mark Millington, Deborah Parsons and Peter Schneck. Others who have helped in many ways are: Erica Arthur, Sue Currell, Stephen Daniels, John Fagg, Ilene Susan Fort, Mick Gidley, Richard Godden, Eric Homberger, Kevin Hunt, Diana Knight, Richard King, Christoph Lindner, Peter Ling, Peter Messent, David Murray, James Sanders and Jill Tallack.

Douglas Tallack

–1–

The Visual Imagination in Old and New
New York

"A Great City ... Makes its Own ... Optical Laws"

Henry James's *The American Scene* (1907) is an all-but-obligatory starting point for anyone interested in Old New York and New New York – even when James occasionally misses the point. In chapters that chronologically mark the watershed between the New York he remembered from twenty years earlier and the city he encountered on his return in 1904, James at first adopts the view from the Bay, seeking "a sense, through the eyes, of embracing possession" (1968: 99):

> The seer of great cities is liable to easy error, I know, when he finds this, that or the other caught glimpse the supremely significant one – and I am willing to preface with that remark my confession that New York told me more of her story at once, then and there, than she was again and elsewhere to tell. (1968: 99–100)

As we shall be in a later chapter, James is on his way indoors. Before entering the lobby of the Waldorf Astoria, he pauses to regret the forfeit of visual opportunities in the name of the commercial efficiency of the grid:

> New York pays at this rate the penalty of her primal topographic curse, her old inconceivably bourgeois scheme of composition and distribution, the uncorrected labour of minds with no imagination of the future and blind before the opportunity given them by their two magnificent water-fronts. This original sin of the longitudinal avenues perpetually, yet meanly intersected, and of the organized sacrifice of the indicated alternative, the great perspectives from East to West, might still have earned forgiveness by some occasional departure from its pettifogging consistency. (1968: 100–1)

Yet James, himself, overlooks some different visual opportunities released by the avenues and cross-streets. For him, Fifth Avenue did little more than go on its way, affording no space for contemplation or the elaboration of a complex plot, rooted in family and city history. James's alienated perspective brings welcome insights though and, throughout the New York section of *The American Scene*, he touches on many aspects of a visual imagination that envisages, in interesting formal ways, the material structures and infrastructures of the city discussed in this book: the

representational consequences of a glimpse or a considered view of a downtown location, and how a square or a street relates to the assumed totality, sometimes conceived of as an image and sometimes as a sequence of images; or how a city whose grid plan symbolizes rational uniformity should produce such astonishing excesses; or what happens to the past when change is so relentlessly present to the eye. For a domestic novelist, interested in refined consciousnesses, James is remarkably forthright that the project – such as he set himself in literary terms – of representing a city is inescapably bound to material transformations, as evident in bridges, skyscrapers, forms of transportation, street traffic, consumer goods, and so forth. He had learnt a lesson from the years spent in London that "as a great city makes everything, it makes its own … optical laws" (1960: 11). New York would pose special challenges for those working in explicitly visual media.

When visual artists missed opportunities and ignored what was in front of their eyes it was often to invoke exaggerated artistic allusions that only served to underline the novelty of the challenge. This is Joseph Pennell, who was pleased to acknowledge a debt to Henry James:

> As the steamer moves up the bay on the left the Great Goddess greets you, a composition in color and form, with the city beyond, finer than any in the world that ever existed, finer than Claude ever imagined, or Turner ever dreamed. Why did not Whistler see it? Piling up higher and higher right before you is New York. (Pennell 1912–13: 111)

Pennell was capable of responding to New York less lazily than this overblown hymn to the skyline suggests, and at no time more than when he went below ground and inspected excavation sites. When Pennell and other artists did look, or were forced to look, more rigorously and to resort in less automatic fashion to existing models, they not only confronted the dramatic manifestations of rapid urban growth, but sometimes investigated in their works what was literally rather than transcendentally invisible: for example, cross-sections of the city's material and economic infrastructure. Such explorations are commonly credited with becoming more searching, following American artists' enthusiastic embrace of modernism, which came at a pre-existing reality combatively or at least suspiciously. Nevertheless, some of the most intriguing visual projects can be found in the determinedly representational art that was dominant in the late nineteenth and early twentieth century in the United States. Accordingly, one should avoid presenting the visual culture of the two decades either side of the turn of the twentieth century in the light of modernism's subsequent triumphs, initially in the late teens and 1920s, and then, more comprehensively, in the 1950s.

Georg Lukács, a critic preoccupied with the juncture between representationalism and abstraction around which much of the present book circles, is similarly inclined and promotes narrative realism as putting up the stoutest objections to modernist abstraction (Lukács 1978: 131 and 133). The still-influential positions Lukács

advanced on literature give valuable leverage when analyzing a spatial visual form, prompting an understanding of how artists engaged with new kinds of urban spaces. Of course, his conclusions may still be questioned. For instance, in distant views of the city (analyzed in Chapter 5), abstraction, for all its apparent anti-humanism, offers unique structural knowledge of New York City. For his part, Henry James's awareness of an experiential dimension of seeing – an amalgam of modernist obliqueness and symbolist feeling that sought to take "possession" of a sight – comes up against the, for him, dull material contingency of the city's streets. Setting out the commission to illustrate the New York edition of his works to photographer Alvin Langdon Coburn, James directs him to city streets but with a non-representational image planted in his mind, a "presentment" of this or that building or scene (quoted in Weaver 1986: 33). James's own response in *The American Scene* is to dramatize the struggle of the "restless analyst" (1968: 11) with the city streets. The commonality between many writers and visual artists and a lexicon of shared metaphors of perception should not hide differences in approach and agenda. James and, equally, Edith Wharton and William Dean Howells were all sensitive Old and New New York watchers. Visual artists also responded to the city's overall shape, as well as to localized forms, and to the city's physical changes over time, in different weather conditions and from different perspectives, including those provided by the means of transportation required to take people into and around the city. However, they had the directness of their media to capitalize upon, but also to negotiate and to test.

In the face of so much literally to see, an interest in invisible aspects of the city turns out to be a surprisingly rich vein in the photography, film and painting of New York, and also – in the years in question – an instance of discovering in representational visual art insights usually credited to modernism. Rosalind Krauss's revival of the rhetorical term, anamorphosis, when assessing modernism's strategies, is helpful when applied to a broader range of visual art than encompassed by modernism:

> The opacity that is figured in anamorphosis is a matter of point of view: one can see the image correctly if one can get to the correct position. Whereas the invisibility that arises within modernism is not so obviously physical: it is tinged or affected by the unconscious, and in this unconscious invisibility there isn't any correct perspective or other vantage point. It can only be reconstructed in the modality of a different form like language. (Krauss 1988: 83–4)

Krauss goes on, in a later study, to explore facets of the optical unconscious (Krauss 1993). The present book has a more limited, though still demanding, aim: to examine, through close analysis of examples, the interaction between visual artists and the phenomenon of a city on the move and growing with alarming rapidity and in vertical and horizontal ways that were different in degree from what the world had seen before. In the process, New York manifested aspects of modernization,

such as rational systematization and loss of visible contact, that produced striking cross-overs with the concerns of artists grappling with such formal developments as abstraction and arbitrary reference.

What was happening, over and below ground level, in sight and out of sight, was undoubtedly taking place and was, tangibly, there. Perhaps, as the word implies, it is the fate of all illustrations, and particularly photographic ones, merely to confirm the prior existence of people, objects and events. This relegation of the visual is questioned by John Kasson when putting the case for close formal analysis as being equally valid for historical understanding as for art criticism:

> The question "What do you see?" can lead to new understandings of the importance of visual evidence, visual thinking, and visual experience in comprehending the life of a culture. Think only how different the whole field of history would be if visual texts were used, not as mere illustrations, selected to confirm what has been previously determined through written sources, but instead as points of entry and springboards for speculation. (Kasson 1998: 95)

In following Kasson's lead, there is no thought to aestheticize images, whether they are already recognized as art objects or are everyday photographs or mass-produced lithographs. Kasson's invitation to "speculate" is rather similar to John Kouwenhoven's call, in *The Columbia Historical Portrait of New York*, to investigate examples of the city's visual discourse as coterminus with the "blind spots and perceptions" of the time, "of which there may be no other surviving evidence" bar the images (Kouwenhoven 1972: 11). It is a lack of consistent evidence of audience reception across such a range of visual sources, as well as some discomfort with the shortcomings of reception methodologies, that leaves us still absorbed with the images themselves and puzzling over what we can make of an anonymous 100-year-old photograph of a section of elevated track or a few seconds of frenetic street activity in a film of a downtown square or even of a comparatively well-known abstract painting of the Manhattan skyline by John Marin. This is less ahistorical than it sounds. The images selected for close attention may be reinserted in an extraordinarily dense and extensive visual record of Old and New New York, whether available in published form (for example, John Grafton's collection of *Harper's Weekly*'s engravings, *New York in the Nineteenth Century*, or the Byron company's *New York Life at the Turn of the Century in Photographs* or Marilyn Symmes' *Impressions of New York: Prints from the New York Historical Society*); or online from the Library of Congress' Detroit Collection of photographs; or in the archives of the New York Historical Society, the Museum of the City of New York and the New York Public Library. Extrapolating from Kasson's and Kouwenhoven's helpful comments, one can pursue productively the line that form and content are in a complex, supplementary relationship to each other that expands across the visual archive. The meaning of a new skyscraper, or a street overtaken by elevated

railroad tracks, or a sometimes unformulated awareness of invisible systems and infrastructures, had much to do with the process of visualizing.

To have included architectural visualizations – other than (in Chapter 2) to enhance an understanding of how the City Beautiful Movement responded to urban change – would have doubled the size of this book, and called for a specialized, professional context. The motives behind an architectural cross-section can be discerned, nonetheless, in some apparently traditional paintings of cross-streets and intersections by the group of urban realists known as the Ashcan School, or in short films taken from the front of a subway train rushing across town. The varied (conditions of seeing) are mixed up with an impulse, running through so much of the visual culture of New York, to obtain knowledgeable points of view on modernity. Certainly, there are theoretical shortcomings in working back from representations of various kinds, but operating the other way round is similarly fraught with objections that can quickly become philosophical standoffs between advocates of form and content, between constructionists and mimeticists. If the complexity, as well as quantity, of images of New York renders the idea of mere illustrations unsatisfactory, we ought similarly to doubt the confidence with which historical conditions are consigned to mere background when a major work of art pursues its formal destiny towards canonic modernism. Inevitably, there is a to-ing and fro-ing between the two positions, but too much methodological introspection could blunt an understanding of the important issues: for example, the multiplying dilemmas facing artists who sought a perspective upon a city expanding like no other, whether the measure is population increase, topography and the grid plan and their impact upon verticality and horizontality, or the technologies of both transportation and representation. By looking at examples of how paintings, films and photographs formally enact change we can come to an appreciation of New York ways of seeing, ways in which urban knowledge is indirectly theorized)

These preliminary considerations inevitably bump up against theoretical and methodological debates dating back at least to Hal Foster's landmark collection, *Vision and Visuality* (1988), Martin Jay's *Downcast Eyes* (1993), and a "uses and abuses" questionnaire on the emerging field of visual culture, conducted by the journal, *October* (1996: 3). No attempt is made, in this book, to venture into the physiological aspects of visual culture and, as noted, reception and audience studies have too narrow an evidential base to be as useful as they otherwise might be. A working, rather than tight, understanding of visuality – the concept announced in Hal Foster's collection – is preferred, and consists of nothing more elaborate than a tension between the material conditions of seeing, and the response, in different media, by a selection of painters (broadly understood), photographers and film makers spread across a range from abstract modernist to journeyman illustrator. That interaction, however, is both extensive and complex. In the many detailed commentaries on key visual works to follow, special attention is given to the conditions of the city, but also to the characteristics of the visual medium because many of the questions mulled

over by Henry James in his encounter with New York are implicated in the resources and practices of different visual media. Though himself visually alert, James's literary vocation enlisted the photographs of Alvin Langdon Coburn primarily as illustrations to the written text. The spatio-visual aspect of the skyline or the avenues or the interior of the Waldorf-Astoria described in *The American Scene* prompted different responses from Coburn and other visual artists, most of whose work James never encountered. Some observations on a painting from a few years beyond the era of New New York, and then on a photograph helping to mark that era's appearance are needed, then, to take us on from James' insights and insularity to locate the theoretical concerns of this study, caught up, as they are, with the questions with which visual artists grappled.

Charles Sheeler's *View of New York* (1931) (Figure 1.1) is an enigmatic visual accompaniment to the etiology of visualizing New York. The lack of a referent for Sheeler's title is intriguing but also troubling: more troubling than in any "untitled" abstract work. Sheeler has not given up on representation in favor of a more modernist aesthetic; if anything, his precisionist style gives *View of New York* a super-real quality, even down to the creases in the cover over the camera in this modern artist's studio. It is not merely the absence of the city that is so arresting, given that the combined resources of painting and photography are on hand. Sheeler questions the underpinning assumptions of visual representation: the open window does not give access to New York and the panes of the window mock the ordering, perspectival grids of the Renaissance. Moreover, Sheeler goes out of his way to confirm that the shrouded object is his camera, the technology that had held out such hopes for capturing reality but which, half a century after Sheeler's painting, became a spur for some of the most astute adumbrations of a visual hermeneutics of suspicion. To make a point about the complexities of visualizing a city, one might put Sheeler's self-conscious, photograph-like painting alongside a photograph of the Flatiron Building (cover illustration) taken around 1902, shortly after the completion of the building. Here, a largely forgotten photographer, Robert Bracklow, beautifully and traditionally centers his composition on Daniel Burnham's skyscraper. The conditions of seeing that result in this photograph are more constructed than is usually the case in architectural photography. In the foreground of this photograph, entitled *Photographing the Flatiron*, there is an anonymous photographer who is intent less upon photographing the Flatiron than upon achieving a close-up of a person whom we (barely) see as part of a now-famous, but then-astounding, New York sight. The mixed motives and overlapping visual spaces do not cancel each other out; neither is the immediacy of the visual medium completely compromised. There could hardly be a better visual introduction to the theme of visualizing New York City.

In *Downcast Eyes*, and in animated debate with other contributors to Foster's *Vision and Visuality*, Martin Jay examines, though eventually resists, what he calls "the denigration of vision" in contemporary theory (Jay 1993; Foster 1988: 3–27).

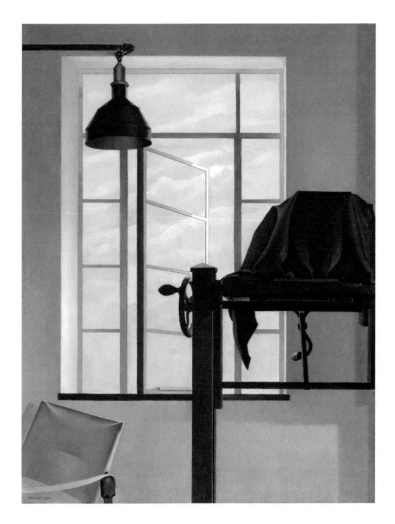

Figure 1.1 Charles Sheeler, *View of New York*, 1931. Oil on canvas, 48 × 36⅜ in. (121.92 × 92.39 cm). The Museum of Fine Arts, Boston, The Hayden Collection, Charles Henry Hayden Fund, 35.69. Photograph 2004 Museum of Fine Arts, Boston.

In reaction against the authority traditionally accorded sight over other senses, right the way from the Enlightenment through romantic and realist aesthetics to high modernism, French or French-inflected theory has identified vision and a prevailing occularcentrism as the site of power relations rather than knowledge. Michel Foucault (1991: 195–228) has had a decisive impact, and the well-documented onset of a surveillance-, panoptic-society has given further credence to critical hegemonic explanations. In *Techniques of the Observer*, Jonathan Crary reworks this paradigm for visual culture and theory, while Michel de Certeau in *The Practice of Everyday*

Life, and Christine Hollevoet and her coorganizers of *The Power of the City/The City of Power*, an influential exhibition at the Whitney Museum in 1992, bring together a critique of visual representationalism and urban space in an opposition between a postmodern mapping impulse and "the scopic pulsion in traditional pictorial representations of cities" (Hollevoet *et al.* 1992: 30). It would be difficult not to be instructed by these critical insights into the visual representation of urban space, especially when, in Sheeler's *View of New York*, we have such a graphic foreshadowing of contemporary theory, coupled with an explicit reference to New York. Situating any urban sight has to be a formative analytic move in which the power of visualization should figure, and it is a move that Chapters 2 to 5 seek to implement. What can be usefully moderated, however, is a headlong rush, in some contemporary theory, to put reference aside. Sheeler does not do this in *View of New York* and, instead, has to represent his doubts. It would be a mistake, then, to dismiss as naive or as merely traditional or as the symptom of a "scopic pulsion," stubbornly optimistic attempts by artists of all kinds – and perhaps, above all, the film makers who traded on a mix of panoramic and voyeuristic city sights – to represent urban space and achieve a point of view. Those efforts accompanied New York's growth, and were redoubled as changes in the city's form created new visual challenges and opportunities.

One should not flatten the rich results of these efforts with overly rigid categories, however useful they may be. It is as well to be cautious when overlaying onto the forty-plus years that encompass the transition from Old to New New York a uniformly smooth development between these eras, or between the available -isms: realism and modernism, with a superior postmodernist scepticism waiting in the wings for the impossibility of representation to be conceded. Briony Fer's advice that, in considering modernism, we might be better talking about "a breach in representation, rather than a building block to abstraction" (1977: 19) is a more enabling outlook, not least because it accepts that modernism could only be a partial representation of modernity, even in New York, a cubist and a dadaist city for arriving European modernists Francis Picabia and Marcel Duchamp. Realism and modernism are so mixed up with each other, and with different aspects of Old and New New York that an account that straightforwardly followed a familiar art-historical story would be as limited as one that related visuality only to material and technological determinants. Sheeler's *View of New York* does sign-off from the viewable city and is a distant anticipation of some persuasive theorizations of this move. At the same time, though, it is the very elaborateness of Sheeler's refusal to see the city that pinpoints his painting as evidence of a compulsion to represent New York that continues to the present. We know what William Taylor is getting at when he regrets that

> Gotham no longer visually registers the dramatic impressions in the way it once did from the shifting economic life of the city. These changes are now registered invisibly. No

wonder the modern city of the comics must resort to the supernatural for explanations of change. Much of what was once fully visible and above ground, on the streets and in the air surrounding its tall buildings, now takes place out of sight, fiber-optically, electronically. (1992: xxvii)

The corresponding theoretical pronouncement is from Jonathan Crary:

Most of the historically important functions of the human eye are being supplanted by practices in which visual images no longer have any reference to the position of an observer in a "real," optically perceived world. If these images can be said to refer to anything, it is to millions of bits of electronic mathematical data. Increasingly, visuality will be situated on a cybernetic and electromagnetic terrain where abstract visual and linguistic elements coincide and are consumed, circulated, and exchanged globally. (1992: 2)

However, invisibility and shifting perspectives have always been a preoccupation of visual artists, lay or professional, even if the onset of modernism and of intangible systems and structures have accentuated it. In our own period we undoubtedly meet more complex forms of representation but, at some level, we cannot but treat them as representations. They help us to get around. Moreover, as responses to the attack on the World Trade Center attest, the option of a return to some older and more trusted visual testimony remains both available and necessary, if not necessarily to be taken purely at face value. The obstinate desire to represent a view of New York persists.

"An Acceleration of Energies": People, Spaces, Movement and Products

This study of urban visuality covers some forty years and makes use of two over-lapping periodizations. The first is Old New York: approximately 1880 to 1900, though in his 1910 photograph, *Old and New New York* (Figure 1.2), Alfred Stieglitz was still able to make visual capital out of the contrast. The second is that in which the city was self-consciously described as the New New York: approximately 1895 to the mid-1910s. John C. Van Dyke may have formally recognized this period with his 1909 book, *The New New York: A Commentary on the Place and the People*, but the period has much earlier roots, but only begins to make sense with the completion of the Woolworth Building in 1913 and its subsequent visual canonization through to the early 1920s. Incidentally, on occasions, as with Sheeler's *View of New York*, some liberties have been taken with the end-date of this study where this has assisted the presentation of key themes. However, the chief focus is upon the 1880s to late 1910s. The Harlem Renaissance, the interplay between modernist art and music, the New York photography of the 1930s, and the full emergence of Hollywood in the 1920s, are all too important in their own right, and in the context of the city in the 1920s and 1930s, to be within the scope of this book.

Figure 1.2 Alfred Stieglitz, *Old and New New York*, 1910. Photogravure, 8 × 6¼ in. (20.3 × 15.8 cm). Minneapolis Institute of Arts, The William Hood Dunwoody Fund.

The remainder of this introductory chapter provides an outline of the main characteristics of Old and New New York and the way they ran into each other and informed the city's distinctive visual imagination. This is a dense relationship, and two complementary theorizations will prove helpful in understanding visual culture throughout this book: Raymond Williams' triad of "residual," "dominant" and

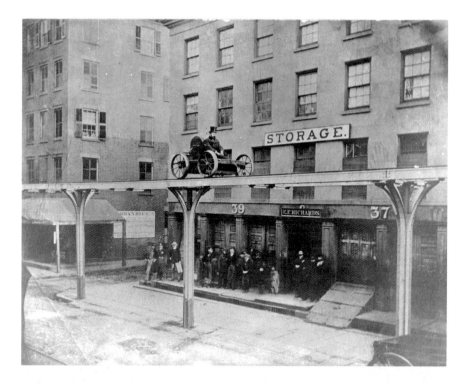

Figure 1.3 Anon., *Colonel Harvey Testing a Cable Car*, ca. 1867, negative number 15129. Collection of The New-York Historical Society.

"emergent" phases of culture; and Fredric Jameson's delineation of an ideological function within modernizing processes: the notion of a "vanishing mediator" (Williams 1977: 121–27 and Jameson 1988: 3–34). Over a forty-year span in New York, visual culture included American versions of impressionism, with its affinity for certain urban spaces; early city photography, for instance of Charles Harvey demonstrating his prototype cable-operated railroad on Sunday morning, December 7, 1867 (Figure 1.3); moving film, again of the elevated trains but of many other exterior scenes across the city; the use of photography for reform and art; and the work of the Ashcan School, a determined group of urban realists contesting for the title of painters of modern American life with a cubist- and futurist-inspired American modernism that now seems inseparable from the city's angular physical structures and varied technologies. The shortcomings or explicitly local context or lack of artistic ambition of many visual works that do not quite make it to what Rem Koolhaas (1994) has called the "delirious" modern of New York, for which a colloquial synonym is the expression "New York, New York," are often more instructive of an emerging modernity or turn out to be just as formally interesting as the more fully achieved image. For comparison, those fully achieved images have been variously found in Berenice

Abbott's *Changing New* York (1935); Jacob Lawrence's *Harlem* series and Mondrian's New York grids, both of the 1940s; the opening sequences of Jules Dassin's *The Naked City* (1948) and *On the Town* (1949); the new phase of Batman films beginning in 1989; Yvonne Jacquette's aerial views, notably *Times Square Triptych* (1986–7); and, terrifyingly, in the visual representations of the World Trade Center tragedy. The quality that has become so evident in these and other examples but which, arguably, appears in more ambivalent forms in the images either side of 1900, may be described as visual excess. We can delineate this quality through formal analysis, often starting out from an understanding of composition. In the years before abstract modernism became dominant in the United States, most visual art worked within a scopic regime, at the center of which (in Martin Jay's words) is "the idea of symmetrical visual pyramids or cones with one of their apexes the receding vanishing or centric point in the painting, the other the eye of the painter or the beholder" (Jay 1988: 6). Against or, more commonly, within this compositional orthodoxy, excessive qualities may be identified and the question of what it is to make visual capital may be posed. Writing of an earlier period, Jay refers to a baroque visuality (1988: 16–8), and this notion is adaptable to New York's visual culture, although an excessive "New York, New York" quality that became firmly associated with the city is beyond the period covered by this book.

The population of New York City doubled to 1.5 million between 1870 and the eve of incorporation of the boroughs on January 1, 1898. The annexation of Brooklyn, the Bronx, Queens, and Staten Island took the population of Greater New York to 3.4 million. By 1925, it was the largest city in the world. The significance for this study of these extraordinary population increases lies in a number of spheres to be explored in detail in later chapters: the appearance of people in the city; the horizontal and vertical expansion of the city to accommodate more people as residents and as workers; and the explicit introduction of time into space via a mass transit system. There was a greater mix of people on local and on through streets, and in the workday population of Manhattan, singled out by E.E. Pratt as a case study in "congestion" and "concentration" (1911: 12). In Lower East Side paintings and photographs by, respectively, George Luks and Jacob Riis, among others, the ambiguities associated with differentiation and discrimination became more evident in the manner in which figures are set against a background, some in their place, while others look out of place. In Riis's work, the details of clothing from different European cultures are preserved but transplanted, by the practice of photography, to a moment in time on a street on the Lower East Side. In close-up street films, such as *Bargain Day, 14th Street, New York* (1905), *Broadway and Union Square, New York* (1903) and *At the Foot of the Flatiron* (1903), particularly when the location is of widely recognized significance, the crowd becomes the background as well as the context in which men and women from different classes and ethnic and racial backgrounds take over the screen. In paintings by American impressionists, postimpressionists and realists, individuals have their own space. In *Union Square*

in Spring (1896) by Childe Hassam (Figure 1.4), people are spread out over a large expanse, whereas in a near-view of Herald Square, *Election Night in Herald Square* (1907) (Figure 1.5) by the Ashcan artist John Sloan, figures are picked out and not merged into a mass, while in Maurice Prendergast's *Central Park* (ca. 1908–10) (Figure 1.6) the horse riders and the passengers in horse-drawn coaches are carefully segregated from the seated onlookers. Generally, people, more than buildings, signal the appearance of a very large city in these street and park images.

The continued increase in population into the 1910s had the paradoxical effect of depopulating many city images. The individuality of the members of the crowds in some early city films, photographs and paintings gives way either to angular or blurred shapes when crowds are included, or to the juxtaposition of buildings, without people. Examples of images conveying this new relationship, or lack of relationship, between people and the city, in which an epic but abstract vision comes through, include Charles Sheeler and Paul Strand's film, *Manhatta* (1920); many of Stieglitz's New York photographs; and paintings by all of the modernists, whether artists such as Hassam, still working in an impressionist style in his Flag series, begun

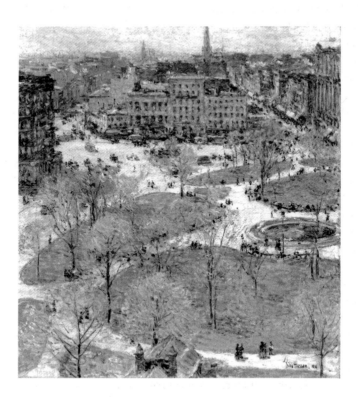

Figure 1.4 Childe Hassam, *Union Square in Spring*, 1896. Oil on canvas, 21½ × 21 in. (54.6 × 53.3 cm). Smith College Museum of Art, Northampton, MA. Purchased 1905.

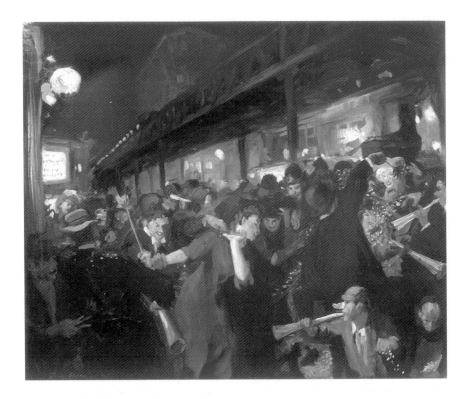

Figure 1.5 John Sloan, *Election Night in Herald Square*, 1907. Oil on canvas, 26⅜ × 32¼ in. (67 × 82 cm). Memorial Art Gallery of the University of Rochester, Marion Stratton Gould Fund.

in 1916, or the new group of John Marin, Max Weber, Georgia O'Keeffe, Joseph Stella and Abraham Walkowitz, all much influenced by postimpressionist European styles. The contrast, sketched out by Georg Simmel, between visuality in rural life, which permitted unobstructed views down a main street or across a landscape, and whatever constituted visuality in a metropolis, derives from European sources but is applicable in exaggerated form to New York, with its concentration of people, many of whom came from either the American hinterland or European villages (Frisby and Featherstone 1977: 175). On city streets, it was rare to find a clear vista, though the city planners of the New York City Improvement Commission found ways, in their visual presentations of a beautified New York, to clear the streets. It is a commonplace that a new style of painting, impressionism, arose in part from the congregating of large numbers of people moving rapidly across one's field of vision on city streets, giving an unexpected authority to the glimpse, while the constant blockages to what was in sight, so that depth of vision gave way to an in-one's-face flatness, encouraged a cubist interest in the fragmented plane of vision; and that certain kinds of painting, but also photography and, especially, moving film lent themselves to the

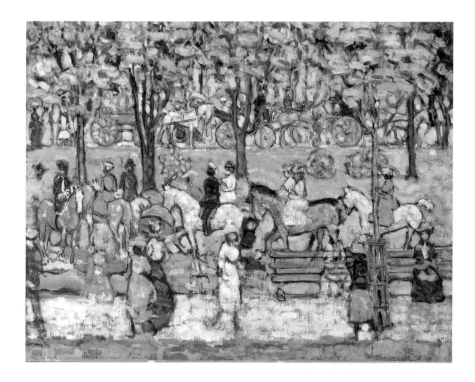

Figure 1.6 Maurice Prendergast, *Central Park*, ca. 1908–10. Oil on canvas, 20¾ × 27 in. (57.2 × 68.6 cm). The Metropolitan Museum of Art, George A. Hearn Fund, 1950 (50.25). Photograph 1991 The Metropolitan Museum of Art.

representation of momentary events and interrupted processes. The artificial lights of the city made light a material form that facilitated representation of the city but also created circumscribed fields of vision, as in Stieglitz's *From the Window, "291"* of 1915 (Stieglitz 1989: 51), in which a lighted sign or lit-up window is surrounded by shadows or more distant grids of lights in the tall buildings.

The physical space of the city had to expand and take on distinctive characteristics to accommodate the rising population. From the 1880s New York began its transformation from a poor copy of Victorian London at the tip of Manhattan and from a poor copy of Parisian modernity around Union and Madison Squares into a city that, by the 1920s, was becoming, and in some eyes already had become, *the* modernist city of the twentieth century. Although Victorian values and ways of doing things remained pre-eminent throughout the Gilded Age and well into the Progressive Era, the urban context of New York consistently tried these values. Victorian forms of order were disrupted in various ways by the speed of the city on the streets, by its skyward and northward growth up the island and by new regimes of electric lighting. Similarly, commerce invaded genteel squares downtown, to be followed

by new arrivals from other parts of the country and Europe. Traveling to and from their places of work, the middle classes made use of the elevated railroad tracks, themselves the signs of a new kind of city and a feature quickly incorporated into the visual discourse of New York. In this rapidly changing environment, the Victorian visual orders to be found in the classical images of Kenyon Cox or the portraiture of John Singer Sargent could only survive in protected and refined enclaves. In New York, the traditional needed to be reimagined more robustly to withstand expansion, and an important strand of City Beautiful imagery, promoted by the New York City Improvement Commission and American Renaissance aesthetics, proved quite successful – with interesting visual outcomes. Two major projects, in effect, re-scaled a city that was otherwise growing incrementally within its rational template. Pennsylvania Station (1902–11), and the adjoining Post Office, and Grand Central Terminal (1903–13) took over blocks of the city and opened up vistas on a European model. In a heavily built-up environment, Grand Central lent itself to some impressionist images in the work of Jules Guerin, whose hazy cityscapes also adorn the City Beautiful's culminating text, *The Plan of Chicago* of 1909. Guerin's Grand Central images project open space into seemingly impenetrable downtowns. A revival of the picturesque in painting and photography also had a transforming, though more localized, impact. Backed up by critical writings by Sadakichi Hartmann and Marianna Griswold Van Rensselaer, artists visualized industrial locations and the newest architecture as though they were exempt from the drive towards modernity. Alfred Stieglitz's comment on the Flatiron Building, whose steel skeleton he had noted under construction as "moving toward me like the bow of a monster ocean steamer – a picture of new American still in the making" (Norman 1973: 45), sits curiously with a snowy vision in one of his best-known photographs, *The Flatiron (New York)* (1903) (Figure 1.7). That photograph exemplifies the way in which Old New York functions, in this instance through aesthetic conventions, as a vanishing mediator to ease and disguise the transition to New New York, at the very time when boosters and politicians coined that phrase.

Writing of the time when New York was pushing north towards Central Park, E.L. Doctorow remarks that "Nowhere else in the world was there such an acceleration of energies. A mansion would appear in a field. The next day it stood on a city street with horse and carriage riding by" (1994: 11). The inscriptions on the landscape of New York were of rivets and string, marking out the streets and empty lots. The grid plan, conceived between 1807 and 1811, consisted of twelve avenues, with 155 cross-streets, running east-west and creating blocks of almost the same size. From its downtown location, south of 14th Street, the city moved slowly northwards to 42nd Street by the 1850s, but by the 1870s and the period covered in Edith Wharton's *The Age of Innocence* (1920), the areas adjoining Central Park to the east, west and north were being unevenly developed. As the frontier of real estate development advanced northwards, the districts left behind were themselves undergoing change, becoming more corporate in the case of the tip of the island. Exponential growth in other directions came in 1898 with

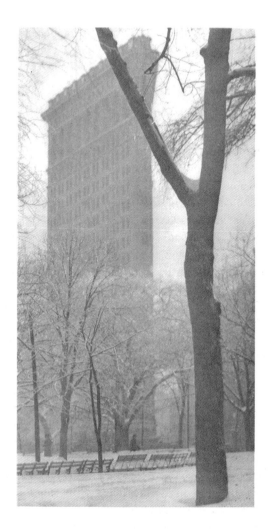

Figure 1.7 Alfred Stieglitz, *The Flatiron (New York)*, 1903. Photogravure, 13 × 6⅝ in. (33 × 16.8 cm). Museum of Fine Arts, Boston. Gift of Miss Georgia O'Keeffe. Photograph © Museum of Fine Arts, Boston.

the consolidation of the five boroughs into Greater New York. This rapid horizontal expansion had other important implications, besides being a test for traditional values and their visual manifestations. The sheer size and heterogeneity of New York made it difficult to envisage a relationship between one view of part of the city and the larger picture; more difficult than was thought to be so in a small town, for instance; or in the vastness of nature, where William Blake's "universe in a grain of sand" at once provoked wonder and a reassuring confidence in the artist's integrating vision. A large city withheld such reassurance, at least until the iconography industry

hit its stride. By the end of World War I, New York's larger picture undoubtedly included an international dimension and this stimulated a proliferation of icons. In the last volumes of Moses King's *Views of New York* (1896–1916), ocean liners and futuristic air traffic begin to embellish drawings of the tip of Manhattan, signaling its pre-eminence as a New York sight. But this is to get ahead of ourselves.

Throughout the overlapping periods of Old and New New York, we can trace a preoccupation, across the spectrum of visual art, with how and from where to envisage a city whose boundaries were either assuming a striking importance in the form of a skyline, or were difficult to identify. Painter George Bellows, sketcher Joseph Pennell, and the camera operators on such short films as *Beginning of a Skyscraper* (1902), *Excavating for a New York Foundation* (1903) and *The Skyscrapers of New York* (1906) found some answers in construction sites to the question, How could the strands of meaning in single static or even moving pictures be knitted together? Construction sites were locations where beginnings, foundations or centers might be visualized. Less dramatically, squares, parks and intersections seemed to reveal aspects of a city from the inside out. Very quickly, the impressions crowding in upon each other around the base of the Flatiron or in Union Square or Central Park lent themselves to sequences, in film but also in series of still images, that make up what many commentators call *flânerie*. But because the physical shape of cities affects forms of visualization, the appropriateness of European models of moving around New York City deserves further consideration. The vertical expansion of the city was visually more dramatic than its horizontal spread. For most of the nineteenth century the city stopped at five storeys but, during the 1890s and 1900s, the skyscraper and skyline became part of New York's image of itself. Remarkably tall buildings and an impressive skyline could be found in Chicago as well but the intensity of the street grid on Manhattan island, and the near 360° opportunities to view the skyline, brought marked differences of degree, rather than kind, between the two cities. Besides which, the film makers and artists gathered in greater numbers in New York. The skyline continued to change, both in height and outline as step-backed skyscrapers followed the Zoning Resolution in 1916, and in company with these changes came the desire on the part of visual artists to identify knowledgeable points of view on this new and different site of modernity. There is a library of images of the skyline, from block diagrams through photographs and panoramic moving films, to almost abstract representations, while there is a further set of images taken or made from the tall buildings themselves. Whatever the visual qualities, though, the overview from a distance is also a historical and material issue, in which – as William Taylor has shown – we may perceive an effort to represent progress, and the specific forces that molded the character of progress in New York (1992: 23–34).

In response to population growth and horizontal expansion, New York developed a mass transit network consisting of the trolleys, horse-drawn and then motorized street-cars, an elev-ated railroad, steam-driven and then electrified, a subway from 1904, and the railroad running into Penn Station, Grand Central and other terminals. William Dean Howells, in the author's preface to his 1890 novel, *A Hazard of New*

Fortunes, refers to "the material city" of New York – to which, like Childe Hassam, he had recently moved from Brahmin Boston and about which he has this to say:

> The transitional public that then moped about in mildly tinkling horsecars is now hurried back and forth in clanging trolleys, in honking and whirring motors; the Elevated road which was the last word in speed is undermined by the Subway, shooting its swift shuttles through the subterranean woof of the city's haste. (Howells 1960: xv)

Movement on trains dramatically changed ways of seeing. This is an argument familiar to us from Wolfgang Schivelbusch's *The Railway Journey: Trains and Travel in the Nineteenth Century*, but in cities rapid transit by elevated railroad gave a notable inflection to the phenomenon. The experience and its formalizing in photography, film and painting was intense: montage-like, with a confusion of elements from buildings, people, signs, and other trains and tracks. Approaching a hundred photographs, paintings and films are devoted to this aspect of New York suggesting, even in the absence of consistent contextual information, a fascination with its impact upon the city and relationship to the city and its expansion. The El was the city's exterior skeleton in its mechanical presence, but it also exerted an intangible influence through the imposition of a time-and-motion structure upon the city. Aside from the views from, and of, the El, the obviously systemic character of any elevated railroad stimulated a specific subset of images. How a system and its infrastructure might be envisaged is an implicit theme that runs through the visual discourse of the El. Some of the most unexpected images are to be found in the papers of the New York City Board of Rapid Transit Railroad Commissioners from the late nineteenth century through to 1907 (see Board of Rapid Transit Railroad Commission, multiple dates). The minutes and reports are regularly punctuated by diagrams, maps and – most revealing of the complexities of envisaging a system – photographs. These are not photographs of the drama and scale of urban transit but of pipes, ventilation shafts, entrances and exits. Although there is not much more that may be said of these once-unremarkable but vital, and now curiously enigmatic, images, they were as much a stimulus to the present study as Alfred Stieglitz's *Old and New New York*, or Charles Sheeler and Paul Strand's *Manhatta* (1920), or George Bellows' *New York* (1911), or seeing the skyline in the distance while crossing the wasteland on the bus from Newark International Airport.

As with population increases and the spread of transportation systems, so too the expansion of the city's economy had an impact upon urban visuality, though not an obvious one. The port handled half of the nation's imports and exports, and by 1914 New York City's manufacturing accounted for around 10 per cent of the nation's output. Comparatively little exposure is given to production in New York's visual culture, although early film interested itself in factory scenes and other work-processes, specialized, as in *Fireboat – "New Yorker" in Action* (1903), and generic, as in films of skyscrapers under construction, sorting refuse and buying and

selling in street markets. Interest waned as the length of films increased but production processes also failed to generate sufficient variety, to the point that the subject had, three decades later, to be halted in exaggerated style in a capstone feature film, Charlie Chaplin's *Modern Times* of 1936. It is true that scenes of work attracted Ashcan artists, while photographers Jacob Riis and Alfred Stieglitz, in their different styles, portrayed, respectively, rag pickers and transportation workers. In the main, though, economic expansion created a world of products for consumption, and an arena in which they could be displayed, and it is in this sphere that the most intriguing interplay between representation and economic expansion can be traced. By showing the purchases in the setting of leisure-class homes, the Byron Company photographers expanded the sphere of display to incorporate any location in which their photographs were viewed in magazines and newspapers. Out on the streets, in *Picture Shop Window* (1907–08) (Zurier, Snyder and Mecklenburg 1995: 154), a painting by John Sloan, we see a darkened street with men and women gazing into the "theatre" of a shop window selling paintings and prints. They are also looking, though indirectly, at the results of hidden production and distribution cycles. These cycles are alluded to a little more directly in William Glackens' *The Shoppers* (1907) (Weinberg, Bolger and Curry 1994: 272–3), in which four middle-class women inspect the dresses laid out by a shop girl. That two of the shoppers are modeled on the wives of Glackens and Everett Shinn suggests a further degree of interest in how images, image makers, consumption, and production interrelate. Among the other locations that regularly inspired painters, photographers and film makers were the walls of buildings or the sides of streetcars covered with posters and advertisements. Film makers, ostensibly recording the passage of an elevated train or a crane lifting a girder on a building site, pause to allow the movie camera to scan advertisements and notices. At one level, the resulting images are simply records of common scenes in a city but these are depictions of a then barely understood phase of an economy at work, the phase in which the object that has been produced to be sold and used has entered its most insubstantial state, as a sign; it has, in effect, become made of the same material as the forms of representation that record it.

Vachel Lindsay, writing about motion pictures in 1915, describes the United States as a "hieroglyphic civilization … that very aspect of visual life which Europe understands so little in America" (1970: 22). In the sheer presence of advertising signs, street information, circulation of images in publications, in exhibitions, in illustrated lectures and, most prophetically, in the locations where movies were shown, New York led this particular American way. In contrast to a political capital, from whose center a marked proportion of information and signs would emanate, in a metropolis based upon capitalist commerce and industry there is no predominant source or location. The city exists in its exchanges. All of this was in place before modernist aesthetics enshrined vision and the spectatorial attitude in an American setting, although it has been a modernist questioning of referentiality and transparency, allied to its interest in surfaces and opacity, that has prompted us to return to images of all kind in a more informed manner.

While the approach, in the following chapters, is to select compelling images and then slow down to do justice to their particularity, it is also important to register the sheer quantity of visual representations of New York across different media – painting, photography, lithographs and woodcuts, cartoons, film, maps and plans – and spanning the spectrum from high art to ephemera. New York became a metropolis at the same time as new technologies of visual representation emerged and interacted with each other and with a city that was introducing other technologies: of transportation across the city but also vertically with the electric elevator; of lighting; and of construction at a more rapid rate than any other city in the world. Moreover, the fact that each representation has a prehistory – even if most cannot now be reconstructed – is at once obvious and, when one thinks about it, quite astounding. A photograph of a train making its elevated way down a stretch of this or that avenue can become infinitely strange because of its sheer ordinariness. Both qualities deserve respect.

"Unexpected Vistas": Visualizing Change

Picturesque New York

Change was everywhere evident, as Old New York seemingly gave way to the loudly trumpeted New New York. However, the attempt to visualize change from within the period resulted in a number of many-layered and sometimes contradictory images that are revealing both of what particular visual forms can and cannot do and of the historical assumptions that underpin a period's visual culture. It is a partly matter of technical and formal resources: photography in the late nineteenth century was still relatively new and film was barely that century's invention. In the more traditional forms there was a marked blurring of the boundaries between painting, sketching, and so on. Finally, the challenge was caught up in aesthetic developments, in the case of the United States an overlap between representational and early modernist modes, with impressionism and more abstract versions of modernism themselves vying for prominence. Because change is such an insistent theme in the visual culture of New York, it crops up throughout this book. In this chapter, though, three instances of visualizing change are examined: as part of a rallying call to artists to seek out the picturesque side of New York; as a factor in the portrayal of interior views of fashionable New York; and, most explicitly, as evident in the subgenre of pictures of building sites.

A notable, although somewhat contradictory, visual response to change was a by-product of claims that end-of-the-century New York was actually worthy of picturing (see Blake 2000, and Schleier 1986). Marianna Griswold Van Rensselaer, in "Picturesque New York," published in *The Century Magazine* in 1892, and Sadakichi Hartmann, in "Plea for the Picturesqueness of New York," published in *Camera Notes*, in 1900, were leading proponents of this claim, though the idea of the picturesque crops up to some purpose in many of the guidebooks and literary excursions that were published around the turn of the century; for example, in Jesse Lynch Williams' *New York Sketches*, where he distinguishes between "scenes not representatively commercial, nor residential either ... but more of the sort that the word 'picturesque' suggests to most people" (1902: 8 and 10). Couching New York's visual worth in terms of its picturesqueness, with that concept's invocation of past aesthetic models (mostly European), introduces some ambiguities into the relationship between change and visuality. Sadakichi Hartmann acknowledges the received wisdom of American

cultural jeremiads, implicitly referencing Henry James's diagnosis in his 1878 book on Nathaniel Hawthorne, but remains optimistic:

> much is lacking here [in New York City] which makes European cities so interesting to the sightseer and artist. No monuments of past glory, no cathedral spires of Gothic grandeur, no historic edifices, scarcely even masterpieces of modern architecture lift their imposing structures in our almost alarmingly democratic land. Despite this, I stick to my assertion, and believe that I can prove its truth. For years I have made it my business to find all the various picturesque effects New York is capable of – effects which the eye has not yet got used to, nor discovered and applied in painting and literature, but which nevertheless exist. (Hartmann 1978: 57)

He then identifies examples of the new urban picturesque:

> A peculiar sight can be enjoyed standing on a starlit night at the block house near the northwest entrance of the [Central] Park. One sees in the distance the illumined windows of the West Side and the Elevated, which rises at the double curve at One Hundred and Tenth Street to dizzy heights, and whose construction is hardly visible in the dimness of night… This should be painted, but as our New York artists prefer to paint Paris and Munich reminiscences, the camera can at least suggest it. (Hartmann 1978: 59)

Hartmann risks other "suggestions for pictures": "the Fulton fish market … the Gansevoort market on Saturday mornings or evenings; the remnants of Shantytown; the leisure piers; the open-air gymnasiums at Stryker's Lane and the foot of Hester Street" (1978: 63). As the examples are generated, the notion of the picturesque is expanded: away from its original sphere of nature towards a new world of work; to encompass vigorous rather than contemplative leisure; and even in the direction of the homes of Jacob Riis's "other half" of the city's population. Van Rensselaer enumerates similarly novel topics for the urban picturesque, thereby confirming that change is the implicit theme to be grasped via this promotion of the picturesque. She also shifts between the places and scenes to be pictured and the "how" of picturing, while Hartmann's elliptical references to "effects which the eye has not yet got used to" and – when writing about the elevated railroad – to "construction [that] is hardly visible," suggest that visualizing change involved more than finding new subject matter. One question is whether the "hardly visible" infrastructural dimension of change is compatible with the emphasis in the picturesque upon visual completeness. Another is whether, with the growth of a cityscape that cannot be located within a landscape, nature could still be relied upon as an important element in the picturesque. At the time, these were often rolled up into the broader artistic preoccupation with how "the eye" accustomed to older cities – European cities but also Old New York – should respond to the modern as it was appearing in a new New York. The underlying issue, however, is extracted by Peter Conrad in *The Art of the City*, where he argues that the picturesque "has an investment in maintaining the status quo" (1984: 72).

Although Van Rensselaer's and Hartmann's essays have the proactive thrust of a manifesto, if a gentle one, the use of the picturesque as a means of looking differently at New York and recording change was already apparent in New York's visual culture. Nonetheless, despite the coming together of criticism and practice, the aesthetic of the picturesque is an unusual choice, given that it has its origins in an eighteenth-century appreciation of a landscape that is other than regular and classical but does not revert to wildness (Gilpin 1974; Price 1971). The urban picturesque is a more confusing visual discourse than we find in the eighteenth-century invention of the picturesque. In the face of dramatic changes in the built environment, a return to nature is not a straightforward option and Van Rensselaer and Hartmann have to look for ways of softening, elaborating upon, editing out the signs of rationalization, the uniformity of rails and gridded streets.

On his return to New York from Europe in 1890, Alfred Stieglitz seemed not to know quite what to do with the city, and *Picturesque Bits of New York and Other Studies*, published in 1897, is one result, although the individual photographs which he, Alvin Langdon Coburn and Edward Steichen made of the Flatiron in the early twentieth century are more revealing. Sadakichi Hartmann welcomed the publication of Stieglitz's book, and picked out *Winter Day* and a few other mostly New York photographs for praise (Hartmann 1991: 278–82). Subject matter initially drives Stieglitz's efforts, though formal issues are inevitably entailed, and these become stronger in *The Flatiron* (1903) (Figure 1.7), where, it can be argued, he fastens upon the literal meaning of picturesque, as that which has the quality of becoming a picture. Thus, he pays careful attention to the limits of the photographic picture, the edges (including the surface) that separate the photograph from what is not photographed. Although all composition is exclusionary, there is little sense of this in *The Flatiron*, which seems to contain all it needs to be meaningful. The photograph is also tonally consistent throughout and, even as the representational drive of the medium asks us to look through the surface, we are largely held there by the softness of outline of the building, the other trees and the benches. Stieglitz's interest in the picturesque overlaps with the phase of photographic history known as pictorialism, and also with his own campaign on behalf of photography as an art that led him beyond both concepts. For a while, at least, the picturesque offered Stieglitz the possibility of retaining aura in a medium that came to typify its loss through the reproducibility of the image. Particularly in his, Steichen's and Coburn's photographs of the Flatiron building, we discern the form of the picturesque as a response, mediated through a specific scene, to a city that was undermining aura through its rapid expansion, channelled via its peculiarly modern spatial layout. The original topography of Manhattan had been flattened, drained, covered over, and gridded throughout the nineteenth century. In reaction, the picturesque mode became a way of according places a special quality by pictorially recomposing them. This is why Hartmann's and Van Rensselaer's essays on the subject turn out to be descriptions, not of places *per se*, but of pictures that might be made by photographers and painters, alike. It

is noticeable that film, with its greater drive towards realism and a sustained, direct temporal relationship with the places, people and events filmed, barely dallied with the picturesque in its early years. The short film, *At the Foot of the Flatiron*, from the same year as Stieglitz's photograph and discussed below, allows none of the time and distance for contemplation that the picturesque image requires. New York so obviously suited the speed-up of film that it was only with the cinematic rise of other cities, to the west, southeast and southwest, that Woody Allen was able to position the city in the past in the opening sequence of his 1979 film, *Manhattan*.

In Stieglitz's *Picturesque Bits of New York and Other Studies* and in *The Flatiron*, the compositional dimension of the picturesque is merged in a sophisticated manner with the theme of nature, which is used to render the city picturesque, though hardly in the eighteenth-century understanding of the concept. Nature becomes a way of creating a picture out of a New York scene that probably did not compare well with the scenes Stieglitz had encountered in European cities and that he includes as "other studies" in his 1897 book. But *The Flatiron* cannot be slotted comfortably into Hartmann's and Van Rensselaer's agenda or regarded as a footnote to the eighteenth-century picturesque. Stieglitz compares the Flatiron with the approaching "bow of a monster ocean-steamer – a picture of new America still in the making" (Norman 1973: 45), yet his photograph of the Flatiron in the snow, while conveying a sense of movement, does not create much, if any, dissonance in the natural snow-covered park scene in the foreground. If anything, the line of benches pens the building into its space, and the stark Y-shaped tree-trunk further halts the forward movement of the building's prow. In effect, the blocking of forward movement makes a picture of the Flatiron by subtly integrating the building into the park scene, with its snow-laden trees in the middle ground, and by creating a textural affinity between the building and the sky. John Marin took this merging of building and background even further in a watercolour from around 1909, *The Flatiron*, and, as in Stieglitz's photograph, the forked tree in the foreground keeps the towering building in its space, an internally framed space because the forked tree also functions as an "antirecessive device," to borrow Mike Weaver's expression (1986:13). In both Stieglitz's photograph and Marin's painting, the Flatiron, in the middle of a cityscape, becomes a part of what is an irregular, but not wild, pictured landscape. The meaning of picturesque in these examples is a scene that is capable of being pictured – in the sense of a scene that attains a certain completeness and can be framed with an apparently casual authority. At this point, a scene worthy of being pictured has become a pictured scene. The supposed authority is nature, in which – because there is no logical place for a frame (each element is synecdochal of the whole) – the frame does not call attention to itself.

In Coburn's *The Flatiron Building* (1909) (Figure 2.1) the onrush of the new America, symbolized by Daniel Burnham's skyscraper, is accommodated by what Weaver calls "a compositional analogue of the building's structure" (1986: 13). The triangles in the line of the building against the sky repeat those of the branches of the

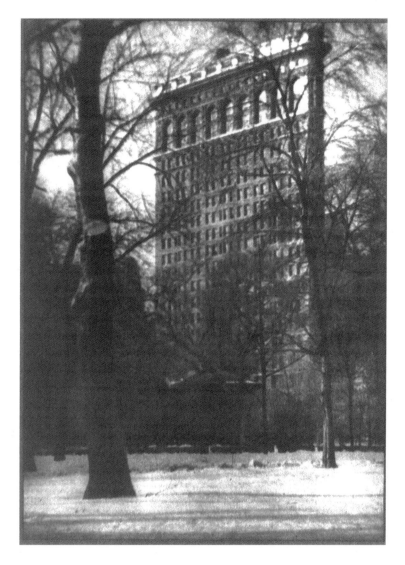

Figure 2.1 Alvin Langdon Coburn, *The Flatiron Building*, 1909. Coburn Archive of the International Museum of Photography at George Eastman House.

trees and suggest a reconciliation, through overall design, between constructed and natural spheres. Coburn's painterly techniques, including use of soft-focus lenses, also gathers the photograph at the surface to a greater extent than in Stieglitz's most pictorial work. Coburn's photograph does not lose its subject matter and does not directly anticipate modernist and abstract work, as do his later vortographs. On the other hand, in this work he does restrain the temptation to look directly through

the surface, as though through a window, and this helps formally to preserve the picturesque. When one does attempt to look through the surface what is seen becomes part of a larger, functioning totality, as Rosalind Krauss explains with reference to "photographic cropping [which] is *always* experienced as a rupture in the continuous fabric of reality" (1986: 115). In Coburn's and Stieglitz's Flatiron photographs, the cutting out seeks not to imply the totality. If it did, the conclusion would be that the picturesque scene had merely to be discovered. Instead, the picturesque must be made by a process of new-seeing in which, as Allan Sekula puts it, "the [authentic] photograph is believed to encode the totality of an experience" (1982: 100). There is a process of what Krauss calls "internal framing," in which an attempt is made "to resolve the image inside its frame and to do so by means of strategies of design that are very familiar from the history of painting" (1979: 134).

The third great Flatiron photograph is by Edward Steichen. Among Steichen's photographs of the building, *The Flatiron* (1904) (Figure 2.2) is a particularly good example of how painterly framing works in a picturesque photographic mode. The Flatiron is the only object in the photograph in sufficient light for its features to be visible, even though there is plenty of interest elsewhere. The coach driver might have been an alternative center to the Flatiron but he remains subservient to the building. The branches of the trees cross in front of the building but do not obscure it and the lights on the streets, although by far the brightest elements in the photograph, are isolated from each other and do not compete with the Flatiron. These points of focus only serve to "resolve the image inside its frame," as Krauss has it, because they are not fully developed enough either to rival the Flatiron or to take our gaze out of the frame. On the latter point, the branches relate to the Flatiron building and not to the invisible trunk of the tree. In spite of the signs of evening, one result of the use of these painterly techniques is the muting of the temporality of photography. In his accounts of waiting for just the right the moment to take the photographs, *Winter, Fifth Avenue* (1893) and *The Steerage* (1907) (Stieglitz 1978: 30, and 100), Stieglitz makes much of temporality. Time passed slowly in the cold in advance of taking the earlier photograph (Norman 1973: 36). Of the latter, the drama is heightened by shortage of equipment: "I had only one plate holder with one unexposed plate. Could I catch what I saw and felt?" (Norman 1973: 64). Yet, the more the work of Stieglitz, Steichen and Coburn approaches the picturesque, the more we encounter what we might call not-happening moments.

What we look at in these Flatiron photographs are pictorially organized spaces. Steichen's *The Flatiron* is one of many examples in city art in which the indistinctness of evening or night-time light helps to manage change pictorially. The loss of absolute clarity at evening time covertly brings elements of the landscape tradition into the representation of the city: buildings are transformed into shapes that evoke woods, rocky outcrops and mountain ranges. The principle effect that indistinct light has upon visual representation is the sustaining of enchantment in the very un-natural environment that, with its drive towards uniformity and rationalized spaces,

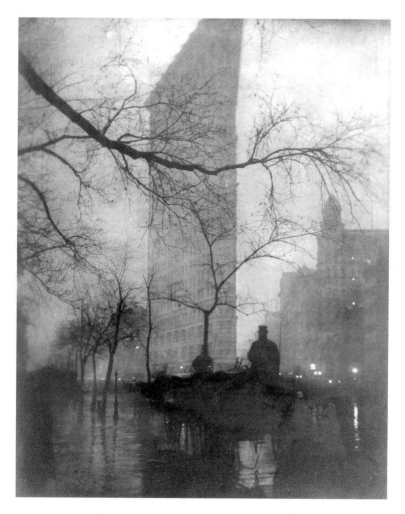

Figure 2.2 Edward Steichen, *The Flatiron*, 1904. Gum Bichromate over platinum print. 47.8 × 38.4 cm (18¹³/₁₆ × 15⅛ in.) The Metropolitan Museum of Art, Alfred Stieglitz Collection, 1933 (33.43.39). Photograph, all rights reserved. The Metropolitan Museum of Art.

was bringing about a modern disenchantment. If electricity was a crucial element in modern rationalization, allowing the transmission of information and the regulation of work and leisure irrespective of time of day or season, its visual effects contributed to the enchantment of New York. Here, too, painting and photography overlap. In the oil paintings, *Spring Night, Harlem River* (1913) by Ernest Lawson, and Childe Hassam's *October Haze: Manhattan* (ca. 1911), and the charcoal, *Skyline View* (ca. 1912), by F. Hopkinson Smith, the loss of clarity is interestingly poised between, broadly speaking, representational and modernist modes: between the realism of straight photography, Ashcan School painting, and actuality films, on the one hand,

and degrees of indistinctness and fragmentation on the other. Of course, there are differences between these nocturnal picturesques (see Corn 1973, Schleier 1986: 33–6, Sharpe 1988, Schivelbush 1988, and Schlor 1998). For instance, Lawson's *Spring Night, Harlem River* (Weinberg *et al.* 1994: 166) and Hopkinson Smith's *Skyline View* are full of the signs of change but present, respectively, a cityscape of magical colors and a city whose angularity has been dispersed into sky and river by the evening light. But in these examples, as in the Flatiron photographs, change is managed through a pictorial re-enchantment of the city. In Alden Weir's *The Plaza: Nocturne* (1911) (Montgomery 1991: 75) or in an anonymous photograph, *Night Scene*, included in the 1915 Moses King's *Views of New York* (King 1977), the lighted city is the totality of the picture. It is difficult to know what could possibly frame, and thereby contextually situate, these images. Either these very similar images of pin pricks of light, in painting and photograph, are the totality of the visual world or there is sheer black nothingness surrounding or framing these lit-up city sights, in which case the impression is much the same: the pictured city is the totality of meaning. There are pictures that share the desire to re-enchant the city by invoking the urban picturesque, but that still acknowledge the incompleteness of such a view, its dependence upon what is invisible. In Coburn's *Broadway at Night* (1909) (Weaver 1986: 47), the low angle positions the streetlights, which are in the foreground, and the neon, which is in the background, in the upper half of the photograph. Beneath this illuminated, super wonderland, in relative darkness, are the tracks in the street and the shadowy lampposts. The effect is comparable to that described by Hartmann, whom we may quote again: "One sees in the distance the illumined windows of the West Side and the Elevated ... whose construction is hardly visible in the dimness of night" (Hartmann 1978: 59). Importantly, though, the still, if "hardly," visible infrastructural dimension of change is not entirely compatible with the emphasis in the picturesque upon visual completeness and unity of composition.

If we follow the crossover between photography and painting in a more sustained way we can pull together into an interpretation earlier observations about the ambiguous relationship between the picturesque and urban change. Joseph Pennell's illustrations for John C. Van Dyke's *The New New York* (1909) tend to contradict the theme of the book, inasmuch as Van Dyke was a proponent of change and the new. Peter Conrad catches the dominant impression: "The illustrations of Joseph Pennell wishfully ruin the city in order to make it pictorially appealing" (1984: 74). *New York from Governor's Island* (1915) (Pennell 1980: Plate 27) frames the tip of Manhattan with embracing trees and the shoreline of the island, while *Sunset, from Williamsburg Bridge* (1915) (Pennell 1980: Plate 30) has the river and its traffic lit up by the sun, and merges the skyscrapers with the "scribble" used to depict dark clouds. Consistently, in Pennell's etchings, skylines are portrayed as irregular natural masses, though the motifs of garlands, ruins and nature are too stylized to be a return to a full romantic aesthetic; instead, Pennell's work fits the understanding of the picturesque as we derive it from eighteenth-century authorities. Pennell's

picturesque is an arena for elaboration, a notion that encompasses decoration as well as the stylistic activity of brushwork or, in photography, soft-focus in Coburn. In Sadakichi Hartmann's words, there is "no difference and no perspective," meaning that there are no sharp outlines distinguishing one feature from another. Moreover, when Pennell stretches the concept of the picturesque too far, to include, again in Hartmann's words, scenes of "the hunger and the filth of the slums, the unfathomable and inexhaustible misery, which hides itself in every metropolitan city" (1978: 60), then Conrad's argument that "picturesqueness tolerates the city's social inequities as a decorative enhancement" and is "a decorative fiction, a lie about society" (1984: 67) seems about right. In looking too singlemindedly for the picturesque in unlikely places, critics and artists sometimes allow the stasis towards which the internally organized picture gravitates to manifest itself in stereotypes. Thus, Pennell's *Not Naples but New York* (1921) (Pennell 1980: 51), and even *Allen Street* (c. 1905) (Zurier *et al.* 1995: 119) and *The Cliff Dwellers* (1913) (Weinberg *et al.* 1994: 194) by, respectively, the Ashcan artists, George Luks and George Bellows, are reactions against the uniformity that the city in its modernizing drive represented, in which a preference for the irregular and the untidily local manifests itself in an interest in the stereotypical.

Having said as much, even Joseph Pennell's work – the chief object of Peter Conrad's indictment of the picturesque – can exemplify an overlooked aspect of the picturesque, if we acknowledge the difficulty of visualizing change with the resources of the past and the present. Just as John Van Dyke was looking for ways to write about the new, Pennell's drawings are not so easily pigeonholed as nostalgic or a rejection of the urban world or a tendency towards stereotypes. It is true that the pattern of Pennell's life resembled Henry James's. He, too, had lived in Europe for twenty years before visiting New York in 1904, on his way to St. Louis, in the same year as James. They were friends and shared many architectural likes and dislikes and an attraction for the older buildings in the city. But Pennell came back to New York, and pursued an interest in construction sites as the most visible intermediary stage between the urban dreamland of fantastic towers that he celebrated in overblown comparisons (New York as "a San Gimignano of the Beautiful Towers" [Pennell 1912–13: 111]) and the old city he knew before leaving for Europe in 1884. To that extent, he was seriously engaged by the challenge of how to picture the changes that were so comprehensively, yet unevenly, under way. Changes often centred upon landmark buildings or structures, and in *Trinity Church from the* River (1904) through to *The Elevated* (1921) (Pennell 1980: 1 and 48), in which it is the elevated tracks that look outmoded, compared with the clean-lined skyscrapers on either side, Pennell respected the importance of giving "the building its due relation to the others which surround it," especially when the surrounding cityscape was being transformed (Pennell 1980: xiii). In his illustrations for Van Dyke's book, but consistently elsewhere, he uses the picturesque and its association with nature and the past to address modernity, specifically to sketch the passing of an older vision

of the city. Rather than turning away from the relentlessly artificial, constructed landscape, Pennell attempts to work out relations between the new and the old. A more sympathetic assessment is that the irregularity of his skyscrapers and their similarity to mountains (a similarity also found in John Marin's work) is a cautious search for a new urban language.

Fredric Jameson (1988) coins the phrase vanishing mediator to explain a process that is not "delightfully, inextricably, mysteriously, perpetually mixed," as Van Rensselaer imagines it to be, but is something more than a conservative impulse. Jameson is writing about modernization theory in Max Weber where the language of religion reassures a society that the future of rationalized behavior is somehow continuous with the present and past of religious observance and devotion. The picturesque, with its use of nature and the past, functions in a similar way in the visual culture of New York to ease the transition to an urban future. A horse-drawn carriage, furrowed tracks and the blurring effect of a snowstorm in Stieglitz's *Winter, Fifth Avenue* (1893) (Stieglitz 1978: 30), combine to act as a transition between country and city, past and present (see Taylor 1992: 5). Aesthetic convention can also function in a similar manner: Lawson's *Spring Night, Harlem River*, for instance, draws on images of royal scenes. Huneker's reference to a "palette of crushed jewels" is apt (quoted in Price 1924: 367). Even as the urban scene is being re-enchanted, though, the delicate paint-marks separate as one comes close to the canvas and never quite recombine at a distance, and in this way introduce a different, discontinuous way of seeing. Impressionism's assault on the assumption that the process of painting ought to be invisible should not be forgotten. Stieglitz's *Spring Showers* (1900) (Stieglitz 1978: 102), is a further instance of the use of nature as a vanishing mediator, one in which the historical context is also a factor. The photograph stands as a reversal of Stieglitz's *The Flatiron* because nature, rather than a building, is central but also penned in. Yet if nature again mobilizes the picturesque by effecting a backward link and compositionally organizing the picture, nature is not necessarily about to disappear. In the terminology proposed by Max Page in discussing "the meaning of nature in the turn-of-the-century city," the sapling is a street tree, and not a tree in a park or in threatened wilderness (Page 1999: 180). Railings protect it. One can reach a similar conclusion about Childe Hassam's painting *Late Afternoon, New York* (1900) (Weinberg *et al.* 1994: 10 and 12), with its lines of saplings, whose protective railings help the trees to resist the inclement weather and proximity of people and traffic just as sturdily as an iron streetlight along the same curb. The trees look to have more of a future than the gas street-light in its competition with the electric light streaming from the buildings in the background.

A few paintings, which might well slot into Van Rensselaer's and Hartmann's search for the picturesque, extend the theoretical explanation offered by Jameson that we have glossed. Peter Conrad offers a clue to taking the argument on a stage when he distinguishes between "the picture [that] laminates and euphemizes the social surface" and "the diagram [that] renders that surface transparent to see how society works"

(1984: 66). George Bellows' *A Morning Snow – Hudson River* (1910) is a good test-case (Figure 2.3). Marianne Doezema treats the riverside paintings as "ingratiating landscapes," made to elicit the approval of the conservative National Academy (1992a: 55), citing Hartmann's "Plea for the Picturesqueness of New York" to the effect that Bellows had successfully redefined the picturesque for the urban scene. It is true that *A Morning Snow – Hudson River* is urban without being ugly and intense, this being a common contemporary reaction to his Pennsylvania station excavation series, to be discussed in the final section of this chapter. In *A Morning Snow* we may be taken by the light palette, the merging, through swirling brushstrokes of snow, earth, smoke, and buildings on the far side of the river, and the typicality of the scene. Still, if its purpose is to mediate change, the picturesque does so in ways that are different from Conrad's dismissive characterization. There is a conflict of claims on the space depicted that roughly corresponds to the categories of "picture" and "diagram." Set against the coherent surface, there is the hesitant appearance of a grid structure.

Patently, this is not an abstract work and the gridlike infrastructure is to be found in the content rather than in Mondrian-like lines. The trees provide the chief verticals, and there are four broad horizontal divisions: the path in Riverside Park with a man and boy walking and an old man clearing the snow; the waterfront place of work;

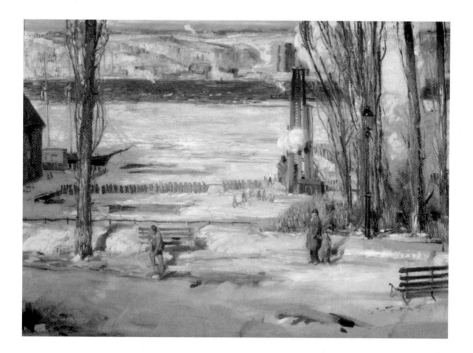

Figure 2.3 George Bellows, *A Morning Snow – Hudson River*, 1910. Oil on canvas, 45⅜ × 63¼ in. (115.2 × 160.7 cm). The Brooklyn Museum of Art, New York. Gift of Mrs. Daniel Catlin 51.96.

the iced-over Hudson River and free-flowing river; and the far shore of factories and then residences, all of which are compositional enlargements of the park benches and metal and wooden fences (see Weinberg *et al.* 1994: 173). This grid gives the picturesque scene a different kind of legibility, more infrastructural than at the surface. It can be tentatively interpreted as a critique of a city spatially divided by class lines that are increasingly, if paradoxically, hidden by the grid plan in identifiable and therefore avoidable districts. To this extent, *Morning Snow* forfeits its pictorial completeness, but can be appreciated as a highly complex painting because the infrastructure becomes partially visible in depicting one location. *Morning Snow* is both general and particular, map and scene. It maps larger structural patterns from within the specific scene. Some of Bellows' paintings of more obvious scenes of deprivation or the impressionists' overviews tend to fall into one category or the other, much as modern life was being similarly sifted, sorted and categorized. The grid in a representational painting becomes a valuable way of thinking about a totality that is more than picturesque, even as it was a material means by which the city could be divided up, and even as it became – in the modernist concept-city – a totalizing vision.

As a final example of what might constitute New York ways of visualizing change in the years before modernist abstraction, we can discuss Maurice Prendergast's post-impressionist *Central Park* (c. 1908–10) (Figure 1.6). This is a very different kind of painting from Willard Metcalf's impressionist *Early Spring Afternoon – Central Park* (1911), in which the city is barely visible (Hiesinger 1991: 226). Metcalf's nature eases, by disguising, the transition from the foreground to the background and to the urban future suggested by the misty outlines of tall buildings. In Prendergast's painting, though, we are made aware of the infrastructure that makes the picturesque possible in the first place. Prendergast's divisionist style produces almost a grid in the park, if the trees and the marked flatness of the painting are also taken into account. The marked horizontal/vertical pattern, aided by the thick paint, brings the painting to the surface, as it were. At which point, we cannot but notice a mistake: the representation of a partially completed figure on a bench competing with what ought to be the continuing but invisible lines of the three wooden backrests. Prendergast even compounds this revealing carelessness by adding a couple of downward parallels, as though the impetus towards the grid has all but supplanted the representation of the person. When we think of Central Park, we usually think of the curvy, natural quality set against the grid by Frederick Law Olmsted and Calvert Vaux when planning the park. But, as Barbara Weinberg *et al.* confirm, nature is structured by the paths, cross-town roads and areas of differentiated activities (1994: 160–1). When Olmsted designed Central Park he also laid out corridors to separate different forms of traffic and with provision for cross-town traffic roads. The incipient grid in Prendergast's painting acknowledges the ordered pageantry that was required if horse, carriage and pedestrian traffic that was approaching urban proportion within the park was to be handled.

The picturesque could not cope with the direction of, and form taken by, change in New York City from the 1910s onwards, on the one hand, and degrees of fragmentation within abstract modernism on the other. Stieglitz and Coburn both abandoned the picturesque by then. In the decidedly un-picturesque modernism of Georgia O'Keeffe's *City Night* (1926) (Benke 2000: 53), night-time light dislocates buildings. The basic elements of light and dark take precedence over manifest content with the result that the relationship between scene and pictured scene that the picturesque seeks to observe is undermined by the abstract, angular pattern. These visual options were not available a few years earlier, however, and the picturesque mode, for all its adherence to the status quo, brought together elements of the old and new. To varying degrees, the picturesque provided a means for visualizing change in the years before abstraction, offering ways of seeing the emerging modern city that was New York in a manner that at least gestures towards theoretical knowledge.

"Phantasmagorias of the Interior": At Home with the Leisure Class

An obsession with elegance, sometimes jarring with a passion for eclecticism, characterized the display of wealth by the great New York families from the Gilded Age to World War I. Three palatial mansions for different members of the Vanderbilt family went up in the early 1880s within a few blocks of each other on Fifth Avenue. At the same time, the Morgan, Astor, Carnegie, Pulitzer, and Whitney families made equally striking moves to remodel parts of New York in their own image. The construction sites that accompanied such activities attracted the interest of visual artists but the changes overtaking New York were also visible inside the houses and other buildings occupied by the leisure class, from new or after renovation. Peter Simmons, the curator of the exhibition, *Gotham Comes of Age: New York Through the Lens of the Byron Company* (1999), instances W.C. Whitney, who spent over $1,000,000 renovating his house on Fifth Avenue and 68th Street and, with the expertise of Stanford White, created "one of New York's most sumptuous Gilded Age interiors" (Simmons 1999: 82. See also Homberger 2002).

The names of the great families indicate that the leisure class was an unstable mix of old and new money. Had it not been so then the leisure class would have kept itself more to itself, even allowing for the cultural vocation that some members of the class pursued. Had there been more segregation, the representation of leisure through elements of a mass, as well as a more select, media would not have become such a cultural imperative. With more heterogeneity in the leisure class than the phrase suggests, the need to display, in order to differentiate oneself from one's peers, fed the proliferation of images, which, along with an expanding population and geography, marked New York's growth as a metropolis. In *The Theory of the Leisure Class* (1899), Thorstein Veblen presents the conundrum for those who sought to display the intangible attribute of being at leisure, not least because of

the awkward requirement that someone should be present to bear witness to one doing little or nothing; perhaps even resting or sleeping during the day. Moreover, ideally, this someone should be less at leisure than the object of attention but, nonetheless, capable of discerning the considerable effort involved in being at leisure. Consumption of goods was a better solution to this troubling challenge, particularly consumption of household goods that offered more scope for making often-subtle distinctions than did exteriors. Yet lavishing attention, discrimination and money upon domestic interiors was still insufficient; these places had to be seen by more people than could possibly visit them, whereas the exterior of one's mansion on Fifth Avenue was easily displayed. One solution was photographic commissions.

Leisure class interiors were a speciality of the Byron Company (the most successful New York photographic enterprise), for instance, when working to a 1894 commission from P.F. Collier, the publisher of *Once a Week*, to concentrate on the houses of New York's Four Hundred. Byron's and others' images of opulent interiors – usually reception rooms of one kind or another – were published in the society pages of New York daily papers, in Sunday supplements, and in *Harper's Weekly*, *Ladies Home Journal*, the *New York World*, *Vogue,* and *Once a Week*. In addition, there were more specialized publications, such as *The Art Amateur: Devoted to the Cultivation of the Art of the Household* (1879 to 1903); *The Decorator and Furnisher* (1882–98); Maria Richards Oakey Dewing's *Beauty in the Household* (1882); *Artistic Houses, Being a Series of Interior Views of a Number of the Most Beautiful and Celebrated Homes in the United States* (1883); and the lavishly illustrated ten volumes of Earl Shinn's *Mr.Vanderbilt's House and Collection* (1883–4) (see Montgomery 1998: 141–62). All helped to spread the tastes of the leisure class, which, accordingly, were no longer a world apart but were consumed within the public culture of the city: vicariously consumed by most but, without doubt, registered in more subtle and penetrating ways within the circles of the leisure class itself. Close analysis of the photographs and also of a few paintings reveals that these images were more than a vehicle for spreading news about leisure class lifestyles. Byron, above all rivals, helped to create an interior visuality that reflected macro-changes, though much less directly than views of New York's phenomenal external vertical and horizontal growth. Skyline and street scenes captured by painters, photographers and film makers have had the greatest impact in defining our view of New York, whereas images of interiors (much like picturesque images) have been too hastily dismissed as part of a late-Victorian cultural drag on modernity. While not as numerically significant as photographs, paintings by American impressionists William Merritt Chase and Childe Hassam are also a part of the visual discourse of leisure class interiors; more than simply a part, because Chase's paintings of his studio in the Tenth Street Building in New York helped to shape the image of the domestic interior in both painting and photography. His studio was a domestic-looking interior to which the public was invited and which was then presented publicly through such paintings as *In the Studio* (ca. 1880) (Weinberg *et al.* 1994: 45) and *The Tenth Street*

Studio (ca. 1889–1905) (Plate 1), both of which strategically position well-dressed women engaged in perusing cultural materials.

In a photograph from 1894 of the parlour in the home of Mrs Leoni (Byron 1976: Plate 8) drapes adorn the windows, naturally enough, but also, and presumably at the direction of Mrs Leoni, the two-tiered mantlepiece, the lamps, and the piano. As Maureen Montgomery has shown, leisure class women capitalized on the greater visual awareness promoted by economic opportunities and new technologies of representation and display to refine a familiar vocation, notwithstanding its domestic sphere: "Women in turn-of-the-century New York 'worked' at signifying leisure" (Montgomery 1998: 12), the insight, in the end, being Veblen's that leisure and consumption were driving forces and signs of status even in a society in which few men and women could afford not to work. Middle- and upper-class women consumed leisure and commodities on behalf of their men and also took on the role of displaying such consumption. Interestingly, though, Mrs Leoni's gingham dress renders her one of the least significant elements of the scene. She merges into the décor of the room. This is also a characteristic of Chase's studio paintings in which the artist and any visitors give way to the room as an expression of the artist's aesthetic. Mrs Leoni's interior scheme emphasizes pattern. We can see that pattern is more exaggerated still in an 1896 photograph of the Reception Room of the Hall House on West 45th Street (Byron 1976: Plate 13). This room is described by Clay Lancaster:

[It] gives the impression of a tent… Except for window stanchions, no hard architectural lines are in view. Ceiling, fenestration, doorway, chimney breast, walls to each side are all draped in billows of patterned textiles. The floor is completely covered with carpeting… Cushions, small tables and tea service are handy for one's comfort and refreshment. It is a room in which to luxuriate, heedless of particulars. Here one's eye can roam passively from one color, one intricacy, one sheen … to the next. The room is an artful achievement conducive to complete complacence. (Byron 1976: xviii)

The photographer is positioned so that the effect is total, suggesting that the intention behind the room and its portrayal was to give relief from the outside world by creating an alternative sphere for display. Lancaster's description also applies to the Hall of the Edward Lauterbach House (Figure 2.4), but the effect of the room is accentuated because the deep focus of an 1899 Byron photograph takes us through a door and into the dining room in the same house. That room features in its own photograph, also dated 1899 (Byron 1976: Plate 29), with a third photograph of the same house, this time of the drawing room, taken in the same year, reinforcing the impression of a space that, while fascinating in its detail, is nonetheless enclosed. In an 1893 photograph of one corner of the Picture Gallery in the Havemeyer House on Madison at 38th Street (Byron 1976: Plate 4), palms intercede between the viewer and the window, rendering faint and indistinct what little we can see through

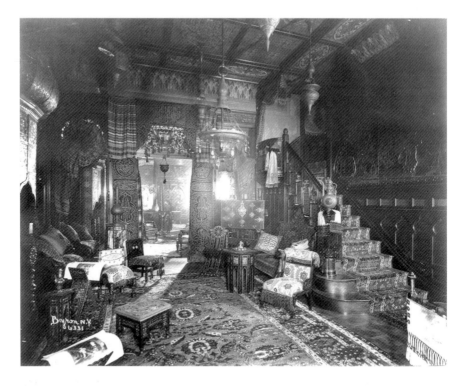

Figure 2.4 *Hall of the Edward Lauterbach House*, 1899. From the Byron Collection of the Museum of the City of New York, 93.1.1.17599.

the window, namely the house opposite and a facing window. When windows are central, as in a photograph of the drawing room in the Whitney House (1899–1900) (Byron 1976: Plate 27), it is still impossible to see out of them. They are, in effect, an opaque wall, facing that occupied by the photographer but offering at least some scope for decorative furnishing through curtains and large plants. As we have seen in the photograph of the hall in the Lauterbach House, the absence of an outside view is compensated for by a view into a competing over-furnished room. Other photographs make much of rooms that give onto conservatories, where giant plants effectively bring the outside inside and help to create interior vistas. The photographer of the Havemeyer Picture Gallery is careful to present the paintings on the walls, while the mirrors in a photograph of a drawing room in Mrs Leoni's house increase the complexity of planes and representations by reflecting a Japanese landscape painting (Byron 1976: Plates 4 and 9). Japanese prints, often on screens, figure prominently in the Byron photographs and counter the illusion of depth, which photography so capably introduces into methods of representation, by bringing the background towards us, not simply because there is little depth in the Japanese images themselves but because the screens frequently block access to the recesses of

a room or stand directly in front of a door, as in a photograph of the dining room in the home of Mrs Mayer (Byron 1976: Plate 14).

The use of furnishings and paintings on the walls constantly elaborates on space. Paintings on the walls are given particular emphasis in the Byron photographs, and are a mixture of classical, society and landscape scenes, with the last of these bringing nature into this interior world. The repeated theme is of Old New York interiors creating a self-referential space that insulates them from the external world. Edith Wharton was greatly interested in interior decoration and coauthored *The Decoration of Houses* (1898) with Ogden Codman, Jr., but it is her novel of old New York, *The Age of Innocence* (1920), which helps to put us quickly in the historical picture and also highlights the spatial dimension of the visual imagination. Early in the novel Newland Archer, in leaving the opera at the Academy of Music on Fourteenth Street for a ball on Fifth Avenue hosted by the Beauforts, a nouveau-riche family, substitutes one relentlessly interior scene for another. Houses such as those described by Wharton stood out against the naked commercial impetus of the grid and the labor needed to fill it. Analogously, the public manifestations of Old New York, such as the Academy of Music and the Astor Place Opera House, were often situated on the few New York squares to have deflected the grid, as though guarding the interior sphere of Old New York. The Astor Place Riots of 1849 marked a temporary failure to patrol the spatial borders, while the Academy succumbed to the competition from the Metropolitan Opera House, which opened in 1883 (see Homberger 2002: 226–31). The Academy closed in 1885, and before the building was demolished in 1926 it had slipped into the world of popular entertainment as a vaudeville theater and a cinema. Wharton's plot drives home the impression that the world of fashionable Old New York was one that furnished itself against the outside world through its tribal rituals and literal furnishing of the interior world, although, as we have seen, Wharton hardly has to exaggerate the visual discourse of the Byron photographs. There is almost too much to look at but it is within a detailed interior circuit, which the photographer takes care to complete, just as Wharton's narratives envelop her characters.

From time to time, in the Byron collection, we are reminded that these are photographed interiors and we are made aware of a tension between an apparent turning of one's back upon the world and a seeming compulsion to display the results of such seclusion. A 1900 photograph of the luxurious parlor in Frederick Wallingford Whitridge's 16 East 11th Street home organizes itself around an elongated mirror on the facing wall (Figure 2.5). In the mirror we can see the reflection of the Byron photographer, framed by the doorway to the parlor. The photographer's right hand is operating the invisible camera and his left hand, above his head, seems to be occupied with the flashlight, with the edge of the flash just visible. We, as viewers, are implicated along with the photographer because we are brought into this supposedly private space and positioned between the mirror and the photographer and his camera. Everyone and everything is within the photographed room. In many respects, then, the Byron camera

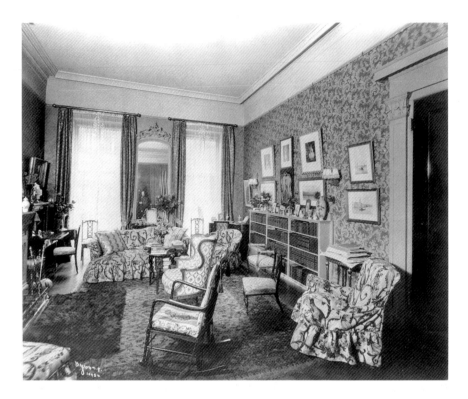

Figure 2.5 *Parlor in the Home of Frederick Wallingford Whitridge*, 1900. From the Byron Collection of the Museum of the City of New York, 93.1.1.10551.

follows William Merritt Chase's brush, and cooperates with the interior designer's campaign to reconceptualize interior space in order that it bear little relationship to the surrounding world of the city. Moreover, in complicating the impression of depth, most of the photographs of New York interiors in the 1890s and 1900s differ from photographs, drawings and paintings of the interiors of houses from earlier in the nineteenth century, which have more in common with representations of sparse colonial New England interiors, or from deep-focus photographs of the modernist houses of Frank Lloyd Wright and Le Corbusier. In these very different interiors, space is organized around depth of vision, sometimes with a key piece of furniture centered and other furniture along the walls contributing to the narrowing perspective that enforced the overlapping ideologies of programmatic modernists, Puritans and Victorians. The effect of a Bryon photograph is also different from that in the many contemporary stereographs of the same over-stocked interiors. Stereographs, as Jonathan Crary explains, were most effective in conveying the experience of "an object-filled space." He adds that that "there are endless quantities of stereo cards showing interiors crammed with bric-a-brac" (Crary 1992: 125), the difference being that in Byron's photographs we lack the (admittedly illusionist) sense of a realistic

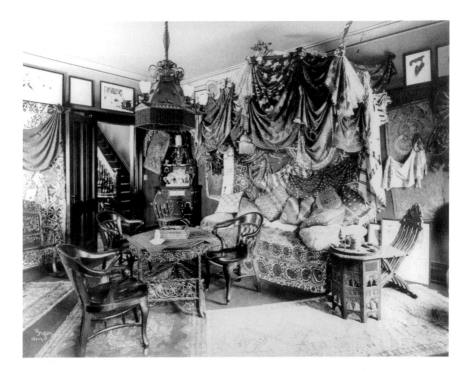

Figure 2.6 *Interior – Lillian Russell's Home*, 1904. From the Byron Collection of the Museum of the City of New York, 93.1.1.9201.

order of this in front of that, that behind this, which the stereograph uncannily imports. The perspective most commonly adopted by the Byron photographer tends to emphasize the surface and the baroque quality of these interiors, making it difficult to identify a point from which everything could be seen all at once.

Martin Jay helps us to understand a baroque visual regime and what is going on in the Byron photographs (Jay 1988: 16–18). Attention concentrates momentarily on a surface detail in such a regime before moving to another detail, a tendency strongly reinforced by a culture of commodities. For instance, at the centre of Byron's photograph of actress Lillian Russell's Turkish den at her West 57th Street home (1904) (Figure 2.6) is a sofa whose plumped up and carefully placed cushions leave little space for sitting. The heavy drapes hanging from the ceiling resemble a curtained stage on which the functionality of objects is put in abeyance. The sofa is at the center of the photograph but the patterns on the drapes and rugs, and inlaid designs on the large pieces of furniture, along with the frieze of framed silhouettes and cartoons, constantly distract the viewer's gaze laterally into horizontal corridors of vision. Aside from a glimpse of the stairway through an open door in the left background, this Byron photograph gives no respite from the onslaught of elaborated detail, from sheer surface eclecticism in which everything is significant

and there is no apparent common denominator. It all fails to add up, this being the kind of devastating understatement that Edith Wharton and Henry James patented in novels that dissected the mix of Old New York interiors and New New York money. Something usually betrays the efforts made by their leisure class characters to keep the outside world at bay. Similarly, to interpret the sheer fullness of any of the interior views by Bryon and others as merely a self-contained "picture" and not as a "diagram" of the larger urban society and the changes it was undergoing is to miss something. In introducing this distinction, Peter Conrad contrasts the indoor New York of James and Wharton with the streets of Stephen Crane by categorizing the former as a picture and the latter as a diagram, which somehow gives access to the informing causes, the infrastructure, one might say, of the image (Conrad 1984: 66). Yet James and Wharton and, in different ways, the Byron photographers do offer access to the compelling, but often bizarre, interior visual logic that Thorstein Veblen also explores in an, at the time, unorthodox theorizing of the surfaces of life and their relationship with reality. Instead of making sense by reference to the common-sense function of a sofa or a window or by reference to the realities of an outside world, these photographs of material excess make sense according to an internal order in which giant plants relate to winding, carved balustrades, and windows and doorways relate to painted or photographed views. The profusion of material goods signifies the commercial trade that brought them together in such an apparently peculiar set of internal relationships. In the 1904 photograph of Lillian Russell's West 57th Street home, for example, we see the results of trading links in the fabrics and furniture of her Turkish den. The foreign and exotic were an antidote to the crassness of economic expansionism on the streets outside, and entered leisure class interiors through many sources, artists' studios being one.

William Merritt Chase's studio became a collector's store, and *In the Studio* (Weinberg *et al.* 1994: 45) and *The Tenth Street Studio* (Plate 1) convey an impression that the artist follows the trader in bringing back items from abroad to embellish a house and inspire an art. In these two paintings, we can make out a Persian carpet, a potted palm, and – hung as ornaments on a wall – a Japanese hat, a lute, and a stuffed swan. But the paintings and photographs reveal more than just the source of goods. The point is that the interior views show capital assuming indirect and often contradictory images, comparable, for example in the apparent unrelatedness of a Persian rug and a Japanese landscape to the contiguities then being encountered in the new department stores, and in a succession of exhibitions. Walter Benjamin has written on such sites of consumption, and has used the concept of phantasmagoria to associate them with interiors in the reign of Louis-Philippe:

> For the private citizen, for the first time the living-space became distinguished from the place of work. The former constituted itself as the interior. The office was its complement. The private citizen who in the office took reality into account, required of the interior that it should support him in his illusions... From this sprang the phantasmagorias of

the interior. This represented the universe for the private citizen. In it he assembled the distant in space and in time. His drawing-room was a box in the world-theatre. (Benjamin 1997: 167–8)

However, there must be a relationship to externality and change, even as both seem to be kept not so much at arm's length but actually out of sight or vaguely intimated through the barely transparent glass of a window. The sheer overfilling of interior space with objects and its presentation as an image signifies infrastructural processes; or rather, as Veblen helps us to understand in *The Theory of the Leisure Class*, the overfilled spaces tell us that infrastructural processes have become all but invisible in a period when the sights of consumption, and the currency of exchange value within a world of accepted conventions of worth were assuming a less supplementary relationship to production. Veblen is quick to add that the image of leisure remains powerful as one goes down the social scale to the point that productive work is essential if even the most minimal pretensions to leisure class membership are to be realized (Veblen 1970: 70). Thus, a useless object retains its power to signify status even when there are few hours free from labor in which to enjoy that object. In *Slum Interior* (1896), one of the few Byron photographs of a tenement interior, a boy is opening a dresser to reveal what appear to be the precious possessions of the rest of his family, who are posed for the photograph (Simmons 1999: 77). Byron's photographs of New York's Four Hundred bear a revealing relationship to the outside, public world, just as Old New York and New New York were linked in a decipherable historical process and not marooned on either side of a cultural rupture. To some extent there is a diagram in the picture, to revert to Conrad's terms. The photographs convey a broader social perception, one that the concept of hegemony helps us to grasp but which is more interestingly pursued here as a substitution of spatial for temporal relations. All of the objects depicted fill space, space that has its logic of relations but which might otherwise be filled by people. When, rather rarely, people are featured in the Byron photographs of leisure class interiors they are all but camouflaged. Quite simply, people are not needed when things are visually so much in evidence. The leisure class is both what it owns and how it displays what it owns. In the photograph of the Whitridge parlour, the Byron photographer doubles as the proprietor of the scene, telling us that these images of overstuffed interiors were made to be seen.

Every now and again, Byron's photographs reveal another dimension of the relationship between interiors and exteriors, one that amends Veblen's basic thesis. A photograph from 1897, captioned *Relaxing in the Parlor* (Byron 1976: Plate 16), is unusual in using a model to depict a young leisure class woman surrounded by the usual accoutrements and with an open book on her lap, but staring vacantly across the room. The photograph catches the sense of visual overload, one element in what Jonathan Crary terms a "crisis of attentiveness" as "the changing configurations of capitalism continually push attention and distraction to new limits and thresholds,

with an endless sequence of new products, sources of stimulation, and streams of information" (Crary 1999: 14). There is little contextual information available to help us with this photograph, but more can be said about a similar photograph of Elsie de Wolfe, in her East 17th Street home. The Byron Company's work photographing the homes of the wealthy overlapped with a commission on the homes of the theater stars whom its photographers had captured on stage. The photograph of actress Lillian Russell's Turkish den at her West 57th Street home, which we commented on earlier, conforms to the dominant impression of a self-contained world, even recreating a theatrical arch through the use of drapes, but it is more difficult conclusively to decipher the 1896 photograph of the sitting-room of Elsie de Wolfe, also an actress, in the home which she shared with Elisabeth Marbury (Figure 2.7). As in the photograph of Lillian Russell's home, there is a strong hint of a stage in the tasselled arch over the sofa in the Cosy Corner on which De Wolfe reclines. The usual accompaniments are visible: large indoor plants, and barely any floor space without cushions or other furniture, or wall space without a painting or drawing. The wallpaper, too, is full of detail, as if in answer to Clarence Cook's *What Shall We Do With Our Walls?* (1881). What is interesting

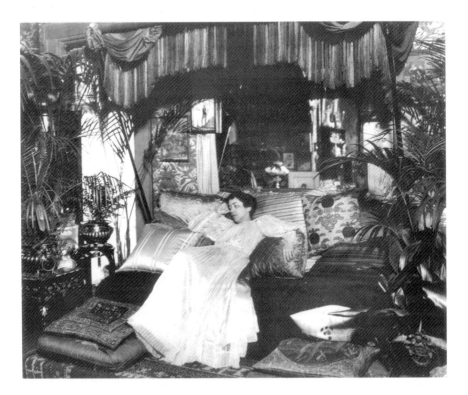

Figure 2.7 *Elsie de Wolfe in her "Turkish Corner,"* 1896. From the Byron Collection of the Museum of the City of New York, 93.1.1.18271.

about this photograph, though, is the vacant expression on De Wolfe's face as she lies propped up on the sofa. She, like the model in *Relaxing in the Parlor*, is a picture of inactivity, apparently an adornment to the room, except that her facial expression does not suggest contentment. The suggestion of vacancy hints at dissatisfaction with this form of enclosure. In 1896 de Wolfe had recently given up her career as a professional actress and was in the process of becoming an interior decorator through her work for Stanford White on the Colony Club at 120 Madison Avenue. While still a truly Gilded Age interior, the Colony Club was a social club for women and, to a degree, took leisure class women out of their homes and involved them in cultural and social activities. In 1912 De Wolfe, herself, took part in a march on 5th Avenue in support of women's suffrage, and also interested herself in the promotion of apartment houses as secure home bases for single, middle-class women looking to the city for careers. Byron's photograph, probably unwittingly, catches Elsie de Wolfe's blank resistance at fitting in with an image of life at home when so many changes were under way in her own life and in those of women generally. But the suggestion of an unwillingness to fit in might also be interpreted as a comment on the package of house and interior photography (for the purposes of public display) which figured so often in society magazines. Interestingly, De Wolfe had opted for a modernist, light and hard-edged style when she remodeled her dining room a few years earlier. This room was also photographed by Byron (Byron 1976: Plate 19) and it may well reflect the preferences of a woman who set out on a career as an interior decorator and set up home with another woman.

When windows are included within Byron's leisure class domestic interiors they are barely visible or are rendered uninteresting in comparison with the excess within. But there is a group of paintings that, in their use of the window as a boundary, speculate upon the question of how to picture change. During the period when Old New York was giving way to New New York, Childe Hassam adapted the standard domestic interiors of William Merritt Chase, Frank Benson and Edmund Tarbell to an urban environment. City windows do appear to some import in the work of Ashcan artists, but they painted windows from the street and either depicted people looking into shop windows or painted people eagerly looking out of windows (see Zurier *et al.* 1995: 146–56). Hassam picked up on a noticeable demographic development in New York, the occupancy by women of Manhattan apartment houses and hotels, and he set out to depict women from within fairly confined city rooms and in ambiguous relations with windows and the city beyond. There is something to be gained by extending the boundary of the leisure class to include women of the rising middle class when depicted at leisure. Between 1907 and 1922, Hassam's *Windows* series reveals a tension between genteel, domestic values and the impact of the changing city of New York. In the same year that Hassam was finishing *The Breakfast Room, Winter Morning* (1911) (Plate 2), George Santayana delivered his memorial lecture to William James, better known as "The Genteel Tradition in American Philosophy," in which the skyscraper, as the symbol of the new, masculine, urban-industrial

America, is juxtaposed with the interior of a colonial mansion, complete with modern conveniences and inhabited by a woman (Santayana 1968: 37–8). Hassam's painting seems quite nicely to illustrate a comparable turning away from the city with its depiction of a woman sequestered or even genteely imprisoned in a room dominated by the veiled window, to which the woman has turned her back. On the other hand, we can still make out the image of the skyline that had been figuring for some fifteen years in magazines, on postcards, and in early films as the pre-eminent visual icon for the city, and which was about to become a favored image in American visual modernism.

In another intriguing painting from the Windows series, titled *Tanagra: The Builders, New York* (1918) (Plate 3), more of the city is visible. We can see the vertical grid of a steel-frame skyscraper through the window, with another tall building behind, even as the city is kept at a distance. Hassam concentrates upon interior elaboration: the woman's dress, the curtains, the expanse of canvas devoted to the screen and its intricate pattern; and upon rival verticals: the woman, the figurine and the tall plant. Hassam reduces, screens out, mythologizes, even naturalizes, the city, and such artistic choices are revealing of the relationship between visuality, historical change and, particularly in his Windows paintings, gender as well. The view of the city and of change is mediated through the solitary woman, the furnishings and drapes of her room, the occasional painting or design, and a window through which light enters, as in a camera obscura. It is as though the outside world is not to be known by the apparently simple act of looking out of the window. Thus, the woman in *Easter Morning (Portrait at a New York Window)* (1921) (Fort 1993: Plate 36) is barely looking out of the window; her eyes seem to be turned inward. Rather, if the city outside is to be known it is as an image in the room, perhaps suggested by a male bust on the window sill in *Easter Morning* looking back into the woman's room. Here, Hassam anticipates Edward Hopper, a very different painter of solitary, urban women. In spite of the polished surface of the table in *The East Window* (1913) (Fort 1993: Plate 29), we do not find an image of the city reproduced in the room, this being the purpose of the aperture in a camera obscura. Instead, we are prompted to look for an allegory of the city to be deciphered through the interior signs. The furnishings, even in *Tanagra*, are not excessive, as they are in the Byron photographs, where there is little temptation to look outside. Still, the city is too indistinct to be a fully satisfying visual alternative. And so the picture, like the woman at the center of the pictorial narrative, remains on the boundary, fully comfortable with neither interior nor exterior view. *Tanagra* suggests the woman is indifferent to the city, and at least momentarily preoccupied with the interior details as she holds the figurine and partially merges with the pattern on the screen. On the other hand, the viewer is permitted to see past her to a building site, then, as now, one of the most typical scenes of change.

A reasonable interpretation of the New York Windows series is that while Hassam never quite came to artistic terms with New York, he had, nonetheless, acknowledged

that its form of urban life pressed more insistently upon interior views than seems to have been the case in his other American city, Boston. In the work of Benson, Tarbell and other members of the Boston School of painters, interiors can sometimes be tense but either no relationship with the city is evident or it is very muted. As the subtitle to *Tanagra* confirms, this is not so with Hassam. Moreover, Elizabeth Hawes' study of the apartment house in New York City from 1869 to 1930, helps to situate Hassam's Windows series. Apartment houses represented a break with tradition, as one male commentator noted: "For family life there is still, I know, a lingering feeling against a flat because it is flat, or on the ground that it is not on the ground" (quoted in Hawes 1993: 213). Apartments were also taken up by feminists. Elsie de Wolfe did not herself live in an apartment but helped to design and promote them: "This is the age of the apartment... Modern women demand simplified living, and the apartment reduces the mechanical business of living to its lowest terms" (quoted in Hawes 1993: 213). Women felt safer in an apartment house than in a private house in a city. There is insufficient visual evidence to link Hassam's women to the lifestyle outlined by De Wolfe but they are poised between it and that portrayed by Benson, Tarbell, Chase, and the photographers of leisure class interiors.

This hypothesis is reinforced by an overlap between the Windows series and Hassam's more famous Flag series. Dating from the period of World War I, this series consists of patriotic paintings of the flags of the United States and its Allies strung out in different New York locations. Three of the twenty-four paintings exhibited at the Durand-Ruel Gallery in New York in 1918 as "A Series of Paintings of the Avenue of the Allies" are of women at windows. All three have been lost but in *The Flag Paintings of Childe Hassam*, Ilene Susan Fort includes black-and-white reproductions of two of them and a photograph of the third on display at the Durand-Ruel Gallery. With the help of her commentary, we can suggest that the parades and the flying of the flags attract the women to the public urban world to a greater extent than in the Windows paintings. In *The Flag Outside Her Window, April 1918* (1918), also known as *Boys Marching By*, a seated woman in an off-the-shoulder garment, pulls the curtain slightly back and peeps out. In *March, 1917* (1919), also known as *The Fifty-Seventh Street Window*, a different, seated woman pulls her curtain fully back to gaze at buildings and an American flag. While in *The High Balcony* (1917), a woman stands looking out through an open window without curtains (Fort 1988: 108–10).

By way of a coda to this specific argument it may be noted that, just as the domestic interior of the leisure class was never purely private, so the extension of the home into selected semi-public spaces, such as restaurants, theaters and hotels was a logical development. These locations became, in Maureen Montgomery's (1998: 64) apt phrase, "a kind of public domestic space." In the Waldorf Astoria, Henry James observed "huge-hatted ladies" encountering "the very firesides and pathways of home" (1968: 105). As Carolyn Brucken explains, writing about the earlier years of the luxury hotel, "while the hotel's exterior proclaimed its connection to a male,

business world, the hotel's interior quietly aligned with the private, familial model of the home" (1996: 211). In a hotel the décor could not be of their own design and, therefore, women could not display their husbands or fathers through the furnishings. Instead, they did so by cultivating their own image in a public place and by putting aside the relative invisibility of Mrs. Leoni in her parlour. Hence, the women appear quite forthrightly in the photographs of hotel and theater interiors in a way that is rare in the photographs of domestic interiors but they could less easily control the images that photographers produced. The leisure class in public was a valuable source of visual copy for newspapers and magazines and for this reason we cannot advance a straightforward argument about women using their photographed images for their own purposes during the Old and New New York eras.

The attempted separation of interiors from exteriors that runs through the photographs and paintings considered in this section has an unintended but authoritative source in Wharton's and Codman, Jr.'s *The Decoration of Houses*, and their efforts to reinstate decoration as a part of architecture, and to respect the value of the domestic interior, in particular (Wharton and Codman, Jr. 1975: xix–xxii and 1–16). After looking more closely at the images, however, one can conclude that the excess of the interior world is inextricably connected to the outside world of the city. And this is where Wharton's novel, *The Age of Innocence*, is once again so perceptive. In looking back, from the 1920s, on Old New York and the rise of new money, *The Age of Innocence* corrects the theory of decoration Wharton had earlier advanced. She uses Mrs Manson Mingott's house to encapsulate the changes that were overtaking New York. Although her house is located in "an inaccessible wilderness near the Central Park ... she was sure that presently the hoardings, the quarries, the one-storey saloons, the wooden green-houses in ragged gardens, and the rocks from which goats surveyed the scene, would vanish before the advances of residences as stately as her own" (Wharton 1974: 15 and 26). In the meantime, Mrs. Mingott persists in the insulating and recreating process that characterizes the grand houses downtown, so much so that the house is self-contained on the ground floor. There are the usual interior vistas, and paintings serve to bring an outside inside. However, as the fate of the Mingott house indicates, the geography of the city did interest Edith Wharton. As the novel moves us northward to Mrs. Mingott's house, the outside cannot be entirely excluded. Although *The Age of Innocence* is a very visual book, the full impact of this tension between the spatial dispensations of the two New Yorks is only made explicit in a startling shot in Martin Scorsese's 1993 film of the book. The geographical location of the Mingott house, and then the arrival of the Countess Olenska and Julius Beaufort after their risqué walk from Madison Square up Fifth Avenue, prepare for what is almost a still of the "large house of pale cream-coloured stone" (Wharton 1974: 14) located within the grid plan, which it sought to deny. Laborers or the unemployed – it is not clear which – inhabit the empty lots, while the city stretches northward, with outcrops of building in an urban Monument Valley, to complete the pairing used by Alfred Stieglitz for his 1910 photograph *Old and New New York*. However, Wharton was possibly more acute

than Stieglitz; or Henry James, who was perturbed by how difficult the city of New York made it to write his kind of novel, though in 1902 he did exhort Wharton to "DO NEW YORK!" (Powers 1990: 34). Where James tended to set old New York against New York, Wharton saw the connection when she remarked that "every Wall Street term had its equivalent in the language of Fifth Avenue" (1965: 365).

"A Sense for Construction": Building Sights

The hero of Henry James's story, "The Jolly Corner" (1908), is surprised at his "sense for construction" (James 1964: 195) on returning to New York City after thirty-three years. It was shared by painters, photographers and film makers who were attracted to the many building sites across the city. Once on the scene, artists had the opportunity to record change and even to address visually the infrastructural bases of change before these were literally covered over. Large construction sites, such as Pennsylvania Station – the main example in this section – were, at once, expansions of the city and interactions between the past and the present, *in situ*, rather than at the edges of the city where the countryside supplied new land.

Even if Joseph Pennell's work should not be pigeonholed as nostalgic and oblivious of the complexities of change, on the whole, he opts for a harmonious view of the old and the new and this is evident in his depictions of construction sites. In his etching, *Hole in the Ground* (1904) (Pennell 1980: Plate 13), old and new are pictured as stages in a process, for all the apparent confusion of activity at ground level. And this was the official view, underpinning the boosterism of New New York. Pennell's friend, Childe Hassam, ventured much less willingly into the sphere of construction, in part because painting change was for him more likely to be essayed in the vein of an impressionist preoccupation with the effects of light and shade and the weather. However, *The Hovel and the Skyscraper* (1904) (Fort 1993: Plate 25) signals an interest in different subject matter. Where labor and urban construction are kept at a distance in Hassam's *Tanagra: The Builders, New York*, or partly smoothed over by Pennell, they are not simply foregrounded but provide the frame for *The Hovel and the Skyscraper*. This painting reverses the composition of *Tanagra*. At the bottom edge of the painting, men are at work on the scaffold of what Hassam chooses to call, and depict as, a skyscraper rather than the church building it apparently was. The inaccuracy of the title confirms what the composition and style tell us, that Hassam wanted to make a point. Labor and urban construction are rendered distinctly, whereas the middle and far-ground of trees and sky, respectively, are blurred in impressionist style. The laborers' tools and equipment are also rendered with some clarity, particularly the pulley mechanism to the left of the painting. Together with a partially visible building, the pulley also forms the left-hand edge of the in-picture frame. A red-brick building is to the right and the top of the painting is taken up by the sky but also by the urban skyline of tall buildings. In this way the painting's extensive but fairly indistinct middle-ground

of park, strollers, carriage, horseriders and hovel is enclosed by the city and its characteristic form of construction: the building of a skyscraper, with all that this form implies about a city and its economic structure.

Alfred Stieglitz's *Old and New New York* (1910) (Figure 1.2) demonstrates that economic power can reverse the usual logic of perspective. In this photograph – taken a year before Santayana delivered his lecture on the genteel tradition – the skyscraper under construction in the background receives the sources of light whereas the older, lower nineteenth-century buildings in the foreground are in the dark, overlooked by us, as viewers, and by the rising structure in the background. In *Old and New New York*, as in Hassam's *Tanagra* and in a great many images from the period, verticality is presented as a steel frame, a grid in the sky. It is not surprising that this image was so common because it was so extraordinary to see infrastructure: to see the full structure appearing before the substance of the building. In the early modern period in New York, a structural vision was being essayed, stimulated by material developments and within what was still a representational aesthetic. A construction site impacts upon visuality to allow for novel construction sights. It is the "space of appearance." This is Hannah Arendt's (1958: 178) phrase, and while she does not apply it to the world of labor and construction, it catches the visual-spatial sense that comes through in much of the visual culture. It should be added, though, that when something appeared in the New York cityscape, something else disappeared, whether forever or fully or partially, and the surroundings changed. Wallace Stevens' poem, "Anecdote of the Jar" has a rural setting but his insight that a new element in the landscape – "I placed a jar in Tennessee" – changes that landscape, also applies in a concentrated fashion to the cityscape (Stevens 1965: 36).

Yet Stevens' insight cannot do justice to the response of early film makers to appearance and disappearance in the cityscape. In *Star Theatre* (1902), cameraman Frederick S. Armitage uses the technology of time-lapse photography to telescope into one minute, fifty-five seconds, the four-week demolition of the famous theater at Broadway and 13th Street. Aside from being a sight that the normal eye could never see, the city is presented as even more unstable than in the regular cycle of demolition and construction. Although he probably had something less frenetic in mind than the upheavals depicted in *Star Theatre*, Joseph Pennell is to the point when he remarks on the "unexpected vistas" that accompanied the demolition and construction that dramatically signaled the process of change in the city (Pennell 1911: n.p.). While not completely overturning the Emersonian romantic priority of natural vision, the influence of the material surroundings upon vision is undeniable and can be explored further through a case study.

When George Bellows, a representational artist, opted for a series of paintings on a topic, rather than discrete works, he was trying to paint change but in an entirely different way from the impressionists or abstract modernists. Impressionists sought to catch the effects of changing light in a single painting, while the later modernists could paint an abstract image and call it "Change" or "Movement" or whatever. By

the time Bellows completed *Blue Morning* (1909) (Plate 4), the fourth and last of his Pennsylvania Station paintings, early American modernism was about to overtake Ashcan realism as the pre-eminent mode for the painting of modern life. Works by John Marin and Max Weber, among others influenced by the Armory Show, evince a lack of literality combined with a desire to know more than can actually be seen. Rosalind Krauss's comments (noted in the first chapter) on the "invisibility of modernism," and her use of the trope of anamorphism are relevant (Foster 1988: 83–4). Anamorphism is probably best exemplified by cubism in which different and literally invisible sides of an object or scene are included in the single image, thereby letting viewers know that what is not normally visible can only be made so through non-representational techniques. Yet there are glimpses of an alternative and – if it does not sound too paradoxical – more material, notion of invisibility at work in the more traditionally painted works of Bellows, as well as George Luks, John Sloan and other urban realists: that of the invisible but historically changing infrastructure, which gives meaning to an apparently discrete surface scene of local color. Bellows was one of a number of artists who not only saw series of paintings as mapping the changes in spatial and temporal relations in a city, but was also drawn to buildings under construction because these are places explicitly undergoing change. Bellows must also have felt that the building of Pennsylvania Station offered the opportunity to represent both historical process and immediate causes, and have realized that construction (as well as light and weather conditions) changed the conditions of visuality: what could be seen and from what point of view. The vast geographical and technological scale of the Pennsylvania excavation was a scene, an event, a process, and a space that was once a place, and would become a different place. Thus, *Excavation at Night* (1908) (Zurier *et al.* 1995: 33) depicts the remnants of that place, even as the tenements on the edge of the Tenderloin were being transformed into the indeterminate space of the excavation crater. The crater is shown as a temporary home for those gathered round the fire. While in *Pennsylvania Excavation* of 1907 (Zurier *et al.* 1995: 99) and *Blue Morning*, a very different place emerges as the great building took shape. This place had become different in itself (a vast hole in the ground and then a hole filled by a building), but was also in a different relationship with the city. The building of Pennsylvania Station brought people fully into the city from the west, rather than depositing them at the New Jersey waterfront. As part of the integrated mass-transit system following consolidation of the boroughs, the new station centralized the area, competing for centrality with Grand Central Station. The meaning of space itself changed, posing questions of how the new station related to the existing grid and how it changed it as it became a new gateway to the city (in the sense that an airport is a gateway to a contemporary city). One could say that Bellows uses a local, particular site as a frame with which to try and comprehend the general and rapidly changing picture. Insofar as this claim has validity, then Bellows' excavation series is another way of painting New York from that which he later tried in his one-off 1911 painting entitled *New York* (see Chapter 4).

In an effort to understand what is going on, Bellows tries out a number of points of view in the series and, as the invaluable research into Bellows' excavation paintings of Marianne Doezema (1992a: 19–55) has shown, *Pennsylvania Excavation* (1907) is painted from Ninth Avenue looking towards the skyscrapers of New York's commercial district. The grid is less visible than in some of the photographs of the site taken from a higher angle, but the trestle carrying Eighth Avenue traffic can be seen, confirming the persistence of the grid in the midst of change. The tall buildings are incorporated into the background to suggest the integration of transportation and commerce. Bellows uses the indeterminate subject matter of *Pennsylvania Excavation* to bring together a vertical/window-perspective and at least the impression of an overview, conveyed by depicting the spatial co-ordinates of the grid. In the middle of all the large-scale material changes, Bellows looks for places and ways in which people can appear in public and thereby at least partially sustain the belief that this is a human narrative. Where the panoramic views of the impressionists (American as well as European) assimilate people into the landscape as smudges and dashes of paint, Ashcan artists often opted for anecdotes: incidents with implied narratives that have a less-than-obvious or an ambiguous relationship to the larger process and picture (see Fagg 2004: 475–8). At times, John Sloan, George Luks and Everett Shinn verge on making anecdote central to their work. In *Cross Streets of New York* (1899) (Figure 2.8) Shinn displays more interest in the meeting, or it may be an altercation, between two local residents than in the larger picture of the street grid. In the Pennsylvania Station series, however, Bellows uses anecdote more traditionally to situate figures in a cityscape and to explore oppositions: center/periphery, and foreground/background, where the background is often more significant. Thus, in *Pennsylvania Excavation* and in *Pennsylvania Station Excavation* (1909) (Haskell 1999: 57) the figures in the foreground are a little similar to the hunters, explorers and Indians who appear in the foreground of mid-nineteenth century Hudson River paintings and suggest a not-always-convincing relationship between historical movement and human agency. There is something of this in the Bellows' paintings, but at least the figures are given some character and are active. Similarly, although the figures around the fire in *Excavation at Night*, painted a year later, are dwarfed by the surroundings, the image evokes labor disputes, even preindustrial rituals, rather than incorporation into the great building project. And again, in *Blue Morning*, a rural scene is evoked by the detail, in the foreground, of a fence and a man sitting on it taking time out from the regime of work.

To a degree, then, people have a place and scale, and modern forces do not wholly diminish them or their role in the city's changes. Bellows seems to achieve this individuation more successfully than the photographers who sought to capture the scale of the Pennsylvania excavation. The more official record of photographs of the excavation for the station and of the completed concourse, together with the maps of Manhattan which superimpose the railroad and subway lines onto the street grid, convey a logical process of construction and usage (Doezema 1992a: 19–55

Figure 2.8 Everett Shinn, *Cross Streets of New York*, 1899. Charcoal, watercolor, pastel, white chalk, and Chinese white on blue-gray paper, 21⅝ × 29¼ in. (55.3 × 74.3 cm). Corcoran Gallery of Art, Washington, DC. Gift of Margaret M. Hitchcock through a Museum Exchange.

and Zurier *et al.* 1995: 30–4). But, as is apparent in *Excavation at Night* and *Blue Morning*, in particular, Bellows offers an infrastructural vision of confused exchange between labor and product, and between the cityscape before excavation began and what might emerge from the smoke and infernal machinery. There is, for instance, no discernible relationship between the builders and the shimmering almost utopian building (reminiscent of the architecture of the 1893 World's Fair in Chicago) on the other side of the pit in *Blue Morning*. In a film set in the excavation crater that Bellows painted, there is a clear separation between workers and the product of their labor, and between means and ends. *Pennsylvania Tunnel Excavation*, filmed by Billy Bitzer and over three minutes in length, is an unusually long film for 1905. It begins with a works train, carrying building materials, appearing from the left and crossing the site. The train has an anthropomorphic quality as though operating irrespective of the laborers, an instance of a machine intervening in the already attenuated relationship between labor and product, people and the changing city. At no time in the 180° pan, does the camera rise far above ground level in the crater. There is a trestle, possibly that depicted by Bellows in *Pennsylvania Excavation* carrying Eighth Avenue across the site but, that apart, this is a world of its own. There is a structure to the excavation world, though, with narrow-gauge tracks

dividing and circling the large site, and from time to time workers cross the tracks or gather to one side. The train at the start of the film also reappears at the end, giving a sense of order. Putting aside the sheer historical fascination of such a film, made in the excavation site of what would become a major New York landmark, the impression conveyed is of extraordinary activity but disconnected from the world at street level. Bellows is more successful in picturing change.

Blue Morning is a very striking painting. An art-historical explanation might easily take off from the title and link *Blue Morning* with tonalism and impressionism, thereby suggesting a largely positive, even triumphal meaning for the series. With the help, again, of Doezema, we can situate the painting differently and thereby identify a more complicated process of knowing and viewing in this depiction of a vast construction site. The painting brings together three elements: the elevated railroad, labor and the building. By 1909 the El was still quite successful, but noisy, and would eventually lose out to both the commuter railroad, which ran into Pennsylvania Station, and the subway, which had opened in 1904. The elevated line in *Blue Morning* is the Ninth Avenue El, and Bellows uses it as a partial frame. This kind of scene, with different elements in the expanding city in competition and often in close physical juxtaposition, fascinated artists. It would be treated very differently in the more explicitly modernist painting that took over after the Armory Show. In work by John Marin, Max Weber and Abraham Walkowitz, abstraction is used to convey the force and energy of the city's elements. The commonsense spatial coordinates that govern representational art are put to one side. In *Blue Morning*, the use of the El and the curious, though still recognizable, perspective adopted accentuates the distance between labor and its eventual, soaring product, the monumental station building. As noted, there is even a suggestion in *Blue Morning* of a rural fence, with someone perched on it taking things easy. Jameson's concept of a vanishing mediator might well explain the conjunction of fence, smoke and the colors. The third element in *Blue Morning* is the building. Pennsylvania Station was a McKim, Mead and White building, and therefore part of an alternative, horizontal, anti-modernist, civic definition of the city that competed with the dominant commercial definition (Taylor 1992: 51–67). But the Beaux-Arts building is partially framed by the Ninth Avenue El. Compositionally, the El emphasizes the surface plane, much as in the more common use of a window frame in discussions of realist art. In twentieth-century art, the grid broke free of its subordinate role as a template, parallel to the picture plane. As it happens, in Bellows' case it is less necessary to argue for representational versions of the modernist grid because he was fascinated by new geometrical investigations and planned many of his paintings accordingly (see Quick 1992: 9–95). Trying to assimilate Bellows to modernism is less interesting, however, than noting the to-ing and fro-ing between formal and historical/geographical commentary. It is this that best brings out the importance of Bellows' work. Accordingly, we should recall that the El was also part of the surface grid plan of New York City, overscoring north-south avenues. As such, its appearance in *Blue Morning* qualifies it as a centrifugal

grid, disappearing off Bellows' canvas as the Ninth Street El did. Rosalind Krauss offers this helpful definition of the centrifugal grid in Mondrian's work:

> By virtue of the grid, the given work of art is presented as a mere fragment, a tiny piece arbitrarily cropped from an infinitely larger fabric. Thus the grid operates from the work of art outward, compelling our acknowledgement of a world beyond the frame. (1986: 18)

It is possible to argue of *Blue Morning* that Bellows shifts back and forth between the different dimensions of the grid in order to represent the complexity of New York's infrastructure in and around Pennsylvania Station or – in painterly terms – the complexity of spatial planes in that building site. The painting's conventions shift, too, between those of a vertical representation and a horizontal map, between the illusion of three-dimensional space and the reality of two-dimensional space on the canvas. To adapt a deconstructive insight, representationalism would seem always to contain its other – abstraction and the impulse to see all at once – just as an abstract work cannot but provoke the effort to interpret through apparently outmoded representational criteria. Bellows' achievement in *Blue Morning* and in the three excavation works that preceded it is defined most clearly as the integration of a historical and material perspective into the formalist and theoretical task of composition. The different ground levels and the intersections of horizontality and verticality were changing daily during excavation and construction and Bellows' series of paintings and the individual works in the series constitute a visual representation of Raymond Williams' entirely sensible proposal that a scene will usually reveal "dominant," "emergent" and "residual" traces of change (Williams 1977: 121–7). But visually representing space in this manner is very difficult – difficult on the canvas because of a shifting between representing and mapping impulses and their associated conventions, and difficult in the decision when and where to paint because the city was changing so rapidly and, with each change it could become more difficult to encompass the city, see its point, and view it. According to Doezema, "it was physically impossible to gain the view of the terminal buildings which Bellows used" for *Blue Morning*. It is somewhere in mid-air with no place, not even a ledge, from which this sight could have been seen in this way (Doezema 1992a: 53). Yet it is precisely by contriving a fictional point of view and representing it conventionally that Bellows seems to have seen in the intersection of the building, the laborers and the El, and in the representational and abstract aspects of the grid, a way of painting what could not be seen. Put rather too straightforwardly, in comparison with Bellows' efforts, there is no one place from which to visualize change. This recognition is at the heart of an important strand of modernism but George Bellows, in common with other seemingly traditional Ashcan painters, contrives to get his feet on the ground from which to try.

"Accident and then Exigency": Elevated Views

"Rapid Transit ... the Most Visible Manifestation of Urban Haste"

Writing about the turn-of-the-century period in *Metropolitan Corridor: Railroads and the American Scene*, John Stilgoe reports that "rapid transit appears again and again in magazine articles as the most visible manifestation of urban haste" (1983: 25). New York's elevated rapid transit system, as it was assembled following the first Rapid Transit Commission of 1875, was supplemented by an extensive visual discourse made up of photographs, films, paintings, and prints of various kinds. By 1922 and John Sloan's painting, *The City from Greenwich Village* (Glueck 1992: 79), images were becoming nostalgic, but in the intervening years the visual discourse had undergone modifications in many respects, affected by changes in the city, in visual technologies, and in aesthetic movements, notably the transition from representational modes to those associated with modernism. In the relationship between the elevated railroad, as a material site, and the images it generated, the founding distinction between the El as subject matter and the photograph, as just one example of a visual form, is not easy to sustain. The El created a distinctive visuality but was itself visually interpreted in both everyday and artistic representations. Including such apparent extremes as an abstract painting of the El and a journeyman photograph can be enlightening. It is precisely the crossovers between the delay and representational distance involved in an abstract painting and the seemingly instantaneous quality of a photograph that remind us that images are neither to be treated as autonomous nor confused with their subject matter.

Three images can serve as a selective introduction to the structure and the thematics of the visual discourse of elevated transit. They appeared in the chapter on "Transportation and Transit" in the second, enlarged edition of the hugely popular *King's Handbook of New York City, 1893*, "First Planned, Edited and Published by Moses King." A photograph, taken at track level at Coenties Slip, emphasizes the freedom of the trains from the confusion of the streets and dock area below (King 1893: vol. 1, 126). A steam engine is approaching the sinuous curve, giving a clear view of the docks, the East River and the far shore, thereby making the connection between the elevated railroad and seeing the sights: we see the broader scene through or via the engine, a notion which Wolfgang Schivelbusch speculates upon to good

effect throughout *The Railway Journey: Trains and Travel in the Nineteenth Century*. The accompanying text in *King's Handbook* declares the elevated railroad to be "the crowning achievement in solving the problems of rapid transit" and favorably compares the views it offered of "the wonderful changing panorama of the Empire City" with "the darkness and monotony and poisonous air of almost continuous tunnels" of London's Underground (1972: volume 1, 138). A drawing, taken from street level looking up at the El at 110th Street and Ninth Avenue, puts the emphasis upon the engineering, the sky above the structures and the amount of light beneath (King 1972: vol. 1, 135). And then a nondescript photograph of the El at South-Ferry Station exemplifies the claims being made for the systemic character of the elevated railroad: the coordinating of the El with water- and street-level transportation, the latter consisting of horse-drawn cars, carriages and carts awaiting the arrival of passengers (King 1972: volume 1, 134).

These everyday images, as much as those formally acknowledged as works of art, help us to explore, as John Kouwenhoven has it, the "blind spots and perceptions" of the time, "of which there may be no other surviving evidence" bar the images (1972: 11). One of the most significant perceptions is probably the time-space equation. While this concept was usually associated with modernist artists, before being comprehensively synthesized by Siegfried Giedion (1967 and 1969), the Rapid Transit Commission also formulated its task as a space-time equation, and turned to illustrations to understand it more fully. New York's fragmented geography of bays, rivers, a mainland that was the source of commuters rather than the object of their transit, and islands, one of which was the narrow strip of Manhattan, where the most intense transit problems were encountered, sealed an affinity between New York City and the project of rapid transit:

> There the greatest traffic flow of its kind in the world occurs twice each business day, [Manhattan] being the bottle-neck into which millions of passengers are poured between eight and nine in the morning, and from which these same millions are siphoned out again between five and six in the evening. (Federal Writers' Project 1938: 346)

The images to be discussed are not, then, a simple illustration of policy or the debates in magazines of the period or the historical development of mass transit or a minor theme in art and literary history. Instead, they offer an understanding of forms of urban knowledge.

"The Right of Way": Representing a System

Following Charles Harvey's first attempt, in 1867, to run an elevated railroad from the Battery to 30th Street, achieving a point of view on what must have seemed an outlandish urban structure proved to be a practical challenge but it was also implicated

in some of the theoretical concerns outlined above. Photographers were among the first to try out different points of view upon, and from, the trestles, tracks and trains. Two photographs of the same area, with similar titles and both from between 1900 and 1906 and, conceivably, sequential images, portray, respectively, the elevated railroad from a distance across a small park and then from almost beneath. In the first, *The Elevated, New York* (c. 1905) (Detroit Publishing Collection: n.d.), a train is photographed crossing the curving tracks over the open space of the park and, in the other, a train is shown coming out of the curve to enter one of the avenues (Figure 3.1). The ground-level perspective accentuates the height of the elevated structure so that it becomes part of the vertical cityscape when the city was not notably vertical. It also becomes an object to be looked at, making this an establishing shot of the El triumphing over the traditional traffic below and assuming its "right of way." Moses King's paean says as much:

> **The Elevated Railroad** is the crowning achievement in solving the problems of rapid transit. By its aid the New-Yorkers fly through the air from end to end of their teeming island at railway speed and in comfortable and well-appointed cars. The simplicity of their structure and the free gift to the companies of the right of way enable these routes to be built at a fraction of the cost of the urban rapid-transit lines in other great cities. (King 1972: vol. 1: 138)

Much the same impression is derived from another group of photographs of the curve of the El at 110th Street (Detroit Publishing Collection n.d.), and from the highly positive images in *King's Handbook of New York City*, which might be seen as a semi-public endorsement of the Rapid Transit Commission's efforts to control and intervene in a private-enterprise economy and thereby resolve the chaos of commuting and integrate different forms of transportation. The *Handbook* was written when "projected subterranean transit" (King 1972: vol. 1: 139) was

Figure 3.1 Anon., *The Elevated, New York*, 1900–6. Library of Congress Prints and Photographs Division, Detroit Publishing Company Collection, LC-D4-18530 DLC.

a doubtful option (the first subway line was completed in 1904) and the elevated railroad is depicted as, at once, physically transcending the confusion of the city yet integral to it.

By 1906, the latest date attached to the photograph of the elevated train entering one of the avenues (Figure 3.1), the idea of transcendent travel had been checked by a number of lawsuits to counter the noise, dirt and ugliness as the single-track roads to one side of the street and powered by cable, quickly gave way to the steam-powered trains on two-way tracks, which all but took over the comparatively narrow streets of the New York grid. In *A Hazard of New Fortunes* (1890), William Dean Howells referred to "L-bestridden" streets (1960: 55), and photographers became interested in the darkness beneath the tracks. More generally, though, the visual discourse of the elevated city adjusted by emphasizing linearity as a sign of progress. In a photograph of the Ninth Avenue Elevated at Gansevoort Street (1873) (Black 1976: Plate 97), the photographer was below the up- and down-town lines. The perspective is so emphatically classical, with the lines of the tracks narrowing severely into the distance, that there is no question of what is dominating the scene. Furthermore, the scene chosen is in need of dominating. At ground level there is virtually nothing: it is almost a frontier scene of mud, a marooned carriage, and a few temporary-looking buildings and the elevated railroad therefore symbolizes what Moses King and other advocates of New New York felt about the city: that it was capable of infinite growth. There is a less harsh lithograph version of this photograph in which the street level is paved and fairly busy, suggesting that whatever the reality – after all, the photographer selected a moment to take the image – the technology could lend itself to severity and an accentuated linearity.

Many photographers and, later, film makers favored a perspective just above track level, which redescribed the visuality of the city and blinkered out some of the problems associated with the right of way and the technology. They adopted the new visual plane of the tracks, rather than standing back to see the elevated railroad primarily as architecture, and portrayed the elevated tracks' streamlined movement through the complexity of downtown areas. The photograph of the snake-curve at Coenties Slip in *King's Handbook* emphasizes the elevated sweeping over the surrounding disorder, while a group of Bowery photographs from the Detroit Publishing Company favor the straight lines of the (Third Avenue) El, with up- and down-town lines on either side of the street (Kouwenhoven 1972: 405 and the Detroit Publishing Collection n.d.). Some photographs were taken from just above track level but also mid-street, and the converging lines of the tracks propel the viewer progressively onwards, irrespective of the Thalia Theater and other immediate locations of pleasure and in contrast to sight-seeing in the traditional, leisured way. In the photograph *Elevated, New York*, discussed earlier (Figure 3.1), the surroundings assume less importance as the train straightens up and attention is fastened upon the converging lines ahead. The view, that is, becomes disciplined to the clear, purposeful line in what might be called a protestant scopic discourse.

While the camera can be used for multiple purposes, photography, as the latest in a line of practices that included the camera obscura, daguerreotype, stereopticon and panorama, helped create an urban visuality that was not neutral but which appeared to be so.

The promise of speed and movement is not always so blatantly presented because the new regime of rapid transit also needed to accommodate itself to tradition. Images that performed this function were often a hybrid of new and old media. As Kouwenhoven notes, for a while the new technology of the photograph assisted rather than supplanted older forms of representation and he instances a pictorial letterhead by Charles Magnus, publisher, depicting the El adjacent to the Thalia Theater. A photograph, dated around 1879, has been used to refine perspective and detail (Kouwenhoven 1972: 27). Yet there are differences, most importantly the impression given by the letterhead that "society" continues at track level. Above the bustle of the street below, well-dressed passengers wait on the elevated platform for what were, in the early days of the elevated railroad, upholstered and gas-lit carriages. In his celebration of turn-of-the-century New York, Steven Millhauser imagines his hero, Martin Dressler, seeking to impress his female companions with the style of the city by introducing them to the interior of the Columbus Avenue El cars:

> Inside he gestured proudly toward the oak-paneled ceilings, as if he had designed them himself, pointed out the mahogany-trimmed walls painted with plants and flowers, the tapestry curtains over the wide, arched windows; and guiding the three women past the long seats that ran parallel to the walls, he led them to the center of the car, where a group of red leather seats were set at right angles to the wall and faced each other. (1999: 90)

Similarly, one of the visual images which accompanied the opening of the subway in 1904 was a sheet-music cover for Edward Laska and Thomas Kelly's *Come Take a Ride Underground*. It portrays almost a society scene on the subway platform in the underground/vaulted station, with an inset of the singers, Inness and Ryan, in similar dress to the passengers waiting for an approaching, wood-paneled train (Zurier *et al.* 1995: 31).

More commonly, photographs of the elevated affirm not simply the linear drive of the elevated, irrespective of social mores, but its dominance over the darkened sidewalks and the roadway below; even when a street has its own significance. For example, in a photograph from around 1908 of Herald Square, the focus is very directly upon the 1893 landmark McKim, Mead and White two-story Herald Building (Figure 3.2). Yet, the stark inclusion of the Sixth Avenue El striking northwards to the right of the building enforces the linear organization of the whole photograph and isolates the motivating force of the elevated. In contrast, the angle and orientation of the photograph presents the carriages meandering and pursuing apparently idiosyncratic trajectories along Broadway and across Herald Square. The

Figure 3.2 Anon., *Herald Square, New York*, ca. 1908. Library of Congress Prints and Photographs Division, Detroit Publishing Company Collection, LC D423 – 71A.

rail-bound trolleys lack something of the purpose of the streamlined elevated system because their intercourse appears to be more with the street than the track. They relate to the buildings on the street differently because even when the buildings on either side of the elevated track are taller, rather than decoratively significant, as in the case of the Herald Building, the line of the El assumes a priority unavailable to the trolley, with its more obstructed route. Photographs taken in the heyday of the El make buildings appear accidental, whether or not they had been there before the elevated. In a photograph entitled *"L" Station, Chatham Square, New York* (1905) (Detroit Publishing Collection n.d.), the focus is on the low-slung station and its extension into the right of way in the foreground. The ten- and eight-storey buildings to the left and right are accordingly reorientated towards the tracks, the new visual right of way.

In one of the essays in William Taylor's *In Pursuit of Gotham*, he and Thomas Bender outline a visual and spatial tension in turn-of-the-century New York between the horizontality of the monumental, civic architecture of the city and the verticality of the skyscraper-aesthetic of modernism (1992: 51–67). However, the visual plane of the tracks posits an intriguing alternative. True to its name, the elevated created a (moderately) high-level view for a five-storey late nineteenth-century New York, as is evident from photographs that look up at the tracks as well as from photographs that look down from track level. But the elevated railroad was also part of the horizontality of the city and, to this extent, is an aspect of the relationship with an increasing verticality that Taylor and Bender investigate primarily in architectural

terms. When examined from an explicitly visual perspective, the horizontality of the El is of an unusual kind, one in which the progressive linearity we have already commented on is but a single aspect. The relations between the elevated railroad and what was directly contiguous with it produced a novel cityscape of juxtaposed, even montaged, images which, for a while at least, matched the developing modernism of verticality associated with looking up at or looking down from the first generation of skyscrapers. There are hints of the complexity of these contiguous relations in the series of still photographs of the Third Avenue El at the Bowery, discussed earlier; for example in the image of trains leaving the theater behind and cutting across its decorative face it is intriguing that tracks and façade are part of the same image but the logic of substitution is hardly a metonymical one. It was actual movement on the elevated track that precipitated the full visual complexity, though novelists sought to portray something of this temporal experience. During their journeys on the elevated railroad, Howells's Mr. and Mrs. March in *A Hazard of New Fortunes* become enamoured with the lighting, the station architecture "spun in iron over the cross-street," the branch roads, the intersection with the Grand Depot, and the sights from the tracks, whether they rode "the length of the West Side lines, and saw the city pushing its way by irregular advances into the country" or the Third Avenue line, where Basil March witnesses the "accident and then exigency" of "the frantic panorama" that the line opens up before him (Howells 1960: 61, 260 and 155). However, only a few years after Howells' novel, film was on the (moving) spot.

An American Mutascope and Biograph Company film, *Elevated Railroad, New York* (1903), was shot from the front of an elevated railroad train at one of the large curves in the system, perhaps at 110th Street, on February 24. At the beginning of the one minute film a train coming in the opposite direction is passing alongside but once it has disappeared there is an open view over tenements and then, as the track curves to the right over a road that is itself a bridge over open ground. The camera pans across from left to right as the train curves, at first catching an elevated train traveling in the same direction ahead over the trestles and then a park before coming alongside a dense area of tenements. As the train begins to straighten, the camera pans back to the left, crossing the track before settling briefly upon buildings very close to the track to the left. In negotiating the curve to the right and then back to the left before straightening up the train creates almost a 180° panorama to complete a cityscape that could hardly be imagined prior to the intersection of railroad and cinematic technologies (see Kirby 1997). A film such as *Elevated Railroad, New York* tests critical terminology. Montage is the best bet, and the link between the rapid juxtaposition of images of trains, tracks and city and formal aesthetic practice is basic to this and the other elevated railroad films that have survived. Some hedging of the term is needed, though, because there is an intentionality to montage, notwithstanding the unpredictable results. The freewheeling sequence of images in *Elevated Railroad, New York* is partly determined by the railroad infrastructure, which – aided by the factor of speed – sets up a visual genre, complete with its own

checks and balances. The montaged landscape receives one decisive check from the material infrastructure because the visual exhilaration of the juxtapositions and blurred images is regulated by the linearity of the track. Initially, this occurs when the passing train blocks out all other views; then the track bisects the panorama as the train swings round and back; and, finally, the camera rights itself as it were and compensates for the swing over to the left by fixing on the now straight track ahead. The discipline of the view ahead is emphatically asserted by the prospect of two trains ahead, one on the right-hand track and the other approaching on the left-hand track, leaving the viewing train to pass safely between them on what now emerges as a middle track. Wolfgang Schivelbusch has it that "the railroad choreographs the landscape ... and thus displays in immediate succession objects and pieces of scenery that in their original spatiality belonged to separate realms" (1980: 63). He concentrates on the side-out view, and to it *Elevated Railroad, New York* adds a frontwards view, while retaining the characteristics Schivelbusch notices. The unavoidable signs of the tracks are another indication that vision, whether traditional renaissance vision or fragmented modernist vision, is always implicated in the conditions of seeing.

Having said all this, a qualified, less intentional, notion of montage probably does come closest to conveying the visual effects in *Elevated Railroad, New York*. Thinking back to Taylor and Bender's thesis, the film gives us a consistently horizontal but highly mobile view because, with so much going on at eye level and below eye level, there is no temptation to look upward. Parts of the city become visible from the elevated train that, otherwise, would remain hidden. Its trajectory is one that the walker or the rider on street-level transportation would have been crossed by. Hence, the considerable explanatory value of John Stilgoe's concept of the "metropolitan corridor," which he defines as the "trains, right-of-way, and adjacent built form," their combination of "part environment, part experience" (1983: ix). He instances, as the most intense manifestation of the corridor, the commuter's view of bridges, railroad tracks, roads, canals, and rivers in the industrial zone near Hell Gate Bridge. Rapid transit accentuated the visual discourse of the already established nationwide metropolitan corridor because the sights on the urban stretch were crammed in to shorter journeys and involved constant interaction with the surrounding environment and more frequent intersections with other forms of transport. Naturally, the visual discourse changed as commuting became less of a novelty and photographers and film makers also began to tire of it. Nevertheless, for some years rapid transit remained a visually intense discourse. Within it the cityscape is recombined; blurred by the speed of passage/viewing; and also flattened. The film *Elevated Railroad, New York* is an assault upon the figure/ground relationship in traditional one-point perspective. The visual space is not one that can be easily entered and, for future reference, it is relevant that in this and other early films the issue of modernist abstraction is raised, but via mechanical movement rather than a process of formalist editing out of the signs of depth.

The horizontal visual plane has a second important aspect to it that, again, refines Bender and Taylor's reminder of its importance in a city then becoming more vertical. Rather than direct contiguous relations to either side of the horizontal track, the visual discourse of the El includes literally invisible connections along the tracks that are yet stimulated by the image of one stretch of photographed tracks. Rapid transit shares characteristics of "the machine ensemble," which Schivelbusch defines as "a machine consisting of the rails *and* of the vehicles running on them" (Schivelbusch 1980: 19–20). Part of the meaning of the Herald Square photograph or of the Chatham Square and Bowery photographs taken at track level or of empty or almost empty tracks lies in the implied connections with what is up or down the tracks. These connections are difficult to theorize. They are contiguous and they are metonymical but only within the elevated railroad system. Once accepted, though, this relationship serves to make the commercial, industrial and residential zones part of the same elongated space and time dimension as the suburbs and the countryside.

The particularity of so much of the visual discourse of rapid transit derives directly or indirectly from the idea of a system. This is hardly surprising because from the 1880s through to the 1930s the United States led the way into rationalized, systematized modernity. Two photographs of rapid transit on Brooklyn Bridge are especially instructive. One, dated 1898, is taken at the level of the elevated tracks as they curve in at the Brooklyn end of the bridge and then rise to the apex of the roadway, with Manhattan laid out in the distance on either side of the far tower (Figure 3.3). The photograph supplies a clear view of traffic below and on both sides of the elevated tracks: the trolleys queue in an orderly manner and outside of them are horse-drawn carts. On a walkway between the tracks a few pedestrians cross the bridge. Shop signage is oriented to the curve and the height of the elevated track. A second photograph, dated 1883 and taken from the Manhattan side of Brooklyn Bridge, centres upon the tracks of the cable cars, to be augmented in 1898 by the King's County Elevated trains with both types running at peak times for a further ten years (Figure 3.4). Horse-drawn vehicles are on the outside roadways of the Bridge. Although there is a cable car on the down side, about to leave the bridge, the photograph is centered upon the empty up-side track and upon the wire cable disappearing under the track and driving the car which, though invisible, is making its way into the Brooklyn terminal on the other side of the bridge, in this way compensating for the incoming car. In this photograph, too, the needs of the system appear foregrounded. The wire cable and the cable car on the descent into Manhattan are the most telling signs of the system at work in the larger cityscape. Yet one sign is minimal while the compensating Brooklyn-bound car is literally invisible, telling us that a system can never be fully visible; indeed, that conceiving of a system involves – in both of these examples and also in the case of images invoking other images down the tracks – a detachment of visual signs from their referent. Or as Martin Jay summarily puts it: "modernity, in short, has sometimes seemed coterminous with the very differentiation of form from content" (1993: 147).

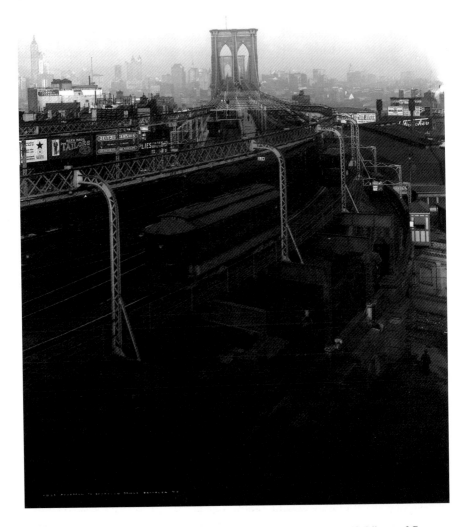

Figure 3.3 Anon., *Approach to Brooklyn Bridge, Brooklyn, New York*, 1900–10. Library of Congress Prints and Photographs Division, Detroit Publishing Company Collection, LC-D428-883.

The railroad industry in general is regularly associated with the dramatically increased systematization of life across the United States after the Civil War: from standardization of timetables to rationalization of business and industrial practices within an emerging corporate economy. Alan Trachtenberg's (1982) "the incorporation of America" is an apt phrase but is not easy to visualize. A photograph,

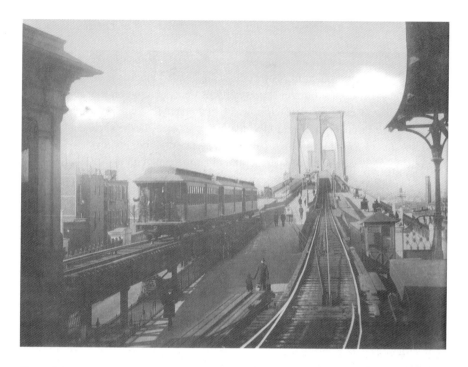

Figure 3.4 Anon., *Cable Cars*, 1883. M.J. Shapiro, *A Picture History of the Brooklyn Bridge*, Dover Publications.

such as the elevated train at Coenties Slip or at the Bowery, might convey physical transcendance but misses the all-but-invisible signs of the integrated system and its accretional apparatus of rationalized internal modification, which became the Taylorization of life under the regime of Scientific Management. Most intriguing are the photographs and diagrams that are included in the New York City Board of Rapid Transit Railroad Commissions' documents, reports and proceedings between 1897 and 1904. Photographs of pipes in the corner of a station or of some switching equipment, or a diagram of power supplies are striking reminders of efforts to envisage elements within a system. Admittedly, photographs of the elevated railroad track, with or without a train in view, come closer to the point than the innumerable close-ups of locomotives (or any engine) in popular and trade magazines in which merely the mechanical structure is on view. In key respects the machine age was not easily represented and, arguably, might be more accurately entitled the age of systems. Understandably, this tag is usually attached to the period of computer technology yet it was the movement of capital itself that was the decisive factor in inaugurating what has now become our own quite familiar virtual age. The railroad companies were simply instrumental in managing this abstraction and giving it a marked temporal dimension in line with their business. In the specific sphere of

rapid transit the integration of economic, administrative and technological factors was merely speeded up, made more intense.

The visual discourse of the subway – the other and, eventually, more successful element within rapid transit in New York – exaggerated this sense of a functioning system, detached from the street-level reality of transportation on foot or by horse-driven vehicle or even by elevated railroad, and created the impression of a world apart (entered through architecturally distinctive kiosks). In the sheet-music cover for *Come Take a Ride Underground*, mentioned earlier (Zurier *et al.* 1995: 31), there is, in the glimpse of a flight of stairs, a hint of connection with the street above, but all the interest is within the subway world and its internal relations. But this or any other image hardly solves the problem of how to represent the larger system, as is indicated by arguments over the years, in New York, as in London, over the best kind of subway map. As designers gave up on the idea that the best map was the one that followed the street-level reality, so they confirmed the new mental orientation that accepted that it was the internal coherence of the system, evident, for example, in its decorative color-scheme, which mattered most. There was a correlation between the greater degree of detachment from the usual coordinates of reality and the success of the subway, over the El, in meeting New York's acute rapid transit needs. However, well before the subway supplanted the El, Rapid Transit Commissioners themselves confirmed that they had made the considerable mental shift and were thinking through the smooth functionalism of the system.

The conclusion to be drawn from the discussion of photographs of the elevated railroad system in general, though the ones of the El at Brooklyn Bridge are particularly revealing, is that photographs can gesture towards abstract or infrastructural knowledge. This is interesting, given that photographs undoubtedly include far more content than any painting and that it is photographs to which we rightly turn for tangible historical information. This issue of abstract knowledge is related to the debate over photography and its claims to represent truth "outside of representation" (McQuire 1998: 30). But the idea of abstract knowledge is to one side of the more familiar debate within photographic theory. Or perhaps this issue turns the debate around because it is the very realism of the photograph, its indexical quality that points to what is not there. The reality of the elevated railroad's tracks in all of the photographs we have looked at makes it difficult to conceive of *those* tracks as discrete and autonomous, as *not* going anywhere or *not* connected with other tracks into a system. And, as painting approaches or draws on photography so it, too, can signify in this manner. Photography and seriality (or perhaps connectedness would be a better term), rather than photography and the one ideal image, is a pairing that theorists from Walter Benjamin to John Berger have insisted upon, though they have tended to argue on the basis of the reproducibility of the photograph rather than the sense of invisibility which is being explored here. In this respect, Stephen Poliakoff's television drama, *Shooting the Past* (1999), is a better guide because his photographic librarians base their actions upon the premise that a photograph's

meaning depends upon there being at least one other photograph to which it relates sequentially; according, that is, to the logic of a life lived in the age of photography.

Railroad images seem to reinforce the pairing of photography and seriality in quite a direct manner. For those tracks in those photographs to be autonomous, someone (an artist) would have to have made them so but the photography of rapid transit carries with it not just the anonymity of the photographer but the odd feeling that the photographer need not have been there. The exigency of photography, which forms part of many claims for photography as an art, is converted into the typicality of the accidental, the notion that this stretch of track just happens to have been the stretch photographed. This is why the title or caption of a photograph is even less adequate than the title of a painting: "Imagine trying to name [in a caption] all the objects in even the simplest photograph, to describe their appearances and catalogue their relations to other objects" (McQuire 1998: 48). Modernist photographers have had to go to much greater lengths than, say, abstract painters to eschew this connectedness, this implying of a larger totality through means other than symbolism. The totality in any one photograph of elevated rapid transit is the rapid transit system itself and, beyond that, the larger infrastructure of urban modernity and the circulation of commodities which railroads of all kinds helped to institute. If the link was straightforwardly synechdochal the photographs of rapid transit would not possess the mix of fullness and emptiness which, in one way or another, equally characterizes a crowded and an empty scene on the El.

"Arbitrary Beginnings and Ends": The Return of Content

At the turn of the century, the elevated railroad began to make an almost casual appearance in a number of paintings of New York. In *Street Scene with Snow (57th Street NYC)* (1902) (Weinberg *et al.* 1994: 11), Robert Henri depicts a spur of the Sixth Avenue elevated railroad crossing 57th Street in the background, and becoming part of that New York scene. Although Henri's is a painting of a relatively affluent street, whereas Everett Shinn's *Cross Streets of New York*, from three years earlier (Figure 2.8), is of a Lower East Side street, the El features and functions in a similar way in both paintings. Compositionally, the El blocks the narrowing vista down a street, the Taylorizing of vision that results from an alliance between the camera and the discipline of the tracks, this being a staple of the photographic discourse of the El. For Barbara Weinberg *et al.* "we are urged into the distance by the convergence of long lines of elegant four-story brownstones on either side of the wide thoroughfare" (1994: 12), but it should be added that the El supplies, in conjunction with other structures, a "back" to the painting, thereby enclosing the space and making it something of a place rather than a space that is merely traversed on our way to the horizon. This section of 57th Street is a place in which residents can walk and meet.

In *Cross Streets of New York*, a street becomes local rather than a thoroughfare once the El crosses it. Shinn's traffic, in particular, seems very local, while his shops and Henri's church become integral to the partially enclosed spaces, seemingly catering to their needs. In one respect this is a surprising impression to receive because, throughout the 1880s and 1890s, many lawsuits claimed that properties that abutted the elevated railroad lost their value because of the noise, the dirty trains and the elevated structure itself, which cut out some people's views and turned their houses into views from the El. In Shinn's charcoal drawing *Under the Elevated* (undated) (Zurier *et al.* 1995: 93), the low angle presents an elevated railroad intruding upon and overshadowing a street scene and a group of cowed people, who are probably too poor to bring law-suits. But in *Cross Streets of New York* and the Henri painting, the El is part of the scene. It is a convenient borderline. Although the snow, the rutted tracks in the streets and the rather threatening sky disallow the idea that these are comfortable scenes, both paintings convey a sense of a peopled neighborhood and it is the materiality of buildings and structures that contributes to this impression. For all their interest in people, the Ashcan artists were hardly oblivious of the material components of visuality. With an obvious qualification, it is tempting to say that the elevated railroad is an important part of the return of content to this city sight. Obviously, content does not return in the sense that there is more detail and information. The photographs we have looked at achieve this end much more successfully than either, or any, painting. But content is there in Henri and Shinn as a theme of community and place that is put into a relationship with the larger transportation system and its meaning for territorial communities, at least. And – though it is at once an oblique and an obvious point – content can only return through the enclosed form of both paintings. The right-angle selected by both Shinn and Henri makes it difficult fully to confront certain aspects of the El that are evident in the photographic discourse. Instead, they seek a reconciliation between the El and the local scene that "places" moments of rapid transit.

John Sloan's *Six O'Clock, Winter* of 1912 (Plate 5) is rather different, even though he shares in the Ashcan School's interest in local, anecdotal scenes. *Six O'Clock, Winter* departs from the careful putting-in-place of the El in Shinn's *Cross Streets of New York* and Henri's *Street Scene with Snow (57th Street NYC)*. In common with many photographs of the city taken between the 1880s and 1910s, and also with two of his other paintings, *Election Night* and *Sixth Avenue and Thirtieth Street* (both 1907) (Figure 1.5 and Plate 7), *Six O'Clock, Winter* brings the elevated railroad nearer to the forefront of the scene. Sloan's compositional perspective allows him to comprehend the significance of what Stilgoe calls "the metropolitan corridor" (1983) in its downtown manifestation, and to see the city not exactly from the El, but from alongside it. Sloan's image of an elevated train and rush-hour crowds would be a strong contender for the typical New York scene of the early twentieth century. He went to a scene full of tumultuous activity, combining mechanized and human movement, and signifying, from within and below rather than from afar and above,

the spectacle of urban life. Sloan's title, though, points towards more than a desire to catch the city in one of its seminal guises. His depiction of an elevated train and rush-hour crowds milling around makes particular sense in the context of the larger, implied, picture of the transportation revolution, consequent upon the consolidation of the five boroughs into Greater New York in 1898. As Oscar Handlin notes in "The Modern City as a Field of Historical Study," a classic essay on the modernizing of traditional patterns of life:

> The altered situation of the city called also for a new conception of time… The arrival of all those integers who worked together, from whatever part of the city they inhabited, had to be coordinated to the moment. There was no natural span for such labor; arbitrary beginnings and ends had to be set, made uniform and adhered to. (Handlin 1973: 25)

In his title Sloan chooses to be precise about the time, the arbitrary end of the working day for commuters. It hardly needs adding that he could not have taken in all that was happening at six o'clock and painted it up then and there to capture that existential moment, as in a photograph. Even the Ashcan artists' practice of sketching on the spot could not match the technology of the camera. It is possible, therefore, that identifying the time in the title is Sloan's way of painting a city in transit – but at one remove from the precise and discrete scene that he had left after making his sketch or collecting his thoughts. In painting the standardization of urban life and its scale and reach, but still with an orientation towards the local scene, Sloan has to make his traditional techniques work in complex ways that add an important dimension to the visual knowledge of rapid transit. There is something in *Six O'Clock, Winter* of the part-planned, part-piecemeal, mass-transit system that the city possessed by the 1900s. It is a scene of excess, comparable with *Election Night* except that the cause in *Six O'Clock, Winter* is the establishing of "arbitrary beginnings and ends." In other words, the excess arises from the impact of urban rationalization. Elements do interrelate, up to a point, and Sloan attempts, at least along the right-of-way and at a station, to paint what Stilgoe calls "organized haste" (1983: 13) and to envisage the city as more than the sum of its parts, those parts having come together because of the impersonal schedules of the rush hour. Sloan is helped in his efforts to capture the local and the general by what, in biographical accounts, seems to have been an open and optimistic outlook on the city. The system is crowded but there are signs that it functions: trolleys (he includes a traffic light at street level); a man handling deliveries; people going home after work; and the electrified El. He evinces an awareness of the infrastructural aspect to any scene but – in contrast to the photographs of the elevated we have been considering – he is interested in the conjunction of system and people. This dual focus roughly corresponds with the "above" and "below" sections of *Six O'Clock, Winter* but is less a structural than a painterly problem. When Sloan seeks to represent the modern city he opts for a peopled system and, in ways that are relevant to the

formal dimension of any visual regime, this also means a painted system. The sheer fullness of the painting – even the sky is active – and its rush of painterly strokes create a visual metonymy of the city, which suggests a narrative of sorts. There is a narrative or getting-there relationship between the train and the people, with the station mediating between them. The train, moreover, is pictured waiting for the people. Wherever we look in *Six O'Clock, Winter* content keeps getting painted – awkwardly painted – even as the system is being implied. The dark paint used to depict the stanchions and the tracks retains the detail of iron fretwork, while the faces remain individual almost to the vanishing point of perspective. As we approach the canvas and look more and more intently at, say, the woman in the bottom right-hand corner, the paint retains its relationship to representation almost until the last. This is quite unusual given the modernist subject matter: rush hour, the loss of light in a winter's evening, and the train and tracks.

These observations on brushwork will carry more weight when we look at contributions to elevated views made by modernist art, in which painterly marks commonly "do their job of representing in a way which barely makes sense," as T.J. Clark (1985: 20) has it. There is little in Sloan of the blankness of expression that was already a staple of European and minority of American city art, and which suggests an ambiguous association between commodification and abstraction. Nor does Sloan's painting seek a formal equivalence with an abstract concept, such as speed, circulation, movement, or energy, among others. Detail works against this kind of unity. Sloan's effort to maintain a connection between paint and representation does, however, have some relevance to the question – broached when examining photographs – of how to represent a system. Almost until the point of pure materiality, the paint refuses *not* to add up; refuses the blankness that is the end-result of the sequence of substitutable units in any system. There are surprisingly few painterly ellipses; really, only in the bottom left area where Sloan paints the distant spaces under the station structure. In Sloan's painting the technique seeks to counter the systemic movement of passengers that informs much of the photographic discourse of the El, where people are noticeable for their absence, their inconspicuousness or their merely representative function.

The wider import of painterly marks on a canvas can be generalized further, as a conclusion to this section and to underline the theoretical connection between urban knowledge and medium-specific representation. Sloan and, to a lesser extent, Henri and Shinn seek ways of representing a system. However, as more self-conscious realists than the many photographers of the elevated city, they also seek to maintain a connection with that which, in one way or another, is believed to lie outside the system, or any system. They seek to restore content, but without a didactic message. This is an objective of realism generally and it was the crux of the disagreement between Sloan and colleagues at *The Masses* over political art. In *Six O'Clock, Winter*, the train is at once an object of attention and a sign of something else, that of which it is a part. But the purity of the system of exchange in the system of

rapid transit keeps being interrupted. The tracks certainly impact upon the older surrounding buildings but they do not erase them; the most insistent source of light in the painting comes from the ground-floor shop windows. And although the angle that Sloan adopts has the effect of centring the elevated train and its track, it also opens up the street and the foreground occupied by the rush hour crowd. It is an individuated crowd, with anecdotal incidents, notably the man handling the large package. He is quite startlingly framed by the red uprights and roof of the cart, although not entirely enclosed by these lines: to the right his action continues past the upright and he stands out from the crowd below. When particularity is lost or anecdotal narrative is interrupted there are explicable reasons for this – principally, the interruption of vision by other people. Sloan is interested in the individuality of the crowd while also drawn to its collectivity and its relationship to impersonal systems of transit and circulation.

"The New Landscape of Abstraction and Artifice"

Although John Sloan and other Ashcan artists may be differentiated from their contemporaries, the American impressionists, there are similarities that, briefly noted, can assist in marking off a further dimension of the visual discourse of rapid transit: the interest taken in it by early American modernist and, to varying degrees, abstract artists. Of all the American impressionists, Childe Hassam took most interest in rapid transit and some five of his works include the elevated railroad. *The El, New York* (1894) is forthright representation, compared with the indistinct urban contours in his more famous urban paintings, *Winter in Union Square* (ca. 1890) and *Washington Arch, Spring* (1890) (Fort 1993: 16 and 4). Ilene Susan Fort isolates *The El, New York* as the painting in which "Hassam seemed most in awe of American engineering feats" (1993: xii). The prominence given to the El, and the angle selected for the painting, suggest a limited comparison with Sloan in *Six O'Clock, Winter*, notwithstanding how much the two artists diverge in other respects, not least in their politics. In *The El, New York* Hassam succeeds, as Sloan does, in getting alongside the elevated and conveying something of the tempo and immediacy of what Cecelia Tichi so aptly terms the "rapid transit moment" (1987: 248). Yet, the increasingly abstract, systematic character of modernity, which is evident in the more pervasive photographic discourse of the elevated railroad, is not pursued by Hassam or Sloan. Their techniques, or at least similarities in their brushwork, do not lend themselves to this investigation. Nor do their different social orientations, Hassam troubled by standardization because it undermined a leisure-class outlook and Sloan opposed to it because it had the potential to dominate people.

The photographs of the El Station at Chatham Square, the Third Avenue Elevated at the Bowery and Herald Square (Figure 3.2) all convey something of the repetitive, serial quality of the elevated line and its overall system. The seriality, above all, is

evident, whereas in the Ashcan artists and the impressionists it is interrupted by other concerns and a different viewpoint. In Sloan, though even more in Robert Henri and Everett Shinn, the point of view of the neighborhood intervenes, while in another of Hassam's El paintings, *Flags on the Friar's Club* (1918) (Fort 1988: Plate 15), the El in the background blocks off the rest of the street, but does not otherwise impact upon the reserved, traditional street. Seriality is also not an option for impressionist and Ashcan artists because it is not easily representable through their formal approaches: respectively, the preference for a blurring style and the broad application of paint often on top of a canvas neutrally pre-painted that Henri pioneered among his group. In *Six O'Clock, Winter*, Sloan includes the detail of ironwork and the expressions on faces, but he does not attempt to represent repetition. Although the El runs down the streets in *Six O'Clock, Winter*, *Election Night* and *Sixth Avenue and Thirtieth Street*, the angled and close-up point of view adopted prevents any obvious aligning of the tracks with a larger image of the street-grid. And, by the time of *The City from Greenwich Village* (1922) (Glueck 1992: 79), which does take more of an overview, Sloan identifies the El with an older city and depicts it twisting around the Village streets rather than racing up or down town. Sloan is certainly interested in the underlying system but particularity keeps being asserted, with the result that *Six O'Clock, Winter* as well as Hassam's *The El, New York* possess the one-off, momentary feel that probably stems from Monet's Gare Saint Lazare paintings of the 1870s and the attempts to catch time and movement, as defined by light and as experienced by a passing observer of city life. In *Six O'Clock, Winter* and *The El, New York*, content is stubbornly painted in the face of the necessary systematizing of rapid transit and the disciplining of vision in the photographic record, both of which were making the representation of content much less straightforward. In a curious way, the elevated trains in most of Sloan's paintings and in Hassam's *The El, New York* are (whether heroically or naively) going somewhere, whereas the line in the everyday photographs of rapid transit is part of an invisible enclosed system that determines the line of the line, as it were. A new self-consciousness about form and representation would be needed to visualize the invisible, though the outcome – as the orthodox histories of modernist abstraction tell us – was potentially a turning away from the representable world towards the art-object.

Rapid transit in Hassam's impressionism and Sloan's realism is accorded a distinctive modern quality but at the expense of a different conception of modernity as abstractly formal. This conception of the rapid transit moment is articulated most decisively by Charles Sheeler and Max Weber, though works by others across a variety of genres should be mentioned, even if they go beyond the period of this book: John Marin's *Lower Manhattan* (1920), Paul Outerbridge's *42nd Street Elevated* (1923), Francis Criss' *The "El"* (1933) and *Sixth Avenue "L"* (1937), Stuart Davis' *Sixth Avenue El* (1931), Mark Freeman's *2nd Avenue El* (1933), Howard Cook's *Christopher Street* (1928), and Frederick Whiteman's *Elevated* of 1935, probably the most highly abstracted in this list. That Sheeler was also a photographer and film

maker is an advantage in maintaining as broad a visual focus as is consonant with detailed analysis. The work of Weber and Sheeler, along with other early American modernists such as Marin, Joseph Stella, Arthur Dove, Georgia O'Keeffe, and Marsden Hartley, tends to be an implied footnote to the story authoritatively told by Clement Greenberg. That story is of the flattening of illusionist space into pattern as modern art heroically explored all of its formal options and embraced autonomy and not the world. Treated this way, though, abstraction would have little to say about the rapid transit moment, as we have been historically situating it. Greenberg's orthodoxy cannot be ignored because it provides an indispensable language of critical description for many abstract paintings but it should not monopolize the analysis. For whatever else it is, abstraction is integral to modernity and has one of its sources in the ways in which key modern elements of the city were becoming visually known. An observation by Briony Fer about modern art turns out to be very helpful in grasping the tendency towards abstraction in the rapid transit moment. Abstraction, according to Fer, "focuses attention on the question of temporality, or the way time relates to serial imagery and sequences of forms" (1997: 11). The photographic discourse of the El emphasizes rational geometry and the idea that once any system is even partially abstracted then, from the resulting image or even detail of an image, that totality can be invisibly reconstructed, whether through notions of infinite growth, serial repetition or essential attributes, but less so by means of the narrative impulse discerned in John Sloan. The usefulness of Fer's definition of abstraction is apparent if we think of images of empty tracks, whose repetitions contain a structure that informs the static image and foretells how forms succeed one another. There is, here, some gravitating of form towards content to the extent that abstraction and system are both fictional or as-if forms and, as such, are equally invisible. Curiously, this proves to be the link with photography.

In his "A Short History of Photography," published in 1931, Walter Benjamin refers to the "optical unconscious" (Benjamin 1980: 203). While he is not specifically advancing a materialist position on photography his insight provokes the thought that the routine photographs of the elevated railroad that we have been considering do gesture towards material explanations for the invisibility of modernity. Abstraction is part of the material city as it undergoes modernization and, in these photographs of local scenes of elevated transit, there is an implied systematizing of the wider city. Although the reference is not to New York or any one city, Robert Smithson succinctly expresses the change in question: "The old landscape of naturalism and realism is being replaced by the new landscape of abstraction and artifice" (quoted in Perloff 1986: xviii). The irony in reading the photographs in this way is that, in the story of aesthetic modernism, photography's claims on the real proved to be one of the provocations for the modernist turn towards abstract art. And, admittedly, the dominant mimetic impulse behind the kind of photography that made the elevated railroad its subject restricted widespread enquiry into abstraction, some vital experiments with abstract photography notwithstanding. Importantly,

though, the realism of the photograph did not prevent modernist painterly abstraction capitalizing upon the occurrence, in the rapid transit moment, of the systematic sequence repeatable along what Ezra Pound called a "speed-line" (Pound 1975: 224). In so doing, modernism contributed importantly to visual knowledge of the city.

Charles Sheeler's one urban transit painting, *Church Street El* of 1920 (Figure 3.5) relates very directly to photography and also to the short film, *Manhatta*, made with Paul Strand earlier that year. However, the special contribution that *Church Street El* makes to the visual regime of rapid transit depends, ultimately, upon a move away from the film and its stills, both of which inspired the painting (some stills from *Manhatta* later appeared in *Vanity Fair* in 1922). In *Church Street El* Sheeler employs an angled top-down perspective from the Empire Building and the result is the most severe set of geometric lines in any of his works and an almost abstract pattern. Had the perspective been fully top-down, rather than at a steep angle, the signs of depth would have disappeared entirely, notably the one instance of decorative detail on the steeple of the Sexton's Office. As it is, *Church Street El*

Figure 3.5 Charles Sheeler, *Church Street El*, 1920. Oil on canvas, 16⅛ × 19⅛ in. (40.6 × 48.6 cm). The Cleveland Museum of Art, Mr. and Mrs. William H. Marlatt Fund, 1977.43.

is a radically upright and therefore flattened version of the many photographs from earlier in the El's history that portray the tracks running at an angle beside buildings. An abstract tendency is further reinforced in Sheeler's painting by the gridded windows on the building to the left, the lines on a roof, and, especially, the lines of track, all examples of the geometric repetition that governs much of the work.

Away from the compression of space and the distortion of point of view brought about by New York's vertical angularity, Sheeler tended to use railroad tracks differently. In *Classic Landscape* (1931) and *American Landscape* (1930) the greater, though still stylized, realism arising from a more traditional photographic perspective results in a still landscape. In both paintings the railroad tracks only emphasize linearity. In *Church Street El*, however, the more Sheeler tends towards the abstract, thereby reducing the possibilities for simple linear movement into the distance, the more dynamic the increasingly irregular visual space becomes. The meaning of Sheeler's dynamic movement is highlighted if *Church Street El* is compared with *Manhatta*, its chief source. In one section, we look down on the same scene as in *Church Street El*. Details are not too difficult to identify: for example, the switching track and the pedestrians below and to the left of the tracks. Moreover, an elevated train literally moves diagonally from top to bottom. Yet the movement of the train in *Manhatta* is no more than that. This is in accord with the argument, advanced by Jan-Christopher Horak, that *Manhatta*'s reputation as America's first avant-garde film is tempered by quite traditional points of view, a narrative and elements of closure when, in the final section, we look towards the romantic sunset over Staten Island, as, in the opening images, we look from that direction towards Manhattan (Horak 1987: 8–15). In *Church Street El*, in contrast, movement is created abstractly by perspectival inconsistencies but within a single location (in contrast, also, to the short film, *Elevated Railroad, New York*, discussed above) as well as within a single pictorial space. Moreover, these inconsistencies center on the elevated railroad. The hints of depth in the roof and steeple of the Sexton's Office initially corral most elements in the painting into a coherent, if mostly flattened, visual space: the skyscraper to the left has windows that orient it towards other buildings, some in front and some behind the Sexton's Office, and the space between the buildings appears. However, the elevated railroad refuses to conform to even this semblance of a coherent space because the individual tracks do not narrow and, therefore, neither does the whole track structure. Consequently, where the buildings appear to move downwards to the bottom left corner (they lack the tops which would help them rise), the elevated remains isolated to the right, apparently on the same plane as the ground beneath it. In *Manhatta* the elevated railroad is integrated into the rest of the scene and the perspective is entirely coherent throughout. The sense of movement in the painting, therefore, is excessive to anything that could be created within traditional, one-point perspective: the tracks are patently not going somewhere and taking the train. Instead, as Carol Troyen and Erica Hirshler have argued, movement arises from the disjunction in the formal visual order of

the painting, and this implicates the viewer, arguably at the expense of the subject matter: "The plunging perspective [was] deliberately chosen, Sheeler claimed, to 'include the spectator ... give him importance'" (Troyen and Hirshler 1987: 80). The viewer becomes important inasmuch as a perception of the space is undermined and as the rationalist geometry generates excess rather than ensuring uniformity.

Perceptual involvement in the visual space of rapid transit is greater still in Max Weber's *New York* (1913) (Plate 6), less because of the deliberate abandonment of representational space that becomes apparent when comparing *Church Street El* and its source scene in *Manhatta*, and more because Weber draws dramatically on the experience of being speedily on the move but in the static medium of painting. *New York* is one of a number of works painted after Weber's return to New York in 1909 and for some eight or nine years his paintings easily competed with the work of Marin and Stella as the most determined painterly engagement with dynamic urban space. He was fascinated by the rapidly changing cityscape and its coincidence with a cubist-futurist project. He did not become a futurist and was much less influenced in this respect than Stella, but the futurists' interest in the intersection of technology and the "moment" gelled, for Weber, with the incessant movement within a cubist visual environment of angles and impossible planes that afforded him a lens with which to see downtown New York. The results can be seen in his two paintings most directly concerned with transportation: *New York*, and *Rush-Hour, New York* (1915) (Plate 6 and Krane and North 1991: 62).

Important as this art-historical delineation of Weber's cubist-futurist amalgam is, his paintings are a telling contribution to the heterogeneous visual discourse of rapid transit. Painting of Weber's explicitly modernist kind reconceives rapid transit in ways that relate to, but differ from, the conceptions that come with more representational painting (including impressionism), with photography and with film. For its date, Weber's *New York* is an extraordinarily mobile painting, primarily vertical but with competing angled skyscrapers, some obeying the dominant narrowing orientation but others going their own way. The top-down perspective that gives us the "octopus" of Madison Square – made similarly visible in Alvin Langdon Coburn's photograph, *The Octopus*, of the previous year – will not hold for the major foreground skyscraper which we see almost side-on. And then there are the "snakes" that introduce curves into the predominantly angular painting. Dominic Ricciotti has, quite reasonably, identified the elongated shapes that snake across the surface of *New York* as elevated trains, and even refers, for partial corroboration, to the snake bend at Coenties Slip (Ricciotti 1988: 131, 144 n 15). Yet these snakes seem to enter tunnels and, because of the cubist breaking up of the picture plane, it is difficult to determine whether they pass behind or in front of the compressed and tilted skyscrapers. Weber, himself, is reported as referring to the "Subway influence" upon *New York* (quoted in Krane and North 1991: 15).

However, we risk missing the point of Weber's modernism by getting too embroiled in the particularities of what is being directly represented: elevated or

subway transit. Weber's retention of locational or spatio-temporal titles, in the face of the increasing irrelevance of titles as an important strand of modernism pursued its quest for autonomy, indicates a wish to maintain a tangible connection with the city. In *New York* and *Rush Hour, New York* Weber is chiefly interested in seeing and explaining the city's conceptual processes: rush-hour and rapid transit, when, as Lewis Mumford has it, "time becomes visible" in the city, in large part because of the lead given to urban transit in the United States by the railroad, which "was permitted, or rather, was invited to plunge into the very heart of the town" (1987: 524–5). Accordingly, Weber's conceptual focus prompts him, in *New York*, to try out what was, in the United States, a new visual language of simultaneity.

Sheeler, we have seen, adapts and works off the photographic image and does not make as much of a jump to conceptual visual thinking about movement and process. Admittedly, the blankness of the walls in *Church Street El* may signify a dehumanized urban outlook, as in Karen Lucic's (1991: 59–63) interpretation. Dickran Tashjian is probably closer to the mark when he observes that Sheeler thought "abstraction ... could be achieved simply by following representational motifs" (1975: 216). As for the Ashcan artists and, to a lesser extent, an impressionist such as Hassam, their orientation towards content made it difficult to represent the kinds of ideas or concepts that the city was, in effect, inventing or redefining. Admittedly, there is a determined effort to connect part and whole, local and general scene, in Sloan's rush-hour painting, *Six O'Clock, Winter*. And in photography and film, where the mimetic charge is very strong, the images of an empty track have a wider connotation, but this is as far as it goes; arguably, as far as it can go. "Photography," Sheeler states, "has the capacity for accounting for things seen in the visual world with an exactitude for their differences which no other medium can approximate" (quoted in Tashjian 1975: 216). But what Weber's abstract modernism brings is an effort to see time and place together, to find a visual language for such novel urban preoccupations as speed, system and so forth. Weber accepts speed and takes it to a point that exceeds even the effort in film to find a mobile point of view from which to picture modernity.

In Schivelbusch's account, from *The Railway Journey*, "transport technology is the material base of potentiality, and equally the material base of the traveler's space-time perception" (1980: 44). To this end, Weber amalgamates distinct elements of that material environment: tracks, tunnels, the striking buildings in the downtown corridor, but no trains or people. Trains, for Weber, suggest not the effects of movement but merely the content, that which moves or is moved. Even in *Rush Hour, New York*, in which Weber comes in close to the activity in a central station or terminal, we do not see the trains but the signs of movement. In Ricciotti's precise account: "Weber recreates through a pattern of sharp angles and zigzags the sequential motions of braking, acceleration, and velocity" (1988: 132). The human dimension is incorporated into the process of seeing so that *New York*, where the city of tall buildings is seen while on the move, is the painterly equivalent of the "machine

ensemble" that Schivelbusch announces as peculiar to railroad travel in general: the inseparability of vehicle and location/point of view. The overall impression is of a montage of images of multiple locations. These are similar to those that present themselves while on the move in Thomas Edison's *104th Street Curve, New York, Elevated Railway* (1899), and the American Mutascope and Biograph Company film, *Elevated Railroad, New York* discussed earlier, but they have been combined in the same picture space. The issue of whether Weber is painting overground or underground movement is superceded by the fact of movement within a space, and it is this that possibly explains why Weber exaggerates the curves in the elevated or subway system. The lines can then wind around and, to some degree, enclose the cityscape rather than cut through it in a linear manner – whether above or below ground. Because of its radically modernist fascination with the modernity of rapid transit, *New York* is best described as an abstract work in which there is no retreat into optical autonomy. Instead, in Andrew Benjamin's words, there is an "enactment of specific reinaugurations," which is mobilized as this or that "event" takes place within the time/space continuum of rapid transit (1995: 53).

By the 1920s, the El's role in photographic and more traditional painterly representations of New York City created little sense of dynamism or modernistic transitoriness. There is virtually none in the moving images in *Manhatta*. The El had become part of the background, slipping into the version of figure/ground relationship that is central to representational art. In John Sloan's sketch, *Snowstorm in the Village* (1925) (Williams 1994: 14), the El has slipped into the realm of nostalgia. We see an "elderly" elevated train buffeted by winds and snow and – because of the high angle selected – seeming to creep between buildings that dominate it. It would not be surprising to discern a face on the front of this most put-upon train. Realism, with its orthodox figure/ground organization of space, proved less capable of visualizing the passing of the El. As we have begun to see in Sheeler and Weber, modernism offered some possibilities, although these two artists differ in their conclusions.

In Weber and Sheeler any figure/ground order of priority is patently refused and the rapid transit moment might be said to have passed into abstract form but retained a dynamism and an openness that neither Greenbergian abstraction nor a Taylorized perception of the world can offer. The difficulty in deciding whether rapid transit in Weber's *New York* is above ground or underground is not a matter of deciphering the painting's detail, but it is precisely the theoretical point that is at stake. The material fact of rapid transit has been reconceptualized as a qualitatively different image of urban speed and spectacle. Equally, though, what we have in *New York* works back against a standard explanation of abstraction as the extraction of pure form at the expense of representational content. John Lechte's alternative explanation is more promising. "Abstraction is the condition of possibility of every possible set," he writes, and goes on to propose that "abstraction is simultaneously 'full' and 'empty.' It is potentially ready to accept new contents, but is never definable in terms of those contents" (Lechte 1995: 25 and 26). This reinterpretation of abstraction helps us

to see *New York* and *Church Street El* as important perspectives upon the systemic character of modernity and, therefore, as *forms* of urban knowledge. Weber's painting anticipates a combination of excess and abstraction that one is tempted to associate peculiarly with New York – the quality that is colloquially conveyed by the phrase "New York, New York" (see Chapter 6). In Weber's *New York*, the transit system has an undoubted transitory, open aspect to it. Sheeler's painting is more troubling. In the context of his career, *Church Street El* can be read as a warning against the autonomy of both abstraction and system, although this seems not to have been a warning that Sheeler himself heeded as his career moved, by the 1930s, to a preoccupation with isolated, fetishized machine images and an inappropriate design aesthetic for the Great Depression, or towards *View of New York* (Figure 1.1), which suggests that abstraction can be an abdication of urban understanding, an acquiescence in the unintelligibility of the city.

Stuart Davis's print *Sixth Avenue El* (1931) (Figure 3.6) is a final example of what modernism can achieve. He presents the El as a partial frame, but the collage-like structure resists the desire for perspective, for a vista. The structure has the effect of mixing up the El's pillars and the other images or fragments of images. The oversized woman's face, the lamp, the ticket machine, and the sections of elevated architecture inhabit each other's space. Davis's visual theorizing of this space of commodities and signs – and not a lot distinguishes these two categories in Davis' work as a whole – proposes a different logic besides that of the old (Sixth Avenue El)

Figure 3.6 Stuart Davis, *Sixth Avenue El*, 1931. Lithograph. Print Collection of Reba and Dave Williams.

and the new (advertising images). There is no easy recourse to nostalgia in a work that lacks a clear figure/ground relationship. And consequently there is less chance that a historical perspective will be lost, consigned to the past, as in Ogden Nash's little tribute, "What Street is this, Driver?":

> Oh El, thy era is o'er;
> I am glad that thou are no more;
> But I'd hold myself lower than ditt
> Weren't I glad that once thou wert. (Nash 1937: 118)

Instead, Stuart Davis uses a collage-like technique to bring to the visual discourse of elevated transit an awareness of ways in which past and emerging elements may interact in the present.

"Scene and Story": The City Up Close

"The General is at the Heart of the Particular": Downtown Scenes

George Bellows' 1911 painting, *New York* (Plate 8), could hardly be more different from Piet Mondrian's similarly titled, though better known, *New York City* of 1940–2 (Figure 4.1). In its own time, Bellows' painting also differs from three works with the same title from a year later by the early American modernist, Max Weber: an oil painting and two water colors. Mondrian's is an abstract grid and, insofar as it represents the city, is a top down and distanced view, whereas Weber's are cubist-

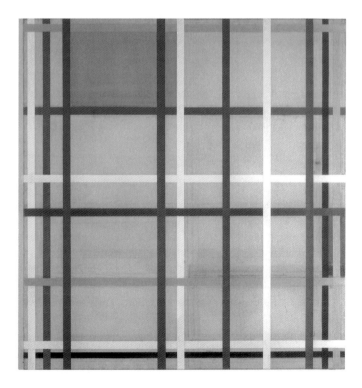

Figure 4.1 Piet Mondrian, *New York City, New York*, 1940–2. Oil, pencil, charcoal and painted tape on canvas, 46 × 43¼ in. (117 × 110 cm). Museo Thyssen-Bornemisza, Madrid.

futurist amalgams. *New York*, by Bellows is, in contrast, an up-close, street-level, representational painting of a city scene, full of people, objects and recognizable, rather than obviously abstract, shapes. Even so, the overlapping titles confirm a shared ambition to capture the city as a whole. Where the modernists' attempt tends to be from the outside, Bellows operates more from the inside out.

Throughout its history, New York has inspired an ambition to see it all and catch its essence proportionately more than most cities: witness the many images carrying the title "New York" or close variants upon it. The next chapter concentrates on distant, bird's eye views, taking its cue from Mondrian's New York grid paintings while making passing use of in-period work by Weber in an effort to appreciate how abstraction assisted visual artists in their efforts to see the city whole. For his part, though, George Bellows resorts to different means to live up to his all-encompassing title, and any one of a number of implied subtitles that we might supply for *New York*, such as "A Modern City" or "An Urban Spectacle" or "Rush Hour" (actually, part of the title of a 1915 Max Weber painting of New York). Although there is no necessary equation between up-close views of New York and varieties of realism, whether in painting, photography or film, this is a reasonable working association in the years covered by this study, at least; it certainly does not rule out revealing cross-overs with modernism or at least less-realist modes because an ultimate generic inconsistency within images may well reveal some of the most telling connections between visual culture and the city of New York. Within a broad, if not consistent, representationalist approach, then, different visual media offer varied responses to a key challenge that cities pose in an accentuated way – and New York City in an especially sharp way, with its intense vertical as well as lateral growth: the challenge to explore how, visually, part and whole relate or fail to relate when a limited, local perspective on the city is chosen or accepted, and what to make of this relationship. Gérard Genette explains what is at stake:

> This is the paradox of every poetics, and doubtless of every other activity of knowledge as well: always torn between those two unavoidable commonplaces – that there are no objects except particular ones and no science except of the general – but always finding comfort and something like attraction in this other, slightly less widespread truth, that the general is at the heart of the particular, and therefore (contrary to the common perception), the knowable is at the heart of the mysterious. (1980: 23)

The present section considers downtown scenes, for example the foot of the Flatiron Building, and an intersection in the Tenderloin district. The middle section of the chapter tries to add something to the well-worn association between the city and the *flâneur* in downtown stories; between, that is, an image and getting around the city, from cross-streets to parks to street markets. And the last section highlights the depiction of signs in the city. Although urban signs are a specialist subset of up-close images, they enable some conclusions to be reached about the project of seeing

the city from the inside out, and, more particularly, about the matter of the spectacle and its relations or lack of relations with the surrounding city.

Art history is, at once, helpful and unhelpful in understanding Bellows', and his contemporaries', efforts to paint New York. Helpful because, in the vein of the opening comparison, art history can chart progress beyond the realism of Bellows, through the more angular elements in Weber, to Mondrian's late grid paintings of New York. Alternatively, but in the same way of thinking, art history can conclude that there has been a falling away from the brave attempt to represent a city and its inhabitants in all possible detail. Admittedly, Weber and Mondrian also focus on a part of the city, but abstraction does offer a distinctive metaphorical transfer to the whole in which, for instance, the pattern of tracks in Weber's *New York* of 1913 (Plate 6) is effectively synechdochal of urban transit in ways that the depiction of the El in the background of Bellows' *New York* cannot match. Realism, though, goes about the task differently, working metonymically from detail to detail and cumulatively assembling a scene and, sometimes, narratives of the city. Realism also rests on a common-sense synergy between ways of seeing and ways of constructing an image. The proposition that there are gains and/or losses as realism gives way to modernism is, understandably, important to different formulations of the internal transformation within the discipline of art history. An overly narrow use of art or visual history, when lining up works, can be less helpful in appreciating how realism and modernism, and the relationship between them, depend upon ways of seeing in historical and material contexts. What is at stake for the notion of New York sights when an artist adopts an up-close, rather than a distanced, abstracted view, and employs a still or a moving visual medium? Art history is also less instructive in any effort to expand upon a central claim of this book, that material changes in New York are intimately implicated in aesthetic changes. Guy Debord has a much broader agenda, but has a point, when he announces that "that which changes our way of seeing the streets is more important than what changes our way of seeing painting" (Knabb 1981: 25). In the field of visual culture, knowledge depends, to some extent at least, upon achieving a point of view but gaining a clear sight of what was happening in New York was often physically impossible because of the pace and sheer crowded quality of city life at the turn of the century. And, as spatial forms, painting and photography – more obviously than the then new visual form of the movies – labor under the special difficulty of representing connections between part and whole when a metonymic association between details is assumed.

Realism presupposes a visual completeness that could, in principle, be represented were there sufficient time and physical access to warrant the effort. To this extent, realism reflects an assumption that one could encompass and know a city by travelling through all of its parts. John Sloan's *Sixth Avenue and Thirtieth Street* (1908) (Plate 7) exemplifies this coincidence of assumptions, and may be treated, prototypically, as a window upon an urban scene that we cannot now visit in its precise spatial moment but which is, nevertheless, recognizable. *Sixth Avenue and Thirtieth Street*

is also a typical example of the Ashcan School, inasmuch as Sloan depicts people in the setting of city streets and does not display any obvious self-consciousness about representing three-dimensional space on a two-dimensional canvas. Although, in the pantheon of realist art, Sloan's is a fairly provincial contribution, his is precisely the kind of art whose in-principle claims on reality are undermined by modernist skepticism, and then firmly checked by post-modern constructivist theory. For instance, in *Techniques of the Observer*, Jonathan Crary inspects a correspondence between one-point, Cartesian perspective, the technical paradigm inaugurated by the camera obscura, and the acceptance as reality of this "optically constructed space" (Crary, 1992: 126). His critique is only one example of a thoroughgoing skepticism levelled at (in Martin Jay's words) "the ubiquity of vision as the master sense of the modern era" (Jay 1988: 3). Of course, no one needs to triumph in this visual version of a familiar theoretical debate. Post-1960s literary and, more recently, visual theory has successfully run the rule over some founding assumptions, while building upon modernist critiques of mass (visual) culture in the work of Theodor Adorno and Max Horkheimer, among others. Unfortunately, its enthusiasm for explaining what cannot possibly be achieved, rather than acknowledging limited but tangible achievements, can lead us to miss interesting complications.

In his effort to see New York, and in his compliance with traditional perspectivalism, John Sloan – along with the other painters, as well as photographers and film makers covered in this chapter – had to engage with the kinds of theoretical issues to do with representation and space that interest Crary and that have been given a decided urban inflection in theorizing from Walter Benjamin, and on through Michel de Certeau to postmodern analyses. Some of these complications are evident in, or between, the technical and interpretive meanings of point of view. In *Sixth Avenue and Thirtieth Street*, Sloan's viewing position is easy to plot in a painting organized around one-point perspective: exaggeratedly so, because Sloan uses an urban scene to compose orthodox viewing-and-viewed triangles created by the elevated railroad arrowing in from the left, and the cornice-line of the buildings to the right, both of which in turn create the viewing position. In painting the receding tracks of the elevated railroad, the cornice-line and also the curb of the street, Sloan might be seen to be painting in the invisible converging compositional lines that, since Alberti, have been judged to afford a painting depth while, at the same time, locating the painter/viewer at the apex of a matching triangle extending into the space in front of the canvas. Notwithstanding that the curb disappears behind some figures and a cart, we remain confident that it invisibly continues towards the point around which the painting, the scene and, it is implied, the wider city all cohere. If this was not so, nothing else would make full sense in the painting, whether it is the relationships between the people, or the fact that we can just about read the nearest sign ("Lion Brewery") on the nearest building, but cannot read more distant signs, yet we know they are signs. Nevertheless, Crary's suspicion of an "optically constructed space" is as helpful in understanding *Sixth Avenue and Thirtieth Street* as is its antithesis, the commonsense

analogy of a window upon a world. There is a vital tension in this painting between composition and representation.

Farther along Sixth Avenue in Sloan's painting, the confident route of the receding tracks of the elevated railroad becomes barely conceivable. In a flurry of brushstrokes the tracks sink to ground level, so constricted is the space between the buildings created by another compositional triangle constituted by the curb and the line of buildings on the right of the painting. The tension, one might say, is between the completeness of the painting, achieved in this representational mode by the perspectival lines that establish the illusion of depth, and the real-world implications of such composition, which has the elevated train, the red trolley-bus beneath the tracks, and the people continuing on their way. The methods for constructing the painting in order to convey depth and completeness within its own space must, at some point, come up against the knowledge that activities continue – but out of sight. The indistinctness in the background identifies that as the vanishing point. But there are other points of tension. It is not that Sloan has failed to complete the painting or has made sociological mistakes in his research. Rather, there are a number of competing orientations in *Sixth Avenue and Thirtieth Street*. Moving to the left from the right foreground (from our perspective), we notice three unpromising looking men outside a bar. They are looking towards the left. In their line of vision are two slim young women with elaborate hats and scarves, fashionable above-the-ankle dresses and high-heeled shoes. They, too, are looking left, slightly over their shoulders, and in their line of vision is a bulkier woman, without a hat, with dishevelled hair, and wearing a shapeless, ground-length, white dress, and heavy boots. One hand is across her chest and the other carries a pail. The stares of the onlookers and her red nose suggest that she is carrying a pail for beer. She stands, in our line of vision, almost in front of the vanishing point of the painting. From our point of view, then, this startling woman in white is the center of the painting, and comes to signify the interpretive center of *Sixth Avenue and Thirtieth Street* as a depiction of the somewhat rough and rowdy Tenderloin district in which an outlandishly dressed woman can be out getting beer in daylight, with passers-by staring at her while, themselves, revealing to us their social class and not-entirely respectable attitudes and forms of behavior. If this is the meaning of *Sixth Avenue and Thirtieth Street*, it relies on the dominant point of view. Yet once there are recognizable figures in a painting, other points of view and other meanings tend to be generated. The figures described above mark a movement across the painting from right to bottom left. And they do so by a relay of looking that is not focused consistently on the woman in white. The men look at her but also, and with distinctly more interest, at the two young women. The dressed-up women look at the poor woman and pay no discernible attention to the men. The relay of looking continues. The woman in white herself looks at something off to our left, and her hand across her chest is as likely to be a response to a person or incident or object entirely invisible to us, as a manifestation of her shame or confusion, within the visible relay

of looking. In spite of our privileged occupancy of the apex of the viewing triangle that balances the apex of the triangle at the picture's vanishing point, we seem to be deprived of important subject matter, and yet, conceivably, one and up to six figures in the painting could be looking at this invisible source of interest. The notion that there are focus points to the painting other than the dominant semantic and compositional one is reinforced, first, by a couple who, though oblivious to the relay of looking in the foreground, walk off to the left, under the tracks and, second, by a pointing hand-sign that directs us into one of the buildings to the right.

Sixth Avenue and Thirtieth Street has a descriptive title in the realist documentary tradition to which Sloan belonged. In common with his own *McSorley's Back Room* (1912) and a painting about a very different area of the city, William Glackens' *Skating in Central Park* (ca. 1910) (Zurier *et al.* 1995: 76 and 186), Sloan's painting has a sociological bent and depicts the details of life in an area of the city. But, whereas there are few signs of the wider city or of the changes under way in *McSorley's Back Room* and *Skating in Central Park*, and the hint of nostalgia hangs around Sloan's bar and Glackens' park, from its title onwards, *Sixth Avenue and Thirtieth Street* takes us beyond location and local, sociological information. In New York, more than in most cities, the crossing of streets in the grid has citywide ramifications: Sixth Avenue links the downtown and uptown areas, while Thirtieth Street links the East and Hudson Rivers. Moreover, the elevated tracks and a trolley route across the streets, tell of routes across the wider city, but do so according to a different logic from that in Weber's *New York* (1913), in which it is the abstraction of the tracks which signifies a presumed totality. A discrete scene is part of the wider city, though the discussion of how people also cross each others' paths, and the other instances of incompleteness that have been noted, do not leave us confident that we know how one part, and one story, relates to another. Finally, the relay of looking suggests that there may well be a point of reference and, therefore, another coordinate that is invisible to us, off to the left of the frame of the painting. In this most accessible realist painting, we cannot see everything but we are made aware of more than we can see, as things and people go on their way.

There would have been occasions when, in their professional activities as painters and, for some of them, as newspaper reporters, the Ashcan realists would have encountered competition from photographers and film crews at the most well-known city sites, and particularly at intersections, when the larger city could be more easily implied and people and places brought into a contextual relationship. William Taylor's important essay, "Psyching out the City," considers how New York photographers "relate[d] the people of the city visually to their surroundings" given that it "proved difficult to portray people in such settings without dwarfing or dehumanizing them" (Taylor 1992: 2). Using 1915 as a watershed date, Taylor proposes that "during the transitional years before the modern city became a recognized visual entity, it was difficult for anyone, photographer or not, to conceive of these sprawling, amorphous communities as a whole" (1992: 3). A photograph, from around 1902,

by Robert Bracklow of the newly completed Flatiron Building, encapsulates one response to the difficulty Taylor identifies and historically situates. *Photographing the Flatiron Building* (cover illustration) capitalizes on the visual transformation of the intersection between Broadway and Fifth Avenue at 23rd Street, consequent upon the construction of the Flatiron Building, completed in 1902. A view across the paved Madison Square, as it was then, and down Broadway gives the photograph depth. In contrast to the better known presentations of the Flatiron in photographs by Alvin Langdon Coburn, Eduard Steichen and Stieglitz (analyzed in Chapter 2), in this Flatiron photograph there is a head-on focus on the prow of Daniel Burnham's striking skyscraper. The centrality of the triangular point of the building is reinforced by being lined up behind a photographer with a tripod in the immediate foreground of the photograph. Space is created by the distance across the open square between Bracklow and the photographer-in-the-photograph, and the Flatiron, as well as by a relegation of the buildings of Broadway and Fifth Avenue to the borders of the photograph, where they function to enforce a narrowing perspective. Thus, Bracklow's photograph appears to concentrate upon the relationship between space and architecture in one of the few New York City locations where perspective could be successfully mobilized from street level. The square seems to have been cleared to emphasize perspective and, quite appropriately, a street-cleaner is at work.

One reason why *Photographing the Flatiron Building* is a very unusual photograph is that while the above description accords with one's initial and overall response and with the title given to the photograph within the Alexander Alland collection, it is patently not an adequate description of what is going on in it. The title plays in more than one way. While appropriately entitled *Photographing the Flatiron Building*, and utilizing the built environment to frame the skyscraper, Bracklow's photograph does have a foreground that also associates it, in interesting ways, with up-close views of the city, though not with the busy local scenes promoted by the Ashcan artists. The unusual character of *Photographing the Flatiron Building* stands out if we compare it with Joseph Pennell's etching, *Flatiron Building* of 1908 (Pennell 1980: Plate 24). There is a similar angle of vision: looking up from ground-level at the towering building, with another tall building to the left. However, Pennell's perspective reduces people to indistinct marks in the vast expanse of the foreground. Much the same can be said of the Flatiron photographs of Stieglitz, Coburn and Steichen. However, in the photograph by Robert Bracklow, in clear, focused view are a photographer and his camera. This reminds us of photography's ability to capture a moment in time in a space created by the camera, for which a significant, in-focus foreground is, if not essential, then at least an important requirement. The photographer in the foreground is taking a photograph. He is a worker in the city, to be compared with the street cleaner to the left. The comparison is visually reinforced. The street cleaner's broom creates a triangle with his body, as does the photographer's tripod with his body. These two figures are also contiguously associated by a triangle formed by another broom at an angle with a tree half-way

between the street-cleaner and the photographer. Unquestionably, *Photographing the Flatiron Building* can be treated as an architectural photograph in which a building is located in an urban space, but it has a very definite foreground. In that space, the photographer-in-the-photograph is not taking a perspective view of the Flatiron but a close-up of another person, whose presence is revealed by a glimpse of his or her head just beyond the photographer, and by a shadow. Although the Flatiron Building dominates the photograph, it does not, as we shift our perspective, eclipse the figures in the foreground, including the road sweeper. The competing, local compositional triangles attract our attention, but the chief factor in reorientating us, away from the Flatiron building and towards a close-up view of the city, is the self-consciousness introduced by Bracklow's choice of a photographer-in-action to dominate the foreground. After all, this other photographer has, himself, relegated the Flatiron to the background in his focus upon the person a few feet away from him. The photograph is about visualizing a city, an act in which Bracklow has made decisions about the light (the sun's direction is signified by the shadows cast by the tree, the photographer and his subject), composition and the moment to take the photograph, signaled by the street clock in the middle ground. The resulting city sight proposes an order of priority between the city and the human figure, and between the human figure in focus in front of the lens, and the street cleaner, to the left and excluded from the close-up photograph being taken. There is an important tension both within the photograph titled *Photographing the Flatiron Building* and between that photograph and the photograph about to be produced by the photographer-in-the-photograph, a close-up of a person but one who is all but invisible to us to the extent that we are even unsure whether it is a man or a woman or an indeterminate child. The meaning of this visual space, at an important intersection in New York, cannot be determined from a single perspective, whether it is one that privileges the people of the city or the larger urban environment. Whereas John Sloan's *Sixth Avenue and Thirtieth Street* is a painting about people that leaves us wondering about the invisible spaces of the city, Bracklow's *Photographing the Flatiron Building* leaves us more curious about the people apparently dwarfed by a stunning skyscraper, but reinstated by us, as viewers aided by the stubborn representational properties of the medium. In the second section of this chapter we can continue a discussion of time and photography in the work of Alfred Stieglitz, where the relationship between the local scene and the larger city is explored rather differently.

The up-close, realist view of the city is nowhere pursued more vigorously than in the photography of Jacob Riis in New York's Lower East Side. We may, tangentially, contribute to the critical debate over Riis's motives and his attitude to the poor (see, for example, Alland 1993, and Stange 1989), by examining the extent to which he is able to relate the local view to a larger view of the city, the "other half" to the whole, in the terms announced by his best-known book, *How the Other Half Lives* (1890). As with Sloan's *Sixth Avenue and Thirtieth Street*, the construction of the pictorial space is a suitable starting point, making use of two photographs included

in *How the Other Half Lives*. In *Bottle Alley, Mulberry Bend* (Figure 4.2), the three figures from the slum occupy a yard, with the balcony to the right and shed and house to the left serving to emphasize perspective. These three representatives of the ghetto are definitively positioned in their space, and not in our space; as there, rather than here, and as other and not the same as those on our side of the space of the photograph. They are object-ified, elements in the disposition of space ordered by the photograph. Importantly, the here as well as the there of the photograph are both constructed by the detached authority of one-point perspective. This is not merely a formal issue, because the optimum viewing position, which orders and controls the space, was occupied by a photographer. By extension, the optimum viewing position is also occupied by a specific class of viewers, as is now clear from what we know of Riis's illustrated lectures and his philanthropic campaigns (see Stange 1989: 1–26).

Buildings dominate the space. They are on either side, enclosing the alley, and they loom above the scene and reduce the amount of sky to a small irregular section. An outside to this deprived area – a lateral or contiguous link, that is – is suggested by the large but faint building in the distance. Yet this possibility is kept firmly in the distance. Instead, the photograph signifies vertically, connecting the unkempt space with the undifferentiated concept of the other half. The formal order of the photograph and the overall appearance of the space, which photography is so well

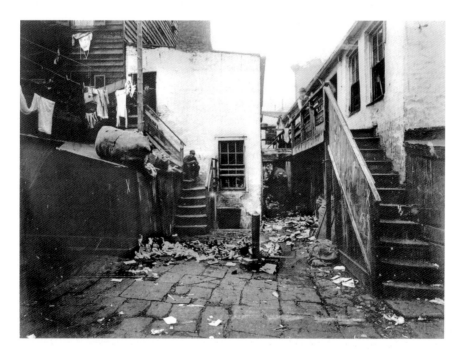

Figure 4.2 Jacob Riis, *Bottle Alley, Mulberry Bend*, ca. 1890. The Jacob A Riis Collection, Museum of the City of New York, 347.

suited to detail, combine to depict these people as, at best, an unknown quantity and, at worst, as threats. It is hardly surprising that a few years later, when experimenting with cinematic language, D.W. Griffith should have gravitated towards the Lower East Side for his portrayal of villainy in *Musketeers of Pig Alley* (1912). Griffith made use of "New York's Other Side," according to a caption, to achieve greater, even documentary, realism, and there are similarities to Riis's photographs (see Stein 1983). *Musketeers of Pig Alley* is predicated upon an audience, much like Riis' middle-class audiences and viewers, interested in two-dimensional types. Accordingly, the women shopping, the street vendors, and the men and women hanging around are detached from a meaningful context. Context, in Griffith's film, becomes no more than a mostly undifferentiated background. And when an up-close view becomes an early and celebrated use of the close-up technique, the context is removed entirely. Consequently, as the camera moves in, a super-realism turns alarmingly into a fantastic image, another instance of what Walter Benjamin – thinking of enlargements of cell forms – terms the "optical unconscious" (Benjamin 1980: 203).

The developmental artistic logic of representation, from realism to modernism, implied in Griffith's film, does not easily transfer to Riis' photograph, despite a similar ideological feel to their depiction of the Lower East Side. A moment in time is represented in *Bottle Alley* but it is not confined by the space of the photograph or telescoped into a disorientating close-up image. The man on the stairs (or perhaps the man on the balcony) might – a moment or two earlier – have called out the man in the doorway to look at Riis, an intruder; but quite probably to look also at Riis's companions. We know Riis, himself a police reporter early on, to have been accompanied on most of his visits to The Bend and adjoining areas of the Lower East Side by police officers and, on some occasions, by others interested in photography's power to bring into view the hitherto invisible areas of the city. Riis and any other contemporary photographers would have been carrying a battery of outlandish equipment. In a reversal of one-point perspective, then, these indistinct figures are looking out of their place at Jacob Riis, his companions, and – more indirectly – at the viewer. In a sense, they are also looking at the practice of photography and its claims upon space. And, as they do so, the metonymical relations within the photograph can be glimpsed. The three figures are less types or specimens to be understood with reference to the abstraction, "the other half," and more a small group whose identity has been constructed in time by what is at least a very plausible immediate prehistory of the photograph, amounting to something like a narrative. *Bottle Alley, Mulberry Bend*, like any photograph, is a photograph of a time as well as a place, but that time is not a moment but part of a continuum of what happened before and after the taking of the photograph. We can, it would seem, read into a static image a drama in which the other half looks back, and in which Bottle Alley, but also Gotham Court, the Five-Cents-a-Spot room, and the many other locations visited by Riis become places rather than merely spaces, a distinction well expressed by Erica Carter *et al.*

It is not spaces which ground identifications, but places... How then does space become place? By being named: as the flows of power and negotiations of social relations are rendered in the concrete form of architecture; and also, of course, by embodying the symbolic and imaginary investments of a population. Place is space to which meaning has been ascribed. (1993: xii)

From this alternative point of view we can begin to envisage the in-betweens that signify commonality and a daily routine. Whatever else it is, Bottle Alley is also a domestic place, though the washing, as a sign of ownership and care, must compete with the undeniable signs that this is still an abandoned space. Riis seems to be more aware of this tension in another photograph from *How the Other Half Lives*, captioned *Baxter Street Alley, Rag-Picker's Row* (Figure 4.3).

The washing is firmly associated with the domestic left half of *Baxter Street Alley, Rag-Picker's Row*. To the left is the house, with its shutter suggesting a desire for privacy; the steps, reaching to the house, and possibly separating it from the alley; the water barrel and pile of kindling; and one and perhaps both of the young girls. The girls are dressed as little women, with the girl at the top of the steps seemingly in charge of the house and its routines, and striving for respectability. The men at the far end of the alley and one man looking out from a doorway on the right of the alley occupy the right half of the photograph. The tension is between the alley and the house, the men and the young girls, with the girl at the foot of the steps poised between the two spaces; even, it might be added, poised vulnerably between the place of the home and the threatening space of the alley. The girls and the space they inhabit are accessible and can be saved by those on this side of the divide; that is, the edge of the photograph and of the ghetto. Down the alley are those who cannot easily be saved and who represent the worrisome future for the girls if something is not done to alleviate their socioeconomic conditions and connect them to the wider city inhabited by the viewers of the photograph. Riis strongly suggests a contrast between the two young girls on the stairs who seem to be striving for respectability, orderliness and the stability that fosters community, and the activities at the far end of the alley that threaten to overwhelm the possibility of respectability. It is at this point, though, that the same kind of reversal of perspective occurs that we noted in *Bottle Alley* when the inhabitants look out at Riis, his contemporary audience and us. Judging by the way the girls are positioned, it would seem at least likely that Riis has asked them to pose, and it would follow that all of the elements in *Baxter Street Alley* are posed, or at least to a greater extent than in *Bottle Alley, Mulberry Bend*. Riis undoubtedly set up other photographs, most obviously *Members of the Gang Showing how they "Did the Trick,"* the trick being a mugging (Riis 1971: 177). If so, then the men down the alley are watching what Riis is doing, possibly with the intention of intervening to protect the girls if the novel photographic act got out of hand.

A comparison of the Baxter Street and Bottle Alley photographs elicits a further connection between the girls and the men. As the title tells us, the activities depicted

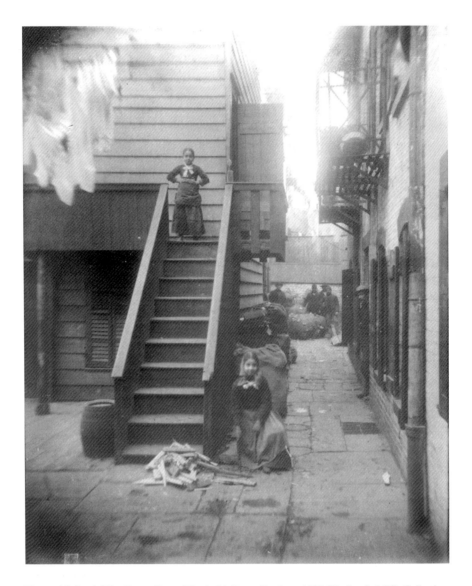

Figure 4.3 Jacob Riis, *Baxter Street Alley in Mulberry Bend*, ca. 1890. The Jacob A Riis Collection, Museum of the City of New York, 111, 90.13.4.114.

down the alley in *Baxter Street Alley, Rag-Picker's Row* are not necessarily nefarious, in spite of the seemingly threatening figure in a doorway to the right. The men at the far end of the alley and the bulging bags point to the rudimentary economy of the rag-pickers. A bulging bag links the two photographs. The sack teetering on the edge of the shed in *Bottle Alley* is a source of some of the rubbish in the yard and therefore

is part of the image of a life that transgresses the standards of respectability. At the same time – and particularly when these two photographs are considered together – the sack is a sign of work. The figures are part of an economy. An economy requires exchange and therefore signifies both an outside to this enclosed scene and relations within it: the bag full of rags, the men as rag-pickers, and the homes and signs of home life that their work (barely) supports. The other half becomes differentiated within the apparent homogeneity captured by the camera, and also (perilously) connected economically with the surrounding society. The internal relations are much clearer in *Baxter Street Alley, Rag-Picker's Row*. The girls who look after the house are necessarily connected with the men who provide some income, although doubtless, not enough income. The sacks are the counterpart to the washing in signifying a life in the midst of deprivation. The washing also functions as a link between the respectable classes and the slum dwellers. It is common to both halves and is – in the signifying system of the photograph – recognizable, as are the signs of drainage in the alley. Had the other half been pictured as wholly other, completely untouchable, then this would have been counterproductive to Riis's efforts to raise funds from philanthropic sources, an endeavour acknowledged by critics and advocates of his work.

At the Foot of the Flatiron (1903), an American Mutoscope and Biograph film, presents a very different Flatiron building from that in the photograph discussed earlier. Film, in its basic, one-shot, static form may be considered, initially, as the equivalent in a new visual medium of the realist image. While realism is as contentious a term in film studies as elsewhere, this "short" may be compared with the paintings and photographs discussed above, insofar as it uses a static camera to record, in documentary mode, a downtown scene. The camera was set up at the edge of the pavement looking towards, and past, the right-hand edge of the building on the Fifth Avenue side of the Flatiron Building. There is, then, some context, provided by glimpses of traffic passing along Fifth Avenue, as well as by the title. Pre-eminently, though, it is an up-close film of a busy city intersection. There are no edits, but there is plenty of movement on film, with people constantly crossing in front of the camera from both sides. The action is heightened by the location: at the foot of this pointed building at a junction of three streets the wind is whipped up and all but knocks some people off their feet, while terrorizing hats and skirts. A few people notice the camera and look into the lens, thereby creating a more dynamic two-way effect than that possible in photography, and obliging us to pick them out from the crowd. There is something of a story in *At the Foot of the Flatiron*, as a young man crosses, checks back and stares into the camera; a man smoking a cigarette loiters in the background and a policeman briefly seeks the limelight by crossing and recrossing in front of the camera. Aside from this interplay, the movement is in what is represented and not, in any very significant way, in the contribution of the camera, which stays immobile. In an Edison film, *Herald Square* (1896), however, the eleven seconds of comings and goings are supplied with an additional frame that goes

beyond the frame of a photograph or painting, that signified by a trolley crossing from right to left, and, at the end of the film, another trolley crossing from left to right. The notion of a cityscape, rather than merely a city, which comes with more sophisticated uses of the medium (see Bruno 1997a: 46–58), is nevertheless evoked when the scene gains some order amid the changing images via the main object of attention, a policeman directing traffic and seeking to bring one form of meaning to what strikes us as frenetic activity. The scene in between the two trolleys is thereby given an additional dimension, not a narrative exactly, but an expanded horizontal scope, implying a systemic order to complement the localized order symbolized by the policeman. Later in the present chapter, we can follow the cityscape coming even more into the foreground, as film begins to realize more of its potential than in static, so-called actuality, films such as *At the Foot of the Flatiron* and *Herald Square*. As film makers explored the medium's technical and imaginative resources so it became possible to envisage citywide transactions, and, indeed, to transport viewers around the city.

The greatest challenge to depict the city was levelled at painting and its associated forms, and, accordingly, we may return to George Bellows' ambitious work, *New York* (Plate 8) to conclude this section on downtown scenes. Ashcan art is, one might say, determinedly shortsighted because it eschews the techniques for painting at a distance popularized by impressionist artists since the 1880s, and remains primarily intent upon detail and the local sphere. Admittedly, *New York* is less local than Sloan's *Sixth Avenue and Thirtieth Street* or his own *The Cliff-Dwellers* (1913) or his boxing paintings, as well as the work of Everett Shinn, Robert Henri, William Glackens, and George Luks. But *New York* is of special interest because it evinces an explicit desire to reconcile a responsibility to represent the detail of an urban scene and to achieve something of an overview. To this extent, it illuminates a different facet of the part-whole issue from that which we have discerned in the other examples we have worked through to this point, from *Sixth Avenue and Thirtieth Street* to the film of the comings-and-goings at the foot of the Flatiron. In Michel de Certeau's formulation, the overview was the view from the top of the World Trade Center, which we might chronologically reimagine as the view from the top of the Flatiron or the Woolworth Building, constructed in 1902 and 1913, respectively; while its opposite was the view from the streets (De Certeau 1984: 91–110). Bellows' painting asks how painters could represent but also map, and be close-up to life on the streets yet not be limited to a street-level viewpoint.

New York follows a number of paintings of the city by Bellows, and looks to be an attempt at an overview, but made from the perspective primarily of Union Square. As a comprehensive statement of how the Ashcan artists, as the leading urban realists, saw New York in possibly its most dramatic modernizing era, Bellows' painting can scarcely be bettered. To pick up the earlier account of this painting, its foreground is jammed with people, rushing to work and to shop, and at work directing the traffic, driving the horse-drawn carts and clearing snow. In the middle-ground, around the

ellipse of Union Square, the horse-drawn traffic competes with trolley buses, while the open, public space of the square competes with the encroaching skyscrapers that form the backdrop and reduce the sky to an irregular patch at the far end of Broadway. In this meeting place of streets, elements of the old and the new, as well as such different versions of the new as motorized street-level, and elevated railroad, transportation meet and seem about to collide, although the policeman directing the traffic endeavors to provide order and the elevated railroad points to a differentiation of function within the apparent chaos of urban movement. Bellows seeks to reveal New York's fascination with itself and the new kind of urban life that was emerging as a consequence of demographic movements, consolidation of the boroughs into one city and key economic drivers. Bellows' response, allied to a desire that he shared with other Ashcan artists to know the city up close and from the inside out, can be deciphered in the perhaps surprising formal complexities of his busy but seemingly traditional art. One-point perspective is assumed by Bellows, and there is a vanishing point beyond Union Square. That the representational and localized view has to compete with, but also leaves traces of, abstraction and an overview in which perspective is not the controlling factor, is apparent the longer one stares at *New York*. Arguably, inspecting the detail and then stepping back to look at the totality of *New York* illustrates a pivotal American art-historical moment, as realism and modernism overlap. Something similar is evident, but with a starting point of modernist abstraction, in Joseph Stella's *Battle of Lights, Coney Island* of two years later, in which, within the incredible swirl of painterly action, the Luna Park tower can be momentarily deciphered, only to be lost as one visually steps back (Haskell 1994: 49). In *New York*, there is a struggle between the almost crude representationalism of the painting and elements, at least, of abstraction in the blocks of tall buildings, themselves gridded by uniform bands of windows and the many signs which cross the piers of the buildings but also climb up them, and appear, also, on a truck and a bus.

There is a tendency for the skyscrapers at the far side of the square to coalesce as shapes. And, as they do so, the detailed but homogeneous space created by perspective takes on a more relative, heterogeneous aspect, though in painterly ways that differ from those perceived in Sloan's *Sixth Avenue and Thirtieth Street*, in which one is encouraged to permit the relay of looks to generate counternarratives from that established by one-point perspective. The intrusive glazed, painterly surface also draws one in to the surface, while the sheer detail of the painting, which announces its devotion to the reality of the scene, has an all-over quality, making it difficult to settle upon a focal point and reconstruct contiguous relations between those details. The difference is apparent if one compares Bellows' *New York* with William Glackens' crayon and watercolor of a year later, *Christmas Shoppers, Madison Square* (Zurier *et al.* 1995: 146). Both are eventful scenes, with people rushing to shop or actively selling. There is a similar confluence of horsedrawn and motorized traffic, and the use of a square, with a canyon-like street heading off into

the background, also bears comparison with *New York*. But the more precise medium and a lower viewing angle permit far more local discrimination. The exact details of an "XMASS [sic] DINNER" offer on a sandwich board in the bottom left can be seen, and the route – "FIFTH AVE TO 19TH ST" – and serial number of the green open-top bus are easily visible, thereby quite precisely defining the viewing position as looking north from the corner of Fifth Avenue and 23rd Street West. We know that it is windy from the hats that are being held or retrieved and the overall impression is not of New New York but simply of a scene in New York City, punctuated by mini-stories and anecdotes keyed to the approach of Christmas in a city. One gentleman looks as though he will be home later than planned because the southbound bus is full. And, at that moment, at least, none of the street vendors are making any sales, although the shoppers are carrying lots of goods, probably purchased from nearby department stores.

Although Bellows' painting is also excessively full of the detail that is a hallmark of Ashcan realism, and that contributes to the "too-much-ness" quality of this painting, the details coalesce, as they do not in Glackens' painting. And while any discussion of Bellows' work will eventually put him back into the company of the Ashcan artists and urban realism, the characteristics that make *New York* Bellows' most modernist work are apparent. Bellows' foreground suggests similarities with George Grosz's crowded modernist city scenes, which relate to the wider city in different ways from those utilized by realists, while the pressing forward of the background intimates that a future development could be towards the paired down, archetypal urban shapes of Lionel Feininger's *Architecture II: The Man from Potin* (1921) and, even more so, *The Lady in Mauve* (1922), in which windows, aligned as grids, or skyscrapers come to the fore, and in which the few human figures are cubistically rearranged in architectural form. Yet one baulks at the prospect of too firmly connecting Bellows' *New York* with these works and, by extension, with Mondrian's New York grids. Any attempt, consonant with the painting's title, to associate local scene and larger city in Bellows does not point towards Mondrian's take on synechdochal construction, though the cubist-futurist amalgam then being tried out by Max Weber, is less far away from Bellows' endeavors than one might initially assume. What holds the attention most in the work of Bellows and the Ashcan painters is a sheer over-fullness, even a messiness, and the reassertion of depth just when this characteristic seems to be losing out to modernist indiscriminacy, evidenced in the flatness of a Weber – or Mondrian – view of New York. Yet, a firm grip on the local and the detailed was, paradoxically, being loosened by the exponential increase in detail in the city, as, for example, telephone and telegraph lines threatened to obscure the sky; as bridges multiplied and the movement of people on foot and on wheels was funneled onto them during rush hour; and as the production of goods of every kind filled department stores and then the homes of those who could afford to consume and display them. The role of realist detail in undermining realism can be perceived in Bellows' *New York*. There is a preoccupation, not so much with accuracy, as in Glackens' *Christmas Shoppers*,

Madison Square or in the more famous manner of Canaletto's paintings of Venice, but with a material "there-ness." Where Canaletto, typically in *View of Piazza San Marco* (1723) and *View of the Grand Canal from San Vio* (1723), paints Venice as a city of plots, of carefully delineated encounters, whether commercial meetings, assignations or whatever, and as a city of equally carefully delineated buildings, Bellows' is a city is in the making in a different sense, almost a perpetual rush hour, with the future image of the city still undecided. A woman heads in one direction; a man passes in the opposite direction; a street-car cuts across their paths. A traffic policeman – unlike Glackens' policemen or the policeman in the short film, *Herald Square* – looks to be overwhelmed. New York City's plots and myths – constituting New York-ness or the Gotham quality – had yet to be firmed up and were generically urban, whereas the logics of politics and trade were already evident for Canaletto, though he contributed to their clarification through his art. Moreover, in Venice locations had already become key sights but these were still under debate in New New York.

In *New York* an initial Ashcan commitment to detail and local specificity struggles with an emerging impulse towards abstraction and an image of the city. Bellows' painting helps lay claim to the image of the rush hour, with a backdrop of skyscrapers and large signs giving it a strong New York inflection. Alternatively, if one steps back, one sees primarily the skyline or at least a wall of tall buildings, with people and their activities subject to that enclosing frame, the implication being that, with the work of Weber, Stella, Marin, O'Keeffe and Walkowitz, people may, temporarily at least, disappear from the art that most captures the quality of the New York. Either way, Bellows' local-scene painting of a city on the verge of international iconicity broaches the question of what it is to make visual capital. Perspective is reinforced by Venice's waterways and collonaded squares, but artists either side of the turn of the twentieth century had yet to capitalize fully upon New York's topography, especially when faced by the additional factor of its stark upward movement. Marianne Doezema helps us to appreciate further the to-ing and fro-ing of perspective we have noticed in Bellows' *New York*. His attempt to do justice to an all-encompassing title, while maintaining an interest in people, objects and activities, led him to amalgamate elements of Union Square and nearby locations (Doezema 1992b, 111–14. See, also, Zurier *et al.* 1995, 85). Trolleys, street-cars and elevated lines have been re-routed by Bellows, in order that these familiar signs of New York life may come together, but in *New York*; that is, in the space of the painting rather than in the space of the city. Bellows' effort to create a typical New York street scene produces an excess of signification commensurate with the emerging meaning of New York but beyond what any one site in the city could generate. The lack of literality (this is a space which, in its combination of particulars, did not and does not exist) suggests that Bellows is painting a need to know more than could actually be seen; in effect, visually to speculate while rooted in the local clash of old and new.

Getting Around the City: "The Unexpectedness of Onrushing Impressions"

A now-extensive tradition of modernist theorizing tells us that one way to encompass the city from within has been through the *flâneur*'s mode of perception, his urban connoisseurship, and his trajectory around a city. That tradition runs from Baudelaire, through Henry James and Walter Benjamin, and on to Michel de Certeau, and some imaginative variants outside of the modernist paradigm. "For the perfect *flâneur*, for the passionate spectator," Baudelaire writes, "it is an immense joy to set up house in the heart of the multitude, amid the ebb and flow of movement, in the midst of the fugitive and the infinite" (1964: 9). The very mobility and class-less, or at least occupation-less, definition of the *flâneur* supplies a crucial critical margin that, so the argument goes, affords some protection against being co-opted into both the routine and the rationale of shopping and trading, and into the protocols of display. Following Baudelaire's essay, "The Painter of Modern Life" (1863), the *flâneur* is accorded strong visual attributes, even in literature. When surveying impressionist and realist art in the United States, Barbara Weinberg (1994) and her co-curators identify a number of *flâneur*-like figures, fascinated by urban parks, squares, crowded streets, and shops; and note, further, that the *flâneur* emerges as the type of the artist. The artist/*flâneur* wanders around New York, as well as (typically) Paris, and – later or at that moment, and depending upon the medium – paints, sketches, photographs, or films the sights of the city, connecting part and whole, and seeing, in a detail, the larger picture. This section will, eventually, recommend a degree of skepticism that the European and, typically, Parisian figure of the *flâneur* can be simply transferred to New York City around the turn of the twentieth century; and will, moreover, conclude that when we do encounter instances of the *flâneur*, as subject and as point of view, a less programmatic definition is warranted than one that highlights visual consumption and an unmotivated or loosely motivated urban trajectory. Nevertheless, in Weinberg *et al*'s exhibition, as in many other studies, the figure of the *flâneur* prompts an appreciation of the dual aspiration to focus down on a scene and yet pursue a citywide vocation. This aspiration was held by Ashcan and impressionist painters alike; by photographers as different as Jacob Riis, Alfred Stieglitz, and those employed by the Byron Company and by film makers, who, while learning that they need not be restricted to one-shot films that, in effect, elongate one static image, had, nonetheless, to work with the startling realism of their new medium in imaginative ways if they hoped to map the city. Georg Lukács (1978: 110–48) maintains that only realism, developed scene by scene into narrative, can overcome the tendency towards reification of modernist images, whether of the abstract or impressionist kind. To support Lukács, to a degree at least, one can repeat that the very elements of George Bellows' *New York* that gravitate towards abstraction nevertheless serve also to stir one-point perspective to reassert itself and sustain the illusion of depth in the converging lines of Broadway; that is, to allow for city stories as well as city images.

Plate 1 William Merritt Chase, *The Tenth Street Studio*, ca. 1889–1905. Oil on canvas, 47⅞ × 66 in. (121.6 × 167.6 cm). The Carnegie Museum of Art, Pittsburgh. Museum purchase 17.22.

Plate 2 Childe Hassam, *The Breakfast Room, Winter Morning*, 1911. Oil on canvas, 25¹⁄₈ × 30¹⁄₈ in. (63.8 × 76.5 cm). Worcester Art Museum, Worcester, MA. Museum purchase.

Plate 3 Childe Hassam, *Tanagra: The Builders, New York*, 1918. Oil on canvas, 58¾ × 58¾ in. (149.2 × 149.2 cm). National Museum of American Art, Smithsonian Institution, Washington, DC. Gift of John Gellatly.

Plate 4 George Bellows, *Blue Morning*, 1909. Oil on canvas, 34 × 44 in. (86.3 × 111.7 cm). Chester Dale Collection, National Gallery of Art, Washington, DC. 1963.10.82.

Plate 5 John Sloan, *Six O'Clock, Winter*, 1912. Oil on canvas, 26⅛ × 32 in. (66 × 81.3 cm). The Phillips Collection, Washington, DC. Acquired 1922.

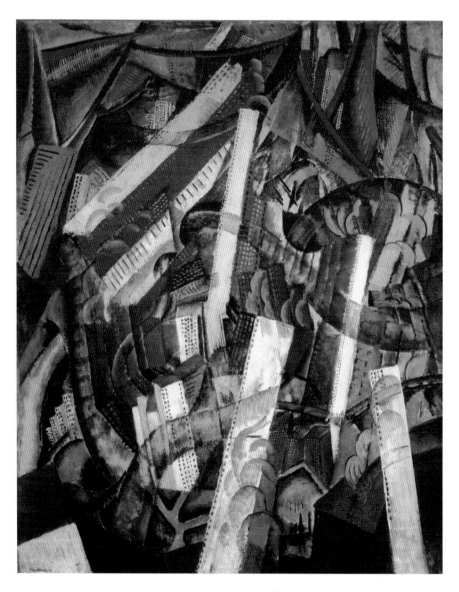

Plate 6 Max Weber, *New York*, 1913. Oil on canvas, 40⅝ × 32½ in. (103.2 × 82.6 cm). Mr H. F. Lenfest. Private collection.

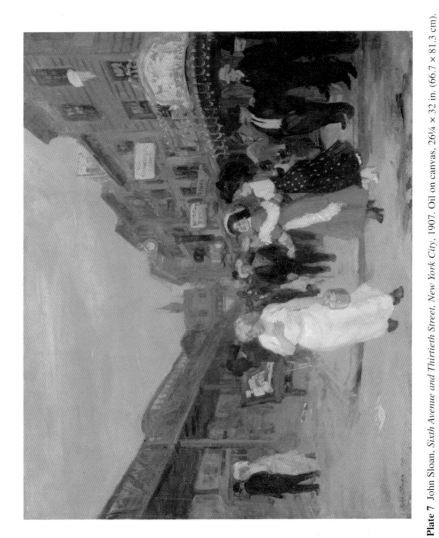

Plate 7 John Sloan, *Sixth Avenue and Thirtieth Street, New York City*, 1907. Oil on canvas, 26¼ × 32 in. (66.7 × 81.3 cm). Philadelphia Museum of Art. Gift of Meyer P. Potamkin and Vivian O. Potamkin, 2000.

Plate 8 George Bellows, *New York*, 1911. Oil on canvas, 42 × 60 in. (106.7 × 152.4 cm). Board of Trustees, National Gallery of Art, Washington, DC. Collection of Mr and Mrs Paul Mellon.

A somewhat unsophisticated effort to narrate the sights informed the many guidebooks and travelogues of New York at that time. For example, *New York: The American Cosmopolis* (1894) from Moses King, and *Scenes of Modern New York* (1905) provide informed movement around the city. The more literary and picturesque end of this functional and promotional genre is exemplified by *Shepp's New York City Illustrated: Scene and Story in the Metropolis of the Western World* (1893) by James and Daniel Shepp, and Jesse Williams' *New York Sketches* (1902). All encouraged image-making in a variety of locations and the threading together of images into tourist or more specialist itineraries. A journalist concluded, as early as 1890, that "the *flâneur* seems at last to have made his appearance [in New York]" (quoted in Stern, Gilmartin and Massengale 1983: 20), though Robert Snyder and Rebecca Zurier comment on the guidebooks' overly regimented "block-by-block, incident-by-incident" format (Zurier 1995: 85). Guidebooks also edited out the less attractive parts of the city towards which the *flâneur* gravitated. Nevertheless, a contemporary viewer of Bellows' *New York* who was inclined to wander might do so by leaving Union Square via Broadway, and would be in good company because this was one of the favored routes for walking the city: "The walk up-town," writes Jesse Williams, "reaches from the bottom of the buzzing region where money is made to the bright zone where it is spent and displayed; and the walk is a delight all the way" (1902: 29). We can comment, later, on this blithe discounting of the economics of urban walking. In these guidebooks there is also a nagging tension between the model of getting around favored by the *flâneur* and the character of the city that is being walked and pictured, and, on one occasion, Williams openly regrets the onset of rapid transit, objecting that "the surface and elevated cars" move people too quickly along the city streets (1902: 30). His predilection for the slower movement of walking, in a city that was speeding up exponentially, is conveyed by the format of his book, the pacing of image and text reinforcing the importance of strolling. The images, in effect, slow down city life on the walk up-town, permitting digressions to side-streets, away from the rush hour. To this extent, the images in the Shepps' book and Williams' have something in common with those of the American impressionists, who looked explicitly to European models of walking the city. Attempts to create public, monumental space suited to strolling largely failed. The Commissioners of the 1811 Plan rejected what they called "circles, ovals and stars" (quoted in Schuyler 1886: 18), and did so on real-estate grounds. Suggestions that the long New York block be divided by Parisian arcades had not been implemented; neither had hopes that intersections be used for new vistas, ornamental architecture and promenading, as in nineteenth-century Paris. What ought to have been New York's meeting places and places of display were not squares, however laid out. Instead they were and are mostly intersections, which is why artists gravitated towards Central Park and the few smaller downtown parks. And even at those intersections that are complicated by the diagonal trajectory of Broadway, expectations fostered by European cities are dashed, as in the frenetic activity captured by the film *At the Foot of the Flatiron*. At

the intersection of Fifth Avenue, Broadway and 23rd Street, the wind whistles round the prow of the Flatiron and – in the late-nineteenth century – raised women's skirts above their ankles. Men, standing there, would have been interpreted as hanging around with intent rather than promenading, and the police would have moved them on with the embarrassing shout: "23rd skiddoo." It would be some time before the grid would openly influence ways of seeing – to the point that the grid became an icon of modernism and the evolution of Mondrian's grids met with New York's physical layout in a series of paintings from the early 1940s. In advance of that important intersection we must look for incipient signs of the grid's influence upon New York's visual culture (see discussion of Bellows' *A Morning Snow – Hudson River* and Prendergast's *Central Park* in Chapter 2, above).

Guidebooks did not make much use of photography. Printing costs may have been a factor but photography also has an association with the speeded-up city. For photography in the snapshot mode we can turn to some street images produced by the Byron Company's photographers. The caption, *The Fifth Avenue Hotel*, to a 1896 photograph (Byron 1985: Plate 13) draws attention to subject matter that would fit a more leisured view of the city, in which fashion and behavior may be presented for consideration. And there is, for sure, a pleasing vista along an uncrowded Fifth Avenue into a square with, at the center of the photograph, two well-dressed women promenading, and a horse-drawn carriage augmenting the scene. However, the snapshot quality is signaled by the large street clock, showing 12:37 p.m., with temporality embodied in the activities around the two women. A boy looks directly at the photographer; a man is fast disappearing off to the left; and two men look over their shoulders at the women but, equally, at the women-being-photographed. Similarly, in *The Broadway Squad, Broadway and Fulton Street* (ca. 1898) (Byron 1985: Plate 2), a creeper-covered mansion and pedestrians at the intersection are firmly kept to the background, as a policeman engages with a bowler-hatted, bearded man, while a young man speeds away from the scene. His image is, accordingly, blurred, a sight invisible to the eye but signifying a moment in the city.

Time is more self-consciously embedded in Alfred Stieglitz's philosophy for catching the city through a local scene. In his discussions with Dorothy Norman, and particularly when describing his preparations for taking photographs, Stieglitz is primarily intent upon creating an aesthetic vocation for the art-photographer (Stieglitz 1989 and Norman 1973). Invariably, though, he emphasizes the temporal dimension. In the case of *Winter, Fifth Avenue* (1893), the precise moment chosen by Stieglitz gathers up a memory, however fleeting, of a stagecoach and a rutted country road, into an urban setting (see Taylor 1992: 5–6). This practice – what William Taylor calls Stieglitz's "search for an aesthetic of the modern American city" (1992: xx) – also runs through other seminal photographs: *The Terminal* (1892), *Reflections, Night, New York* (1896–7), *Spring Showers, New York* (1900), *The Flatiron* (1902), and *Snapshot – From my Window, New York* (1900–2) (Stieglitz 1989: 27). In the last of these, a beautifully proportioned tree competes with angular

buildings, while horse-drawn vehicles obediently follow the tracks of trolley cars in the snow. The slanted angle of *Snapshot – From my Window*, even aside from its title, also draws attention to the moment, one in which pedestrians struggle along in a snow storm, and in which Stieglitz spies upon them. For Stieglitz, time in his New York photographs seems chiefly to be the time in which he chose to take this or that photograph of an unpromising urban scene, rather than time as a dimension in which he is integrated into the life of the city and could encounter a passer-by, this being common in the more vernacular modernism of the Byron photographs. In this respect, Stieglitz's *Snapshot – From my Window* differs from his *A Snapshot: Paris* (1911) (Stieglitz 1989: 35), which is taken at ground level and includes a potential encounter with the men and women walking purposefully in his direction. The moment, in *A Snapshot: Paris*, is part of the street scene, a city built up metonymically and therefore randomly, moment to moment, street by street. We may be prompted to wonder whether the any of the pedestrians headed towards the photographer will acknowledge him. Conveniently putting aside the orthodoxy, in which Paris is associated with impressionist modernism, it can be suggested that this sense of contact and the range of temporal and spatial options in *A Snapshot: Paris*, is what we find, not in Stieglitz's New York photographs but, in Ashcan realism, as instanced already in John Sloan's *Sixth Avenue and Thirtieth Street*. The moment in the New York *Snapshot – From my Window* seems, in contrast, to be part of a city conceived synecdochally, even mythically, as some of Stieglitz's other titles more directly confirm: *The Hand of Man* (1902), *The City of Ambition, New York* (1910), and *Old and New New York* (1910).

Turning from the streets to another haunt of the *flâneur*, parks and squares, the relationship between part and whole that we have been following may be helpfully redescribed as a tension between the private and the public spheres, and, in visual culture, between what can and cannot be seen. Although Central Park attracted visual representations from the outset, including the maps, diagrams and drawings in the mid-century Olmsted and Vaux Plan, and in illustrations in magazines and newspapers thereafter, parks in general only became a consistent theme in the city's visual culture from the 1880s onwards, in part because of the full onset of photography and other image-reproduction technologies but also because American painting and photography began to turn its attention away from nature to the city. Parks became a convenient meeting place for some of the issues that had informed the original debates over Central Park: how societal divisions might be manifested in a park, and nature's role in the city. American impressionists often opted for more distanced views, most obviously in Willard Metcalf's *Early Spring Afternoon – Central Park* (1911) (Weinberg 1994: 164), where the perspective creates large open spaces in the foreground in which human figures are isolated from each other, but ordered by the disposition of these spaces. Paths separate horse-riders from pedestrians. Yet the careful ordering of space is apparent even in a number of up-close works by other impressionists, for example, Childe Hassam,

in *Spring in Central Park* (1898) (Hiesinger 1991: 46–7), who transfers the theme to a nanny-and-children relationship in the foreground, with horsedrawn carriages safely leaving the area to right and left backgrounds. Even in the more crowded scenes of Maurice Prendergast's Central Park paintings (Mathews 1990: Plates 36–8 and Weinberg *et al.* 1994: 159), a public place is presented in which men and women and members of different classes may meet, but where the controls of the wider urban society still function. The same parceling out of space is evident in journeyman artists, W.P. Snyder and W.T Smedley. In *Harper's Weekly* for February, 1886, and 1889, Snyder's drawing, *Sleighing in Central Park*, depicts a parade of sleighs directed by a mounted policeman, overlooked by the sober statue of Daniel Webster, with the recently completed apartments on the Upper West Side positioned as a country house through the trees. In *Central Park: The North Meadows*, and in *Harper's Weekly*, but for October 1889, Smedley uses tennis courts to distribute people across the space (Grafton 1997: 121 and 117). This could be a landscaped country park, with a vista in the central background. Trees enclose people, near and far. Robert Reid's *The Red Flower* and *Reverie* (both 1890) are paintings informed by a genteel romantic aesthetic that effects a clear association between a public park and a private garden. The vegetation protectively encircles a child in *The Red Flower*, and a woman in *Reverie* (Hiesinger 1991: 129). William Merritt Chase's *The Nursery* is a Central Park painting, but conveys the behind-the-scenes activity of a large garden (Hiesinger 1991: 126–7). Gentility is conveyed stylistically in Paul Cornoyer's *Washington Square* (1900) (Weber 2001: Plate 7), through impressionist feathering, reinforced by the arrangement of figures walking, and the trees and Stanford White's arch in the early evening sun. There is nothing of the south side of Washington Square, where immigrant families, transient lodgers and political radicals had moved in, and changed the carefully maintained relationship between private and public spheres.

John Sloan's *Sunday Afternoon in Union Square* (1912) (Figure 4.4) presents the city differently, even though less of the city's buildings are visible than in some of the examples, above. This is a place of urban looking, a theme formalized sociologically in Simmel's "The Metropolis and Mental Life" (1903), though Sloan slows down the rapid visual impressionism that had registered so emphatically with Simmel. It is, initially, difficult to get beyond the behavior of three male figures staring at the principle female figures, controlling them in their fixed gazes. As a park picture it has other dimensions, though, particularly when considered alongside paintings that keep the city at a distance and envelope the human figures in a surrounding, domesticated nature. Sloan's painting is also about the ways in which cities can integrate people: in the background, barely distinguishable people mass on the path. A couple in straw hats on a bench engage in conversation. Another couple, sitting on the benches look to be in some distress but are at least sharing it as they bend their heads towards each other. In the foreground, two younger girls whisper comments on the subject of the two slightly older women at the center of the painting, and

Figure 4.4 John Sloan, *Sunday Afternoon in Union Square*, 1912. Oil on canvas, 26¼ × 32¼ in. (66.36 × 81.6 cm). Bowdoin College Museum of Art, Brunswick, Maine. Bequest of George Otis Hamlin.

encompass the blatant interest evinced in them by the rakish man behind them. The two older women are also united in their awareness of his gaze, as suggested by the flimsy white bag that the red-haired woman trails in the eyeline of the man. It is a less sinister and anxious scene than has perhaps been thought (Zurier *et al.* 1995: 179). Among the figures, only the three staring men are alone. And, finally, through the trees, we can see the tall buildings breaking up any sense of nature surrounding society and of this as an undisturbed arena for the male gaze, the product of which is, typically, the female as an object lacking any social or wider spatial context.

The theme of integration and undramatic narrative action is pursued in Theresa Bernstein's *Bryant Park* (1914) (Figure 4.5). It is an unusual blend of Ashcan School interest in everyday encounters and a post-impressionist style of figuration and use of color that, in Pissaro's paintings of the Tuileries gardens, for instance, preserves a sense of distance. In *Bryant Park* and in Bernstein's other city vignettes of the 1910s, however, the result is a surprisingly integrated image of people and the wider city. *Bryant Park* presents an intense scene as a small part of a larger picture. The section of this recently created park viewed from the New York Public Library is full of urban encounters. There are sailors on the benches; a trio of men lean towards

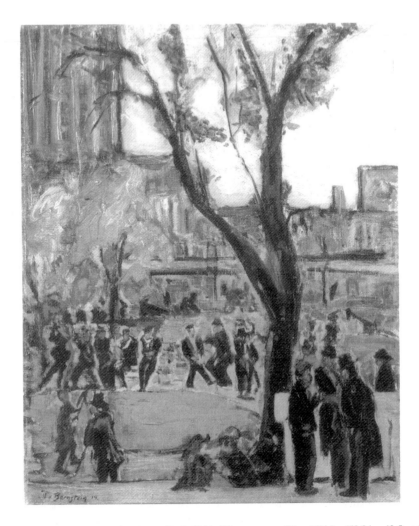

Figure 4.5 Theresa Bernstein, *Bryant Park*, 1914. Oil on canvas, 21 × 17⅛ in. (53.34 × 43.5 cm). Museum of the City of New York. The Robert R Preato Collection, 91.76.1.

each other to talk in the right foreground; two women with fashionable hats are also engrossed in conversation; and two men have set up easels to catch the scene. There is less clarity of detail than this summary suggests – and less clarity than in Sloan's *Sunday Afternoon in Union Square* – because Bernstein's brushwork does not permit sharp outlines and the depiction of facial features. On the other hand, the shapes of the people convey activity and one can surmise that such activity continues even when the population of the park on the Sixth Avenue side becomes a series of dark smudges. Moreover, the foreground of the park and its people; the middle-ground of the El and tall buildings on Sixth Avenue; and the light orange of

the sky are in reasonable harmony. Indeed, the sky (partly because of its peculiar color) seems to come forward at least to where the buildings start, while the people in the foreground sacrifice some individuality in return for an evident commonality in all parts of the park. The forked tree finally binds the elements together. Shifting from formal matters to content, the painting implies that the Sixth Avenue El has been instrumental in bringing this mix of city-dwellers together.

Two films set in Central Park, *Sleighing Scene* (1898) and *Skating on Lake, Central Park* (1902), appear to confirm that parks can insulate people from the less-predictable aspects of city life. The city is invisible in both films, even though in *Sleighing Scene* the camera looks down a long road, and in *Skating on Lake* the horizon frames the single shot throughout. But no buildings can be seen. With little context provided, they could be set anywhere. Yet, the behavior of the people is citylike: the carriages pass each other in *Sleighing Scene* in an orderly manner, and although only two pedestrians appear, they each, in different ways, cross the road and weigh up the traffic. The first man waits for an opportunity and crosses smartly. The second man is a policeman, who relies on his uniform to make a measured crossing. In *Skating on Lake*, the activity is akin to a rush hour, with men and women in close proximity and the protocols of skating interrupted by idiosyncratic skaters, including one boy who plays to the camera, as people did whenever a movie camera was set up. The reference points tend not towards the private end of the spectrum – nature or a garden or a country park – but towards the city streets.

Quantitatively, film gravitated far more to the city's streets and railroads than to its parks; that is when not panoramically tracking the shoreline, or swinging across the roofs of an increasingly jagged city. To categorize up-close films of the streets and railroads as actuality films is to accept that, in the five or so years on either side of the century, the sheer there-ness of moving images in the city was the chief attraction of the new medium. The first one- and two-minute films made in New York about New York rush us through tunnels and across bridges on trains or deposit us on street corners or in squares, and without the camera movements that are synonymous with later cinema making a contribution. However, those up-close films following soon after the pioneer "shorts," in which movement becomes associated with the camera as well as with the city's activities, add an important further narrative dimension to the presentation of the city, not as background to action or objects but as a subject in its own right. Such films illustrate a distinction that another twenty years of developments in film would authorize between, in Dziga Vertov's phrases, "the elements of the art of movement" and "the movements themselves" (1984: 8). This is a cue to endorse, for the moment, Giuliana Bruno's proposal that "like the urban spectacle of *flânerie*, the mobile gaze of the cinema transformed the city into cityscape, recreating the motion of a journey for the spectator" (1997a: 48–9), and the observations by Baudelaire on the *flâneur* in "The Painter of Modern Life" which Bruno quotes, with cinema in mind:

...to see the world, to be at the center of the world, and yet to remain hidden from the world ... we might liken him to a mirror as vast as the crowd itself; or to a kaleidoscope gifted with consciousness, responding to each one of the movements and reproducing the multiplicity of life and the flickering grace of all the elements of life. (Bruno 1993: 48–9)

It is true that film-making and *flânerie*, as modes of perception, have different attitudes towards the speed of city life. Nevertheless, an articulation is feasible that proved to be beyond the capabilities of the guidebook genre, though some modification of the association of the *flâneur* with the Parisian urban stroll in the context of a faster-moving and differently laid-out New York is called for. As we have seen in the films, *At the Foot of the Flatiron* and *Herald Square*, passers-by and traffic constantly cross in front of the camera. And while a detail can attract attention in a painting or photograph, details in film slip into the devotion to the ephemeral that Baudelaire seizes on as the essence of the modern. Equally, the people criss-crossing Herald Square, with trolleys blocking their and our view, are a striking example of Simmel's characterization of metropolitan life as "the rapid crowding of changing images, the sharp discontinuity in the grasp of a single glance, and the unexpectedness of onrushing impressions" (Frisby and Featherstone 1997: 175). However, there are no edits, and nor does the camera move. In contrast, in *New Brooklyn to New York via Brooklyn Bridge, No.2* (1899), *Interior, N.Y. Subway, 14th St. to 42nd St.* (1905), and *104th Street Curve, New York, Elevated Railway* (1899), film starts to realize the potential of its medium and to explore a more intimate relationship with the city. These short and still quite simple city films also question the advantageous viewpoint of the *flâneur* that, according to Baudelaire, permits him "to see the world, to be at the center of the world, and yet to remain hidden from the world." *New Brooklyn to New York* was filmed from the front of a train crossing from Brooklyn to Manhattan. Although the camera angle is not altered during the two minutes, thirteen seconds film and there are no edits, the camera moves as the train moves and therefore the view of the city changes dramatically, as the Bridge's towers and then the Manhattan skyscrapers come into view, even as we are kept in visual contact with the pedestrians crossing Brooklyn Bridge in both directions. Also, the view of the approaching city is presented through the lattice-work of the bridge. It is not a montaged view because there are no cuts, but the combination of a close-up of the structures of the bridge and tracks, and a distanced view of the city constantly changes. The details alter second to second. There is no city as such in *Interior, N.Y. Subway* and so it exaggerates the effect in *New Brooklyn to New York* which is to transfer movement to the camera. In over- and underground movie, the viewing eye may not be economically identified or exposed according to class, gender or any other designation, but neither is it hidden. Rather, the viewpoint is quite dramatically located. The nature of this optic involvement is left unexplored, other than that there is a taste for speed rather than repose in this drama of viewing.

The first forty seconds of the two minute *104th Street Curve* supplies a view close-up to the tracks, facing a building identified as Allcock's, combined with a classic perspective view into the distance along the narrowing tracks. We are made aware of the 104th Street curve of the film's title to our right by an elevated train coming across our view from right to left, blocking the building. As it passes, we are moved (presumably by the train carrying the camera) slightly towards Allcock's and the signage becomes larger. At that point – and it could be an intended edit or a splice carried out subsequently – a train crosses from left to right and, as it is about to pass, once again revealing the Allcock's building and the longer view down the tracks, it, quite startlingly, positions us looking along the tracks in the opposite direction, towards the 104th Street curve. The remainder of the film is shot from the front of a train taking the right and then left curve of the famous "S" curve. The combination of the edit or splice and the camera moving on the train alerts us to the making of movement and what Giuliana Bruno calls "the perceptual mechanism of the cinematic apparatus" (1993: 55). The mere recording of movement is reduced in importance. The linked motifs of circulation and exchange are everywhere in these films: people moving from place to place on different forms of transportation. Eventually, the camera and the train are implicated or when a passer-by pauses to stare at the camera, viewer and viewed are implicated.

To the two types of early, up-close film considered so far – that is, films in which the camera remains static and the foreground is dominated by people and their movements, and films in which there are rudimentary edits, or the camera moves but only with the movement of a train, boat or street-level vehicle – we can add films in which narrative plays a part. The issue, here, is not whether early cinema is a precursor to Hollywood but the extent to which downtown stories enable part and whole to be related. Or, to put this important point another way, in the period before the hegemony of the feature film, very many short films of New York take the viewer around the city, local scene to local scene, without the city becoming primarily background or mere setting. *Move On* (1903) is a one minute, forty-two second Edison film photographed on October 22, 1903 in the Lower East Side, and is transitional between one-shot, one-location, films and edited, multi-location films. Thus, there is only one scene in *Move On*: a street-market. There are no edits, but there are at least ten sideways movements of the camera that selectively follow some of the activities, which primarily center on a bowler-hatted owner of a fruit barrow, a younger man, his assistant perhaps, and a policeman. One example of a camera movement includes tracking right to follow a policeman appearing from under the elevated railroad, and bossing people and carts. Another camera movement follows a street vendor maneuvering his barrow (having seen the approaching policeman) and hurrying off to the right. The film ends with the fruit man wheeling his barrow round and leaving his illegal pitch. This is a street drama, with a title whose appropriateness we would endorse whether or not we suspect that the policeman who fills the screen at the end has been on duty when a number of actuality films were shot in and around

New York City at that time. The street vendors are, from the outset, aware of the film makers, and the assistant plays to the camera, which follows the action. *Move On* is patently not a documentary. On the other hand, as the camera moves, so other activities – as opposed to the action – are caught on film. Connections, verging on collisions in some instances, partly escape the organizing frame.

An entirely well-founded skepticism about representation should not blind one to what film can do and especially these very early films, which were shot in unpredictable surroundings and within a paradigm that did not, in any case, have coherence (of meaning, of story, of character) as its motivating concern. In spite of the filmic frame, the vendor's attention turns to the street; to business; and to the risk of damage as other vendors move their carts. In effect, these are the sights of an economy in action and evidence of the sheer detail of the negotiations involved. The policeman causes the vendors to move their carts – which were thought to block traffic – and, in enforcing the law, enforces one kind of narrative. Yet, at the same time, the interactivity of street life continues, with an accumulation of less-conclusive narratives that are not encompassed by the ostensible meaning of the film's title. The virtually open-ended structure of the film, in conjunction with a different meaning for its title, implies that these are scenes that will be reproduced elsewhere but also at a different time in this location, and without the need for the fictional apparatus. The women shopping; the activities of the children; and, generally, the criss-crossing of the street by many people, come together to suggest that the official designation of this as *not* a market-street has only been temporarily reinstated by the police. The street in *Move On* is crossed by an elevated railroad track and this, too, is of interest, alluding to the lack of isolation of the area. We may recall Jacob Riis's designation of another elevated railroad scene – the El station at Franklin Square in the same geographical area – as the last outpost before entering "the domain of the tenement," the "rush and roar" of the El "echoing yet in our ears" (Riis 1971: 27). And the El, in turn, dominated the local area, erasing parts of it in a process that became all too common. However, the process of modernization was itself double-edged because the El linked the local area with the wider city. In this case, the local scene is a marketplace, albeit a transient one, a location for interchange and negotiation, primarily within the Lower East Side but also between it and the wider city. Streets and squares, but also alleys and even less formal routes, constructed a logic of the local, which replicated itself in the face of the modernization that trade and political networks encouraged as well as resisted. If the film's title draws us in to a local and specific scene, the underlying logic of moving on opens the film out to the processes of the city.

Narrative is more explicit in films that James Sanders (2002: 31) treats as the obituary of the actualities. Nevertheless, there is still an interesting area of overlap. For example, chases, in *Personal* and its "re-make," *How a French Nobleman Got a Wife Through the New York "Herald" Personal Columns* (both 1904), present a variety of downtown and up/midtown locations that might otherwise

not be associated in anyone's mental map of the city. If anything, the linking and exploitation of locations takes precedence over the function of forwarding the story, not least because – as in the later Keystone Cops' chases – the extent of the chase attracts attention more than its outcome. In *The Life of an American Policeman* (1905), it is the itinerary of an occupation that acts as a vehicle for getting around – also at some speed. In a number of films, the film industry and its need to distribute reels of film around the city or the fires that started or were started in film studios, generate embellished city narratives. James Saunders cites *Traffic in Souls* (1913) as offering a "sustained view of the city far beyond the quick glimpses of earlier films" (2002: 35). Even though the era of narrative feature films was well under way with this ten-reel film, the parallel journeys through the city by the actresses playing the foreign and domestic white slaves reveal a hidden map of money and sexual power, encompassing the Battery and Penn Station, as arrival points, and spreading north to the Upper West Side, and a vertical shift from sea-level to the tops of buildings in Brooklyn. *Catching an Early Train* (1901), however, signals, in an exaggerated manner, the relegation of the city to the background in favor of character and action, but also of cinematic tricks. A commuter awakes one morning, late for his train to the city. Nevertheless, with the assistance of magical, invisible hands to his left and right, which fling his clothes and his briefcase at him – an indication that film is realizing some of its visual potential – he makes it to the station, and, along with other commuters is seen chasing the departing train that will allow him to rejoin city life for the day. With the onset of narrative feature films from around 1910, a conscious and, usually, avant-garde effort was needed to reassert the place of the city in film – as in Sheeler and Strand's *Manhatta* (1920). It is, in any case, unwise to posit an intentional *auteur* model when considering the turn-of-the-century New York films, in order to suggest a relationship with later, *avant-garde*, urban film. Achievements and effects were frequently accidental or dependant upon non-cinematic technologies, notably the trains and tracks of the elevated railroad, and street-level traffic, and the disposition of buildings, particularly tall buildings in the case of the panoramic, at-a-distance films discussed in the next chapter. By the time of King Vidor's *The Crowd* (1928), what is arguably the most dramatic cinematic attempt to connect the wider city to the local scene of a man, in a skyscraper and at his desk in a vast open-plan office, gives way to the powerful combination of narrative and individual character. Similarly, in Jules Dassin's *The Naked City* (1948), the city-as-character cannot withstand the human narratives, notwithstanding the famous opening and closing sequences. In summary, between *At the Foot of the Flatiron* and *The Naked City* and on to *City Hall* and *Taxi Driver*, explicit narrative feature-film shifted attention from the all-foreground view of the city that absorbed early film makers, and was shared with painters and photographers alike, towards the city as an important narrative element.

In his guidebook, *New York Sketches*, Jesse Williams recommends *flânerie* as a way to get around and appreciate New York and its downtown stories. He then

baulks at accelerating his stroll to match the speeding up of the surrounding city, and, as we have seen, if the common association of film and *flânerie* (for example, in Bruno 1997a and 1997b) is to be carried over into a New York setting, then some modifications may be helpful. Williams also mentions, only to put aside, the economic motivation to walking New York: "The walk up-town reaches from the bottom of the buzzing region where money is made to the bright zone where it is spent and displayed; and the walk is a delight all the way" (1902: 29). As an important example of the appearance of more motivated stories of the city than are commonly associated with the *flâneur*, a very local painting can be cited in the context of a critical debate over its meaning. George Luks' *Hester Street* (1905) (Figure 4.6) provoked diverging interpretations in two important exhibitions of American art: *American Impressionism and Realism* and *Metropolitan Lives*. In the former, *Hester Street* is instanced as another painting in which the *flâneur* adds an American chapter to his career as a European figure of modernity. In this reading, the key to the painting is the man in the white fedora, standing slightly to one side of the activity of this Lower East Side market scene. He is an American embodiment of the *flâneur* of modern life, and, in the curators' words, is "the artist's surrogate, observing the exotic culture without immersing himself in it" (Weinberg *et al.* 1994: 192). The curators of *Metropolitan Lives* disagree, insisting that the significance of Luks' painting lies in its unresolved contrasts. A youngish woman in a blue blouse

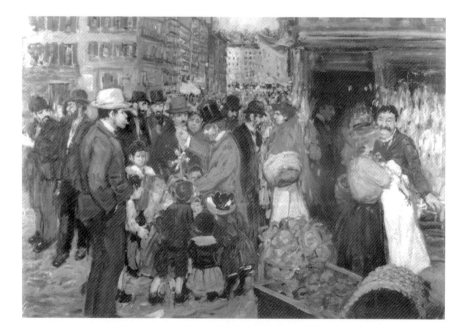

Figure 4.6 George Luks, *Hester Street*, 1905. Oil on canvas, 26⅛ × 36⅛ in. (66.3 × 91.8 cm). The Brooklyn Museum of Art, New York, Dick S. Ramsay Fund 40.399.

and hat with trimmings who is bargaining over a rooster with a shopkeeper seems to be of a different generation, or at least outlook, from a woman with a shawl who heads towards a group of traditionally clothed men. These men are contrasted with the man in the fedora, perhaps – in the words of the organizers of this exhibition – a "former resident ... who has taken on modern American ways" (Zurier *et al.* 1995: 26).

This disagreement over whether the man is a "former [but now assimilated] resident" or a *flâneur* is pertinent to the question of how to achieve urban knowledge up close to the city. The question can be stretched because this disagreement also asks how a scene may be capitalized upon in order, visually, to establish the margin that brings a wider perspective. Typically, the *flâneur* knows the city through desultory wandering, and a trajectory that catches the transitoriness and ephemerality of the modern city. And when *flânerie* was updated by Dadaists in the early 1920s, the same lack of intentionality was evident in their plans to visit pointless, boring places. These modernists and proto-postmodernists endeavored to know the city through their detachment from the usual social referents, though there is a sub-tradition of *flânerie*, remarked on by Elizabeth Wilson, which stimulated a "new journalistic literature of vignettes, anecdotes and 'travellers' tales'" (Wilson 1991: 54). From a biographical angle only this offshoot fits with Luks and the other Ashcan artists, who moved around the city precisely through not being detached. As former reporters – more in the mainstream of the profession than even the journalistic European *flâneurs* – they were carried along by the routines of the city: newspapers arriving in the early morning; getting to and from work during the rush hour; purposeful shopping; and work. The man in the fedora might indeed have "taken on modern American ways," but to the extent that he could be interpreted as intimately caught up in the scene: involved as a wheeler-dealer, someone with a calculating eye for an economic opportunity in a traditional scene undergoing transformation. He is a figure of the future. The ephemerality that Baudelaire made central to his definition of the modern is a by-product not of the cross-cutting, random route taken by the *flâneur*, and of the functioning of memory, but derives from economic motivation. Arguably, it is another sociological type, Simmel's figure of "the stranger," who manages to combine the sense of involvement and detachment that Luks has captured in *Hester Street*. Stringing together a few statements from Simmel assists in appreciating economic motivation as the key to the stranger:

> The stranger ... is an element of the group itself ... Throughout the history of economics the stranger everywhere appears as the trader, or the trader as stranger ... Trade can always absorb more people than primary production; it is, therefore, the sphere indicated for the stranger, who intrudes as a supernumary, so to speak, into a group whose economic positions are actually occupied. [And, most interestingly:] Objectivity is by no means non-participation ... but a positive and specific kind of participation'. (Simmel 1950: 402–4)

These observations may persuade us that George Luks is not a local-color painter. The people depicted in *Hester Street* have come together for identifiable reasons and the painter has followed them to this site to catch the historical resonances of the local scene. The artist who is at the scene and the artist who, later, seeks to capture the scene are not so easily distinguishable because the reasons the artist was on the scene are implicated in the images that are created. Luks' man in the fedora would be more at home in the company of the businessmen, detectives-for-hire, and journalist/ reporters that populate American urban culture later in the twentieth century, at least, and who prosper or at least survive in a market economy. Although Jesse Williams, with whom we initiated this discussion of the *flâneur*, has a preference for moving slowly through the city, he too admits to less of an interest in random wandering than in the "homeward stream of working humanity at the close of day" because "that is what 'the walk up-town' means" (Williams 1902: 30). From the man with an eye on the main chance to workers at the end of the day, these narratives are some of the ways in which capitalism has been visualized.

A John Sloan painting, *Three A.M.*, of 1909 (Milroy 1991: 195), gives us a further reason for quibbling with the now-standard definition of modernity as the knowledge of ephemerality and with the association of modernity with such transitory figures as the *flâneur* or the prostitute (or other vaguely related figures). Although prostitution was the lot for some women in New York (Gilfoyle 1992), we do not have to follow Baudelaire, the Surrealists and, later, the Situationists and define prostitutes as the epitome of the transitoriness of modern life, and effect an easy association between the *flâneur* and prostitute as walkers in the city streets. Baudelaire's critique of bourgeois respectability can slip too easily into a romanticizing of the transitory figures of modern urban life. The two women in *Three A.M.*, which was a painting rejected by the National Academy of Design, are having a cup of tea and one is frying some meat on a large hob. It is a kitchen scene and although they seem to be relaxing after some kind of night work (very conceivably it is prostitution), they are not wholly defined by their implied work, and their implied work does not isolate them in a specialized category because the details of daily life anchor them to what sustains most people: family, companionship, home, and ordinary routines conducted in identifiable places. This is not to denigrate the insights of Baudelaire, Benjamin and others who have so acutely understood aspects of modernity. But it is to say that in the Ashcan School's paintings of modern life, as in so much of New York's visual culture, there are more signs of relations and an infrastructure – and of the knowledge that this brings – than is sometimes thought to be the case. Modernity was a contradictory phenomenon, containing both traditional and contemporary elements. It matters less whether these elements are in a teleological relationship than that they are in a relationship, even as the "society of the spectacle" was making its appearance in early modern New York.

"ZEVO to Clean": Signs in the City

A final aspect of George Bellows' *New York* can sharpen this discussion of up-close views of the city (Plate 8). In its highly mobile foreground, Bellows' painting is a lively but familiar representation of exchange – of bodies, functions and goods – in which we, as observers, can locate ourselves in the position of the painter: slightly above street-level and facing Broadway at the far side of the square. The middle-ground and the background of the painting are more unusual, intimating, in their hints of abstraction, a different way of seeing the city. One element in this shift in perspective, however, brings form and content closer. The many signs on buildings, but elsewhere as well, contribute to the flatness of *New York* and also to that of a modern city. David Henkin argues, in *City Reading: Written Words and Public Spaces in Antebellum New York*, that the idea of a legible city predated the period of decisive growth of New York by some fifty years. In New York of the 1830s, Henkin notes, lithographs offered an "image of verbal frenzy" that suggested, even then, a potential difference of degree from European and other American cities (1998: 48). It is rare to find a photograph of Old and New New York in which a sign does not feature, indicating a continuing preoccupation with impersonal yet very direct communication. Film, too, incorporates signs into its view of the city, usually in an incidental way. Sometimes, it seems to be more deliberate, as in *Excavating for a New York Foundation* (1903), in which the camera follows a four-wheeled cart being hoisted out of a pit. Then the camera pauses long enough for viewers to read a sign on a nearby building. Two paintings by John Sloan, *Sixth Avenue and Thirtieth Street* and *Hairdresser's Window* (both 1907), also confirm that signs were, themselves, more and more a striking aspect of the content of the city that realist artists sought to capture. The Ashcan artists's awareness of city signs in turn influenced Edward Hopper and Reginald Marsh, among others, while this formal theme can be picked up in Stuart Davis, Charles Demuth, Robert Rauschenberg, Jasper Johns, Andy Warhol, Roy Lichtensetein, through to anonymous graffiti artists as well as Jean-Michel Basquiat.

Some signs in Bellows' *New York* are indistinct or rendered incomplete by the angle of the painting, whereas others blur into adjacent areas of this downtown scene to contribute to an image of urban disorientation or spectacle, to be approved or disapproved of as appropriate. *New York* lacks the surreal coloring and dreamlike anecdotes of George Grosz's *Metropolis* (1916–17) and his lithograph, *Memory of New York* (1917), but possesses something of Grosz's energy and his willingness to fling together human figures, the angular shapes of buildings and urban signs. In *Metropolis* and *Memory of New York*, signs are especially notable, with some detached from their buildings to appear as objects in their own right. These two works from a different tradition help to highlight those elements of Bellows' painting which may be said to anticipate the combines and collages of Rauschenberg, as well as Jasper Johns' more relentless focus on signs. The stack of signs in the right background

of Bellows' painting, for instance, lacks sufficient accompanying, as well as in-between, words for an urban sentence to form. Whether reading left to right across the stack or top to bottom, the discontinuities become almost a montage of signs in which reference matters less than shape and color. Because signs contribute to the theme of exchange – here, the intersection of an individual element in a city and the larger structure or system – they help us to wind up this discussion of how part and whole relate from the inside out and often from apparently incidental details in a painting, photograph or film.

Important as it is, an art-historical lineage needs to be reintegrated into the period in which Bellows was painting New York because to do so will assist in understanding better how particular and general are related. The proliferation of signs that Bellows records in *New York* occurs, typically, when the inhabitants and visitors to a city do not know many other people or, perhaps in the case of newcomers, anyone at all in the vicinity but, nevertheless, are themselves addressed in the abstract because a new market had emerged. In a systemic, rather than face-to-face, way signs incorporate inhabitants and visitors in the city's life of buying and selling, coming and going. As Crary puts it, writing of the period covered by David Henkin, "what occurs is a new valuation of visual experience: it is given an unprecedented mobility and exchangeability, abstracted from any founding site or referent" (1992: 14). An exaggerated instance would be the façade of a corner building covered with advertising posters, some even replacing windows, depicted in a 1909 photograph captioned *New York, Times Square* (Charney and Schwartz 1995: 74). Ben Singer cites this photograph as evidence of "the proliferation of signs" and the city's "crowded, chaotic, and stimulating environment," its "new intensity of sensory stimulation" (1995: 73). The jarring disconnectedness of advertisement juxtaposed with advertisement across a building nonetheless coexists with a form of inclusiveness, because everyone is potentially a consumer, and few areas of experience are excluded. In Bellows' painting, there is a similar inclusiveness but, in addition, we encounter a mixture of the common commercial culture and an abstract modernism, whether understood in compositional or sociological terms as, respectively, flatness or the spectacle. On the inclusiveness side, the sign on the side of a tall building at the back of the square reading "ZEVO TO CLEAN" exemplifies the direct, to-the-point, language of a hurrying crowd. In the 1909 photograph of Times Square, the inhabitants of the city are included in the address: "Turkish Trophies. 10 [cents] for 10. Why Pay More?" Coincidentally, at about the date of the Times Square photograph and Bellows' inclusion of words in his painting of New York, Ferdinand de Saussure reached the conclusion, in the lectures that made up the *Course in General Linguistics*, that, whatever the peculiarities of depiction (capitals, font or whatever), letters have a basic functionality in their communicative aspect as part of a language system (Saussure 1983). In Bellows, signs are part of a system of largely commercial advertising, making sense in its relations to other advertising techniques. Most of those relations are lost to us, though "ZEVO TO CLEAN" does

tell of the extent of the urban marketplace: the sign is not simply visible across the square but is also large enough to be seen across the roof-tops from a distance. If this and other signs constitute an assault on the senses, they are also quite rational in their appeal.

Wherever one looks in the visual culture of the period, signs have a doubleness: at once fragmenting urban life by their arbitrary disposition in the cityscape, and reconstituting it through their systemic basis. A Byron Company photograph, *The Eastern Hotel, Whitehall Street* (ca. 1906), is bordered by lines of signs (Byron 1985: Plate 1). Running the full length of the roof of the Eastern Hotel, along South Street and turning into Whitehall Street, is a large advertising board for The Bird Archer Company. The sign gives the company's headquarters as 209 Washington Street, thereby connecting the viewer to another potential location. Along the bottom edge, in the foreground, are three horse-drawn street-trolleys. Their rails lead us to the edge of the photograph, and their route signs position this street within a transportation network: "SOUTH FERRY AND CENTRAL PARK" and "BELT LINE: TO ALL FERRIES." Though slightly before the period covered by the present book, two photographs of Chatham Square also deserve a mention. The first, an anonymous photograph from around 1865, looks up the Bowery and attention is particularly focused upon a five-storey building and the sign on top of it: "BAILEY SIGNS" (Lightfoot 1981: Plate 83). Five years later, in a photograph of the same scene by E. and H.T. Anthony, a sign for Pendletons was on the top of the building, and a John Syms business, Emblematic Signs, had taken over from Bailey's on a lower floor (Lightfoot 1981: Plate 84). Indeed, only a sign for a hardware company etched into the brickwork of the next-door building remains the same in 1870. That the sign of the hardware company has substance makes no difference; a replacement sign may be ephemeral in its form but is meaningful by being part of a larger structure of communication. And yet the very systemic dimension of signs enables semantic freedom from the ordering and controlling dimension of signs. An arbitrary sign can appear in a different context elsewhere in the city, where there is an outlet for a business, or when painted onto a truck or sandwich boards in, respectively, Bellows' *New York* and Glackens' *Christmas Shoppers, Madison Square*. As in so much of the city's visual culture, these two works register the fact that precise reproductions can travel to different parts of the city, entering into different semantic contexts. Interestingly, in the foreground of *New York*, Bellows includes a traffic policeman who gives a human face to a signifying function as he points towards an oncoming car pulled by two horses. One of the nearby women turns to look at the policeman or to look where he is pointing, thereby turning signification into a human exchange.

Even as this historical contextualizing of signs opens up the painting, implying the system within which "ZEVO TO CLEAN" or the other advertising signs make sense in structuralist fashion, a further intersection of particular and general categories arises from the substance of the form, rather than arising from the mere inclusion of signs as part of what Bellows paints. When Bellows or John Sloan, in *Hairdresser's Window* (Figure 4.7), or, following on from them, Edward Hopper and

Reginald Marsh, include signs as an aspect of the new urban content, signs are given the same treatment as a building or a bus or a person, for that matter. In so doing, the painter – to a far greater extent than the photographer or film maker – provokes consideration of the status of signs. As one looks at the "ZEVO TO CLEAN" sign, it becomes an image in itself, a spectacle lacking an anchorage in usage. Understood in this manner, the temporal hustle and bustle of the city is, momentarily, ordered by this sign and transformed into "a space of time," in Gertrude Stein's apt phrase (Conrad 1998: 505). The brand-name "ZEVO," which is given more space than

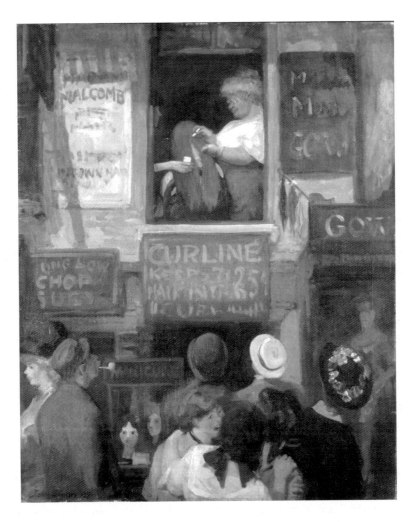

Figure 4.7 John Sloan, *Hairdresser's Window*, 1907. Oil on canvas, 31⅞ × 26 in. (81 × 66 cm). Wadsworth Atheneum, Hartford, Connecticut. The Ella Gallup Sumner and Mary Catlin Sumner Collection Fund.

some of the buildings in Bellows' scene, provokes uncertainty, precisely because it is a painted sign. Bellows' depiction of the letters is no exception to the overall style of *New York* but because what we have is a representation of a representational mark, the painterliness of the signs cannot quite be put aside. The letters are quite crudely painted and some letters are a little difficult to read. Notably, there is a suggestion in the extended lower arm of the "Z" of a swan, a possible, but by no means certain, hieroglyph for the quality of a cleaning enterprise. The brush-stroked roughness gives the letters an individual quality, even approximating a form of graffiti. To the extent that, in this effort to represent aspects of the city, Bellows makes his own mark on the cityscape he approximates the motivation behind, at one end of the economic spectrum, those companies and organizations that designated this or that building as theirs by having their names inscribed into the stone of the building, and at the other, the graffiti artists who seek to make their own this or that structure. Although the instance of signs in Bellows' *New York* lends itself to different interpretations of the city, it is the inseparability of *langue* and *parole*, system and speech act, historical context and self-conscious individual intervention, that reveals how, when Bellows, Sloan and other locally orientated urban realists paint a particular scene, the general or the citywide perspective impinges upon their point of view. This part/whole relationship is not exactly synecdochal, if, by synechdochal we mean symbolic of the whole. Instead, from the people depicted on their way to work or to shop or at work, through the images of transportation and the images of signs, the parts are connected through the structure of exchange. In contrast to a synechdocal relationship, this logic cannot be encompassed by the richness of individual detail or by some assumed boundary, whether the physical city or "New York-ness." Correspondingly, when a totalizing impulse comes to the fore, from the title of Bellows' painting through to the implied controlling of the urban masses through systemic communication or through the theorized image of the city as chaotic, dadaistic or collagist – to invoke familiar paradigms – the quirkiness/roughness of representation brings us back to the individual mark on the cityscape. Much as when repeating a common word over and over, looking steadily at the signs in a painting such as *New York* alerts us to their curious status, as well as their historical importance.

Most of the Ashcan artists were journalists, and newspapers are a motif in many of their works: *The Newsboy* (1916) by Bellows; two sketches, one by William Glackens entitled *One Boy After Another ...* (1913), and John Sloan's *The Woman's Page* (1905); Everett Shinn's *Park Row, Morning Papers* (n.d.), and Sloan's *Sunday Afternoon in Union Square* (1912). The painting most worth pausing over, however, is *Moving News* (n.d.) by Francis Luis Mora, because it illustrates the ubiquity of news in urban art. Mora was associated more with impressionist styles, studying drawing with Frank Benson and Edmund Tarbell in Boston, though he also worked and studied in New York City. In *Moving News* a man is reading *The New York Times* on a streetcar in the rush hour, and two more newspapers figure in the scene, as well as two women. It is a local scene to the extent that it has the clearly defined boundary

of the bus's interior, but the bus is on the move through the city and tall buildings can be glimpsed through the windows. There is little interaction between the passengers but while the man is oblivious of his companions and they look vacantly outwards, as a reader of a newspaper he is in contact with the wider world of the city and on his way, presumably, to contacts with those in his place of work. It is an oblique comment upon the nature of community in a modern city. Modernizing processes alter local and general relationships so that physical contiguity may be less relevant than various communities of interest brought together in the pages of a newspaper (see Park 1940).

Shinn's *Park Row, Morning Papers* (Zurier *et al*. 1995: 73) concentrates on the infrastructure that underpins scenes of private and public reading, portrayed, respectively, in Sloan's *The Woman's Page* and Mora's *Moving News*. At a junction on Park Row in Lower Manhattan, the location of the *Sun, Journal, Tribune, Times*, and *World*, bundles of newspapers are being sorted ready for the morning delivery to the rest of the city. The wheel of a delivery cart is visible to the left, a truck heads off down the cross-street, and a passing elevated train signifies that this junction with Newspaper Row is part of a comprehensive transportation and communication network, the basis for the circulation of signs and people. Newspapers thus figure as content in paintings, part of the visible texture of the city, and they figure as signs of changing social relations and the saturation of the city with information, rather than as the spectacle itself. Thinking back to the opening comparison between Bellows' and Mondrian's New Yorks is enough to remind us that it was the sheer overload of information, when allied to an assumed need to maintain perspectival foreground/background hierarchies, that provoked some modernist painters' and photographers' reaction against what they regarded as the false reality of realism in its different forms, and their removal – to varying degrees – of an excess of detail. Yet the strand of modernism that manifested itself in some of Picasso's collages, in the collage-like painting of Stuart Davis, and, eventually, in Robert Rauschenberg's combination paintings, found its liberation in a excess of detail which may be closer to, say, the busy realism of George Bellows as it is to the pared down modernism of Joseph Stella, Max Weber and Mondrian.

Delivering Newspapers (1903), an American Mutascope and Biograph film, was shot on May 1, 1899 by Billy Bitzer and Arthur Marvin, most likely in Union Square. It catches another stage in the process of dissemination of the news, with newspaper salesmen waiting in the square for the arrival of a horse-drawn van. The horse heads for the camera, then wheels off to its left and stops, with the sign "New York World" facing the camera. It is not unduly surprising that a remarkable number of still photographs of New York streets include the carts and vans of the city's newspapers, each advertising their product. In the Bitzer and Marvin film, the man on the van passes out bundles of newspapers to the waiting adult vendors, while a crowd of excited boys jostle around. The vendors then take the papers off in different directions. During this short period there is plenty of activity in the background as traffic crosses the square. It is hard to draw a

firm conclusion from *Delivering Newspapers*, as about many of those early shorts. Even so, in the context of subsequent critical debates about the anomie, disorientation and isolation of urban life, the inclusion of newspapers, both their infrastructure and their visibility on the streets, and the widespread interest in the mass media generally, are an important reminder that information was not yet associated with the loss of meaning about which, some years later, Walter Benjamin complained. "Every morning brings us the news of the globe, and yet we are poor in noteworthy stories" (1973: 89). Around the turn of the century, in New York, information was beginning to circulate through multiple means, but the Ashcan artists, photographers and even film makers, in the case of *Delivering Newspapers*, wanted to present scenes that explained what was going on. Whatever the medium, visual artists halted the circulation long enough to identify a human scene of communication or a scene of material, physical activity in the service of production and distribution.

We can reasonably conclude this chapter by concentrating upon the concept of the spectacle. An increasingly visual society, with developing media and, accordingly, the emergence in the United States of Guy Debord's "society of the spectacle," would be one way to describe New York for twenty or so years either side of the turn of the twentieth-century (see Stern *et al.* 1983: 20 and 190–201). Moreover, in spite of some difficulties translating the *flâneur* to New York, the urban spectacle can be associated with various American counterparts' preoccupation with commodities and with consumption more than production. Not surprisingly, then, the spectacle figures in much of the street-level, up-close visual culture of the period, as is apparent even from this select list. Among the many paintings, we can cite Childe Hassam's Flag paintings and the street-level military march in George Luks' *Blue Devils on Fifth Avenue* (1917); studies by John Sloan of the promenade, in *Fifth Avenue* (1909), of election night in the 1907 painting of that name, and of the new entertainment form in *Movies, 5 Cents* (1907); William Glackens' *Chez Mouquin* (1905), with its debt to Manet; and Everett Shinn's *Trapeze, Winter Garden* (1903), which belies his reputation as an artist concerned only with scenes of poverty and struggle. W.T. Smedley's and A.E. Sterner's engravings, respectively, *Madison Square Garden Colonnade* (1891) and *After the Opera* (1890), capture the self-regarding well-off crowds at fashionable locations. The Byron photographs of the leisure-class reception and dining rooms, discussed in Chapter 2, overlap with the same company's photographs of the interiors of theaters. And films quickly focused on the spectacle. *Bargain Day, Fourteenth Street, New York* (1905) brings crowds and shopping together outside of the Rothschild store. *Skating on Lake, Central Park* (1902) creates an urban spectacle from a popular pastime, and the many panoramic views of the city take the theme into a new visual sphere. By way of justifying this as the closing issue, the concept of the spectacle gathers together the strands of part-whole relationships explored throughout this chapter, while anticipating the panoramic dimension of the spectacle to be considered in the next chapter. However, when listing examples, it is apparent that the spectacle is itself an

all-purpose and slippery concept in need of further delineation and historicizing. At its most basic, the spectacle is "something made to be looked at" (Clark 1985: 63). This working definition is quickly modified by T.J. Clark, who maintains, critically, that some images may well be on the way towards the society of the spectacle but are complicated by elements as yet unassimilated into the fully commodified form. "The spectacle is disorganized, almost hybrid: it is too often mixed up with older, more particular forms of sociability and too likely to collapse back into them" (Clark 1985: 64). Clark has Manet, and Manet's Paris, in mind, but New York in the period between the 1880s and the 1910s, and its varied visual artists, were experiencing a similar marked shift towards consumption, though with local peculiarities. This debate is too large to be engaged with fully, but a few examples, taken from the list above, can help bring this chapter to a pointed conclusion.

The Ashcan artists were painters of modern life in their fascination with the new life of speed, excitement, disaster, and entertainment then emerging in New York. Stylistically, though, we know that Ashcan art lost its prior claim on modern American life with the boost given to early American modernism by exposure to European modernism at the Armory Show in 1913. It is the mixed claim on the modern that is so interesting, however. In Bellows' *Both Members of this Club* (1909) (Weinberg *et al.* 1994: 236), the members of the audience are not subservient to the drama on stage, and may even be of more interest in their dress and facial expressions than the spectacle itself. Similarly, in John Sloan's *Movies, 5 Cents* (1907) (Zurier *et al.* 1995: 168), there is an image on screen but the activity is in the audience. Everett Shinn cannot but mix up the image of a disaster in the streets in *Fire on Twenty-Fourth Street, New York City* (1907) (Zurier *et al.* 1995: 92) with the visual excitement of a show, complete with audience (see Yount 1992). The most revealing portrayal of an urban spectacle remains Sloan's *Election Night* (Figure 1.5). The election results are displayed on an illuminated screen but this is at some distance and the information is unreadable. The foreground is completely taken up by a throng of celebrating voters. The disregard of the results that initially motivated the gathering is evident in the many local interactions. For example, a woman leans confidentially towards another woman, even as a man seems to have hold of her wrist. Two grotesquely delineated boys engage in a game in the bottom right corner. And a man, with his back to us, leans over to brush the face of a woman with blonde hair. One way to read the painting is as an urban spectacle. However, Sloan's use of election night, and the setting of (probably) Herald Square, the location of newspaper offices where the election news would first break, are set against the individuality – even grotesque individuality – of the members of the crowd, and their reactions to the event. They use the event as an excuse for activities that are not orchestratable into an official spectacle. This is not a scene geographically out of reach of – in this case – a political totality, whether the city or the nation; far from it. The connections between local and general are there in the painting's title, but the connections have been temporarily severed. Strangers become resolutely

local in the immediate vicinity of the news and of an elevated train bringing, and taking, people to and from this downtown scene. A lithograph from 1896, *The Naval Parade* (Grafton 1977: 245), makes for an interesting comparison with Sloan's *Election Night*. Another city-wide event, with national significance – the centennial of George Washington's presidential inauguration – is attended by a respectful group of well-dressed men and women on a balcony above the tip of Manhattan. One man gazes through binoculars, and all of his companions are fixed on the parade of ships, to the extent that they do not interact with each other. Below them, on the roofs of buildings adjoining Battery Park, are similar groups of spectators, while in the Park itself the very large crowds are almost geometrically disposed along the paths and the waterfront.

Representations of shopping are common in the city's visual culture, reflecting New York's power as a marketplace. Posters advertising goods and department stores were everywhere on the streets, although two paintings by Ashcan artists better reveal the tension, summarized by Clark, between "the spectacle [and] older, more particular forms of sociability." In Glackens' *The Shoppers* (1907) (Weinberg *et al.* 1994: 272) the elegantly dressed women shoppers, their purses, the luxury goods on display, and the attentive saleswoman, are a concentrated scene of consumption. That the luxury clothing is probably on sale in one of the new department stores denotes, further, a highly organized system of production, distribution and retail. Female shoppers of this class do have power and may, *flâneur*-like, get around the city, but gender is manifested in Glackens' painting as central to the enclosed space of consumption. Women lower down the social scale are portrayed by Sloan in *Picture Shop Window* (1907–8) (Zurier *et al.* 1995: 154) and Shinn in *Window Shopping* (1903). Sloan's two women, with an accompanying man looking at them, stand in front of the windows of a shop selling visual art of various kinds, weighing up options, including that of buying compared with other commitments. Shinn's wistful lone woman, out in the wind and rain, makes up a triangle with the two mannequins clothed in fine dresses.

Sloan's *Hairdresser's Window* (Figure 4.7) has a very different inflection, endorsing neither inclusion in, nor exclusion from, the cycle of consumption. It shares some of the features of the paintings, above, but there is a distinct self-consciousness about the representation of display. There are people on both sides of the divide: that is, in the street and in the shops. A small crowd forms to watch the hairdresser and her assistant at work in the open window. On the street, these spectators are not captives in a department store in which display is organized to convert them into shoppers. They compare well with Sloan's people in *Election Night* who may have voted but cannot be categorized as voters even as the results are displayed above them. Sloan's potential shoppers react variously. One woman glances up as she continues along the street. Another woman is almost out of view as she walks past. Three young women laugh amongst themselves but three men are transfixed, though the older workman's demeanor suggests his is a different kind of

consumption from the smarter men at the front. The interaction across the divide is completed by two female head-and-shoulder busts that stare out at the passers-by from a ground-level window. A full mannequin is in the window of a shop for gowns. Even then, the interaction is not quite completed because the painting's structure is of frames within frames that implicate the viewer as well as the pictured spectators. Some frames contain human images: the hairdressing scene in which the arm of the assistant breaks the frame. Others contain signs: the names of the shops are mostly legible but the letters are, of course, hand-painted and reflect back the form of every other mark on the canvas. While the breaking of the cycle of consumption can occur in any medium or form, instances such as the lettering in *Hairdresser's Window* suggest that painting (or drawing) possesses a resource missing in photography and film for commenting upon the commodification of everyday life – that is to say, the absorption of the particular into the general.

Childe Hassam's impressionist style lacked some of the resistances in Ashcan painting, and lent itself more easily to forwarding the image of New York as spectacle. This is nowhere more apparent than in *Flags on Fifty-Seventh Street, The Winter of 1918* (1918), and the *Avenue of the Allies* series (1918) and the many other works in his Flags series, painted between 1916 and 1919 (Fort 1988). Hassam presents Fifth Avenue and other major streets as street-pageant on a grand scale with a fervent nationalist message. The great sweep of the streets and of the flags lend themselves to, and accentuate, the impressionist blurring of detail in favor of color and form. For example, *Avenue of the Allies: France, 1918 (The Czecho-Slovak Flag in the Foreground, Greece Beyond)* (Fort 1988: 20) is a busy street scene but the foreground cannot resist the coming forward of the background, with the Allies' flags, near and far, functioning aesthetically as drapes to give the scene an all-over quality; to make it flatter and more of an image, a scene to be looked at and not entered. The tension with "older, more particular, forms of sociability" that survives in Bellows' *New* York, even as it gravitates towards the flat state of all pure painting, is less noticeable in Hassam. Moreover, the subject matter of the Allies' cause in 1916, and then the Allies' victory in 1918 and celebrations through into 1919, unifies the impression conveyed by the formal qualities of the Flag paintings. Reds, blues and white predominate, with the American flag prominent and representing a new internationalism. This is the effect, even as Hassam's flag paintings seek to transfer the image of a bedecked boulevard from Paris, and Monet's *La Rue Montorgueil: Fête Nationale* (1878), to New York. And, one might add, even as, on the one hand, the United States's role in international affairs at last became fully visible in the postwar negotiations and decisions about the new world order, and, on the other hand, voices were being raised at home against the heterogeneity of the population in New York, especially – a campaign that led to the 1924 Johnson-Reed Immigration Act. In Hassam's Flags series, these matters do not surface; that is really the point, because theme and style interlock in possibly the most complete spectacle in the visual culture of the period. In contrast, Bellows' *New York* is important in the visual culture

of the period precisely because of its unresolved struggle between different kinds of content – at the extreme, people and signs – and between different artistic styles – at its most formulaic, realism and modernism. Throughout the twentieth-century, exercises of power, whether military or economic, have sought to turn space into an abstraction, which has its own standardized semiotic economy. Modernism is implicated, even as, in some versions, it became an adversary. At about the time New York had openly taken over from Paris as the center of modernism, with the successes of abstract expressionism, Jasper Johns began his Flag "paintings," and contributed, in his muted way, to a reaction against mid-century abstraction. Johns makes no mention of Hassam's series in connection with his flag paintings of the 1950s. However, the worked-over surface of *Flag* (1954–5) (Phillips 1999: 90), to use the best example, with its incorporation of bits of newspaper and cloth, soaked in hot wax, is a reaction to the cycle of consumption that had set in more fully in the post-World War II period, and to the full-blown nationalism of the Cold War years. Johns, with a more explicit adversary, does his utmost, through a collage-technique, to prevent *Flag* becoming a national spectacle, either in its representational or aesthetic function. In the turn of the century years, through to the World War I years, the reaction to an emerging society of the spectacle was necessarily more ambiguous.

–5–

"A Sense, Through the Eyes, of Embracing Possession": Views from a Distance

King-size Pictures

Near the end of the nineteenth century and some twenty years before New York's international career took off, bird's eye and other overviews were circulating quite widely and helping to define the city's identity and even its iconic future in some cases. These overviews, whether imaginary or made from across the Bay or from the new tall buildings, pictured the city through discrete as well as mixed media. The physical layout of New York was, and is, instrumental in encouraging an urban prospect. In *The American Scene* Henry James predicted that New York would fail to generate the sights that characterized favored European cities and, accordingly, headed off into the lobby of the Waldorf-Astoria for the preferred "supremely significant" inward view. Others were more optimistic. *King's New York Views* (1896), edited and published by Moses King, was hardly the first response to the challenge to picture the city whole, or at least in large part, by taking advantage of the natural topography to offset the visual drawbacks of the intense street grid. However, King's mini-industry of multi-volume *Views* and his hugely popular two-volume *Handbook of New York City*, first published in 1891, has a representative quality, at least for the turn-of-the-century period. The title and folio-format presentation, as well as the exploitation of the pervasiveness of photography and newly reliable reproduction techniques, give *King's New York Views* a visual authority that ran from the 1896 volume through a barely changing series to 1915, six years after King died. Although photographs predominate, the principle overview in 1896, as in 1915, is a drawing by one of Moses King's chief artists, Richard W. Rummell. It appears in full in the body of the 1896 volume (Figure 5.1), and in a modified form on its cover (King 1977: xii). As an overview, it is an explicit endeavor to know the city, to sight it, and, arguably, make a claim upon it. Conceivably, all pictures address a larger totality but the kind of claim and the means employed differ. Rummell's drawing uses faint water color to produce modulations around the edges and in the background. It has artistic ambitions but mixes genres and sits comfortably within the popular culture of the period.

Richard Rummell's drawing is similar to many map-type drawings of cities that make up a category within the view from a distance. At first, the drawing seems to

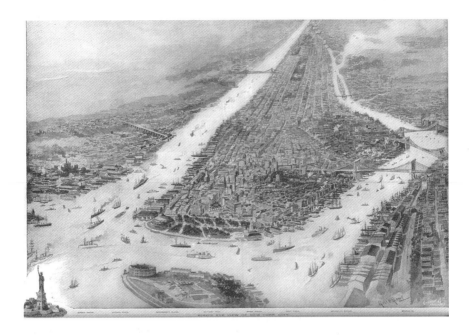

Figure 5.1 Richard W. Rummell, *Bird's Eye View of New York, Showing Contemplated Bridges across the East and North Rivers*, 1896.

co-operate smoothly with New York's inviting geography by supposing a privileged perspective above the Bay and with Governor's Island in the immediate foreground. Even today, this view successfully competes to be the quintessential visual icon of New York with the view downtown from the RCA Building. In Rummell's drawing there are no skyscrapers grouped around the Battery but his low, though still airborne, perspective permits maximum exploitation of the Hudson and East Rivers to accentuate a narrowing perspective and draw viewers through and beyond the thin landmass of Manhattan to where an indistinct hinterland merges with the cityscape. The version of this drawing that appears on the cover of *King's New York Views* for 1896 has an oval frame that further channels vision and justifies this as the establishing view of New York, even for a book priding itself on the plurality of its views. Overall, then, there is a disciplining of vision and a prioritizing of the view chosen for the cover and as the one full-page image in the first of *King's Views*. With the disciplining of perspective, allied to the promotional genre of *King's Views*, comes a simplifying of the realities of the city. The slums of the Lower East Side are quite indistinct and could either be a busy industrial area or, conceivably, open ground with trees. Full legibility is reserved for churches. In ushering us to the urban horizon, the perspective transcends what was becoming an economically and culturally divided Manhattan and – in a theme that became more prominent in the

volumes published after incorporation in 1898 – orders the much larger landmass of what would become the other New York boroughs.

If we turn to theorizations of city spaces from Baudelaire onwards, the strong inclination is towards sympathy for ground-level, everyday, experiential wanderings in the city and the pictures they generate (see, for example, Baudelaire 1964, Benjamin 1997, Debord 1995, de Certeau 1984 and Chambers 1999, and, for a more skeptical view, Donald 1999). Panoptic overviews figure as anti-humanist bids for control and a means to exclude heterogeneous elements. These are certainly aspects of the overview but the genre has other dimensions, not least a sheer fascination with the idea of the city. Overviews also take on different meanings when they become more difficult to achieve as the city expands: horizontally because of the sheer expanse of Greater New York, evident in the Risse Map of 1900 (Cohen and Augustyn 1997: 145), and vertically, as one vantage point is blocked by others. And – to anticipate the end of this chapter – overviews are not necessarily anti-humanist and they do offer a knowledge of the city which is equally as important as site-specific knowledge. It is prudent, then, to side-step the tempting stand-off which Michel de Certeau elegantly endorses when favoring street-level walking "below the thresholds at which visibility begins" over "the exaltation of a scopic and gnostic drive" when "seeing the whole" from the top of the World Trade Center (1984: 93 and 92).

The perspective in Rummell's drawing turns out to be a mixture of uniformity and heterogeneity; as is the form, which is somewhere between an upright drawn and partially painted picture, a flat map, and even a photograph. Rummell's drawing evokes a photograph in its precision, and in its proximity to a preponderance of actual photographs in *King's Views*, even as it possesses a different kind of map-like precision that, as we shall see, contravenes perspective in the way it selectively represents far-off objects. Locations are lined up with a key along the bottom edge: from Jersey Shore to Brooklyn. Whatever else is involved, this picture offers the knowledge and surface detail of a map. Yet when Rummell then signs the drawing he signals that it is neither map nor, for that matter, photograph, although signing over part of Brooklyn (alongside Moses King's copyright) perpetuates a lingering uncertainty about the status of this picture. The perspective, which gives Rummell's drawing an upright window character, coexists with the remnants of an older tradition of visualizing a scene, in which the material surface becomes a space for elaboration (see Alpers 1989: 119–68 and Jay 1988: 16–20). A detail, such as the sailing ship docking on the East River or the bridge over the Hudson, west of Central Park, monopolizes a section of the drawing, taking up more space or possessing a greater clarity of depiction than should be allotted to it by the rules of perspective. Words and images are included that, more blatantly, are inconsistent with the representational context. Such attention to the surface does not transform the scene, but it does pick out a counter-tradition of map-pictures. These had been common in New York since the 1840s, but date back to synoptic representations

of cities and especially trading cities in the Middle Ages. We think of engravings of London or Venice in which, through radical foreshortening, the totality of the city is depicted, surrounded by its landscape and with its port function emphasized. Visual and textual information is prominent in such pictures and human figures are included, often in a spectatorial role, to introduce a scale that the rules of perspective would gradually reduce (see Caws 1991: 24–5). Synoptic cartography, in general, permits a plurality of overlapping points of view, as when a map includes the illusion of three-dimensional buildings. This is a convention that Dorling Kindersley's *Eyewitness Travel Guides* have recovered, although the elaborate process of framing and sometimes reframing of a view only draws attention to the arbitrariness of the viewpoint.

Coming at the end of the nineteenth century and in the wake of the full acceptance of photography, Moses King's overviews are towards the naturalistic end of the spectrum. Yet there are some telling details. On the cover of the 1896 *Views* the Statue of Liberty is a vignette, integrated into the embellished letters of the book's title. In the full drawing, later in the volume (Figure 5.1), the Statue of Liberty appears more naturalistically but the conventions of synoptic cartography continue to operate and furnish it with a penumbra, relocating it in a part of the Bay where it is not – or at least not quite – and enlarging it relative to some other objects in the drawing. Within these conventions, it is quite logical for the statue to throw no shadow (in contrast to the larger ships), and to require no change of course for the yacht heading towards it. The statue also transgresses the frame of the drawing. There would need to be a much greater manipulation of scale for human figures to feature in this distanced view but including Liberty in the drawing, though floating in its own dimension, signifies the human story of the port during the period of mass-immigration from Europe. Long-standing conventions of synoptic mapping have introduced a discursive elaboration that competes with photography's supposed naturalism. The complexity of the surface increases as one is drawn into it, rather than drawn through it by one-point perspective. While there is no convenient art-historical story to link Rummell's journeyman drawing and modernist developments, his bird's eye view has something in common with an abstract image. There is little possibility of responding to it as an all-at-once abstract image, but there is a horizontality to it, in addition to the elaborated, even inscribed, surface on which overlapping perspectives can be included all at once.

Other features of Rummell's overview bring the viewer into the elaborated surface. First, the space in the foreground is not entirely disciplined by the invisible perspectival lines that, in other respects, guide us confidently through the drawing. Instead, while still sufficiently subservient to the narrowing Manhattan as the object of attention, the foreground is very busy. Water-borne trade is a pressing theme with liners, ferries, barges, dredgers, and leisure craft depicted, some patently out of scale. The shallow angle and more inclusive perspective give plenty of foreground space but, rather than contributing to the ordering of space, the shipping is given space to

assume a ceremonial character, with some of the ships and boats from the Hudson and East Rivers meeting, as in a regatta, at the foot of Manhattan. This discursive dimension (which, we should not forget, serves to frame the "straight" photographs that follow in the rest of King's collection) is strengthened by the composite image on the Introductory page to *Views* (King 1977: 1896: 1). The unattributed drawing on this page is made as though almost at sea-level looking towards the tip of Manhattan through a selection of craft, from ocean liner to sailboats. The drawing is enhanced by an oversized sun, setting behind the skyline, and the large, capitalized, letters, "NEW YORK," complete with baroque curlicues at the base of each letter. There are two out-of-scale ornamental tablets advertizing New York as "The Metropolis of the American Continent" and "The Foremost City of the World." The Introductory page to the 1896 *Views* is packed with such visual and textual information, as though the effort to picture New York and say what it means requires every technique at the editor's disposal. Visual hyperbole is also present, though more naturalistically, in Rummell's establishing overview for 1896, inasmuch as he depicts a cityscape well ahead of schedule. For instance, we see what appear to be the completed Manhattan (1905), Williamsburg (1903) and Blackwell's Island (1909) bridges on the East River. And there is a large bridge over the Hudson River at about West 8th Street, presumably included on the basis of Gustav Lindenthal's 1884 plan for a Hudson crossing. The first Hudson Bridge would be the George Washington Bridge, not completed until 1931. Two road approaches on the New Jersey side also look as though they will shortly warrant bridges over to Manhattan. Indeed, the expansive, proleptic rhetoric goes further because the version of Rummell's drawing used for the cover to *King's Views* has a second Hudson River bridge at about 42nd Street. The bridges are part of the predictive visual discourse, a naturalistic "as if" or "when."

The cover of the 1908–9 double volume (Figure 5.2) is unattributed, although it is in the house style exemplified by Richard Rummell. Here, the perspective has shifted to the west, taking in the corner of Battery Park and looking north-east across Manhattan Island to Brooklyn Bridge. The angle is steeper than in the 1896 drawing and the viewer sees from approximately the point of view of a large statue on a plinth that peers down upon the city. It as though Bedloes (now Liberty) Island has been relocated just off the tip of Manhattan and occupied by a figure, conceivably Isaac Bedlow, an English merchant who owned the island in the seventeenth century. The information that Manhattan had been "purchased from the Indians for the equivalent of twenty-four dollars" is supplied by the accompanying text, itself reproduced as the legend on a cartouche. Although we do not see with the merchant's eyes (because we could not then see him), the cartouche unambiguously supplies his economic perspective. He has taken the place of Liberty in a narrative that connects the past with the present through land-deals rather than ideals. Elsewhere in the drawing, in a re-enactment of the familiar theme of country and city, the view to the hinterland in earlier overviews gives way to the impact of the dense cluster of high downtown commercial buildings. The few civic downtown spaces are on the point of being

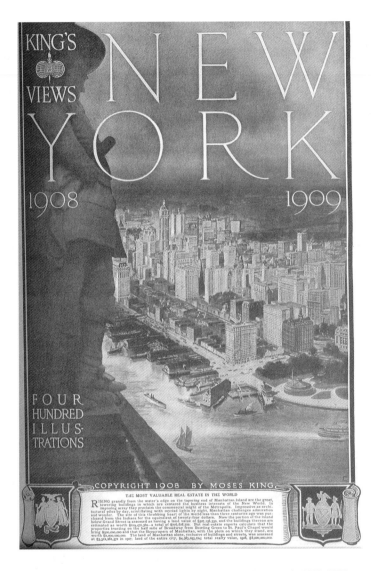

Figure 5.2 Anon., Cover illustration, *King's Views of New York, 1908–1909*.

crowded out, while Trinity Church is invisible, even though it is a landmark in many overviews after 1846. The docks are still in evidence, as is some shipping, but both are rendered less prominent by the steep perspective. In another Rummell overview, *Skyscrapers of Lower Manhattan* (1911), included in the 1915 *King's Views of New York* (King 1977: 1915: 24–5), the viewing position is similarly close to the Battery but at a lower angle, with the result that the ocean liners, ferries, tug boats, barges, sailing ships, and piers become part of the downtown scene, mediating between

us and the massed buildings that, by the second decade of the new century, had become the titular reference of the drawing. The motif of serried windows appears in the liners, the pier buildings along the Hudson River, and then in the skyscrapers. The last of these do not make up a gridded wall but there is a suggestion – as in the 1908–1909 drawing – that the tall downtown buildings will soon present a face to the Bay, blank not in its lack of features but in the uniformity of its features. This suggestion is made more firmly still in a 1907 Rummell drawing close up on the Financial District in which the dominant impression is of storey upon storey of windows (King 1977: 1908/9, 40–1).

Richard Rummell's drawings for Moses King are not the only overviews from the turn-of-the-century period but their formal heterogeneity and evocation of the map, as well as the descriptive, rather than expressive, aspects of the photograph, make them typical of ways of visualizing and knowing New York from a distance. His king-size drawings theoretically open up the genre by asking questions that do not, seemingly, have technological answers. After all, accurate maps of the city had long been available, and photography was the preferred technology for nearly all of the images in *King's Views* and his *Handbook*. Moreover, although aerial photographs did not become common until the 1920s, James Wallace Black had taken one of Boston from a hot-air balloon as early as 1860. Whatever the technological resources, intriguing pictorial problems refuse to go away because the effort to unify the cityscape in a comprehensive representation, provokes an amalgam of philosophical, ideological, formal and technological concerns. Around the turn of the century Rummell's house style in *King's Views* offered itself as the appropriate response; while, from the 1940s, William Fried's Skyviews company lent itself to the changed topography and the available technology (Fried 1980 and Campanella 2001). But just as IMAX and other cinematic technologies have not become the real thing, so Fried's aerial views of New York are at once startlingly clear but strange. Currently, computer-generated images have gained in authority but whether in *Sim City* or in architectural and planning applications of computer-aided design, these images only throw up new visual conundrums.

"The Attempt to Take the Aesthetic View": New York City as a Work of Art

The short introduction to the 1896 *King's Views* concludes by acknowledging that New York's outlines are not those of the city as a work of art, compared with London and Paris, at least:

> There is as yet a lack of noble public structures, and perhaps a needed symmetry of outlines in external construction; there is still quasi-crudeness in forms of development attained by cities of the Old World, but even in these no city ever before reached such a thorough development in a few centuries after its settlement.

At no far distant day New York will have erected a series of public buildings, founded an array of public institutions, beautified a number of thoroughfares, and added to her palatial homes, to her area, and to her population to such a degree that she will be freely accorded the pre-eminent position of the Chief City of the World. (King 1977: 1896: 1)

Some attempt is made in the accompanying overview by Richard Rummell to visualize this story (Figure 5.1). The distinctive buildings of the older downtown area are delineated with care, and towers, steeples and an occasional dome stand out. The twists and turns of the streets insinuate a confused element into this attempt to picture New York as a city with some historical grandeur. As if in reaction to this confusion, and at the expense of the cross-streets, the avenues in the grid to the north of downtown are emphasized by being aligned forcefully with the northward point of view. This accentuated perspective takes us up the island to where Rummell is at pains to pick out the few signs of coming aesthetic maturity. He does this by exempting the bridges, a cluster of domed buildings north and west of Central Park, and the High Bridge farther to the north from the loss of detail that perspective produces elsewhere in the middleground and background of the drawing. This evidence supports the claim that the city will soon have its vistas and thoroughfares and that this will bring economic and aesthetic maturity to a New New York, but without – literally – losing sight of the past. As late as the 1915 *King's Views of New York*, which adopted a futurist theme in Rummell's title-page drawing, the past of sailing ships is kept in sight in several of the full-page overviews.

About the time that Rummell started his series of overviews, and the Introduction to the 1896 volume of *King's Views* set out the commercial and cultural options for the city, the New York Reform Club and the Municipal Art Society began to press for wide-scale civic reform, and found common cause with aspects of the City Beautiful Movement. In the journals, *Municipal Affairs*, founded in 1897, and *Public Improvements*, founded in 1901, through to the New York City Improvement Commission, with its 1904 interim report and final Plan in 1907, significant efforts were made to re-visualize New York. The results are less relevant, here, than the important impulse to express a coherent, ideal urban form in a number of arresting overviews. In 1898, writing in *Municipal Affairs* and influenced by both Charles L'Enfant and Baron Haussmann, architect Julius Harder made some enthusiastic City Beautiful type proposals that stressed the importance of visual aesthetics in conceiving of the city:

> The system of diagonal avenues results, aside from its practical and economical superiority, in conditions known as "Vistas." These occur not only at the actual point of intersection with others of their own kind, where the area of intersection necessarily becomes so large that its center may be occupied by a structure of importance, but also at their intersection with every street of the rectangular system by affording greater length of vision and bringing larger objects or an increased aggregate within the extended angle of sight. In general, the view, instead of terminating in a perspective [on] nothing, rests upon an object. (quoted in Stern, Gilmartin and Massengale 1983: 28–9)

By the time of the 1907 Plan, the diagonals promoted by Harder were visualized as spanning the East River in a pointed attempt to unify the incorporated city. Two bird's eye perspectives are particularly revealing. One, looking north, closely resembles Rummell's drawing from 1896 in both its angle and point of view from Governor's Island but superimposes upon the avenues some diagonal streets, which opened up the kind of monumental vistas recommended by City Beautiful aesthetics. The cross-streets are barely visible (Stern *et al*. 1983: 29). In another illustration from the Plan two diagonals, crossing Brooklyn Bridge and the proposed "Bridge No. 3" (later the Manhattan Bridge), meet at a proposed Bridge Plaza in Brooklyn (Stern *et al*. 1983: 32). The influence of the City Beautiful Movement is evident. The Brooklyn grid, while visible, is dominated by the classical plaza and the seven radiating diagonals. Manhattan, in the middle distance and with a highish horizon beyond, is rendered so that the grid is entirely invisible. New York has been given new axial co-ordinates that revisualize the city and orientate the parts to an integrated whole within a larger space. This space is framed by the horizon, in the view from Brooklyn, and by the city's hinterland in the looking north view. Mario Manieri-Elia's summary of the City Beautiful, at least in the version promulgated by Daniel Burnham, is a helpful interpretation of what is going on in these Commission images. "Grid-planned areas," Manieri-Elia explains, "…can be brought into a miraculous formal equilibrium by the imposition of a different logic, which is comprehensive and abstract in respect to the ordinary scale of spontaneous alterations of the urban fabric" (Manieri-Elia 1980: 89). The New York Improvement Commission sought to provide the vistas and the idiosyncrasies that the Commissioners of the original 1811 gridplan had outlawed. The new diagonals and the muting of the grid are the primary "What if?" or utopian elements which entered the visual discourse of the overview under the influence of civic reform. The utopian view is almost, by definition, an overview because of the impulse to see the integrated totality afresh. Close-ups necessarily depend upon the overview in such a projection. A combination of an idealist abstraction from reality and, subsequently, an often tiresome preoccupation with the realistic details, which seeks to persuade skeptics is found in City Beautiful overviews, as it is in the utopian novels of the late nineteenth century. The combination tends to be achieved by a cluster of linked views, typically published in a planning project or magazine article. Thus the two bird's eye illustrations we have been discussing from the 1907 Plan, looking north over Manhattan and then looking across Brooklyn's Civic Center to Manhattan, can be associated with two drawings of proposed improvements to Fifty-ninth Street from the 1907 Plan and one drawing of a proposed parkway for Delancey Street from the 1904 Interim Plan. The bird's eye views create an ideal, imperial perspective that contextualizes the insistent classicism of detail in the more realistic perspective views of the new grand thoroughfares stretching to the horizon. These drawings bring the viewer closer to the redesigned city but still share the values enunciated by Julius Harder: "greater length of vision and [the] bringing [of] larger objects or an increased aggregate within the extended angle of sight."

If the bird's-eye views retain something of the map, the lower level drawings in the 1904 and 1907 Plans translate the image of unity into a window-picture. The cornice-line is squared off in the drawing of the proposed parkway for Delancey Street (Stern *et al*. 1983: 30). Trees are planted in two rows down the middle to give shade to the pedestrianized areas that are on top of tracks carrying street trolleys. Other traffic passes on the outside in both directions to complete an orderly separation of functions. These features remain consistent right to the vanishing point. The drawing of the proposed Fifty-ninth Street leading to Queensboro Bridge similarly capitalizes upon the bridge as a route to the horizon of Greater New York (Figure 5.3). In spite of Harder's prescription, a monument is not introduced as the termination of a closed perspective. Instead, Delancey Street continues to the horizon and Fifty-ninth Street continues on to the bridge. However, the linearity of the view is complemented by symmetrical features, which bind it into a space. Boxed trees provide covered walkways. In a different and this time fully street-level perspective view on the Fifty-ninth Street extension, classical accoutrements make the street an image of order, the static quality further suggesting that this is an image of the city at any time of the day (Stern *et al*. 1983: 33). The impression is of decorum and the calm prosecution of affairs, in contrast to a money-making city in which individual elements are liable to fly off in unanticipated directions in search of the innovation that makes a market dynamic. Yet there is an underpinning to this ordered space provided by the technology of mass transportation (see Figure 5.3). The bridge functions not in a uni-directional fashion but as an element in an integrated transport

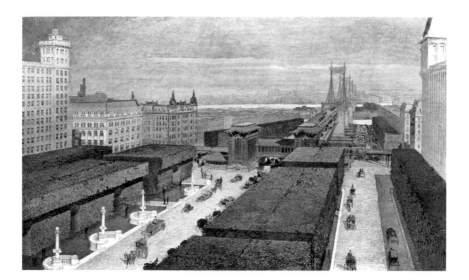

Figure 5.3 *Proposed Improvements to Fifty-ninth Street between Fifth Avenue and Queensboro Bridge.* New York City Improvement Commission, 1907. Perspective View of the Manhattan entrance to the Queensboro Bridge. Avery Library, Columbia University, New York.

system that would knit the rapidly expanding city together in many directions at once. Thus, the Third Avenue elevated railroad station is presented as crossing the thoroughfare in front of the narrowing approach to the Bridge and allowing transfer to rail and road transportation which cross the Bridge. The combination of architecturally disposed space and of an ordered rather than kinetic and multi-dimensional transportation envisages a city that is decidedly not the overfull city before the subway began (temporarily) to relieve the twice-daily chaos of rush hour and its destabilizing of spatio-temporal relations. Neither New York nor Chicago – for which a much more comprehensive Plan would be published in 1909 – would become a city on a European model but both were subject to Baron Haussmann-like visualizations, with their sources in Renaissance forms of visual and social order.

In the combination of idealist and realist views of the city we can see ways in which criticisms of an imperial overarching visual regime for New York might be countered. In 1903, approximately half-way through the controversy over the future of City Hall and City Hall Park, which dated from a design competition in 1888 and continued into the early 1910s, Henry Hornbostel and George P. Post proposed a Civic Center and Brooklyn Bridge Terminal (Stern *et al.* 1983: 64). It would correspond with the Bridge Plaza in Brooklyn, which became part of the 1907 Commission Plan and would, therefore, complete a key diagonal, a motif that is picked up in the axial garden design in Hornbostel and Post's proposal. This drawing, within a well-illustrated planning proposal, retains a grand, even imperial scale, certainly at ground level. However, as William Taylor and Thomas Bender argue, in the course of an important revisionist interpretation of City Beautiful planning, the concept of "ensemble," which derived from the Beaux-Arts training in Paris that so many American architects and planners received and which became pervasive during the era of civic reform, shifted the focus away from the individual grandiose building or single, stunning vista. They define "ensemble" as "the pattern of construction perceived collectively" (Taylor 1992: 53). The proposed Civic Center addresses the transportation needs consequent upon the emergence of a rush hour and the somewhat piecemeal development of a rapid transit system that, each working day, deposited and then collected commuters at the Manhattan end of Brooklyn Bridge. Hornbostel and Post seek to combine this transportation focus with a civic function, evident in the grand space of City Hall Park and the use of City Hall as the center point, in the face of calls to demolish or relocate it. The result is an endorsement of the horizontal dimension that was coming, in the face of an emerging vertical city, to symbolize a commitment to public, civic space (Taylor 1992: 51–67). Yet the vertical is not denied but, in the form of an office tower with a pyramid top, incorporated into a tense but vital equation between commercial and civic culture. The scheme was not implemented for cost reasons but Taylor and Bender's point is that, in the period they call early modern New York, an "essentially horizontal perception of urban form" persisted, and engaged with the new impetus in a crowded Manhattan to build upwards (Taylor 1992: 57). A panoramic drawing,

such as that submitted by Hornbostel and Post, is the main evidence for such a visual perception of the city.

Before continuing with another type of City Beautiful overview, there is an interpretative dispute that needs laying out, if not resolving. Although the overview can signify a bid for total visual control, Taylor and Bender help us to see that it also signifies a collective vision of urban form, one that looks to the relations between buildings to release a concept of public space. This is achieved by a modulation between bird's-eye and lower-level views, the former envisioning the pattern and the latter giving the human realization, complete with enough, but not too much, architectural detail. However, as the establishing overview is necessarily buttressed by closer though still broad views, the claim for "ensemble" becomes somewhat vulnerable to the critique of Beaux-Arts architecture that is implicit, and occasionally explicit, in Veblen's *The Theory of the Leisure Class*, published in 1899 in the middle of city beautification. From Veblen's utilitarian position (much disguised by his ironic style), it was the architecture of the American Renaissance and not the commercial, functional architecture then being pioneered in Chicago that bore the most significant relationship to capitalism. For instance, in 1902, just off Wall Street, "a Beaux-Arts extravaganza" (Tauranac 1985: 11) was designed for the Chamber of Commerce to celebrate New York's emergence as an imperial trading city. It had no steel girders but, instead, depended upon a structure of marble blocks, with portraits of the Astor dynasty recreating a self-contained version of New York's mercantile history on its walls. At the grand opening, Sir Albert Rollit, chairman of London's Chamber of Commerce, welcomed the fact that the Chamber would have a Beaux-Arts home and had not moved to the top of the Flatiron skyscraper, completed the same year:

> You have no iron flat or flatiron, but you have a beautiful building which recalls a startling change to my mind since I was last in New York 32 years ago. Then I had to go to the top of Trinity Church to see the tops of other buildings, and now I have to go on other buildings to see the top of Trinity. (Tauranac 1985: 12)

Veblen maintains that capitalist rationality has an inbuilt logic of social excess capable of engulfing supposedly non-commercial buildings through the exercise of philanthropy and municipal benefaction. Esteem derives not from exercise of the work ethic and from delayed gratification in the expectation of eventual profit – as Max Weber was shortly to theorize with American culture in mind – but from decoration and other conspicuously visible forms of display, particularly if they have a historicist surface on top of the most up-to-date steel-frame technology. The question of how capitalism is to be envisioned is an intriguing one.

In Taylor's early modern New York, capital assumes a number of images and not in any discernible sequence. The blankness of the gridded façades in some of Richard Rummell's drawings of downtown Manhattan are on the way to being susceptible to the same critique that glass- and mirror-wall skyscrapers would later provoke,

that capital does not have an image, but produces only a reflection of the viewer. The spectacular sights – including some further overviews that we can consider shortly in this chapter – but, more particularly, the montage of images generated in the streets and squares of the city by individual economic endeavors suggest that capitalist visuality is in constant flux. Correspondingly, the ordered cityscape of the City Beautiful, including its emphasis upon civic reform in and around the proposed redevelopment of City Hall Park or Fifty-ninth Street, can be plausibly interpreted – notwithstanding Taylor and Bender's important revisionist case – according to the logic of conspicuous consumption as the organized face of an emerging corporate capitalism. Looked at through Veblen's jaundiced eyes, Hornbostel and Post's drawing of a new Civic Center loses its sense of depth or inhabitable public space and comes to the surface, an impression that is endorsed by the oscillation between the perspective drawing and the plan of the Center, submitted as part of the overall proposal (Stern *et al*. 1983: 445, n. 26).

In Chicago, Daniel Burnham was quite open about the commercial value of aesthetics in public works, although by the same token he used aesthetics to promote a program of large-scale rather than localized, ad hoc reform. "Make no little plans" was Burnham's motto (Hines 1997: xvii). The editorials to *King's Views of New York* cannot quite make up their mind which image to opt for; and, as the Chrysler Building and the streamlined designs of the Depression decade indicate, an arbitrary relationship between economy and visual image would persist well beyond the City Beautiful era. Put too bluntly, no doubt, the reason for such arbitrariness and for the trying out of different images is that capitalism cannot easily be given, or take on, an image because it has no obvious center or focal point; particularly not at a time when a more individualistic capitalism was overlapping with corporate capitalism.

The multi-volumed *King's Views* are full of photographs and a number of drawings of other sites that underwent improvement either directly as a result of the Commission's work or in related developments. Pennsylvania Station was not part of the Commission's Plan, but it overlapped with the Commission's period of most intense activity and it brought together the idea of public and commercial works and the attendant ideological ambiguities discussed above. Moreover, its architects, McKim, Mead and White, were the leading proponents of the Beaux-Arts Classicism at the center of the American Renaissance, the aesthetic movement within which City Beautiful planning found a comfortable place. In a drawing by H.M. Pettit – Moses King's other leading artist – of Pennsylvania Station (1907) for the 1908–9 *King's Views* (Figure 5.4), the artist cooperates with Charles McKim's exterior design for a railroad station that looked more like a neoclassical state building or a museum. But Pettit seems to be interested in more than the architecture and brings out other aspects of the station and its relationship to the city. In his drawing we can see the translation from what is still a picture organized around Renaissance, window-conventions to a visualization of an ordered but commercial city in which the traditional coordinates are less evident. This drawing, in other words, works back

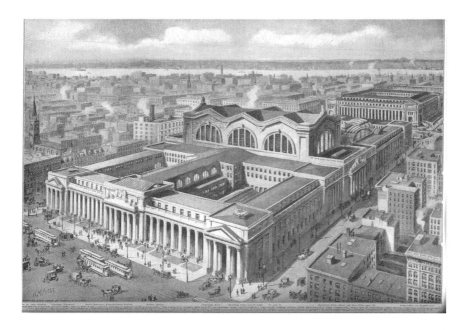

Figure 5.4 H.M. Pettit, *Pennsylvania Station*, 1907.

towards the comprehensive view but on the basis of a different concept of totality than that which informs the axial overviews of the city.

As the paintings of George Bellows remind us, there was much demolition to prepare for Pennsylvania Station. Nevertheless, it fitted into the grid and did not promote or necessitate new streets, as happened at the Gare de l'Est in Paris in the late 1850s with the extension of the Boulevard de Strasbourg. Nor did Pennsylvania Station require the kind of surface replanning, notably of Park Avenue, around Grand Central Station. This makes Pennsylvania Station a more interesting example of how a new development can be envisaged as reorganizing the space of the city. The commercial and industrial streets between the station and the Hudson River are, in the main, indistinctly depicted by Pettit. They are more like a theatrical backdrop when compared with the sharp-edged depiction of the architectural features of the station and the General Post Office, which was part of the same redevelopment of this west-midtown area. With the ordering comes an emphasis upon business, suggested by the hurried comings and goings at the front of the station, the traffic on the surrounding avenues and streets, and the Ninth Avenue El. The traffic is orientated towards the station, rather than towards the horizon/hinterland or, for that matter, towards the station's wider midtown area. To this extent, Pettit's drawing has much in common with the pictures in the Commission's various publications, which include a number of images of important buildings of the city's Renaissance or Beaux-Arts period but situated in a perspectival cityscape.

The Commission's and Pettit's picture are quite revealing of the ways in which a society based on a *laissez-faire* economy was seeking forms of order more commonly associated with a society based upon established divisions. In Pettit's drawing, Pennsylvania Station and the Post Office order, but also modernize, only the adjacent streets. The other streets are more indistinct and look older precisely because there are signs of industry, whereas the Beaux-Arts Pennsylvania Station looks newer, in part, because of its organizing, administering function. The point of view for the whole drawing has been pulled back and up from the entrance to the station so that Seventh Avenue seems much wider than its 100 feet. The sloping paved approach and porticoed entrance to the station become almost theatrical, thereby confirming that the station is not simply the central feature of the picture – its size makes that obvious – but that it has an unusual kind of centrality as an entrance to and exit from the city. It is different from the monuments and important buildings that Julius Harder imagined as situated at the intersection of diagonals, or the naval arch at the tip of Manhattan proposed by the Commission as a gateway to the city. Pennsylvania Station is presented as structuring the city according to a different and, in parts, at least, invisible logic, with only a glimpse of tracks beyond the Post Office to signify that this monumental building is, indeed, a railroad station at the center of a transportation network. As Burnham remarked when arguing for a central station in Cleveland, "With our modern civilization, the railroad has practically replaced the highway, and the railway station in its function at least has practically replaced the city gate" (Hines 1979: 167). The substitution of a centered building for the receding vistas is an indication that a new relationship between city and hinterland and even nation has been pictorially established. There is, in effect, less need of a horizon and a hinterland, although both are still in view. All that is needed is an outstanding place of arrival and departure in the center of the city. Moreover, the impression that the station and post office give of a walled city confirms that what could be going on in this drawing, as in all nineteenth-century overviews, is an attempt to picture a city that is becoming increasingly difficult to depict as a totality.

The move towards greater pictorial realism, allied with the desire to reinstate a sense of order in a modernizing city, continues in an 1895 photograph of Union Square and Washington Equestrian Statue, included in Moses King's 1896 volume (King 1977: 1896: 17). It is an unremarkable photograph and not a City Beautiful scene, although Union Square was regularly mentioned in the schemes that fed into official planning because it had the potential to be a key space within the much-despised grid. In the photograph in *King's Views* the distanced perspective from the south side of the square is the chief method for conveying the impression of order, as in all of the overviews. Fourth Avenue stretches away to the north. The foreground, though, is occupied by three horse-drawn street trolleys, a group of carriages drawn up by the park, a carriage crossing near the statue, and another heading towards the north of the square. But it is the people crossing the street who give this photograph its sense of purposeful, contemporary rather than timeless activity. They and the

vehicular traffic are going somewhere and not frozen into an image of order. This is an order on the move. By the 1908–1909 *King's Views*, the change is presented as all but complete and a lower level photograph of Union Square simply uses Washington's statue and the trees of the park (now dwarfed by tall buildings to the west) as signs of an older socio-economic formation but concentrates on Fourth Avenue as an even more purposive space than in the 1895 photograph (King 1977: 55). Inevitably, this process would be uneven and contradictory – although intriguing from a visual perspective. Here we can usefully turn to American impressionism, as a milder version of the modernism revealed at the Armory Show in 1913 but which is yet capable of a considerable degree of self-reflexiveness about the act of visualizing a city.

From Monet through to Pissaro's late Paris works, European impressionists had favored overviews. There is a direct link with the City Beautiful Movement through the minor French impressionist, Jules Guerin, who did the most important illustrations for Daniel Burnham and Edward Bennett's *Plan of Chicago* (1909) and occasional illustrations covers for special issues of magazines dealing with projects in New York City, although these did not include any overviews. A typical Guerin cityscape is his drawing of the new administrative center from *The Chicago Plan* in which a bird's-eye view, distanced perspective, washed colors that allow modulations towards the horizon, and the embrace of a splendid sunset all combine with the organization of the city along diagonal axes. Better-known American impressionists, although not contributing formally to city plans, shared Guerin's use of distance to mask unpleasant urban realities when they followed Monet and Pissaro and selected an overview for a few paintings of New York. Examples include Willard Metcalf's *Early Spring Afternoon – Central Park* (1911), Alden Weir's *The Bridge: Nocturne (Nocturne: Queensboro Bridge)* (ca. 1910), and Childe Hassam's *Winter in Union Square* (1894) and *Union Square in Spring* (1896).

Snow is a complicating factor in Hassam's *Winter in Union Square* and, therefore, his *Union Square in Spring* (Figure 1.4) is the impressionist painting that fits best with the earlier discussion of the Moses King photographs of Union Square. Overviews, such as Hassam's, also figured in a lively debate over the idea of the picturesque in New York (see Chapter 2), and it is clear from both of these paintings of Union Square that he could not discern the picturesque in the New York grid. His painting is made from a similar position to the photograph of Union Square and Washington Equestrian Statue in the 1896 *King's Views*, though further to the west of the square so that the statue is not visible and more attention is given to the irregular, curved expanses of grass grouped around a circular pond. The bright greens and yellows of the foreground endorse Barbara Weinberg *et al.*'s claim that Hassam's primary interest in Union Square is as a space mostly given over to leisure and not to politics, as was sometimes the case in the decades of labor unrest after the Civil War (1994: 184–8). However, coming at Hassam's painting in the context of other overviews indicates that he at least seeks to picture a city's districts within

the same frame. This is important because without such a relational viewpoint the spatial politics explored by Weinberg *et al.* becomes difficult to establish. The figures in the immediate foreground and around the ornamental pond suggest leisure but these figures shade into those on the more crowded sidewalks of Broadway and especially Fourth Avenue, where traffic is also heavier and we can see that the energy of the city competes with the decorum of the square. Moreover, up against the illustrations in the Commission's Plans, where clarity and differentiation are offered, an overview such as Hassam's reminds us that if distance was to be optically respected, as European and then American impressionists sought to do, then it would indeed produce a blurring effect on the painterly surface.

Admittedly, the technique can mask less pleasant aspects of city life and this is the gist of Weinberg *et al.*'s criticism of Hassam. At the same time, though, impressionist blur serves to break down the separation of functions that we have seen in the regularized City Beautiful images and also, to some extent, in the more unstable map-pictures of Rummell and other illustrators. Hassam's brushstrokes associate the people in the middle-ground and towards the background with the buildings. Interestingly, this sense of interaction is mostly lost when Hassam comes close to his subjects. *Washington Arch, Spring* (1890) (Fort 1993: Plate 4) lacks the scale of the Commission's cityscapes but shares their insistence upon a separation of function. The impressionist variation upon the overview, then, opens up the question of how a cityscape is to be interpreted in its relations. In this respect, the attributes of the map-picture are at least gestured towards by the absence of an explicit window frame. In consequence, *Union Square in Spring* combines a distanced window-type structure, as though we are on a level with the horizon, with what is not so different from a looking-down view. The immediate foreground in *Union Square in Spring* creates a passing sense of toppling forward, although this is righted by the middle ground, while the horizon at once formally secures the scene (imagine if the horizon had been omitted) and eschews the possibilities that a more delineated skyline was beginning to offer New York painters in the mid-1890s. This skyline shades harmoniously into the clouds. Hassam's overview achieves an uneven mix of stability and hints of instability that, though not as unsettling as the paintings of the first European impressionists twenty years earlier, nevertheless questions a traditional hierarchical ordering of space by encouraging the eye to wander over different spheres of urban activity and by initiating a concern for the point of view from which the painting was made.

"Port of New York": The Manhattan Skyline

In *The American Scene*, Henry James is after "a sense, through the eyes, of embracing possession" (1968: 99). His first attempt is from the Bay on a "train-bearing barge" and he comments, animatedly, on what was, by the time of his return to New York after a twenty-year absence, an already distinctive skyline:

You see the pin-cushion in profile, so to speak, on passing between Jersey City and Twenty-third Street, but you get it broadside on, this loose nosegay of architectural flowers, if you skirt the Battery, well out, and embrace the whole plantation. (James 1968: 76–7)

James's assault on "these giants of the mere market" then follows, and pushes to one side further discussion of the embracing view of the skyline (1968: 77). Yet within a few years pictures of the skyline had become the most remarked aspect of the New York view from a distance. More and more drawings, photographs and then films of Manhattan's profile appeared throughout the 1890s and 1900s, with the term "skyline" being first used in 1896, the year Moses King inaugurated his *Views*. The introduction to the first volume refers to "a needed symmetry of outlines in external construction" (King 1977: 1), an aspiration shared by proponents of the City Beautiful attracted by the potential of New York's riverfront. However, in the 1908/1909 volume of *King's Views*, the economic view of the skyline vies with formal aesthetics in a number of photographs of the city's skyscrapers in profile. One, captioned *Skyline of Lower Manhattan*, taken from Jersey City, is exactly centered on the Singer Tower (King 1977: 1908/9: 3). This, the tallest building on the skyline, accords the picture a considerable degree of symmetry. The sky and the Hudson River assist in centering the buildings on the horizontal plane. In contrast, though, the accompanying text conveys the economic calculations of population, land value and office rents that make "profitable the erection of costly skyscrapers," and this information prepares for the text beneath a paired photograph of the skyline of the Lower West Side which announces that "the skyline is being changed from month to month by the erection of new skyscrapers" (King 1977: 1908/9: 3).

The New York skyline was, at once, a startling amalgam of buildings and a phenomenon undergoing monthly change. In the 1890s and 1900s, the dynamic of the skyline was frequently represented through block diagrams, in which we perceive the interchange between representational and abstract thinking that comes about when a traditional, picture-frame format is used to portray a profile. The more common method for representing change, though, was a series of repeated photographs taken from the same position, with buildings named in the margins. These pedestrian techniques were attempts to portray not change alone but also the logic of change, inasmuch as it was possible to read off from the idiosyncratic silhouette the conclusion that the skyline was the result of many individual enterprises taking place in a congested area but with little appreciation of the construction going on around them. Thus, in the photograph of the Lower West Side in *King's Views*, the buildings mass more indiscriminately than in the paired photograph, *Skyline of Lower Manhattan*, which, centered as it is on the Singer Tower, brings order to the profile (King 1977: 1908/9: 3). In the photograph of the Lower West Side, two tall buildings on Thames Street organize the scene to some extent but struggle to maintain "a needed symmetry of outlines." New York aesthetics are inextricably and – other than in such instances as city beautification – often

blatantly related to economics, and in the second of these paired skyline photographs
the sheer heterogeneity of a market economy is itself the accidental visual attraction.
This claim can be made more authoritatively of a drawing by Fred Pansing, titled
*New York Skyscrapers – The Effective Change Wrought by these Buildings on the
City's Appearance within a few Years*, published in an issue of *Harper's Weekly*
in March 1897 (Kouwenhoven 1972: 394–5). There are a great many competing
points of vertical and architectural interest, and in an accompanying essay titled
"The Sky-line of New York," Montgomery Schuyler set out to deal with this new
visual phenomenon: "it is in the aggregation that the immense impressiveness lies.
It is not an architectural vision, but it does, most tremendously, 'look like business'"
(quoted in Kouwenhoven 1972: 394–5). Schuyler is announcing a new aesthetic, but
between 1897 and the authoritative pronouncements in the 1910s of Francis Picabia
and Marcel Duchamp that New York is a cubist city and a work of art in itself, there
is an interesting story to tell. Schuyler's insight is that a skyline that "look[ed] like
business" redefines visuality, and if we jump too rapidly to abstract modernism we
will miss the meaning of visuality in the context of the skyline, for in seeking to do
justice to New York, Duchamp and Picabia paradoxically imply its passivity. Picabia
claims, in a defence of abstraction, that "there is nothing materialistic in my studies
of New York" (quoted in Conrad 1984: 115), and Duchamp recruited the Woolworth
Building as a Readymade, even though its completion dramatically changed the
conditions of seeing in the city. To picture the skyline, which invariably included
the Woolworth Building after 1913, required the quite material fact of distance and
this, in turn, gave a material dimension to the otherwise intangible concept of point
of view. James's lament at the lack of distance when he wanted to see even a single
building, the old Waldorf Astoria, from the street testifies to this materiality as, more
positively, does the agency of the train barge that allowed him, as he thought, "a
sense, through the eyes, of embracing possession." Similarly, Alfred Stieglitz and
Alvin Langdon Coburn sought a necessary distance for their skyline photographs,
respectively, *The City of Ambition* (1910) and *The Waterfront* or *New York* (1907).

The skyline had presented itself as a fit subject for film in the earliest of the
actuality films. *Panorama from Times Building, New York* (1905) takes viewers
directly up from the ground level, before panning round the city. *Panorama of
Blackwell's Island, N.Y.*, *Panorama of Riker's Island, N.Y.* and *Skyscrapers of New
York City, from the North River* all date from 1903, and all make use of a boat. The
following description, from the Library of Congress web-site, is of a small portion
of *Skyscrapers of New York City* but confirms how "full" of the city these panoramas
are:

> The camera passes one of the Manhattan-to-New Jersey commuter ferries to Jersey
> City or Communipaw… Proceeding south, the distinct double towers of the Park Row,
> or Syndicate Building, erected in 1897–98, can be seen in the background… A coastal
> freighter is next … then Trinity Church appears, to the left of which can be seen the

Surety Building, as a tug with a "C" on the stack passes in foreground... Several small steamboats come into view ... and the B.T. Babbitt Soap factory at Pier 6 is seen ... followed by the Pennsylvania Railroad piers (#5 & #4), with a group of docked railroad car floats ... and the Lehigh Valley Railroad piers (#3 & #2), also with car floats. (Detroit Publishing Company n.d.)

But, beyond being "full" of the city, these panoramas parade the city, its tall buildings or its topography, as fundamental to the film's existence: the city as what is seen and where it is seen from. These films do raise expectations of a more complete, because air-borne, view but mostly refuse to meet this desire for meaning and completeness. That need is, however, bizarrely acknowledged in another, but unusually long, early skyline film. The first three minutes of *The Skyscrapers of New York* (1906) are pure actuality, as the camera pans across the cityscape and then rests on groups of construction workers as they walk, sit and work on the skeleton of a tall building, with the New York skyline mistily visible in the background. However, it is as though spending this amount of film time on these high-altitude work-scenes will, sooner or later, provoke more than documentary interest. The outcome in *The Skyscrapers of New York* is extreme, though, because, having used existing documentary footage, the film suddenly turns into a narrative drama for its remaining eight minutes when (to quote from a caption card that suddenly takes over the screen) "Dago Pete Starts a Fight and is Discharged." A robbery follows, then a cover-up, a fight on the top of the skyscraper under construction, and the story ends with Dago Pete in court. There, he is identified by a witness who dramatically points him out and, in so doing, completes the process by which a character is individuated; that is, picked out from the routine of work and the groups of workers. As this process is refined, through plot and stylized acting, so the skyline, which is the focus of initial interest, is converted into a mere backdrop and eventually dispensed with in the interior scenes. Meaning was not built into the material development of the skyline, as it was into proposed (and, in some cases, implemented) City Beautiful sites. But when the skyline receives extended attention through the medium of film, meaning is drawn out of it but then, in *The Skyscrapers of New York*, transferred elsewhere. We can locate the precise moment when this occurs. Some anonymous workers are winched from one precarious part of the skyscraper's frame to another and, just as they sink out of sight, they wave at the camera. In retrospect, meaning is seen to be a latent quality in the skyline, always about to emerge. The narrative drama that emerges in *The Skyscrapers of New York* is only an exaggerated example of a new self-consciousness about visuality that can arise out of the most arbitrarily constructed urban scene.

In what is probably the most renowned skyline film in the early modern period, *Manhatta* (1920), Charles Sheeler and Paul Strand took the Manhattan-bound ferry from Staten Island for the opening shots. Their activity of picturing the skyline may be discussed as a tension between stability and change and between narrative

and abstraction. Accommodating or confronting the full modernity of the city is an option from the credit sequence and the open shots onwards. Strand and Sheeler use an image of the skyline that draws on photographs of Manhattan from New Jersey (we can discern the Singer Tower and the Woolworth Building), but also the block-diagrams used to track changes in the skyline from the mid-1890s. A respect for perspective, symmetry and spatial coherence is noticeable in the opening shot from the ferry of the Manhattan skyline, framed between water and sky. By 1920 the skyline, although still changing dramatically, had become an accepted sight. However, a succession of succeeding shots, which are not obviously connected with each other, disturbs this stable image of the city. For instance, it is not apparent where we, as viewers, are in relation to the rooftops (with barely a glimpse of the sky), parapets and sheer walls. This avant-gardist feel to the film grows stronger as we are taken into the city. The legible visual space of the skyline that accompanies the credits and then the opening shot of the skyline is broken up by the sheer verticality of the city, its geometric repetitions, and the lack of a containing frame. The camera looks up at, and down from, tall buildings, not to complete a represented space, as in classical Hollywood shot-reverse-shot style, but to create instability and uncertainty. After these intense shots and juxtapositions of shots, in which the sheer materiality of the built environment presses in a most deterministic manner (it seems impossible at times to get a spatial grip on the city), it is both a relief and a disappointment when the film issues out into a containing space. Legibility is retrieved when the skyline returns and distance allows for a number of shots that accommodate the startling city and do so with surprising ease, especially after the montaged sequences earlier in the film. The use of smoke prepares the way for a re-linking of fragmented urban space with the horizon and then with the sky – particularly in the scenes organized around the Mauritania in the harbor. Then, at the end of *Manhatta*, the camera looks towards Staten Island and the sunset, thereby completing the story of a day in the city. Jan-Christopher Horak puts this well:

> The subject has thus come full circle; the object of the subject's gaze has become the subject, the subject the object. The filmmakers have inscribed the spectating subject in an actual and a metaphorical journey: in time from morning to evening, in space from Staten Island to Manhattan, in the gaze from an urban cityscape to an image of a natural landscape. (1987: 55)

That *Manhatta* was made as the cycle of immigration was coming to an end, gives the story of a day in the city a reassuring historical resonance, which belied the controversy then attending forthcoming legislation establishing quotas for immigration. That is to say, the *ad hoc* quality of the visual spectacle, and the daily and historical tensions of, respectively, work and arrival as an immigrant, are moderated by a form of narrative closure. The skyline sequences are most subject to narrativization because the horizon helps spatially to enclose an individual shot

and then, when repeated at the end of the film and at sunset, completes a day in the city. The skyline frames the city and also the fragmented sights of a day in the city in those sequences when the city is not seen from a distance. The horizon and the distance necessary to see the horizon are prerequisites for retaining control of the point of view.

It is not that these moving and still pictures represent the skyline other than what it is; it is a theoretical commonplace that, logically, there is always going to be an interpretation in any representation. Rather, the point is to notice the tension between acquiescence in existing conventions, which usually allow for an accommodation with older values, and the forging of new conventions for representing a phenomenon that is not so easily assimilated to traditions, even urban traditions. Montgomery Schuyler's various essays on the skyscraper and the skyline are based on a distinction between the American and, especially, the New York skyline, and the skyline projected by towered cities and towns in Europe. For all the accommodations, Strand and Sheeler's *Manhatta* is a stimulus to further examination of a number of pictures in which the skyline in the background openly asserts visual authority over the foreground and ushers the viewer to new ways of visualizing the city, in which, as the foreground is surrendered as a perceptual position, so there is an accentuated interest in pattern and juxtaposed shapes – in abstraction. There is a perfectly reliable art-historical explanation for this development but, as with the earlier comments on Duchamp and Picabia, more is to be gained from sticking with a broader notion of visuality that includes modernist vision as an important element, but only alongside an awareness of the conditions of seeing. One bonus for this more open conceptual approach is that, as we briefly noted when looking at Childe Hassam's *Union Square in Spring*, the development of an artist's career comes to seem far more varied than is the case in many art-historical studies. Among the artists who bring together abstraction and the skyline are early American modernist painters, John Marin and Abraham Walkowitz, in particular, but also Georgia O'Keeffe and Joseph Stella, and the photographers Alvin Langdon Coburn and Alfred Stieglitz.

Marin's *Downtown from River* (1910) adopts a similar perspective to the photograph, *Skyline of Lower Manhattan*, in *King's Views* (1908/9), inasmuch as the Singer Tower is almost central to the composition, with the sky and river framing it and the other massed skyscrapers at the top and bottom. And his *Lower Manhattan from the River, No. 1* (1921) (Figure 5.5) has similarly traditional elements, differing only because the Woolworth Building has joined the skyline in the intervening years and there is a more explicit enclosure of orange-brown paint. In both works, the shipping in the foreground and the lines slanting outwards from the top of the Singer Building give perceptual space to the painting. Marin's rather unusual combination of water colors and a cubist organization of shapes and planes is a very different response to the phenomenon of the changing skyline from pictures organized around perspective and utilization of the foreground. Where monthly alterations in the skyline could be registered in a series of photographs of the same portion of the

Figure 5.5 John Marin, *Lower Manhattan from the River, No. 1*, 1921. Watercolor, charcoal and graphite on paper, 21¾ × 26½ in. (55.2 × 67.3 cm). Metropolitan Museum of Art, New York City, Alfred Stieglitz Collection, 1949 (49.70.122). Photograph by Geoffrey Clements. Photograph © 1989 The Metropolitan Museum of Art.

skyline, thereby inscribing time in the differences between discrete images, in some of Marin's works change is figured all at once as movement and even instability on the surface of the painting. In *Downtown from River*, the central mass of the buildings, with the partial exception of the outlined Singer Tower, comes forward to the surface.

These tendencies are more apparent in three other Marin works, *Lower Manhattan* (1920), *Downtown New York* (1926) and *Mid-Manhattan, No. 1* (1932), and still more apparent in Abraham Walkowitz's *Cityscape* (c. 1913), *Improvisation of New York City* (c. 1916), and *New York* (1917) (Haskell 1999: 117). The last of these differs hardly at all from Walkowitz's fully abstract *Symphony in Lines* (c. 1915). There is a skyline but virtually no perspective, except at the base of the buildings where a tangled mass of lines and shapes suggests either a foreground of low-level buildings or simply activity. In both Joseph Stella's *The Skyscrapers (The Prow)* and *The Bridge (Brooklyn Bridge)* (1922) (Haskell 1994: 91), and Georgia O'Keeffe's

Radiator Building – Night, New York (1927) (Hughes 1997: 378) the coming forward of the skyline is not so radical as in Walkowitz but deserves some comment nonetheless. In O'Keeffe's painting we can see the curious visual phenomenon of depth (the streets recede) coexisting with the flat, lit-up, surfaces of the skyscraper. There is plenty of evidence of flat surfaces in Stella as well but his gothic motifs and especially the gothic windows affirm the essentially traditional structure of these and his other city paintings. The shining, partially abstracted, skyline in *The Bridge (Brooklyn Bridge)* is framed by the arches of Brooklyn Bridge. The gothic form of the symmetrical (and in this sense quite un-futurist) arches is heightened by the religious symbolism elsewhere in the painting. Stella pursues an older, even religious, order but through the new materials of steel and electricity.

The relationship between flattened, foregrounded buildings and the cityscapes in O'Keeffe and Stella nonetheless introduces a degree of doubt over where the viewer is being located, whereas in Marin and Walkowitz it is the instability of line and their use of internal framing, which reminds us of this key issue. Even Walkowitz – who is the most abstract of these artists – employs the vertical picture form that drawings and photographs in the 1890s employed to register the phenomenon of the skyline. However, instead of the ground/sky, bottom/top sealing of the picture, Walkowitz inscribes the buildings in *Improvisation of New York City* in an inner frame of dark paint. We will need to come back to the device of the frame later because it works against the verticality of the representation (of a skyline) – indeed against representation, as such – by suggesting that the painting need not be viewed in window-picture form at all. Instead, it might be viewed as a map, from above. But this is to get too far ahead of the argument and to omit a more traditional explanation for frames. In a number of works Marin leaves an uneven frame of blank canvas around the natural border of Manhattan, namely the rivers and Bay and the sky that are rendered in blue with rapid brushstrokes. Marin's frames and, to a lesser extent, Walkowitz's may be assimilated in a familiar interpretation of modernism as seeking autonomy; that is to say, that the new set of relations, however apparently chaotic, could always become its own rationale, marked off from traditional co-ordinates.

Roughly speaking, this painterly institution of autonomy parallels the introduction of an accommodating frame or set of mediations drawn from nature, as in Strand and Sheeler's *Manhatta*. The sphere of frenetic urban activity is enclosed by Marin: "within the frames there must be a balance, a controlling of these warring, pushing, pulling forces" (quoted in Davidson 1994: 60). Lukács' critique of this artistic project would be that, as the relationship between a visual sign and an object is replaced by the collisions and fragmentation of modernism – but within a frame – so there is a loss of the power to reveal historical forces in everyday scenes which, he insists, realism provides. Lukács would presumably accept as support for his overall thesis Siegfried Kracauer's observation that "the current site of capitalist thinking is marked by *abstractness*" (Kracauer 1995: 81). However, Kracauer's statement and these early American modernist paintings are by no means explained away by

Lukács' still-compelling thesis. A critique of modernist abstraction as reification undoubtedly lends itself very effectively to pictures of individual skyscrapers. Pictures that humanize single skyscrapers or naturalize them as part of a landscape are the other side of the coin from those that present them as disenchanted monuments, for instance in Hugh Ferriss's expressionist drawings in *The Metropolis of Tomorrow* (1928) or as in O'Keeffe's *City Night* (1926), as abstract autonomous objects, all surface. Once detached from use-value, the single skyscraper could become a commodity, a fate or achievement most usually associated with the Chrysler Building, which, in its ornamentation and use of materials, became an advertisement for the company. Newsreel footage, shortly after the completion of the Chrysler Building in 1930, catches a troupe of dancers on an aerial stage afforded by the roof of a nearby skyscraper. The dancers are dressed in shining metallic costumes and, with the Chrysler gleaming behind them, they perform a mechanical dance, a "mass ornament." According to Kracauer, who coins this expression in an essay provoked by the Tiller Girls and similar "stadium" performances:

> the ornament resembles *aerial photographs* of landscapes and cities in that it does not emerge out of the interior of the given conditions, but rather appears above them. Actors likewise never grasp the stage setting in its totality, yet they consciously take part in its construction... The more the coherence of the figure is relinquished in favor of mere linearity, the more distant it becomes from the immanent consciousness of those constituting it. (1995: 77)

The spectacular images in the newsreel footage of the mechanical dancers support Lukács' revision of modernist authority but, more particularly, the conclusion to William Taylor's essay on the skyline:

> By the end of the 1920s ... corporate aspiration and the symbolization of power had in popular perception been mythologized by an invocation of the city as a silhouette, the city as theatrical façade, the city viewed from across the river. Thus cosmeticized, it was this perception of urban society, ironically, that was invoked to sell every imaginable product, not the least of which was urban life itself. (1992: 34)

This is a convincing argument. On the other hand, the repetition of the style of the Chrysler Building in the costumes of the dancers, together with their syncopated rhythm, can be interpreted as a hyperbolic commentary upon two aspects of the underlying system: the commodification of the object, which is multiplied in front of our eyes, and the commodification of labor, which, from an early actuality, such as *Beginning of a Skyscraper* (1902), through to documentaries on the construction of the Chrysler and, even more so, of the Empire State Building, is depicted in heroic terms, but is, after all, part of the rationalizing of labor in the increasingly mechanized construction industry. Kracauer is again helpful:

The structure of the mass ornament reflects that of the entire contemporary situation. Since the principle of the *capitalist production process* does not arise purely out of nature, it must destroy the natural organisms that it regards either as means or as resistance... The mass ornament is the aesthetic reflex of the rationality to which the prevailing economic system aspires. (1995: 78 and 79)

Unlike Lukács, though, Kracauer maintains that more and more, and – in this instance, we can add – exaggerated, abstraction brings an awareness of the rationalizing processes, which would otherwise remain either invisible or confined to elite art objects, or rejected out of hand as necessarily anti-humanist. Kracauer argues that we cannot simply return to a "false mythological concreteness," taking refuge in the consolations of premodern community. Instead, an understanding of abstract representations offers access to underlying processes, these being the "reality present in the stadium patterns" (Kracauer 1995: 81 and 85). There is a related comment upon the production of images of the Chrysler Building in a photograph which Oscar Graubner took of Margaret Bourke-White on the gargoyle of the Chrysler with the skyline in the background and about to photograph the skyline (Stern *et al.* 1987: 77). This photograph is all the more revealing of the process that is revealed in the mass ornament because Bourke-White had been employed by Walter Chrysler to take photographs of, and from, the Chrysler Building. The intention was to draw even more public attention to this startling skyscraper. However, Graubner's photograph, dated 1934, points to a self-consciousness about image making that, along with the film of the mechanical chorus line, can be set alongside Lewis Hine's photographs of heroic "men at work" on the Empire State Building (Hine 1997). Where Hine directly reveals the human dimension of the skyline, the film of the mechanical dancers against the Chrysler and the rest of the skyline, and the photograph of Bourke-White at work, observe different but increasingly important representational processes also at work.

Lukács is, rightly if unusually for a Marxist critic, interested in style when distinguishing between modernism and realism. Yet the choice of subject matter also bears upon form. Pictures of the skyline rather than of individual or wholly dominant skyscrapers offer abstraction more scope to grasp aspects, at least, of modern reality and are perhaps less vulnerable to Lukács' argument. In Marin and Walkowitz's paintings there is, it has to be acknowledged, a loss of the reassuring anchoring of the skyline in usage and purpose that we noticed in the first drawings and photographs of the skyline, and which is still there in Stieglitz's *The City of Ambition* and Coburn's *New York* or *The Waterfront*. When Henry James complained about skyscrapers, it was precisely because their naked economic function denied them any formal qualities, but what we find in Marin's and Walkowitz's abstract amalgams of skyscrapers is an awareness of – and both words deserve emphasis – *urban form*. In his skyline essays Montgomery Schuyler anticipated this different concept of urban form associated with the skyline; different, that is, from the notion

of embedded, stable urban form with which James was equipped on his return from Europe, and different from the symmetries and the soft impressions that were favored by advocates of the City Beautiful and the picturesque city.

Marin and Walkowitz, but also O'Keeffe, Stella, Coburn, and Stieglitz, fasten upon and, indeed, recognize a novel cityscape. Recognition of the informing processes is provoked by abstraction. Marin refers to "great forces at work" in the city and to the "mass" of skyscrapers exerting influences on each other, understandable only in their interrelationships in a cityscape (Marin 1966: 28), as in *Lower Manhattan* (1920), where the wall of irregular buildings along the East River is bisected by the elevated railroad coming in off Brooklyn Bridge. The energy given off by Marin's skyline is more than the sum of the individual buildings. To this extent, the skyline in Marin's downtown skyline paintings or in Walkowitz's *New York* (Haskell 1999: 117) is a projection into the sky of the transactions and exchanges that characterize the market. But because no market can be simply represented, given that it is a process rather than merely a site, the effort to frame a skyline that "looked like business" is an important gesture towards the invisible process. Visually, Marin's skyline is too unstable to amount to a totality and Henry Adams' recollection of the skyline is apposite:

> The outline of the city became frantic in its effort to explain something that defied meaning. Power seemed to have outgrown its servitude and to have asserted its freedom. The cylinder had exploded, and thrown great masses of stone and steam against the sky. (1931: 499)

Or as Marin himself puts it: "the great masses pulling smaller masses, each subject in some degree to the other's power" (quoted in Davidson 1994: 58). Thinking, again, of Marin's frames of blank canvas, one would have to say that the enclosure is untidy; it is hardly a frame at all but part of the planar structure of the painting, an issue we can pick up in the final section of this chapter.

Paul Rosenfeld's *Port of New York: Essays on Fourteen American Moderns* was published in 1924 but looks back very perceptively over the years of early American modernism. A few remarks on *Port of New York* will help to bring together the argument that in some of the works of this period there is a conjunction between a formal self-consciousness about representation and an understanding of abstract urban processes. Rosenfeld approaches this conjunction in the context of the old problem of how American culture could declare itself independent from Europe. For Rosenfeld, this amounted to independence from European modernism, which, typically, came into the United States through the port of New York. Once Rosenfeld has persuaded himself that the American moderns he has been writing about, including Marin, O'Keeffe, and Stieglitz, are unmistakably part of a genuine cultural renaissance, the language he uses to describe modernist art seems also to describe the approach to the tip of Manhattan, as well as the experience on the

streets. He is briefly tempted by picturesque sights: "There were moments: the river at sundown, West Street with its purple blotches on walls." But it is when Rosenfeld puts New York together with modernism that possibilities emerge and he succeeds in articulating abstraction as a vital urban and, for him, New York phenomenon, in which one encounters "the very jostling, abstracted streets of the city" even though "the form is still very vague." "The port of New York," Rosenfeld comes round to thinking, "lies on a single plane with all the world to-day" (Rosenfeld 1966: 289, 292 and 293).

"Marin has not travelled far from New York since 1908," Rosenfeld writes. "He has concentrated on a comparatively few motifs; the New York of the paintings of 1921 was anticipated a dozen years ago by studies of the promontories and chasms of Lower Manhattan, and by the very much skeletonized etchings of 1913" (Rosenfeld 1966: 165). Rosenfeld has glimpsed a materialist abstraction in Marin that finds general expression in the "Epilogue" to *Port of New York*. In a letter about his "downtown" painting to Alfred Stieglitz from around 1911, Marin sounds like the architect he had been in the 1890s: "the skyscrapers struck a snag, for the present at least, so we have had to push in a new direction, and may be a step forward" (quoted in Schleier 1986: 55). That step forward is abstraction, but materially grounded: the piling of "these great houses one upon another with paint as they do pile themselves up here so beautiful, so fantastic" (Marin 1966: 27). When we come at abstraction in this context, we can perhaps appreciate that it need not be anti-humanist but is seeking to re-visualize the present. Rosenfeld is getting at something like this when he discards his romantic aesthetics and imagines New York City and European modernism on the same global "plane." Once the present could be accepted – meaning not that it was seen clear of all mediations/representations but that some of the old mediations/representations, such as the skyscraper as an ocean liner or a mountain, could be rejected or acknowledged – then the present could stimulate a visual discourse that embraced the future, whether to warn against it or to welcome its possibilities. Abstraction, in these skyline pictures, is not an autonomous pattern on a canvas or even a tendency towards autonomy. It is the sign of a search for a point of view and for urban knowledge in new circumstances and, as such, is as much a part of the human dimension as that which Lukács applauds in narrative, figurative realism. However, there is a struggle to achieve a point of view in all of these early American moderns, and in some instances the struggle is so intense that it produces a final metamorphosis in the views from a distance of New York.

"The City Horizon was the One Horizon": Looking Down on the City

In step with New York's vertical and horizontal expansion, Alfred Stieglitz moved from downtown to midtown and up to the thirtieth floor of the Shelton Hotel. His *From the Shelton, Westward* (1931), *From the Shelton, Looking West* (c. 1931) and *From the Shelton, Looking Northwest* (c. 1931) refer indirectly to early panoramic

photographs, for instance the series *Looking West-Northwest from the "World" Dome*, *Looking West from the "World" Dome* and so on, published in *King's Handbook of New York* (1891 and 1893). But *From the Shelton, Looking West* (Figure 5.6) has a partly obscured skyline. In the background is the steel frame of 444 Madison

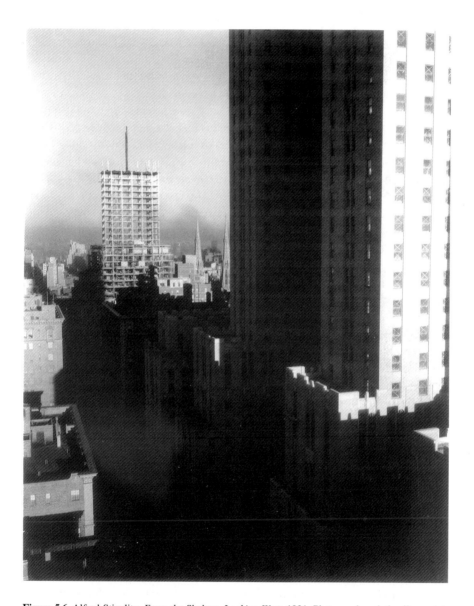

Figure 5.6 Alfred Stieglitz, *From the Shelton, Looking West*, 1931. Photograph, gelatin silver print, 9¼ × 7⅜ in. (23.5 × 18.7 cm). Museum of Fine Arts, Boston. Gift of Miss Georgia O'Keeffe 50.847. Photograph copyright Museum of Fine Arts, Boston.

Avenue, around and through which can be seen the skyline. The spires of St Patrick's Cathedral on Fifth Avenue are suffering the fate of Trinity Church downtown at the time of Henry James's visit. But this, by 1931, commonplace image of skyline change is relegated in importance by the other building then under construction, the Waldorf-Astoria Hotel, which occupies the right half of the photograph and partially blocks the view "from the Shelton." Compositionally, Edward Hopper's *Early Sunday Morning* (1930) comes to mind, but whereas the dark expanse of a skyscraper is near enough on the same plane as the low buildings on the street for Hopper to paint it (however ambiguously), it is the lack of a full view, as much as what is on view that is the subject of Stieglitz's photograph.

The partial blocking of the skyline hints at an abandonment of the vertical format, which is a staple of views from a distance, even in the map-pictures of Richard Rummell discussed at the beginning of this chapter. We do not find this loss of the window-format in Stieglitz's photographs of New York, though perhaps – in a different way – we meet it in his series of cloud photographs called *Equivalents*. In Coburn's *House of a Thousand Windows* (1912) (Haskell 1999: 48), however, the high angle removes the skyline but, more interestingly, gives the impression that the photographer's next image (which was never taken or at least never published or exhibited) will be from directly above, as though he was about to fly over the skyscraper. This tilting of even the photograph to the horizontal and away from the vertical picture frame is an aspect of Coburn's vortography that marked a decisive move towards photographic abstraction. In the most unstable of the skyline views considered in the previous section, Abraham Walkowitz's *New York* (1917) (Haskell 1999: 117), the overlapping planes and the repetition of motifs and units work in the opposite direction from Coburn's photograph but to the same end. That is to say, as the painterly surface moves closer, so the vertical picture form seems on the point of toppling forward. And, as we earlier remarked in passing, the frame of dark paint in Walkowitz's *Improvisation of New York City* also troubles a vertical window-picture form and suggests a map-like horizontality. These examples are on the point of metamorphosing into what would eventually be formally described in the Futurists' *Manifesto of Aeropainting* (1929) as an "aeropittura." The first aeropainting, Fedele Azari's *Perspectives in Flight* (c. 1926), depicts a city of angular skyscrapers rising up from a street grid towards the airborne viewer. As usual, there is a perfectly good art-historical explanation that has, as one endpoint, Mondrian's paintings of the New York grid. Yet, just as the *Manifesto of Aeropainting* identifies airflight as the technological stimulus for works by the flyer, Azari, and then by Gerardo Dottori and others enamored of flight, so it is worth pursuing a conjunction between the changing city and form to which Paul Rosenfeld gestures in his observation that "the city horizon" became "the one horizon" (1966: 284). This development is different from the use of raised horizons in, say, Childe Hassam's *Union Square, Spring* (Figure 1.4), in which the technique creates a great deal of open space in the foreground. *Union Square, Spring* does not become a top-down view, comparable

with John Marin's *Lower Manhattan (Composing Derived from Top of Woolworth)* (1922) (Figure 5.7), Max Weber's *New York* (1913) (Plate 6), and Coburn's *The Octopus* (1912) – and we could follow this development through to Armin Landeck's *View of New York* (1932) and Berenice Abbott's *City Arabesque* (1938), from her book of photographs, *Changing New York* (1939) (Stern *et al.* 1987: 72–3). In all of these pictures we have lost the horizon, and in all but Marin's *Lower Manhattan (Composing Derived from Top of Woolworth)* the other vertical coordinate as well: the ground or the river/bay around the city. Retrospectively, the *Manifesto of Aeropainting* explains what is going on when the "horizontal continuity of the plane on which one is speeding" is supplanted by the loss of both "continuity and this panoramic frame" when the aeroplane "glides dives soars etc" and "creates an ideal supersensitive viewpoint suspended everywhere in the infinite" (Mantura, Rosazza-Ferraris and Velani 1990: 203). The city's setting in a landscape and against a stabilizing skyline that is so much a defining feature of city overviews back to the Middle Ages has been lost as the city has grown, and threatens or promises to

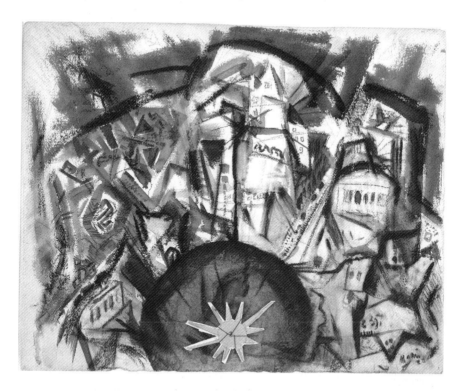

Figure 5.7 John Marin, *Lower Manhattan (Composing Derived from Top of Woolworth)*, 1922. Watercolor and charcoal with paper cutout attached with thread on paper, 21⅝ × 26⅞ in. (55 × 68.25 cm). Museum of Modern Art, New York/Scala, Florence. Acquired through the Lillie P. Bliss Bequest. 1945.

be the only visible subject matter that matters in a modernizing world. As a result, these early American modernists occasionally find themselves looking down – often directly down – onto the city below.

In *Lower Manhattan (Composing Derived from Top of Woolworth)* (Figure 5.7) Marin does not look across at a skyline competing for height with his position on or near the top of the Woolworth Building, but directly down upon the Old World Building. The foreshortening and loss of depth are quite radical, so much so that the top-down view has been rolled into a number of variants of the overview that we have been considering and, with some justification, that has been regarded suspiciously either because it suggests an unwarranted totalizing gaze, panoptic in its visual ambition, which erases differences, or because abstraction and loss of perspective are thought to be anti-humanist. Summarizing a widely held view of artistic abstraction, Briony Fer states that "the *angle* of the point of view fused with the total vision" (1997: 1). Within the subdiscipline of spatial theory, Michel de Certeau's distinction between walking the city and seeing it from above is probably the best known pronouncement:

> His elevation transforms him into a voyeur. It puts him at a distance. It transforms the bewitching world by which one was "possessed" into a text that lies before one's eyes. It allows one to read it, to be a solar Eye, looking down like a god. The exaltation of a scopic and gnostic drive: the fiction of knowledge is related to this lust to be a viewpoint and nothing more. (1984: 92)

The scene in the film *The Third Man* (1949), when Harry Lime looks down upon the people far below, sums up suspicions about the view from above. Whether figured as a modernist concept city, after Le Corbusier, or as the transparent city of surveillance, in the wake of Michel Foucault's critique, the view from above attracts largely negative responses. A "city of ambition," to borrow the title of one of Stieglitz's enigmatic New York photographs, can be a city lacking human presence. Graham Clarke concludes as much when tracing what he takes to be a preference in Stieglitz for "an inferred ideal space in which an idea is given its found but constructed equivalent, but an equivalent at the cost of the 'human' and the social" (Clarke 1990: 22). Here, Clarke echoes Georg Lukács' more sweeping claim that "The loss of the narrative interrelationship between objects and their function in concrete human experiences means a loss of artistic significance" (1978: 131). It is more complicated, though, and while, as in the previous chapter, we can acknowledge the achievement of the street level, obviously humanistic, narrativizing artists of the Ashcan School, we should note that, aside from a few rooftop paintings which cross over into different areas of the city, John Sloan, George Bellows and others had a tough job depicting the processes which in-form a cityscape. For instance, John Sloan's rooftop paintings are, finally, street level scenes but transferred to the roof. The Ashcan artists came up with some interesting visual solutions, but generally within paintings of a local scene whose frame is rarely commented upon because realism assumes that the street or

the elevated railroad track or the activities depicted continue beyond the frame. In an earlier section of this chapter, on the other hand, we have seen that the map-pictures by Richard Rummell (and many others) are so full of information that it is difficult to credit them with an abstract grasp upon the city. Distance can protect by creating an "ideal space," and by hiding the local telling detail. And yet, viewing from above can prompt the effort to see structurally.

Criticisms of the view from above disapprove of its drive to see through in a masterful gaze. The implication is that the gaze is through a window, sometimes looking in a downward direction, by means of which the city is made transparent. Yet if clarity and information are sought by the panoptic gaze then abstract works by painters and even photographers are hardly good sources or models. Their top-down views lack the necessary stability and legibility. Buildings are not in view around the edge of Marin and Weber's paintings, for instance. And the hierarchy of height that the skyline genre, even in its most abstract manifestations, helped to institute is overturned by the radical foreshortening and the flatness of geometric form. If transparency is hardly an issue in these works, the question remains of whether this shift in visual representation should be regarded as anti-humanist in its elevation and distance. Svetlana Alpers has a point when she states that "The mapped view suggests an encompassing of the world, without, however, asserting the order based on human measure that is offered by perspective pictures" (1989: 144). She confirms the link with abstraction by invoking Mondrian: "He withdrew from depth and upended the pier [in *Pier and Ocean*] until it was resolved into a surface articulation of a most determined and single-minded kind... We might see Mondrian's so-called abstractions not as *breaking* with tradition but as heir to the mapping tradition" (1989: 258).

There is, though, no reason to accept that the vertical picture form necessarily derives from "human measure." It, too, is a pictorial convention. It is of more relevance to the present argument, to observe that the picture window view of New York became increasingly difficult to achieve; indeed, one could go further and recall John Kouwenhoven's comment that picturing a city from a distance generally required a "purely suppositious" point of view (1972: 331). The extraordinary expansion of Old into New New York foregrounded the sheer conventionality or artificiality of any view of the city. The loss of a horizon might then be interpreted, with Leo Steinberg's prompting, as a recognition that culture – specifically the constructed cityscape – and not nature had become the sphere for the visual imagination. For Steinberg, Robert Rauschenberg's work signals this transition most clearly: "palimpsest, cancelled plate, printer's proof, trial blank, chart," and, most interestingly, "map, aerial view" (Steinberg 1972: 88). In this connection, when we register the absence of people in skyline paintings by Marin, Stella, O'Keeffe, and Walkowitz, and in some of Stieglitz's and Coburn's photographs, we need not straightforwardly accept Graham Clarke's conclusion that this constitutes "a view of the city informed precisely by an abstract rather than a human context" (Clarke

1990: 13); rather, we might at least wonder why, when people play no role, or only a minimal role, in some landscape art, similar objections are not aroused. Steinberg's comments on the shift from nature to culture are again pertinent in hinting that the human dimension in modernist pictures is often to be located in the *formal* concerns of the picture, notably the signs of a point of view upon a novel urban scene.

Near the beginning of this book, Rosalind Krauss's reconsideration of the trope of anamorphosis was cited:

> The opacity that is figured in anamorphosis is a matter of point of view: one can see the image correctly if one can get to the correct position. Whereas the invisibility that arises within modernism is not so obviously physical: it is tinged or affected by the unconscious, and in this unconscious invisibility there isn't any correct perspective or other vantage point. It can only be reconstructed in the modality of a different form like language. (1988: 83–4)

This is helpful but the material complexities of the city are well known and their explanatory power should not be overlooked. We need not invoke the unconscious in order to read off the invisibility of modernism, by which Krauss means modernist ways of seeing. We can, instead, concentrate upon the multiplying challenges involved in obtaining a point of view upon a city expanding like no other, whether our measure is population increase or topography and the overlaid grid plan and their impact upon verticality and horizontality, and the technologies of both transportation and representation. Christine Boyer supplies the broader context:

> By the end of the eighteenth century ... both landscapes and cityscapes were rapidly transformed as cities began their long expansion, turning themselves into modern metropolises by bursting open their surrounding walls and spilling out into their countryside. As they did, the unifying view holding in place the city center, its architectural compositions and pattern of streets and promenades, and then juxtaposing this scene against the enveloping landscape, was an image torn beyond repair. The traditional city with its unique views and known pathways was being transformed by urbanization and industrialization before its citizens' eyes. (1994: 251)

A "mapping impulse" would be Svetlana Alpers' description of the move towards top-down views, with points of view becoming inscribed in the surface. Alpers continues: "One might speak of the resulting image as being seen essentially from within or being surveyed. It is in a certain respect much like surveying, where the viewer's position or positions are included within the territory he has surveyed" (1983: 138). We can build upon this important, if now accepted, insight into a self-consciousness that is identified with modernism by identifying how the inclusion and inscription of the point of view occurs in the visual text. Sometimes, it is in the title, which, to the extent that it is not treated as actually part of the work, is invisible. Marin's *Lower Manhattan (Composing Derived from Top of Woolworth)*

is an example. Alternatively, in Coburn's *The Octopus*, we can make out the shadow of the Met Life building, which is either where the photographer was positioned to take the photograph, or adjacent to it (Haskell 1999: 49). And we pick up signs of a mobile point of view in the excess that results from the cubist angling of perspective in Weber's *New York* (1913) (Plate 6), or in the activity upon which we have already commented in Marin's work, as buildings collide and bounce off each other. *Lower Manhattan (Composing Derived from Top of Woolworth)* also makes use of a minimal form of collage in the pasted on star, and this is a further reason for treating the top-down view as a visual space of activity, a consequence of the traditional vertical window giving way under the combined pressure of changing conditions of seeing in the city and artistic experiment. This double impetus may be understood as the loss (in the city and on the picture's surface) of an anchoring horizon. It is this that allows for a connection to be made between these highly active early American modernist top-down pictures and the most lively of Piet Mondrian's grids – his New York ones of the 1940s, notably *Broadway Boogie-Woogie* (1942–3). Crucially, these are centrifugal grids. In Mondrian's many centripetal grids, in contrast, a ground is restored – however austerely – in the space between the lines and the frame of the painting, but in his centrifugal grids meaning and orientation has to be constructed from within the representation and from a point of view which admits its partiality even as it assumes the most privileged of locations directly above.

After even this selective summary of views from a distance, from Moses King to a top-down view that reaches a pitch in Mondrian, we can reasonably claim to have fully broached the problematics of an urban point of view. In case art history tempts us to treat abstraction as a solution to the problem, we ought to conclude with two examples that are neither abstract nor top-down. In *The Mirror* (1927) (Figure 5.8) Glenn O. Coleman, a successor to the Ashcan artists, in some respects, depicts the famous New York skyline from an unmemorable perspective, suggesting, perhaps, that the city is so overwhelming that this is one of the few points of view that have not been taken over by the image-making process that got fully under way with *King's Views*. We see the city as a reflection in a mirror that is on a dressing-table in a nondescript room in a poor part of the city. Coleman offers a clear, even childishly simply, diagrammatic skyline. We are, though, looking into the mirror, and out through an invisible window to which we have our backs turned, suggesting that the self-reflexivity which is encouraged when we do not look directly at an object has become a valid position from which to visualize the city. Though not a modernist work, *The Mirror* has a meta-pictoral quality of frames within frames and of a window within a mirror within a picture. And, finally, to the very appropriately titled *View of New York* by Charles Sheeler (Figure 1.1), "painted," as Sheeler reports, "in 1931 in a studio which I had at that time in New York." "So you see," he adds, the title really is authentic" (quoted in Troyen 1998: 371). New York has completely disappeared in Sheeler's painting but other elements in the work suggest that Sheeler is questioning the very concept of representation but within a representational

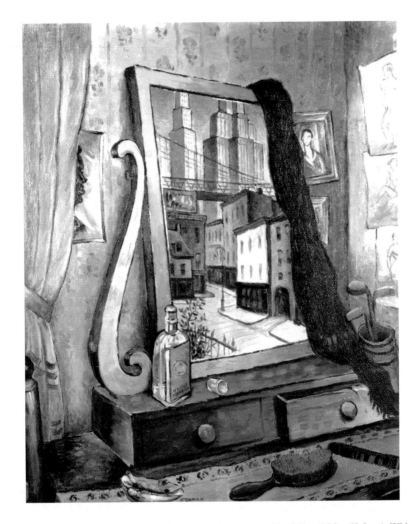

Figure 5.8 Glenn O. Coleman, *The Mirror*, 1927. Oil on canvas, 30 × 25 in. (76.2 × 63.5 cm). Whitney Museum of American Art, New York. Gift of Gertrude Vanderbilt Whitney 31.155.

painting. The window, as a common motif of representational art, looks out on to clouds. By substituting the horizonless sky for a more traditional or an abstract view of New York, Sheeler makes us wonder not so much about the loss of reference but about the loss of limits. By superimposing upon the limitless sky a parody of a perspectival grid and by shrouding his camera, Sheeler brings us back to the means of representation, the conditions of seeing.

Coleman and Sheeler revert to a vertical picture form, but however varied views from a distance may be, they all share a preoccupation with attaining a point of view on a city: sometimes too easily, as in Moses King's project, or sometimes failing to

attain a point of view, but with the self-protective ironic coolness that Sheeler displays. Something is at stake, though, because, with a point of view comes a form of knowledge, an "abstract urbanism" in Simone de Beauvoir's telling expression, provoked by a tour of the United States in 1948 (quoted in Conrad, 1998: 510). It is a slightly later French theorist, Roland Barthes, who – provoked directly by New York – positively articulates case for the human dimension of abstract, structural knowledge:

> We can in fact presume that there exist certain writers, painters, and musicians in whose eyes a certain exercise of structure (and no longer merely its thought) represents a distinctive experience, and that both analysts and creators must be placed under the common sign of what we might call *structural man*, defined not by his ideas or his languages, but by his imagination – in other words, by the way in which he mentally experiences structure. (1972: 214)

And this is Barthes in an essay written about New York in the mid-twentieth century, when one of the city's crisis-points was near its sharpest:

> Urbanism itself, this checkerboard of nameless streets, is the price that has to be paid in order that the streets be useful and no longer picturesque, in order that men and objects circulate, adapt themselves to the distances, rule effectively over this enormous urban nature: the biggest city in the world (with Tokyo) is also the one we possess in an afternoon, by the most exciting of operations, since here *to possess* is *to understand*: New York exposes itself to intellection, and our familiarity with it comes very quickly. (1979: 150–1)

From an inhabitant's point of view, or even a social historian's, Barthes' pronouncement might verge on nonsense but when trying to grasp what is at stake in the city's quite distinctive visual discourse what he has to say turns out to be very acute (see Knight 1997: 48–62). In another urban essay, in which he describes looking down from the Eiffel Tower, Barthes conveys the simultaneous thrill of recognition and sense of estrangement that can attend a visit to an observation deck of a skyscraper or the sight of a city in a camera obscura or in a panoramic film. In spite of so much film history between us and the beginnings of film, we can still imagine those simultaneous reactions by audiences who saw New York City in a new way in the short actuality film *Panorama from the Tower of the Brooklyn Bridge*. Billy Bitzer filmed *Panorama from the Tower of the Brooklyn Bridge* for American Mutoscope and Biograph on April 18, 1899. He was on the Brooklyn tower and the single pan bird's-eye shot takes in the tip of Manhattan and then the East River shoreline northwards beyond the Bridge, crossing the Manhattan tower roughly half-way. Bitzer might have been influenced by a panorama consisting of five sections and made from the top of the Brooklyn Bridge tower in 1876, while the bridge was being built, but moving pictures introduce or sharpen a tension between an embracing vision and the distraction and discontinuity of detail – that we can still

appreciate. The temporal dimension of *Panorama from the Tower of the Brooklyn Bridge* has an arbitrary quality, particularly at the end when, with the camera just north of Fulton Fish Market, the film abruptly finishes. However, the shoreline and the horizon function as tracks for the panning camera, so that at least the spatial dimension has its fixed visual parameters. On the way towards a supposed visual completeness in *Panorama from the Towers of the Brooklyn Bridge*, the potential for distraction is consistently present. Putting the elements of the skyline (and shoreline) together in a continuous shot only draws attention to the heterogeneity of the scene. There must, it comes to seem, be a clue in a detail on the skyline (or shoreline) to the meaning of this scene. But locations lose their particularity in the general sweep across the city and, from that distance, no people are visible. Nevertheless, that sweep becomes a human interpretation of the city, a new and absorbing visualization of the city that is more than the sum of the parts – even if the parts could all be assembled, which, of course, they never can.

Writing about the cinema in 1913, Lukács was horrified by the idea that it portrayed a life "without causes, without motives" (quoted in Conrad 1998: 504) and later met this troubling prospect with his theory of the novel, notably the historical novel, and of narrative realism. But there is knowledge, though admittedly not straightforward causal knowledge, in the abstract works of the early American modernists, whether photographers or painters, or in film makers whose enthusiasm for the medium produced modernist-type effects. The features of frame, perspective and a surface on which figure and ground are less easily distinguished than in traditional pictures, can have an important referential purpose, of course, in that they help to portray dynamism or disintegration, fear and anxiety or exhilaration. These formal features can also be understood, however, as a search for a point of view on, and therefore knowledge of, a city that was literally throwing up new challenges as it expanded vertically as well as horizontally; as its inhabitants moved around it according to the facilities of rapid transit; as changed relations became evident between the constructed and natural world and between the buildings themselves in a skyline; and as these changed circumstances drew out representations (complete with new technologies in some cases). In turn, those representations became part of the picture – part, that is, of the visuality of New York. Picturing from a distance encourages this bid for a structural knowledge of the city.

"New York, New York": Excess and Rationalization

"The Fantastic" and "the Utilitarian"

Old New York and New New York are hardly precise historical periods but the designations highlight important aspects of visuality in the city and the ways in which these changed over the period covered by this book. By way of summary, one could say that a backward- and inward-looking New York culture (albeit one that genuflected to Europe) was ousted by one that self-consciously and often exaggeratedly proclaimed its new outlook, and – through visual artists – sought out the most telling city sights. One of the most telling is a photograph that, in retrospect, is of its time but presages shifts in the city's visual culture, from Old to New New York, but also beyond towards what we can call, and later define as, "New York, New York." A photograph, taken on December 7, 1867 on Greenwich Street, at the junction with Morris Street, shows Charles Harvey, the owner of an experimental cable-operated elevated railroad perched on a handcar (Figure 1.3). Captioned, *Colonel Harvey Testing a Cable Car*, this photograph encapsulates an insight from Raymond Williams that has been useful throughout this book, the idea that the past, present and future are likely to be implicated in any period and, in the case of a photograph, even in any one moment. As evidence of a new urban structure and a new transportation phenomenon, this photograph looks out of Old New York into a New New York, although such was the pace of change that the early twentieth-century rapidly turned out to be the period in which the subway rivaled and then surpassed the El. The visual medium itself looks ahead, away from lithographs and the first paintings of the El and into a world in which the moment can be captured as it happens. The ostensible contrast in the photograph is between a new form of transportation and the slightly ridiculous sight of the owner of the line, in the dress of a Victorian gentleman and sitting incongruously on a four-wheeled contraption at first-storey height. Less obviously, though, the photographer has included a cluster of spectators, perhaps some disinterested passers-by but probably including directors of the company. Either way, this photograph heralds a culture beyond the New New York announced by the elevated railroad, a culture in which sights are consumed *in situ* on the streets and then much more widely through visual reproductions. An era

is being announced in which the image is made for consumption, thereby, in its own mode, advertising the modern and its excess of images.

The more general idea of excess has run intermittently through earlier chapters, but it becomes a defining characteristic of the visual regime of "New York, New York." The over-riding visual motif in the Byron Company's commission to photograph leisure-class interiors in New York is Victorian overdecoration and "stuff-iness," in which objects are all-important. As in certain long stretches of prose in many nineteenth-century novels, the impression conveyed by the Byron photographs discussed in Chapter 2 is of a world of things that seems to overwhelm, even as it defines and celebrates, the people in that world. However, the profusion of goods also prefigures a world in which signs of perceived value circulate, irrespective of the type of goods. Circulation is facilitated by reproducible photographs, and when the Byron photographs appeared in influential newspapers and magazines they would have been picked up and expertly interpreted to sift and sort people on a socio-economic scale. Thorstein Veblen's *The Theory of the Leisure* Class (1899) is the acknowledged guide to the manner in which excess is, at once, Victorian and modern, even postmodern if one accepts that a fully-developed consumer economy predated a recognizable postmodern culture by some forty years. Veblen's post-Victorian understanding of excess has an interesting New York twist, with its sources in the extravagance of the city in the early modern period. Strands of Veblen's thesis are picked up in Rem Koolhaas' *Delirious New York: A Retroactive Manifesto for Manhattan* (1978), and associated firmly with the street grid and its manifestation in the vertical grids of many of the city's most austere skyscrapers. In Koolhaas' formulation, however, there is a perverse doubleness in which excess depends upon its supposed opposite. The minimalist rationality of the grid delivers scope for the imagination of excess.

In very impressionistically continuing, and speeding up, the story of New York's sights in this concluding chapter, the intention is not coverage or emulation of the close analyses of selected images in preceding chapters. Instead, in rounding off the book with the period in which "New York, New York" became more than a postal address, the intention is twofold. First, to reinforce the claim, made at the start of *New York Sights*, that the material, physical city interacted with the visual imagination in ways that intriguingly confuse efforts to distinguish the how and what of representation. The September 11, 2001, terrorist attacks on what was then the most physically prominent part of New York City underline the importance to us of images, while stretching our visual capacity to the most painful limits. The second reason for changing gear, to encompass a painting by Florine Stettheimer from 1929 and some examples of how 9/11 was visualized, is to acknowledge the extraordinary, iconic nature of New York, a city that cannot easily be separated from its visual representations. It is one of those cities that we have already seen before we get to see it in actuality; in which the Empire State Building seems to have been built so that King Kong can climb up it and be shot off it. Wonder and sometimes shock at seeing New

York were part of the personal motivation for writing this book in the first place, as they are for continued visiting of the city in person, and through representations. Michel de Certeau calls New York City "the most immoderate of human texts," and it is. So much so, that saying its name just once, simply would not do. "New York" is almost the only proper adjective for New York.

"New York, New York" identifies the city of New York in the state of New York, but the refrain, as it has become in lyrics and films, highlights other meanings for those interested in what has come to be called the city as a visual text or in the material imagination under the stimulation of the city. "New York, New York" signals the emergence of what became, in the course of the twentieth century, the most familiar urban iconography in the world: countless images of a pin-cushion of skyscrapers within a grid plan contained on the elongated island of Manhattan, or the New York skyline from the Bay with, for three decades, the Twin Towers rivalling mid-town's Chrysler and Empire State Buildings. The refrain connotes the uniform repetitiveness of the city on its grid plan, but conceived in tandem with almost infinite vertical variation, an excessive, hyperbolic dimension. Koolhaas associates "the fantastic" and "the utilitarian": "The Grid's two-dimensional discipline also creates undreamt-of freedom for three-dimensional anarchy. The Grid defines a new balance between control and de-control in which the city can be at the same time ordered and fluid, a metropolis of rigid chaos" (1994: 104 and 120).

Within the spaces of the grid, New York sights could run riot and any number of examples could be given. Some have been slipped in already, out of period: the mechanical dancers filmed against the spire of the newly completed Chrysler building, or Mondrian's New York paintings of the early 1940s. This final chapter will content itself with a few more that confirm the peculiar New York mix of rationalization and excess.

At the point when the canonic works of early American modernism were coming up against the shock of the Wall Street Crash and a revival of realism in various forms, Florine Stettheimer began her series of Cathedral paintings. She fantastically elaborates upon scenes from Wall Street north to the Metropolitan Museum of Art, transforming them into pageants by importing a temporal dimension into the space of the canvas. *Cathedrals of Broadway* (1929) (Sussman 1995), the first of the four-paintings series running through to her death in 1944, is "zoned for time" (Sussman 1995: 82) in the double sense that areas of the painting are devoted to activities taking place simultaneously in the same but also in different locations in the city, notably the movie houses whose medium the painting celebrates and which we see from the inside and outside at the same time. As we have seen, the expansion of space through time is also present in earlier New York paintings by George Bellows (Plate 8), Max Weber (Plate 6) and Charles Sheeler (Figure 3.5), all of whom variously use cubist and futurist techniques to the same end. Even Thomas Hart Benton, a robust anti-modernist, was provoked into imaginative techniques, drawing on film, medieval art and topical New York stories, for his *City Activities with Subway* (part of the

America Today series of murals of 1930). A perception that a sight can include more than any conventionally represented site could possibly contain informs much New York visual culture, whether inside art traditions or in the city's broader culture.

Interior space, too, opens up. Koolhaas sees the illusion architectecturally embodied in the interior design of Murray's Roman Gardens (1907) on West 42nd Street. The designer, Henri Erkins, used lighting, mirrors, screens, and representations of exterior scenes on walls and ceilings, as well as a "garden" in the atrium, to create a "decorative economy" and "an infinity of forbidden space," as Koolhaas puts it (1994: 101). Stettheimer's work is full of such baroque expansions, as is Red Grooms' *Ruckus Manhattan* (1975–6), discussed below. Expansion of an interior sight can occur from a minimalist base as well. In *Hotel Lobby* (1943) (Hobbs 1987: 137), a painting by Edward Hopper that he identified as a New York work, we encounter one of the artist's spare interiors. This hotel lobby, in common with other grander examples, caught in photographs and in the movies, and inspired, in part, by the great New York hotels of the 1920s and 1930s, is a semi-public gateway to private places, a peculiar limbo and another instance of space and time interacting. Hopper's depiction of a hotel lobby has the paradoxical mix of familiar and unfamiliar, homely and unhomely, which Freud calls the uncanny and which, according to a different logic from that discerned by Veblen, also expands space (see Kracauer 1995: 173–85, and Tallack 2002). *Hotel Lobby* produces a form of visual agoraphobia, and one imagines the three main occupants compelled to repeat their almost static activities: reading, staring and waiting. It is less the surprise of discerning a fourth, shadowy figure in the painting, a desk clerk in the right middle-ground, that contributes to the unease than a gradual awareness of the odd angle from which the space is painted and from which we see it and, in seeing it, are drawn into the lobby. It is almost a filmic experience and is, indeed, explored more fully in film itself. Roman Polanski's *Rosemary's Baby* (1968) inflates the interior space of the Dakota Building apartment, while ratchetting up the sense of imprisonment by invoking the plots and tragedies of the past to re-establish the original, large apartment from the 1880s, since subdivided and – the film proposes – superficially rationalized. *Being John Malkovich* (1999) expands interior space futuristically, when – with echoes of King Vidor's *The Crowd* (1928) and Billy Wilder's *The Apartment* (1960) – a file clerk takes a job on the seventh-and-a-half floor of a Manhattan office building, and a portal to John Malkovich's brain opens up.

Beneath the ground, the material imagination was initially tempted by promotional images of leisure-class New Yorkers on wide subway platforms, for example Jules Guerin's *Station at Twenty-Third Street* (1900) (Brooks 1997: 65) and the cover for the sheet-music for Edward Laska and Thomas Kelly's *Come Take a Ride Underground* (1904) (Zurier *et al.* 1995: 31). In the years of dramatic growth of the subway, through to the late 1930s, convenient borrowings from above ground were less of an option. By far the most common subway images were those in which representational approaches were encouraged by excavation. By the time of Louis Lozowick's lithograph, *Subway*

Construction (1931) (Brooks 1997: 144), some elevated lines had already been closed and a point of view is selected along the line of the roof of a new subway under construction, the nearest Lozowick can get to an above-ground angle on the route of a subway. The echoes of track-line photographs of the elevated from thirty years earlier are quite strong, but a different line of vision takes priority. A solitary figure is walking along a road and, crossing the subway bed on a trestle in the distance, but no longer part of the space, there is an elevated train (Brooks 1997: 144). The complexities of below-ground excavation also attracted artists, and William Abbe's lithograph, *City by the Sea* (1940) brings together a functional diagram and modernist distortion into an Escher-like cross-section. Oppressive, gloomy and frightening images became more common from the 1950s, associated with the regimentation and, sometimes, the crimes of the city. George Tooker's *The Subway* (1950) (Brooks 1997: 171) has a woman surrounded by men who do not menace her directly by their actions but are disposed around the receding passageways in ways that account for the frightened look on her face. Where street-level images of the city traditionally make use of perspective to open up the city, Tooker's perspective conveys the sense of an endless network of low-ceilinged passages and stairways.

There are a good many different instances of the same phenomenon of excess within a pictured space to bring us up to the present: Jacob Lawrence's *Harlem Series* of the 1940s; Robert Rauschenberg's black and red paintings of the early 1950s, and the 1960s' work of Diane Arbus, whose photographs of extraordinary and eccentric people in New York make one wonder what environment can possibly produce and contain them. Red Grooms' and Mimi Gross Grooms' installation, *Ruckus Manhattan* (1975–6) is probably the most illuminating example over which to pause, and William Scott and Peter Rutkoff select it to conclude *New York Modern*, their account of twentieth century arts in the city. Grooms, in the company of other installation and performance artists, was in reaction against the abstract expressionists, a New York School that was not New York or even especially urban in its orientation, as had been the early American abstract artsts, Weber, Marin, Stieglitz and Stella. Grooms, Gross and their collaborators on *Ruckus Manhattan* returned to the attempts made earlier in the century to encapsulate a city that had so fascinated artists from the 1880s to the 1920s. Although Grooms coined the phrase "sculpto-pictoramas" for works prior to *Ruckus Manhattan*, that large-scale, inhabitable cityscape drew on some of the spectacles ushered in by the late nineteenth-century technologies, which offered viewers panoramas and dioramas of the city. Yet *Ruckus Manhattan* also celebrated a local outlook, reminiscent of George Luks and John Sloan, and then of the brashness of Reginald Marsh and even Thomas Hart Benton. The sources are also in Grooms' own work: *Self Portrait in a Crowd* (1962) is a bustling street-scene in which he includes himself as the "Walking Man," a persona dating back to one of his theater performances in 1959. *Ruckus Manhattan* gives the visitor a walk-through experience of Lower Manhattan in a large exhibition area, initially on Pine Street inside a modernist skyscraper and, later, in a mid-town location.

The buildings look unstable, an exaggeration of the montage effect that generations of visual artists have derived from the congestion of skyscrapers in New York, particularly in the downtown area that was once again in the ascendancy over midtown with the construction of the Twin Towers of the World Trade Center. Other iconic constructions in the installation included a subway car, the Woolworth Building and Brooklyn Bridge. Quirky New York references were everywhere, from the detail of Gross's *Ms. Liberty* sculpture of a young black woman, to the city's tourist ephemera scattered across the installation. After *Ruckus Manhattan*, Grooms' obsession with the many ways in which New York keeps asserting its physical presence on the eye finds expression in the prints and sculptures of *New York Stories* from the 1980s and 1990s, through to 2003 and the detailed localism of the three-dimensional lithograph, *Extra! Extra! Read All About It!*

Grooms's remark that "New York is all people ... it is so frantic or unplanned or something" sounds just right (quoted in Scott and Rutkoff 1999: 374). Yet, in the spirit of offering generalizations about the city in this conclusion, it is as well to take account of the curious relationship between excess and a rationalizing impulse that has been associated with New York, and specifically with the grid plan. We can quite properly conclude this section by concentrating upon the New York grid. Gertrude Stein, like Florine Stettheimer, was attracted to the idea of movement in a space that the New York grid encourages. She once announced that the United States was the oldest country in the world because it had been in the twentieth century the longest, and if she is right, then we might find one source of the "New York, New York" phenomenon in the New York Grid Plan of 1811. In signaling that the city was not seeking to revive its political ambitions to be the nation's capital, the Plan forwarded explicit commercial aims instead by laying out a rational city north of 14th Street and the twisted maze of streets downtown. The Plan had to be big and, within its eight-foot span, projected the grid north to 155th Street and the village of Harlem at a time when none of the Commissioners had much of an inkling of the logic of urban development (Cohen and Augustyn 1997: 100). Thus, the street grid is itself a curious combination of the most minimal, uniform, and repetitive form of urban layout and the most expansive. Only the diagonals of Broadway and the Bowery interrupted this intense geometry, leaving a number of eccentric triangles in its wake. But, mostly, during the rest of the century, the rectangular Cartesian geometry marched north irrespective of terrain and by the start of the period covered by this book was above 90th Street.

Now, as then, visitors can follow New York's different histories by walking north on smart Fifth Avenue or on the struggling parts of Eighth Avenue, and can get a cross-section of that history by walking from the East River to the Hudson River on 42nd Street. By 1911 the gridiron had been criticized so often that the centennial was not celebrated. The plan was thought to be boring and had put off the well-to-do classes, including Edith Wharton's family, which moved a few blocks up-town to Gramercy Park and the kind of exclusive residential area which resisted the grid. In spite of the Cartesian rationality of its street-plan and the rationalizing ethos that fueled the

commercial growth, New York also failed to enthuse the architect and planner who ought to have been most enamored with it. When Le Corbusier visited New York in 1935, he objected to the contradiction of grid-like logic and the contentless-ness of a market-driven urban development. New York had no one like himself or Baron Haussmann to sort it out and afford it a new visual identity. In a concept city of pure visual form, such as Le Corbusier imagined, the exterior of the city would correspond absolutely with its meaning. But New York was different. It had a grid plan that resembled a modernist concept city but had come into operation for purely commercial reasons. The form of the grid was there before most of New York. Accordingly, it at once controlled what was to come and provoked wild speculation about those blank spaces on the map. Conversely, when the blanks were filled in, the sheer difficulty in seeing the grid as a whole also provoked speculation of an aesthetic as well as an economic kind, as exemplified by Mondrian's New York paintings. In its peculiarly intense New York manifestation, the grid influenced a mode of seeing, an urban imagination eventually to rival that of the "capital of the nineteenth century," as Walter Benjamin titled Paris. Late nineteenth- and early twentieth-century New York was modernism before modernism, the place in time where a dialogue between the visibility and invisibility of modern life could be envisaged. The grid exercised a greater provocation to imaginative speculation than the "circles, ovals and stars" briefly entertained by the Commissioners when reviewing European planning precedents. Similarly, it is in part precisely because of the physical presence of the intense New York street grid in all of its stark uniformity that it has become the site of the most extravagant acts, such as the roller-blader (or roller-bladers) of Fifth Avenue who, in the 1990s, consistently beat the traffic to Central Park South and turned the intersections on the way into arenas for daring pirouettes.

At a personal and less exhibitionist level, too, the street grid generates its obverse for visitors. The grid ought to help people to find their way around quite easily but, on occasions, one does not end up hopelessly lost, as when visiting certain European cities, but rationally lost: that is, five blocks east or west of where one expected to be. An excess of rationalism can turn into rational excess, in an intriguing permutation of the material imagination. The Soviet *avant-garde* film director, Sergei Eisenstein, must have felt something similar on his visit to New York in 1930. He found numbered streets confusing or else he could not remember addresses full of numbers. Therefore, he attached images to the streets and street corners. The rectangular, numerical experience of walking New York armed with images, and the shocks and collisions of its intersections, confirmed and refined Eisenstein's theory of cinematic montage. As an avant-garde modernist, he seemed to be asking what forms of visualization are produced by a modern world that materially presses upon one from above, below and from either side. And interior concepts of space (even when adapted to exteriors) were on the point of becoming inadequate for the rather special representation of modernity that was spatially emerging in New York. European modernist modes of representation sometimes failed to adjust to the

peculiarly intense materiality of New York. This is one conclusion to be derived from the previous chapters, not least because they describe a period in which strenuous efforts were made to apply European models to New York or in which the city lacked the confidence to institute its own models of visually understanding itself. Like the two basic aspects of the aesthetic grid in Mondrian, the European artist most taken with it, the grid in its centripetal mode is a conceptual totality, while the grid in its centrifugal mode can be indefinitely repeated beyond the frame of the painting. The lines go on their way. We can see how Rem Koolhaas arrives at a paradox that New York exemplifies, a paradox that Max Weber describes in his social theory, but never fully articulates (so gloomily did he view the end point of rationalization that the grid symbolizes), namely, that the process of transparent rationalization that informed New York and American life, particularly from the 1880s onwards, is a factor in producing its obverse, however we describe that quality: excess, multiplicity, extravagance, unpredictability, indeterminacy, the uncanny, the opaque, or the baroque.

In the greatest theorists of modernity – Weber, but also Darwin, Marx, and Freud – there is an acute awareness of this doubleness, while postmodern theorists, for their part, have coined the phrase "repetition with a difference" to suggest an intriguing combination of temporality and spatiality. This book began with a writer, and one should acknowledge that literary, as well as visual, artists have responded to this doubleness: from Herman Melville's "Bartleby: A Story of Wall Street" (1853) and William Dean Howells' *A Hazard of New Fortunes* (1890) through to Paul Auster's *City of Glass* (1985), E.L. Doctorow's *The Waterworks* (1994) and Steven Millhauser's *Martin Dressler: The Tale of an American Dreamer* (1999). According to Doctorow's New York narrator: "We practiced excess. Excess in everything – pleasure, gaudy display, endless toil, and death" (Doctorow 1994: 10).

Narratives exemplify this paradox in telling of characters who trace and re-trace their own steps or the steps of others but produce something quite unpredictable in the process. The best known example from the period glossed in this conclusion is one that even slips into visual representation on the page. Paul Auster's detective in *City of Glass* is employed to follow an old man, only to find that he has traced out the giant words "THE TOWER OF BABEL" in the New York grid. Hyperbole, which could well be *the* New York trope, is first and foremost a figure of repetition but with a difference. Moreover, it is apparent that even more obviously mediated, self-conscious literary representations follow the visual examples we have considered in being inextricable from material changes such as the building up and organization of the city on its grid plan (Auster and Doctorow), the conduits, pumping stations and holding reservoir of the mid-century city (Doctorow), the coming of the elevated railroad (Howells), the pressure of streets and buildings around the early financial centre of Wall Street (Melville), and the very New York story of the large hotel (Henry James and Millhauser).

The interaction between excess and rationalization is unusually sharp in a New York genre, the skyscraper collage in which where the expression of functionalism

in an aesthetic of vertical grids encounters a tradition of decoration and baroque elaboration. (In some media, montage would be a better term than collage.) In the history of the skyscrapers, themselves, these two impulses are separated, as in the Seagram building and the Woolworth building, at least to the extent that the steel frame of the latter is overlaid by gothic style. Or they are combined, as in the Chrysler building. But to appreciate how each impulse is an effect of the other, we have to turn to visualizations of the vertical cityscape. The modernist pedigree of the skyscraper collage is apparent in Stuart Davis' *New York Mural* (1932) (Wilson 1993: Plate 16), in which angular shapes mount up and cluster around the Empire State Building. Some obey the order of perspective, while others are flat grids. But Davis' unique contribution is to be-deck the buildings with two brown derby hats, a gas pump, a tyre, and other un-classifiable shapes and demarcations. A year later, Busby Berkeley's choreography in *42nd Street* juxtaposes moving skyscrapers against a dancing Ruby Keeler, while in an aerial photograph of midtown from the mid-1930s, the Rockefeller Center has been inserted into the grid in advance of its completion (Koolhaas 1994: 202–3). The mixing of modes of representation assists the effort to envisage this city within a city ahead of time. Similarly, Raymond Hood's *Manhattan 1950* project uses a collage form even more dramatically in a utopian cause. An image looking up the island of Manhattan recalls the bird's eye views popularized by Moses King, but self-consciously combines the gridded "thickness" of the city with a planned infrastructure of bridges and mountain-like high-rises. However, the best instance of the manner in which standardization can flip over into a dizzying excess is an out-of-character interlude in Siegfried Giedion's *Space, Time and Architecture*, which, even in its first edition in 1941, moves inexorably across the landmarks of European modernism towards New York. The illustrations in *Space, Time and Architecture* are authoritative and accompany a magisterial account of the triumph of modernism in architecture and planning through the Bauhaus and CIAM, and then the International Style. However, it is when Giedion's CIAM-orthodoxy meets the "city" of Rockefeller Center, embedded in what, by the 1930s, was becoming *the* modernist city, that the illustrations outpace the story being told and effect a dramatic change in Giedion's measured prose:

> The actual arrangement and disposition of the buildings can be seen and grasped only from the air... This is all quite rational, but the moment one begins moving in the midst of the buildings through Rockefeller Plaza ... one becomes conscious of new and unaccustomed interrelations between them. They cannot be grasped from any single position or embraced in any single view. There becomes apparent a many-sidedness in these simple and enormous slabs which makes it impossible to bind them rationally together... Such a great building complex presupposes not the single point of view of the Renaissance but the many-sided approach of our own age. (1967: 850–2)

Giedion visualizes it in a somewhat amateurish but, nevertheless, striking photo-montage of the Center. The RCA building is tilted so that it abuts other buildings

in the complex at an angle. The severe verticals that are characteristic of the whole Rockefeller site are themselves tilted so that they confront diagonal lines on the other buildings in a manner comparable with modernist abstraction. A few pages on, and Giedion is composed again, and the story of canonic modernism continues through the triumph of the International Style. Still, that outburst of visual excessiveness remains to disturb pared-down modernism, not because rationalization and excess are opposites but because they are implicated. Montage (rather than strict collage) is, of course, at its most fully developed in film, with the credit sequences in feature films from Jules Dassin's *The Naked City* (1948) through to Harold Becker's *City Hall* (1996), demonstrating how the economy of time intersects with the variety of urban spaces. Steven Bochco and David Milch's television series, *NYPD Blue*, first broadcast in 1993, extends the style of the opening, with its rapidly intercut images from the precinct and the tourists' city, into the rest of each programme.

"The Metropolis," Koolhaas observes of New York, "strives to reach a mythical point where the world is completely fabricated by man, so that it absolutely coincides with his desires" (1994: 293). Put alongside the use made, in the previous chapter, of Roland Barthes' insight into a visual, structural imagination, Koolhaas's idiosyncratic book is of great value in projecting forward from early modern New York and into the future. Excess, in conjunction with an austere quality, defines the visuality of the *Batman* series from 1989 onwards, while both *Spiderman* films (2002 and 2004) picture the hero attached to the city's vertical surfaces, often upside down, before his web leaps startlingly reconfigure relations between New York's skyscrapers. "New York-ness," as a circulating and recycled image, is so prevalent that it can even be projected beyond its geographical limits to be reconstructed in Las Vegas. If, as Koolhaas proposes, Coney Island in the 1890s and 1910s functioned as "an incubator for Manhattan's incipient themes and infant mythology" (1994: 30), at the other end of the twentieth century some of the conjectures about New York are played out in a cityscape in the far-West.

"That Which Changes Our Way of Seeing the Streets Is More Important than What Changes Our Way of Seeing Painting": Visualizing Absence

Not long after the beginning of the twenty-first century, terrorists attacked the World Trade Center. The thousands of personal tragedies and the enormity of the event in world history are memorialized in many ways, one of which is that the look of the city has been changed forever. It is safe to say that September 11, 2001, was the most photographed, filmed, painted, drawn, and otherwise recorded day in history. The destruction of the Twin Towers has challenged the visual imagination in a more dramatic way than the construction of the skyline, the expanding network of the elevated railroad or the other more incremental material changes considered

in this book. New York's visual culture is responding to loss and a very material absence and, in the coming years, will be responding to the reconstruction of a built environment at the tip of Manhattan that, in its concentrated focus, is more intense than any witnessed in during its earlier growth spurts. Without doubt, it will be doing so through a greater variety of visual media. *Here is New York*, the exhibition that began the day after the attacks, attracted around 5,000 photographs. At a Library of Congress symposium in September 2003, George Mason University's digital archive of all four attacks was donated to the Library and it, alone, consisted of more than 130,000 items: photographs, video clips, animations, digital creations, and web sites, as well as texts and audio recordings. Outside of collections and special events, the visual record includes films, paintings and sketches of one kind or another, and – for the wrong reason – ensures that New York must remain the city that has been visually represented more than any other. As it happens, of all the representations, it may be that the release, in 2003, of the sound recordings of calls from the towers is the most affecting but the visual archive is still quite extraordinary. Visual representations of the World Trade Center from September 11, 2001 are more numerous than for the other two disaster sites and address the urban dimension most directly. By selecting just a few examples, it is possible at least to highlight the issues raised and reflect upon the relevance to a study of visuality in New York City.

Video footage of the airliners flying into the Twin Towers, the explosions and aftermath through to the collapse of the Towers dominated the news reporting and constituted a visual event of terrifying drama. The direct spin-offs from this central visual account included the images of an avalanche of smoke and debris heading towards those on the nearby streets, and then of the burning skyline during the night of September 11. These direct and, in most cases, moving images are at one end of the spectrum of sights. At the other end are still photographs, sometimes tangential to the main sight of the stricken Towers, and a 2002 film, *9'11 "01 – September 11*, in which eleven directors respond, through eleven, eleven-minute films. In reaction to the directness of the video footage of the attacks, these directors mostly opt for anti-cinematic films or political commentary or human-interest stories, some true-life and others fictional. The clarity of the Towers against the blue sky but with flames and smoke pouring from the upper storeys, is replaced, in Alejandro Gonzáles Iñárritu's contribution to *September 11*, by a black screen for all but a few moments. Sounds are apparently more telling: voices, terrible crashes, as storeys collapse, and some awful thumps that we realize, on glimpsing images of people falling, are the sounds of bodies hitting the ground. Although the sense is of something that cannot be visualized, the flashes of bodies across the screen anchor the sounds in a visual reality that cannot be ignored. Ken Loach's film is of a Chilean man writing a letter of support and sympathy on September 11 to people in the United States, only to pause and remember that on 11 September 1973 the US-supported overthrow and murder of Salvador Allende ushered in the Pinochet regime. It is an interesting instance of a political hypothesis – that the earlier catastrophe explains the later one

– affording some viewers the protection of analytical distance from the shock of both events.

Still photographs have been a central resource in the response to 9/11, despite the availability of moving images in many more forms than were available when the streets and elevated tracks of late nineteenth-century New York were attracting sustained attention. The barely visible falling bodies in Iñárritu's film are humanized by at least some of the controversial photographs of the "jumpers" taken by Richard Drew, an Associated Press photographer. One photograph has achieved notoriety simply because of the acute particularity of an unknown man caught in mid-air against the verticals of both Towers (see Junod 2003). This last characteristic is an unnerving sight, as though, in his helplessness, the falling man nevertheless captures the double catastrophe. We can see that he is wearing dark trousers and a light, casual jacket or work-tunic, either of these being an impression reinforced by his ankle-high shoes. He is falling head-first and seems to be looking at the approaching ground. This is a person, plucked out of history by the photograph, as – so much less dramatically – individuals on streets and platforms and in rooms in photographs from the previous turn of the century stand out from the city. In his essay on the World Trade Center tragedy, "In the ruins of the future," Don DeLillo returns to "the primal terror" of the jumpers, in the moment "before politics, before history and religion." "The event itself," he adds, "has no purchase on the mercies of analogy or simile" (DeLillo 2001: n.p.).

Many of the digital creations posted on web sites incorporate the American flag. Bill Young's image (*September 11 Digital Archive*: 2383) encircles the intact Twin Towers in the Stars and Stripes. In Paul Mecca's image (*September 11 Digital Archive*: 2371), an outsized American flag flutters in the evening sky behind a New York skyline that includes the Twin Towers. In Richard Drew's photograph of the falling man, the mullions of the World Trade Center – lacking perspective – appear flat and evoke the stripes in the American flag. These stripes are vertical and not horizontal stripes, and are accidentally there and not patriotically invoked. This allusion to the flag and the mental correction that follows along the lines just sketched out help to bring home the numbing reality that we are looking at a photograph of a man who is about to die and, possibly more shocking, a man who a moment earlier had decided to jump. To escape death? To escape a worse fate that awaited him in the building? To be free of iron-clad circumstances, as Melville's Billy Budd is portrayed? The last of these interpretations, much like that in Ken Loach's film or articles that find 9/11 prefigured in disaster movies, are, of course, different from each other but are troublingly suspect ways of regaining distance from the awful reality, in this case, of a man who decided to jump, and who, in the other photographs in the sequence, is pictured out of control, in ungainly and even comical positions, apparently walking up the sides of the building, and losing his jacket. We know, also, that one person who jumped landed on, and killed, a fireman. Richard Drew took some ten sequences of people jumping, a fraction of between 50 and 200 people who jumped over an hour-and-a-half. The photograph of the man falling and

upside down, poised at the vertical divide between the North and South Towers, was the one to go round the world. That photograph usually appeared a single time in newspapers but, along with Drew's other photographs of the jumpers, was then dropped, as though to use the photograph was to exploit a man's death and risk that his family or friends would recognize him – itself a painful enough experience but associated, it seems, with the idea that the jumpers were somehow cowards.

Less immediately stunning photographs were taken by the thousand by amateur and professional photographers and it should not be forgotten that photographs of the missing appeared in very large numbers on the streets of the city. Among the photographs to have been collected and/or exhibited are Joel Meyerowitz's *After September 11: Images from Ground Zero*; Jeff Mermelstein's *Ground Zero September 11, 2001*, at the International Center of Photography, September to December 2002; and *Here is New York*, which opened in on September 25, 2001. Meyerowitz's *After September 11* was a world-wide travelling exhibition with government funding. Through the Museum of the City of New York, he obtained permission to photograph from within Ground Zero and became a descendant of the artists who were attracted to the excavation and demolition sites in the early twentieth-century. To a much greater degree, the attack on the World Trade Center threw photography and other media into the spotlight, asking whether this event was representable. The context of *After September 11*, though, is world politics and security, and not the material destruction and reconstruction of a city. In linked articles for *International Affairs* and *History of Photography* Liam Kennedy interprets the aesthetics of scale and light of the photographs selected for *After September 11* as compatible with the messages that the city and the nation needed to send out to the shocked world. First, that this was a terrible and massive assault on buildings that, in the aftermath, if not before the attack, are reimagined as a working community rather than a vast, anonymous office complex. And, second, that there is already under way a slow and painful recovery after September 11, with this stage also taking on epic qualities. The echoes of Cold War cultural strategies are brought out carefully by Kennedy (2003a: 322–4). Claims that President Bush and his advisors had very rapidly made a connection between 9/11 and Iraq give this argument increased authority, and, indeed, Kennedy (2003b: 278) notes that the final photograph in *LIFE*'s *One Nation: America Remembers September 11, 2001* is of an F-18 pilot getting into his cockpit for a sortie over the Arabian Sea.

It is surprising how often the World Trade Center photographs remind us of New York's photographic record, dating back to the late nineteenth century. This is less surprising in the case of the photographs in Jeff Mermelstein's exhibition, *Ground Zero September 11, 2001*, because his own New York street photography functions as a link. A leafless outline of a tree recalls Stieglitz's *Spring Showers* of 1900, and the empty streets, with visibility reduced by the smoke, have a beauty that can be found as well in Stieglitz's more industrial New York photographs. There is, throughout all of the photography of the disaster, another version of the effort

to picture what could not be seen. In photographing the growth of the city from the 1880s, artists grappled with the question of how to catch the invisible, whether it was the city's infrastructure or the process of change. In the photography of 9/11, the invisible dimension is the worldwide meaning of such an attack by still largely unknown people; the absence of the Twin Towers and of bodies. Bodies can help to fix the meaning, and confirm that the tragedy has occurred and can be memorialized in ceremonies with bodies present. In the absence of bodies, it is the city itself that features: the maimed skyline and the rubble, photographed again when it was transported to Staten Island.

Here is New York is the greatest photographic testament of the disaster. At the outset, it was an "impromptu memorial" (George *et al.* 2002: 8) of photographs in an empty shop at 116 Prince Street in SoHo, the first hung on September 12, but it grew rapidly as the images were scanned in and printed for display. It is impossible to summarize the 5,000-plus photographs that people brought or sent in, but they variously mourn the loss of a vital city sight; or try to explain the Twin Towers' often personal significance for an individual, whether that person was directly caught up in the loss of lives or not; or document the event as a substitute for what may come later, that is, an understanding of it. The last of these functions brings together the city and the medium of photography as though the latter can keep the former intact for the future. Liam Kennedy summarizes a common reaction amongst photographers and theorists of photography, namely that in an age when photography seemed to have lost its pre-eminence, the attack on the Twin Towers revived photography's documentary and democratic vocation, one hitherto sustained chiefly through war photography and other crisis photography, through reform photography, as well as in everyday, personal photographs (Kennedy 2003b: 272–3).

In his opening comments to *Here is New York*, Michael Shulan rightly sees the totality of images taken as the response to 9/11, but we may select a few that exemplify different responses that bear upon the themes of this book and its interest in how a city is envisaged. The skyline is a preoccupation because that is where the tragedy is most dramatically visible. There is the violent impact on the Twin Towers while they still stood and, in photographs taken from a distance, the way the skyline looked before the Towers collapsed, and afterwards when the tip of Manhattan looks almost low-rise. The tip of Manhattan is photographed from a long way off, from what looks to be a standard tourist viewpoint (George *et al.* 2002: 658–9, 666). As on ordinary days, Manhattan is photographed from the other boroughs, with neighbourhoods in the foreground (photographs 180–81, 182); from rooftops with, curiously, a woman smiling, facing the camera to be photographed with the Towers burning in the background (photograph 196). Candles have been lit on Brooklyn Promenade (photograph 443), while a group of candles, nowhere in particular but photographed at pavement level, resembles a burning or lit-up skyline (photograph 445). Another photograph (29) has the skyline replaced by a bank of smoke, with part of a building only to indicate that this is a cityscape. On the facing page, there

is an image of the skyline before the attack, with the Statue of Liberty in the left foreground (photograph 28), but one instance of the use of famous New York sights as points of reference. Intimations of the attack are conveyed in a photograph (832) in which a bird in flight is silhouetted against the intact Towers. Brooklyn Bridge figures quite prominently, and this too is a message of defiant continuity. Similarly, the Woolworth Building, a few blocks away, stands tall, with the smoke billowing out from behind it denoting the attack on a subsequent holder of the title, tallest building in the world (photographs 464–5). The skyscraper collage that has been a staple of New York City photographs also features regularly in *Here is New York*, but here the instability in that genre is literal: many photographs straightforwardly represent twisted shapes, sometimes adorned by the awful beauty of the sun rising through the building's shards. In such images, the intricacy of the design of the Towers is more apparent than when they were standing.

At street level, people, invariably coated with ash, are caught rushing from the scene or heading towards it to help, or to see it, perhaps to photograph it. There is a subset of photographs that, in the immediate and, sometimes, out-of-focus foreground, include people looking at the disaster or a hand holding a camera. The street scenes are full of evidence of the everyday life of the city, now under attack: traffic lights still working, although at red (photograph 289); an abandoned street-vendor's stall, "Now Serving Brewed Decaf Coffee" (photograph 309), familiar street and store signs, and hoardings and news stands full of images, including images of the Towers in flames and a defiant Arab face, as well as the usual product advertising. And then there are the photographs of the missing at street corners, at Ray's Pizza, on walls, plastered over Coca-Cola ads, and carried around the streets by their relatives and friends (photographs 609 and 824). The trademark use of the streets and avenues to create the intense visual perspectives of Manhattan, is blocked by the smoke (photographs 44, 55, 60, 62, 251, 295) or else available to picture-making, except that no one is looking that way, and the photographer is drawn to a woman crying while speaking on a mobile telephone, with others comforting each other (photograph 213). For all the attention given to the stricken Twin Towers, the photographs also convey the equally extraordinary image of people of all types whose faces reveal a common focus on that city sight.

Thinking back to the photograph, *Photographing the Flatiron* (ca. 1902) (cover illustration), one image that may strike us as casually self-conscious is a person holding up a postcard photograph of the Twin Towers in front of his face so that we cannot see it and he cannot see us (photograph 52). And then there is a photograph of a shuttered window, with a painting of a woman with a veil looking out at the disaster and entitled "Islamic American" (90). The destruction of a physical part of a city that has typically spawned a visual culture obsessed with buildings and other structures has produced an unusually close-up focus, and a passing preoccupation with not seeing. The availability of the city to the camera is everywhere apparent but so, too, is a counter-theme of photography as intrusive and exploitative, as in a photograph

of a hand written notice warning against taking photographs. Ground Zero is "not a tourist attraction" (815). However, the enormity of the event has not deterred some from considering the role of images in what is going on: the reflection of a woman in a mirror in a hotel room, waist up, doing her hair, and in the foreground, just below the mirror, a television screen with the burning Towers in view, and, next to the television, a guidebook (203). There is also a short sequence of photographs taken in Times Square, with people looking up at video screens of the unfolding disaster, with the words moving across the screen (220, 221). Photographs document how quickly the image-making process recovers: T-shirts and graffiti anticipating various reckonings with Osama bin Laden, but peace calls as well.

Two final themes stand out that underline the significance of visuality when this New York sight so terribly disappeared. One is the importance of photography in its documentary mode, revived in the middle of a panoply of visual media and techniques. Anyone with a camera could have taken these photographs. They needed only to be there for the moment to be frozen. This or that image is then looked at in different contexts and by different people, accruing meanings accordingly and, perhaps, losing the initial status derived from having been taken then and there. The second theme pulls away from such arbitrariness. In the middle of all of this exercising of the visual imagination, from clichéd, though well meant, flag-waving nostalgia through some trenchant political critiques to the most heart-breaking still-images of four separate, single shoes (261) and another, almost buried in ash (581), certain images stand out: the second plane on its way, a tiny object against the great scale of the Towers (188). A second photograph, of the same plane about to hit the second Tower, is a shocking reminder – through the medium of photography – of the imminent death of those on board, as well as those about to be murdered (187). It is watched not only by the photographer but by a man in the foreground at a window.

And, then, beyond the shock of those still images or of the falling man, there remain the filmed sequential moments of the planes flying into the Towers. There is an awful fascination to these moving images that frames a common theoretical issue that will never be resolved but which takes on different emphases according to context. For sure, the construction of images can never be put to one side. That has been an underpinning tenet of the analyses in this book. But if we are tempted to remark that those images of the planes approaching and hitting the World Trade Center are like watching a movie, then we may have opted too quickly for one side of the theoretical divide. "Some of us said it was unreal," DeLillo recalls. "When we say a thing is unreal, we mean it is too real, a phenomenon so unaccountable and yet so bound to the power of objective fact that we can't tilt it to the slant of our perceptions" (DeLillo 2001). It is the sheer fact that this was not a movie or, in any defensible sense, like watching a movie, that brings us back – if we can stand it – to look at those moments in which the city in its stark "there-ness," as well as its iconic significance, was struck, and in which we saw what had happened. Guy Debord was being unnecessarily polemical when he insisted that "that which changes our

way of seeing the streets is more important than what changes our way of seeing painting" (Knabb 1981: 25). And Henry James, with whom we began this book, was being unusually over-deterministic when he pronounced that, as a "great city makes everything, it makes its own ... optical laws." Nevertheless, there are moments when an order of priority undeniably establishes itself and should be respected, even if this is a temporary stage that gives way when we subsequently recover our sober interpretive senses, rather than using interpretation over-hastily to recover ourselves. Seeing moving film of the planes being flown into the World Trade Center is probably one of those moments.

List of Films

Films marked * are part of *The Life of a City: Early Films of New York, 1898–1906* collection, which is available online through the Library of Congress, American Memory web site: http://memory.loc.gov/ammem.

Age of Innocence, The (1993), director Martin Scorcese.

Apartment, The (1960), director Billy Wilder.

At the Foot of the Flatiron (1903), American Mutoscope and Biograph Company, camera A.E. Weed.*

Bargain Day, 14th Street, New York (1905), American Mutoscope and Biograph Company, camera, Frederick S. Armitage.*

Beginning of a Skyscraper (1902), American Mutoscope and Biograph Company, camera Robert K. Bonine.*

Being John Malkovich (2000), director Spike Jonze.

Broadway and Union Square, New York (1903), American Mutoscope and Biograph Company, camera Arthur Marvin.*

Catching an Early Train (1901), Thomas A. Edison, Inc.*

City Hall (1996), director Harold Becker.

Crowd, The (1928), director King Vidor.

Delivering Newspapers (1903), American Mutascope and Biograph Company, camera G.W. "Billy" Bitzer and Arthur Marvin.*

Elevated Railway (1899), Thomas A. Edison, Inc.*

Elevated Railroad, New York (1903), American Mutascope and Biograph Company.*

Excavating for a New York Foundation (1903), American Mutoscope and Biograph Company.*

Fireboat – "New Yorker" in Action (1903), Thomas A. Edison, Inc., camera, James Blair Smith.*

42nd Street (1933), director Lloyd Bacon.

Herald Square (1896), Thomas A. Edison, Inc., camera, William Heise.*

How a French Nobleman Got a Wife Through the New York "Herald" Personal Columns (1904), Thomas A. Edison, Inc.

Interior, N.Y. Subway, 14th St. to 42nd St. (1905), American Mutoscope and Biograph Company, camera G.W. "Billy" Bitzer.*

Lower Broadway (1903), American Mutoscope and Biograph Company, camera Robert K. Bonine.*

Manhatta (1920), directors Charles Sheeler and Paul Strand.

Manhattan (1979), director Woody Allen.

Move On (1903), Thomas A. Edison, Inc., camera Alfred C. Abadie.*

Musketeers of Pig Alley (1912), Biograph, director D.W. Griffith.

Naked City, The (1948), director Jules Dassin.

New Brooklyn to New York via Brooklyn Bridge, No.2 (1899), Thomas A. Edison, Inc.*

New York City Dumping Wharf (1903), Thomas A. Edison, Inc., camera, James Blair Smith.*

New York City "Ghetto" Fish Market (1903), Thomas A. Edison, Inc., camera, James Blair Smith.*

11 '09 "01 – September 11 (2002), Youssef Chahine, Amos Gitai, Alejandro González Iñárritu, Shohei Inamura, Claude Lelouch, Ken Loach, Samira Makhmalbaf, Mira Nair, Idrissa Quedraogo, Sean Penn, Danis Tanovic.

NYPD Blue (1993 –), Steven Bochco and David Milch.

On the Town (1949), director Gene Kelly.

104th Street Curve, New York, Elevated Railway (1899), Thomas A. Edison, Inc.*

Panorama from the Tower of the Brooklyn Bridge (1903), American Mutoscope and Biograph Company, camera, G.W. 'Billy' Bitzer.*

Panorama from Times Building, New York, American Mutoscope and Biograph Company, camera, Wallace McCutcheon.*

Panorama of Blackwell's Island, N.Y. (1903), Thomas A. Edison, Inc. camera, Edwin S. Porter.*

Panorama of Flatiron Building (1903), American Mutoscope and Biograph Company, camera Robert K. Bonine.*

Panorama of Riker's Island, N.Y. (1903), Thomas A. Edison, Inc., camera Edwin S. Porter.*

Panorama Water Front and Brooklyn Bridge from East River (1903), Thomas A. Edison, Inc., camera Edwin S. Porter.*

Pennsylvania Tunnel Excavation, Billy Bitzer 1905.*

Personal (1904), Biograph, director Wallace McCutcheon, camera, G.W. 'Billy' Bitzer.

Rosemary's Baby (1968), director Roman Polanski.

Skating on Lake, Central Park (1902), American Mutoscope and Biograph Company, camera, Frederick S. Armitage.*

Skyscrapers of New York, The (1906), American Mutoscope and Biograph Company, camera, Fred A. Dobson.*

Skyscrapers of New York City, from the North River (1903), Thomas A. Edison, Inc., camera James Blair Smith.*

Sleighing Scene (1898), Thomas A. Edison, Inc.*

Sorting Refuse at Incinerating Plant, New York City (1903), Thomas A. Edison, Inc., camera, Edwin S. Porter.*

Star Theatre (1902), American Mutoscope and Biograph Company, camera, Frederick S. Armitage.*

Tenderloin at Night (1899), Thomas A. Edison, Inc.*

Traffic in Souls (1913), Universal, director George Loane Tucker.

What happened on Twenty-third Street, New York City (1901), Thomas A. Edison, Inc.*

Bibliography

Abbott, B. (1973), *New York in the Thirties*, New York: Dover, reprint of *Changing New York* (1939).

Adams, H. (1931), *The Education of Henry Adams*, New York: The Modern Library.

Alland Sr, A. (1993), *Jacob A. Riis: Photographer and Citizen*, New York: Aperture.

Alpers, S. (1989), *The Art of Describing: Dutch Art in the Seventeenth Century*, Harmondsworth: Penguin.

Anon. (1890), "The Point of View," *Scribner's*, 7 (March): 396.

Anon. (1902), "Checklist of Works Relating to Street Railways, Rapid Transit, etc., in the City of New York," *Bulletin, New York Public Library*, 5 (April): 160–2.

Anon. (1905), *Scenes of Modern New York*, Portland ME: L.H. Nelson.

Anon. (1908), *Select New York: One Hundred Albertype Illustrations*, Brooklyn, New York: A. Witteman.

Anon. (1912), "Monumental Gateway to a Great City: Completing the Grand Central Terminal, New York," *Scientific American*, 107 (December 7): 484–9, 499–501.

Apollonio, U. (ed.), (1973), *Futurist Manifestos*, trans. R. Brain, R.W. Flint, J.C. Higgitt and C. Tisdall, New York: Viking.

Arendt, H. (1958), *The Human Condition*, Chicago: University of Chicago.

Aumont, J. (1987), *Montage Eisenstein*, trans. L. Hildreth, C. Penley, A. Ross, Bloomington: Indiana University.

Auster, P. (1987), *The New York Trilogy*, London: Faber & Faber.

Baird, G. (1995), *The Space of Appearance*, Cambridge MA and London: MIT.

Bal, M. (2001), *Looking In: The Art of Viewing*, Amsterdam: G & B Arts International.

Balshaw, M., Kennedy, L., Notaro, A., and Tallack, D. (eds) (2000a), *City Sites: Multimedia Essays on New York and Chicago, 1870s–1930s: An Electronic Book*, Birmingham: Birmingham University Press: http://www.citysites.org.uk.

Balshaw, M. and Kennedy, L. (eds) (2000b), *Urban Space and Representation*, London: Pluto.

Barber, S. (2002), *Projected Cities*, London: Reaktion.

Barnard, C. (1879), "The Railroad in the Air," *St. Nicholas Magazine* (October): 800–8.

Barthes, R. (1972), *Critical Essays*, trans. R. Howard, Evanston: Northwestern.

—— (1979), *The Eiffel Tower and Other Mythologies*, trans. R. Howard, New York: Hill & Wang.

—— (1993), *Camera Lucida: Reflections on Photography*, trans. R. Howard, London: Vintage.

Baudelaire, C. (1964), *The Painter of Modern Life and Other Essays*, ed. and trans. J. Mayne, London: Phaedron.

Baur, J.I.H. (1971), *Joseph Stella*, New York: Praeger.

Baxter, S. (1906), "The New New York," *Outlook*, 83 (June 23): 409–24.

Bender, T. (1987), *New York Intellect: A History of Intellectual Life in New York City, from 1750 to the Beginnings of Our Own Time*, New York: Knopf.

Benjamin, A. (ed.) (1995), *Abstraction, Journal of Philosophy and the Visual Arts*, 5, London: Academy Editions.

Benjamin, W. (1973), *Illuminations*, ed. H. Arendt, trans. H. Zohn, London: Collins.

—— (1980), "A Short History of Photography," in A. Trachtenberg (ed.), *Classic Essays on Photography*, New Haven, Conn.: Leete's Island.

—— (1997), *Charles Baudelaire: A Lyric Poet in the Era of High Capitalism*, trans. H. Zohn, London: Verso.

Benke, B. (2000), *Georgia O'Keeffe, 1887–1986, Flowers in the Desert*, Cologne: Taschen.

Berger, J. (1972), *Ways of Seeing*, Harmondsworth: Penguin.

Bernstein, T. (1990), *Echoes of New York: The Paintings of Theresa Bernstein*, New York: Museum of the City of New York.

Black, M. (1973), *Old New York in Early Photographs, 1853–1901: 196 Prints from the Collection of the New-York Historical Society*, New York: Dover.

Blackshaw, R. (1902), "The New New York," *Century*, 64 (August): 492–513.

Blake, A. (2000), "Beyond Darkness and Daylight: Constructing New York's Public Image, 1890–1940," Michigan: UMI Microform, American University. In press with Johns Hopkins, as *How New York Became American: Commerce, Culture, and the Urban Landscape, 1890–1924*.

Blom, B. (1973), *Feelings: My Companions to King's New York*, New York: Benjamin Blom Inc.

—— (ed.) (1982), *New York Photographs, 1850–1950*, New York: E.P. Dutton.

Board of Rapid Transit Railroad Commission for and in the City of New York (1891), *Report of the Board of Rapid Transit Railroad Commissioners in and for the City of New York to the Common Council of the City of New York in Pursuance of the Provisions of Section 5 of Chapter 4 of the Law of 1891, Together with the Documents, Maps and Plans Attached Thereto, October 20, 1891.*

—— (1897–1904), *Documents, 1897–1904: Minutes of Proceedings of the Board of Commissioners of Rapid Transit in the City of New York.*

—— (1901–7), *Reports, 1901–1906.*

(1903–7), *Report of the Board of Rapid Transit Railroad Commissioners for and in the City of New York, Accompanied by Reports of the Chief Engineer and of the Auditor.*

Bois, Y.-A. (1993), *Painting as Model*, Cambridge MA: MIT.

Bolger, D. and Cikovsky, N. (eds) (1990), *American Art around 1900*, Washington DC: National Gallery.

Bouman, O. and Van Toorn, R. (eds) (1994), *The Invisible in Architecture*, London: Academy Editions.

Bowles, J.M. (1906), "A New New York," *World's Work* (December 13): 8301–6.

Bowser, E. (1990), *The Transformation of Cinema, 1907–1915*, New York: Scribner.

Boyer, M.C. (1983), *Dreaming the Rational City: The Myth of American City Planning*, Cambridge MA: MIT.

—— (1985), *Manhattan Manners: Architecture and Style, 1850–1900*, New York: Rizzoli.

—— (1994), *The City of Collective Memory: Its Historical Imagery and Architectural Entertainments*, Cambridge MA: MIT.

Brettell, R.R. and Pissaro, J. (1992), *The Impressionist and the City: Pissarro's Series Paintings*, ed. M.A. Stevens, London: British Academy.

Bronner, S.J. (ed.) (1989), *Consuming Visions: Accumulation and Display of Goods in America, 1880–1920*, New York: W.W. Norton.

Brooks, M.W. (1997), *Subway City: Riding the Train, Reading New York*, New Brunswick: Rutgers.

Brucken, C. (1996), "In the Public Eye: Women and the American Luxury Hotel," *Winterthur Portfolio*, 31(4) (Winter): 203–20.

Bruno, G. (1993), *Streetwalking on a Ruined Map: Cultural Theory and the City Films of Elvira Notari*, New Jersey: Princeton University Press.

—— (1997a), "City Views: The Voyage of Film Images," in D.B. Clarke (ed.), *The Cinematic City*, London: Routledge.

—— (1997b), "Site-seeing: Architecture and the Moving Image," *Wide Angle*, 19(4) (October): 8–24.

Bryson, N. (1983), *Vision and Painting: The Logic of the Gaze*, London: Macmillan.

Bull, M. (2000), *Seeing Things Hidden: Apocalypse, Vision and Totality*, London: Verso.

Burgin, V. (ed.) (1982), *Thinking Photography*, Basingstoke: Macmillan.

Burnham, D.H. and Bennett, E. (1970), *The Plan of Chicago*, ed. C. Moore, New York: Da Capo.

Burns, R. and Sanders, J. (1999), *New York: An Illustrated History*, New York: Knopf.

Burr, S.D.V (1905), *Rapid Transit in New York City*, New York: Chamber of Commerce of the State of New York.

Burrows, E.G. and Wallace, M. (1999), *Gotham: A History of New York to 1898*, New York: Oxford University Press.

Byron, J. (1976), *Photographs of New York Interiors at the Turn of the Century*, text by C. Lancaster, New York: Dover.

—— (1985), *New York Life at the Turn of the Century in Photographs*, New York: Dover.

Callow, A.B. Jr. (ed.) (1973), *American Urban History: An Interpretive Reader with Commentaries*, New York: Oxford University Press.

Campbell, H., Knox, T.W. and Byrnes, T. (1899), *Darkness and Days of Light: Lights and Shadows of New York Life*, Hartford CT: Hartford.

Campanella, T.J. (2001), *Cities from the Sky: An Aerial Portrait of America*, New York: Princeton Architectural Press.

Carter, E., Donald, J. and Squires, J. (eds) (1993), *Space and Place: Theories of Identity and Location*, London: Lawrence & Wishart.

Casson, H.N. (1907), "New York, the City Beautiful," *Munsey's*, 38: 178–86.

Cavell, S. (1979), *The World Viewed: Reflections on the Ontology of Film*, enlarged edition, Cambridge MA: Harvard University Press.

Caws, M.A. (1989), *The Art of Interference: Stressed Readings in Verbal and Visual Texts*, Cambridge: Polity.

—— (ed.) (1991), *City Images: Perspectives from Literature, Philosophy, and Film*, New York: Gordon & Breach.

Chambers, J. (1912), *The Book of New York*, New York: The Book of New York Co.

Chambers, R. (1999), *Loiterature*, Lincoln: Nebraska.

Charney, L. and Schwartz, V.R. (eds) (1995), *Cinema and the Invention of Modern Life*, Berkeley: University of California Press.

Cheape, C.W. (1980), *Moving the Masses: Urban Public Transport in New York, Boston, and Philadelphia 1880-1912*, Cambridge MA: Harvard University Press.

Chefdor, M., Quinones, R. and Wachtel, A. (eds) (1986), *Modernism: Challenges and Perspectives*, Urbana: University of Illinois.

Christie, I. (1994), *The Last Machine: Early Cinema and the Birth of the Modern World*, London: BBC.

Churchill, A. (1970), *The Upper Crust: An Informal History of New York's Highest Society*, Englewood Cliffs: Prentice-Hall.

Ciucci, G, Dal Co, F., Manieri-Elia, M. and Tafuri, M. (1980), *The American City: From the Civil War to the New Deal*, trans. B.L. La Penta, London: Granada.

Cikovsky, Nicolai (1976), "William Merritt Chase's Tenth Street Studio," *Archives of American Art Journal*, 16 (2): 2–14.

Clark, C. (1978), *American Impressionist and Realist Paintings and Drawings from the William Marshall Fuller Collection*, Fort Worth: Amon Carter Museum.

Clark, T.C. (1892), "Rapid Transit in Cities I – The Problem," *Scribner's Magazine*, 2 (May), 566–78.

—— (1892), "Rapid Transit in Cities II – The Solution," *Scribner's Magazine*, 2 (June): 743–58.

Clark, T.J. (1985), *The Painting of Modern Life: Paris in the Art of Manet and his Followers*, London: Thames & Hudson.

Clarke, D.B. (ed.) (1997), *The Cinematic City*, London: Routledge.

Clarke, G. (1990), "The City as Ideal Text: Manhattan and the Photography of Alfred Stieglitz, 1890–1940," in C. Mulvey and J. Simons (eds), *New York: City as Text*, Houndsmills: Macmillan.

Coburn, A.L. (1910), *New York*, London: Duckworth.

—— (1966), *Alvin Langdon Coburn, Photographer: An Autobiography*, ed., H. and A. Gernsheim, London: Faber & Faber.

Cocks, C. (2001), *Doing the Town: The Rise of Urban Tourism in the United States, 1850–1915*, Berkeley: University of California Press.

Cohen, J.-L. (1995), *Scenes of the World to Come: European Architecture and the American Challenge, 1893–1960*, ed., C. Weil, trans. K. Hylton, Paris: Flammarion.

Cohen, P.E. and Augustyn, R.T. (1997), *Manhattan in Maps, 1527–1995*, New York: Rizzoli.

Collins, A.F. (1990), *American Impressionism*, London: Bison.

Committee on the City Plan (1914), *Development and Present Status of City Planning in New York City: Being the Report of the Committee on the City Plan, December 31st 1914, together with papers presented to a meeting of the Advisory Commission on City Plan, December 17th 1914*, New York: City of New York Board of Estimate and Apportionment, Committee on the City Plan.

Conrad, P. (1984), *The Art of the City: Views and Versions of New York*, New York: Oxford: Oxford University Press.

—— (1998), *Modern Times, Modern Places*, London: Thames & Hudson.

Copley, S. and Garside, P. (eds) (1994), *The Politics of the Picturesque: Literature, Landscape and Aesthetics since 1770*, Cambridge: Cambridge University Press.

Corn, W. (1972), *The Color of Mood: American Tonalism, 1880–1910*, San Francisco: California Palace of the Legion of Honor.

—— (1973), "The New New York," *Art in America*, 61 (July-August): 58–65.

Cosgrove, D. (1985), "Prospect, Perspective, and the Evolution of the Landscape Idea," *Transcripts of the Institute of British Geographers*, 10: 45–62.

Crary, J. (1988), "Modernizing Vision" in H. Foster (ed.), *Vision and Visuality*, Seattle: Bay Press.

—— (1992), *Techniques of the Observer: On Vision and Modernity in the Nineteenth Century*, Cambridge MA: MIT.

—— (1999), *Suspensions of Perception: Attention, Spectacle, and Modern Culture*, Cambridge MA: MIT.

Cromley, E.C. (1990), *Alone Together: A History of New York's Early Apartments*, Ithaca: Cornell University Press.

Crow, T. (1996), *Modern Art in the Common Culture*, New Haven: Yale University Press.

Cudahy, B.J. (1995), *Under the Sidewalks of New York: The Story of the Greatest Subway System in the World*, second revised edition, New York: Fordham.

Danly, S. and Marx, L. (eds) (1988), *The Railroad in American Art: Representations of Technological Change*, Cambridge MA: MIT.

Darrah, W.C. (1977), *The World of Stereographs*, Gettysburg PA: W.C. Darrah.

Darton, E. (2000), *Divided We Stand; A Biography of New York City's World Trade Center*. New York: Basic.

Davidson, A.A. (1994), *Early American Modernist Painting, 1910–1935*, New York: Da Capo.

Deak, G.G. (2000), *Picturing New York: The City from Its Beginnings to the Present*, New York: Columbia.

Debord, G. (1995), *The Society of the Spectacle*, trans. D. Nicholson-Smith, New York: Zone.

De Certeau, M. (1984), *The Practice of Everyday Life*, trans. S. Rendall, Berkeley: University of California Press.

DeLillo, D. (2001), "In Ruins of the Future," *Guardian* (December 22), http://www.guardian.co.uk/saturday_review/story/0,,623666,00.html

Detroit Publishing Company (n.d.), *Touring Turn-of-the-Century America: Photographs from the Detroit Publishing Company, 1880–1920, Collection*, Library of Congress, American Memory: http://memory.loc.gov/ammem.

De Wolfe, E. (1913), *The House in Good Taste*, New York: Century.

Doctorow, E.L. (1994), *The Waterworks*, London: Macmillan.

Doezema, M. (1992a), *George Bellows and Urban America*, New Haven and London: Yale University Press.

—— (1992b), "The 'Real' New York" in M. Quick, J. Myers, M. Doezema and F. Kelly, *The Paintings of George Bellows*, New York: Harry N. Abrams.

Doezema, M. and Milroy, E. (eds) (1998), *Reading American Art*, New Haven: Yale University Press.

Domosh, M. (1996), *Invented Cities: The Creation of Landscape in Nineteenth-Century New York and Boston*, New Haven: Yale University Press.

Donald J. (1999), *Imagining the Modern City*, London: Athlone.

Dunlop, D.W. (1990), *On Broadway: A Journey Uptown Over Time*, New York: Rizzoli.

Dunning, W.V. (1991), *Changing Images of Pictorial Space: A History of Spatial Illusion in Painting*, Syracuse: Syracuse University Press.

Eisenstein, S. (1942), *The Film Sense*, trans. J. Leyda, New York, Harcourt Brace.

Elderfield, J. (1972), "Grids," *Artforum*, 10 (May): 52–9.

Elsaesser, T. (ed.) (1990), *Early Cinema: Space, Frame, Narrative*, London: BFI.

Fagg, J. (2004), "Anecdote and the Painting of George Bellows," *Journal of American Studies*, 38 (3) (December): 473–88.

Fainstein, S. and Campbell, S. (1996), *Readings in Urban Theory*, Oxford: Blackwell.

Fairman, D. (1993), "The Landscape of Display: The Ashcan School, Spectacle, and the Staging of Everyday Life," *Prospects*, 18: 205–36.

Federal Writers' Project (1938), *New York Panorama*, London: Constable.

Fell, J.L. (ed.) (1983), *Film before Griffith*: Berkeley: University of California Press.

Fer, B. (1997), *On Abstract Art*, New Haven: Yale University Press.

Ferriss, H. (1986), *The Metropolis of Tomorrow*, Princeton NJ: Princeton Architectural Press.

Fife, G.B. (1913), "A Fantasy of City Light," *Harper's Weekly*, 57 (February 8): 9–10.

Flanner, J. (1974), *The Cubical City*, Carbondale: Southern Illinois University Press.

Fort, I.S. (1988), *The Flag Paintings of Childe Hassam*, Los Angeles: Los Angeles County Museum of Art.

—— (1993), *Childe Hassam's New York*, San Francisco: Pomegranate.

Foster, H. (ed.) (1988), *Vision and Visuality*, Seattle: Bay Press.

Foucault, M. (1991), *Discipline and Punish: The Birth of the Prison*, trans. A. Sheridan, London: Penguin.

Fried, W. (1980), *New York Aerial Views: 68 Photographs by William Fried*, New York: Dover.

Frisby, D. (1985), *Fragments of Modernity: Theories of Modernity in the Work of Simmel, Kracauer and Benjamin*, Cambridge: Polity.

—— (2001), *Cityscapes of Modernity: Critical Explorations*, Cambridge: Polity.

Frisby, D. and Featherstone, M. (eds) (1997), *Simmel on Culture: Selected Writings*, London: Sage.

Fryer, J. (1986), *Felicitous Space: The Imaginative Structures of Edith Wharton and Willa Cather*, Chapel Hill: University of North Carolina Press.

Fyfe, G. and Law, J. (eds) (1988), *Picturing Power: Visual Depictions and Social Relations*, London: Routledge.

Gandal, K. (1997), *The Virtues of the Vicious: Jacob Riis, Stephen Crane and the Spectacle of the Slum*, New York: Oxford University Press.

Gaehtgens, T.W. and Ickstadt, H. (eds) (1992), *American Icons: Transatlantic Perspectives on Eighteenth and Nineteenth Century American Art*, Santa Monica: Getty Center for the History of Art and the Humanities.

Genette, G. (1980), *Narrative Discourse: An Essay in Method*, trans. J.E. Lewin, Ithaca: Cornell University Press.

George, A.R., Peress, G., Shulan, M. and Traub, C. (2002), *Here is New York: A Democracy of Photographs*, Zurich: Scalo.

Gerdts, W.H. (1994), *Impressionist New York*, New York: Abbeville Press.

Ghent Urban Studies Team [GUST] (1999), *The Urban Condition: Space, Community, and Self in the Contemporary Metropolis*, Rotterdam: 010 Publishers.

Giedion, S. (1967), *Space, Time and Architecture: The Growth of a New Tradition*, 5th edn, Cambridge, MA: Harvard University Press.

—— (1969), *Mechanization Takes Command: A Contribution to Anonymous History*, New York: Norton.

Gilfoyle, T. (1992), *City of Eros: New York City, Prostitution, and the Commercialization of Sex, 1790–1920*, New York: Norton.

Gillespie, A.K. (1999), *Twin Towers: The Life of New York City's World Trade Center*, New Brunswick NJ: Rutgers University Press.

Gilpin, William (1794), *Three Essays: On Picturesque Beauty, On Picturesque Travel, and On Sketching Landscape, to which is added a Poem, "On Landscape Painting,"* London: R. Blamire.

Glueck, G. (1992), *New York: The Painted City*, Salt Lake City: Peregrine Smith.

Grafton, J. (1977), *New York in the Nineteenth Century: 321 Engravings from "Harper's Weekly" and Other Contemporary Sources*, New York: Dover.

Granick, H. (1991), *Underneath New York*, New York: Fordham University Press.

Green, J. (ed.) (1973), *Camera Work: A Critical Anthology*, Millerton, New York: Aperture.

Greenberg, C. (1961), *Art and Culture: Critical Essays*, Boston: Beacon.

Greenberg, S. (1998), *Invisible New York: The Hidden Infrastructure of the City*, Baltimore: Johns Hopkins University Press.

Handlin, O. (1973), "The Modern City as a Field of Historical Study," in A.B. Callow, Jr. (ed.), *American Urban History: An Interpretive Reader with Commentaries*, New York: Oxford University Press.

Hales, P.B. (1984), *Silver Cities: The Photography of American Urbanization, 1839–1915*, Philadelphia: Temple University Press.

Hall, P. (1998), *Cities in Civilization: Culture, Innovation and Urban Order*, London: Weidenfeld & Nicolson.

Hammen, S. (1979), "Sheeler and Strand's *Manhatta*: A Neglected Masterpiece," *Afterimage*, 6(6) (January): 6–7.

Hammack, D.C. (1987), *Power and Society: Greater New York at the Turn of the Century*, New York: Columbia University Press.

Harder, J. (1898), "The City's Plan," *Municipal Affairs*, 2 (March): 24–45.

—— (1899), "The Planning of Cities: Paper No. 1," *Public Improvements*, 1 (October): 297–300.

—— (1901), "Greater New York's Future," *Public Improvements*, 5 (February): 645–50.

Hartmann, S. (1973) "On the Possibility of New Laws of Composition," in J. Green (ed.), *Camera Work: An Anthology*, Millerton NY: Aperture.

—— (1978), *The Valiant Knights of Daguerre: Selected Essays on Photography and Profiles of Photographic Pioneers*, eds. H.W. Lawton and G. Knox, with the collaboration of W.H. Linton, Berkeley: University of California Press.

—— (1991), *Sadakichi Hartmann, Critical Modernist: Collected Art Writings*, ed., J.C. Weaver, Berkeley: University of California Press.

Harvey, D. (1989), *The Urban Experience*, Oxford: Blackwell.

Haskell, B. (1994), *Joseph Stella*, New York: Whitney Museum of American Art.

—— (1999), *The American Century: Art and Culture, 1900–1950*, New York: Whitney Museum of American Art.

Hawes, E. (1993), *New York, New York: How the Apartment House Transformed the Life of the City (1869–1930)*, New York: Henry Holt.

Hawthorne, H. (1911), *New York: Metropolis of America*, London: Adam & Charles Black.

Henkin, D.M. (1998), *City Reading: Written Words and Public Spaces in Antebellum New York*, New York: Columbia University Press.

Hess, H. (1961), *Lionel Feininger*, London: Thames & Hudson.

Hiesinger, U.W. (1991), *Impressionism in America: The Ten American Painters*, Munich: Prestel.

Hills, P. (1977), *Turn of the Century America*, New York: Whitney Museum of American Art.

—— (1980), "John Sloan's Images of Working-Class Women: A Case Study of the Roles and Interrelationships of Politics, Personality, and Patrons in the Development of Sloan's Art, 1905–16," *Prospects*, 5: 157–96.

Hine, L.W. (1977), *Men at Work: Photographic Studies of Modern Men and Machines*, New York: Dover.

Hines, T.S. (1979), *Burnham of Chicago: Architect and Planner*, Chicago: University of Chicago Press.

Hirshler, E.E. (1989), "The 'New New York' and the Park Row Building: American Artists View an Icon of the Modern Age," *American Art Journal*, 21 (4): 26–45.

Hobbs, R. (1987), *Edward Hopper*, New York: Abrams.

Holcomb, G. (1983), "John Sloan and 'McSorley's Wonderful Saloon'," *American Art Journal*, 15 (Spring): 5–20.

Hollevoet, C., Jones, K. and Nye, T (1992), *The Power of the City/The City of Power*, New York: Whitney Museum of American Art.

Homberger, E. (1994a), *The Historical Atlas of New York City: A Visual Celebration of Nearly 400 Years of New York's History*, New York: Henry Holt.

—— (1994b), *Scenes from the Life of a City: Corruption and Conscience in Old New York*, New Haven and London: Yale University Press.

—— (2002), *Mrs. Astor's New York: Money and Social Power in a Gilded Age*, New Haven: Yale University Press.

Hood, C. (1993), *722 Miles: The Building of the Subways and how they Transformed New York*, New York: Simon & Schuster.

—— (2002), "Journeying to 'Old New York': Elite New Yorkers and their Invention of an Idealized City History in the Late Nineteenth and Early Twentieth Centuries," *Journal of Urban History*, 28 (6) (September): 699–719.

Hoopes, D.F. (1972), *The American Impressionists*, New York: Watson-Guptill.

—— (1979), *Childe Hassam*, New York: Watson-Guptill.

Horak, J-C (1987), "Modernist Perspectives and Romantic Desire: Charles Sheeler and Paul Strand's *Manhatta*," *Afterimage*, 15 (4) (November): 8–15.

Howells, W.D. (1960), *A Hazard of New Fortunes*, New York: Bantam.

Hughes, R. (1991), *The Shock of the New: Art and the Century of Change*, London: Thames & Hudson.

—— (1997), *American Visions: The Epic History of Art in America*, New York: Knopf.

Huneker, J.G. (1915), *New Cosmopolis: A Book of Images*, New York: Scribner's.

Hyde, R. (1987), *Gilded Scenes and Shining Prospects: Panoramic Views of British Towns, 1575–1900*, New Haven CT: Yale Center for British Art.

—— (1988), *Panoramania! The Art and Entertainment of the All Embracing View*, London: Barbican Art Gallery.

Ings, R. (2003), "Making Harlem Visible: Race, Photography and the American City, 1915–1955," PhD thesis, University of Nottingham.

Interborough Rapid Transit Company (1991), *New York Subway: Its Construction and Equipment*, ed. B.J. Cudahy, New York: Fordham University Press.

Ivins, W. (1973), *On the Rationalization of Sight*, New York: Da Capo.

Jackson, K. (ed.) (1995), *The Encyclopedia of New York City*, New Haven: Yale University Press.

Jacobs, A.B. (1993), *Great Streets*, Cambridge MA: MIT.

Jakle, J. A. (2001), *City Lights: Illuminating the American Night*, Baltimore: Johns Hopkins University Press.

James, H. (1960), *English Hours*, ed. A. L. Lowe, London: Heinemann.

—— (1964), *The Complete Tales of Henry James, Volume 12: 1903–1910*, ed. L. Edel, London: Rupert-Hart Davis.

—— (1968), *The American Scene*, ed. L. Edel, Bloomington: Indiana University Press.

Jameson, F. (1988), "The Vanishing Mediator; or, Max Weber as Storyteller," in F. Jameson *The Ideologies of Theory: Essays 1971–1986. Volume 2: The Syntax of History*, Minneapolis MN: University of Minnesota Press.

Janvier, T.A. (1894), *In Old New York*, New York: Harper.

Jay, M. (1988), "Scopic Regimes of Modernity," in H. Foster (ed.), *Vision and Visuality*, Seattle: Bay Press.

—— (1993), *Downcast Eyes: The Denigration of Vision in Twentieth-Century French Thought*, Berkeley: University of California Press.

Jenks, C. (ed.) (1995), *Visual Culture*, London: Routledge.

Junod, T. (2003), "The Falling Man," *The Observer Review* (September 7), 1–4.

Kantor, H. (1973), "The City Beautiful in New York," *New York Historical Society Quarterly*, 57: 149–71.

Kasson, J. (1998), "Seeing Coney Island, Seeing Culture: Joseph Stella's *Battle of Lights*," *The Yale Journal of Criticism*, 11 (1) (Spring): 95–101.

Kelley, F.B. (ed.) (1909), *Historical Guide to the City of New York*, New York: City Historical Club of New York.

Kennedy, L. (2003a), "Remembering September 11: Photography as Cultural Diplomacy," *International Affairs*, 79 (March): 315–26.

—— (2003b), "Framing September 11: Photography after the Fall," *History of Photography*, 27 (Autumn): 272–83.

Keppel, F. (1905), *Mr. Pennell's Etchings of New York "Sky Scrapers,"* New York: Frederick Keppel.

King, M. (1894), *New York: The American Cosmopolis: The Foremost City of the World*, Boston: Moses King.

—— (ed.) (1972), *King's Handbook of New York City, 1893: An Outline History and Description of the American Metropolis*, 2nd edition, New York: Benjamin Blom, 2 vols.

—— (ed.) (1977), *King's Views of New York, 1896–1915 and Brooklyn, 1905: An Extraordinary Photographic Survey Compiled by Moses King*, New York: Arno Press.

Kinser, S. (1984), "Prostitutes in the Art of John Sloan," *Prospects*, 9: 241–2.

Kirby, L. (1997), *Parallel Tracks The Railroad and Silent Cinema*, Exeter: Exeter University Press.

Knabb, K. (ed. and trans.) (1981), *Situationist International*, Berkeley: Bureau of Public Secrets.

Knight, D. (1997), *Barthes and Utopia: Space, Travel, Writing*, Oxford: Clarendon.

Koolhaas, R. (1994), *Delirious New York: A Retroactive Manifesto for Manhattan*, New York: Monacelli Press.

Kostof, S. (1991), *The City Shaped: Urban Patterns and Meanings through History*, London: Thames & Hudson.

Kouwenhoven, J.A. (1972), *The Columbia Historical Portrait of New York: An Essay in Graphic History*, New York: Harper & Row Publishers.

Kozloff, M. (1973), *Cubism/Futurism*, New York: Harper & Row.

Kracauer, S. (1995), *The Mass Ornament: Weimar Essays*, trans. and ed. T.Y. Levin, Cambridge MA: Harvard University Press.

Krane, S. and North, P. (eds) (1991), *Max Weber: The Cubist Decade, 1910–1920*, Atlanta, Georgia: High Museum of Art.

Krauss, R.E. (1979), "Stieglitz/*Equivalents*," *October*, 11 (Winter): 129–40.

—— (1986), *The Originality of the Avant-Garde and Other Modernist Myths*, Cambridge MA: MIT.

—— (1988), "The Im/Pulse to See," in H. Foster (ed.), *Vision and Visuality*, Seattle: Bay Press.

—— (1993), *The Optical Unconscious*, Cambridge MA: MIT.

Lane, J.B. (1974) *Jacob Riis and the American City*, Port Washington NY: Kennikat Press.

Lavin, M., Michelson, A., Phillips, C., Stein, S. and Tupitsyn, M. (1992), *Montage and Modern Life, 1919–1942*, ed., M.Teitelbaum, Cambridge MA: MIT.

Lechte, J (1995), "Thinking the Reality of Abstraction" in A. Benjamin (ed.), *Abstraction, Journal of Philosophy and the Visual Arts*, 5: 25–35.

LeGates, R.T. and Stout, F. (eds) (1996), *The City Reader*, London: Routledge.

Levin, D.M. (ed.) (1993), *Modernity and the Hegemony of Vision*, Berkeley: University of California Press.

—— (1997), *Sites of Vision: The Discursive Construction of Sight in the History of Philosophy*, Cambridge MA: MIT.

LIFE (2001), *One Nation: America Remembers September 11, 2001*, New York: Time.

Life of a City: Early Films of New York, 1898–1906, Washington DC: Library of Congress collection: http://memory.loc.gov/ammem.

Lightfoot, F.S. (1981), *Nineteenth-Century New York in Rare Photographic Views*, New York: Dover.

Lindsay, V. (1970), *The Art of the Moving Picture*, New York: Liveright.

Loughery, J. (1995), *John Sloan: Painter and Rebel*, New York: Henry Holt.

Lowe, D.G. (1998), *Beaux Arts New York*, New York: Watson-Guptill.

Lucic, K. (1991), *Charles Sheeler and the Cult of the Machine*, London, Reaktion.

Lucie-Smith, E. (1994), *American Realism*, London: Thames & Hudson.

Lukács, G. (1978), *Writer and Critic and Other Essays*, trans. and ed. A. Kahn, London: Merlin.

Lynch, K. (1960), *The Image of the City*, Cambridge MA: MIT.

Mabie, H. W. (1904), "The Genius of the Cosmopolitan City," *The Outlook*, 76 (March 5): 577–93.

MacPhee, G. (2002), *The Architecture of the Visible: Technology and Urban Visual Culture*, London: Continuum.

Madsen, P. and Plunz, R. (eds) (2002), *The Urban Lifeworld: Formation, Perception, Representation*, London and New York: Routledge.

Maffi, M. (1994), *Gateway to the Promised Land: Ethnic Cultures on New York's Lower East Side*, Amsterdam: Rodopi.

Magnum Photographers (2001), *New York September 11*, New York: PowerHouse.

Manieri-Elia, M. (1980), "Toward an 'Imperial City': Daniel H. Burnham and the City Beautiful Movement," in G. Ciucci, F. Dal Co, M. Manieri-Elia, and M. Tafuri (eds), *The American City: From the Civil war to the New Deal*, trans. B. L. La Penta, London: Granada.

Mantura, B., Rosazza-Ferraris, P. and Velani, L. (eds) (1990), *Futurism in Flight: 'Aeropittura' Paintings and Sculptures of Man's Conquest of Space (1913–1945)*, Rome: De Luca.

Marin, J. (1966), *John Marin: Watercolors, Oil Paintings, Etchings*, New York: Museum of Modern Art.

Marshall, G. (2004), "Editing-Out: The Realism of Edward Hopper," PhD thesis, University of Nottingham.

Mathews, N.M. (1990), *Maurice Prendergast*, Munich: Prestel.

Mayer, G.M. (1958), *Once Upon a City: New York from 1890 to 1910 as Photographed by Byron and Described by Grace M. Mayer*, New York: Macmillan.

Maynard, P. (1997), *The Engine of Visualization: Thinking Through Photography*, Ithaca: Cornell University Press.

McNamara, K.R. (1996), *Urban Verbs: Arts and Discourses of American Cities*, Stanford: Stanford University Press.

McQuire, S. (1998), *Visions of Modernity: Representation, Memory, Time and Space in the Age of the Camera*, London: Sage.

McShane, C. (1994), *Down the Asphalt Path: The Automobile and the American City*, New York: Columbia University Press.

Melbin, M. (1978), "Night as Frontier," *American Sociological Review*, 43: 3–22.

Millhauser, S. (1999), *Martin Dressler: The Tale of an American Dreamer*, London: Phoenix.

Milroy, E. (1991), *Painters of a New Century: The Eight and American Art*, Milwaukee: Milwaukee Art Museum.

Mitchell, W.J.T. (1994), *Picture Theory*, Chicago: University of Chicago Press.

Mollenkopf, J.H. (ed.), (1988), *Power, Culture, and Place: Essays on New York City*, New York: Russell Sage.

Montgomery, E.M. (1991), *American Impressionists*, Leicester: Magna.

Montgomery, M.E. (1998), *Displaying Women: Spectacles of Leisure in Edith Wharton's New York*, New York: Routledge.

Morgan, C.H. (1965), *George Bellows: Painter of American Life*, New York: Reynal.

Morse, P. (1969), *John Sloan's Prints: A Catalogue Raisonné of the Etchings, Lithographs, and Posters*, New Haven: Yale University Press.

Moscowitz, H. (1912), "The East Side in Oil and Crayon," *Survey*, 28 (11 May): 272–3.

Mumford, L. (1987), *The City in History: Its Origins, its Transformations and its Prospects*, Harmondsworth: Penguin.

Museum of the City of New York (1958), *Once Upon a City: New York from 1890 to 1910*, New York: Museum of the City of New York.

Musser, C. (1991), *Before the Nickelodeon: Edwin S. Porter and the Edison Manufacturing Company*, Berkeley: University of California Press.

—— (1994), *The Emergence of Cinema: The American Screen to 1907*, Berkeley: University of California Press.

Nasaw, D. (1992), "Cities of Light, Landscapes of Pleasure," in D. Ward and O. Zunz (eds), *The Landscape of Modernity: Essays on New York City, 1900–1940*, New York: Russell Sage.

Nash, O. (1937), *Good Intentions*, Boston: Little Brown.

Naumann, F.M. (1999), *Making Mischief: Dada Invades New York*, New York: Whitney Museum of Art.

Neff, E.B. and Shackelford, T.M. (1994), *American Painters in the Age of Impressionism*, Houston: Museum of Fine Arts.

Nevins, A. and Krout, J. (eds) (1948), *The Greater City: New York 1898–1948*, New York: Columbia University Press.

New York City Improvement Commission (1904), *The Report of the New York City Improvement Commission to the Honorable George B. McClellan, Mayor of the City of New York and to the Honorable Board of Aldermen of the City of New York*, New York: Kalkhoff.

—— (1907), *The Report of the New York City Improvement Commission to the Honorable George B. McClellan, Mayor of the City of New York, and to the Honorable Board of Aldermen of the City of New York*, New York: Kalkhoff.

New York Public Library (1981), *Index to the Microfiche Edition of Photographic Views of New York City, 1870s-1970s, from the Collections of the New York Public Library*, 3 vols, Ann Arbor MI: University Microfilms International.

Norman, D. (1973), *Alfred Stieglitz: An American Seer*, New York: Aperture.

Notaro, A. (2000), "Constructing the Futurist City: The Skyline," in M. Balshaw, L. Kennedy, A. Notaro, and D. Tallack (eds), *City Sites: Multimedia Essays on New York and Chicago, 1870s–1930s: An Electronic Book*, Birmingham: University of Birmingham Press, http:///www.citysites.org.uk.

Oettermann, S. (1997), *The Panorama: A History of a Mass Medium*, trans. D.L. Schneider, New York: Zone.

Orton, F. (1994), *Figuring Jasper Johns*, London: Reaktion.

Orvell, M. (1989), *The Real Thing: Imitation and Authenticity in American Culture, 1880–1940*, Chapel Hill: University of North Carolina Press.

Pachter, M. (1983), "American Cosmopolitanism, 1870–1910" in M. Chenetier and R. Kroes (eds), *Impressions of a Gilded Age: The American Fin de Siècle*, Amsterdam: Amerika Instituut.

Page, M. (1999), *The Creative Destruction of Manhattan, 1900–1940*, Chicago: University of Chicago Press.

Park, R.E. (1940), "News as a Form of Knowledge: A Chapter in the Sociology of Knowledge," *American Journal of Sociology*, 45: 669–86.

Patterson, J.E. (1978), *The City of New York: A History Illustrated from the Collections of the Museum of the City of New York*, New York: Abrams.

Peiss, K.L. (1986), *Cheap Amusements: Working Women and Leisure in Turn of the Century New York*, Philadelphia: Temple University Press.

Pennell, J. (1911), *The Great New York*, London: T.N. Foulis.

—— (1912–13), "The Pictorial Possibilities of Work," *Journal of the Royal Society of Arts*, 61: 111–26.

—— (1980), *Pennell's New York Etchings: 90 Prints by Joseph Pennell*, ed. E. Bryant, New York: Dover.

Perlman, R.B. (1979), *Painters of the Ashcan School: The Immortal Eight*, New York: Dover.

Perloff, M. (1986), *The Futurist Moment: Avant-Garde, Avant Guerre, and the Language of Rupture*, Chicago: University of Chicago Press.

Phillips, L. (1999), *The American Century: Art and Culture, 1950–2000*, New York: Whitney Museum of American Art.

Phillips, P.C. (ed.) (1996), *City Speculations*, New York: Queens Museum of Art.

Picabia, F (1913), "How New York Looks to Me," *New York American,* (30 March): 11.

Platt, F. (1976), *America's Gilded Age: Its Architecture and Decoration*, South Brunswick and New York: A.S. Barnes & Co.

Pound, E. (1975), *Selected Prose 1909–1965*, New York: New Directions.

Powers, L.H. (ed.) (1990), *Henry James and Edith Wharton: Letters: 1900–1915*, London: Weidenfeld & Nicolson.

Pratt, E.E. (1911), *Industrial Causes of Congestion of Population in New York City, Studies in History, Economics and Public Law*, New York: Columbia University, Faculty of Political Science.

Prendergast, C. (1992), *Paris and the Nineteenth Century*, Oxford: Blackwell.

Price, F.N. (1924), "Lawson of the 'Crushed Jewels'," *International Studio*, 48 (February): 367.

Price, U. (1971), *Essays on the Picturesque as Compared with the Sublime and the Beautiful, and on the Use of Studying Pictures, for the Purpose of Improving Real Landscape*, 3 vols., Farnborough, Hampshire: Gregg International.

Prono, L. (2002), "Radical Discontinuities: Literary and Sociological Representations of Chicago, 1915–1948," PhD thesis, University of Nottingham.

Prown, J.D. (1987), *American Painting: From its Beginnings to the Armory Show*, New York: Rizzoli.

Pye, M. (1993), *Maximum City: The Biography of New York*, London: Picador.

Quick, M., Myers, J., Doezema, M., and Kelly, F. (1992), *The Paintings of George Bellows*, New York: Abrams.

"Questionnaire on Visual Culture" (1996), *October*, 77 (Summer): 25–70.

Ramirez, J.S. (ed.), *Painting the Town: Cityscapes of New York: Paintings from the Museum of the City of New York*, New York: Museum of the City of New York.

Reed, R.C. (1978), *The New York Elevated*, South Brunswick, New Jersey and New York: Barnes.

Reeves, W.F. (1936), *The First Elevated Railroads in Manhattan and the Bronx of the City of New York*, New York: New York Historical Society.

Reich, S. (1970), *John Marin: A Stylistic Analysis and Catalogue Raisonné*, Tucson: University of Arizona Press.

Reps, J. (1984), *Views and Viewmakers of Urban America: Lithographs of Towns and Cities in the United States and Canada, 1825–1925*, Columbia: University of Missouri Press.

Revell, K.D. (1992), "Regulating the Landscape: Real Estate Values, City Planning, and the 1916 Zoning Ordinance" in D. Ward and O. Zunz (eds), *The Landscape of Modernity: Essays on New York City, 1900–1940*, New York: Russell Sage.

Ricciotti, D. (1988), "City Railways/Modernist Visions" in S. Danly and L. Marx (eds), *The Railroad in American Art: Representations of Technological Change*, Cambridge MA: MIT.

Riis, J. (1971), *How the Other Half Lives: Studies among the Tenements of New York*, New York: Dover.

Robert R. Preato Collection of New York City Paintings and Drawings, The (1994), New York: Museum of the City of New York.

Roberts, J. (1998), *The Art of Interruption: Realism, Photography and the Everyday*, Manchester: Manchester University Press.

Rock, H.B. (2001), *Cityscapes: A History of New York in Images*, New York: Columbia University Press.

Wilson Rockwell, R. (1909), *New York Old and New*, 2 vols. Philadelphia PA: J.B. Lippincott.

Rose, G. (2001), *Visual Methodologies: An Introduction to the Interpretation of Visual Materials*, London: Sage.

Rosenfeld, P. (1966), *Port of New York: Essays on Fourteen American Moderns*, Urbana: University of Illinois Press.

Rota, I. (ed.), (2000), *New York: Not Only Buildings*, New York: Te Neues.

Rowe, C. and Koetter, F. (1978), *Collage City*, Cambridge MA: MIT.

Ryan, M.P. (1994), "Women, Modernity and the City," *Theory, Culture and Society*, 11: 35–63.

Sanders, J. (2002), *Celluloid Skyline: New York and the Movies*, London: Bloomsbury.

Sanders, J., Ades, L. and Burns, R. (2003), *New York: An Illustrated History*, New York: Knopf.

Sanford, C.H. (1998), *Theresa Bernstein: A Seventy-Year Retrospective*, New York: Joan Whalen Fine Art.

Santayana, G. (1968), *Santayana on America: Essays, Notes, and Letters on American Life, Literature, and Philosophy*, ed. R.C. Lyon, New York: Harcourt, Brace & World.

Saussure, F. de (1983), *Course in General Linguistics*, ed. C. Bally and A. Sechehaya, with A. Riedlinger, trans. R. Harris, London: Duckworth.

Schivelbusch, W. (1980), *The Railway Journey: Trains and Travel in the Nineteenth Century*, trans. A. Hollo, Oxford: Blackwell.

—— (1988), *Disenchanted Night: The Industrialization of Light in the Nineteenth Century*, Oxford: Berg.

Schleier, M. (1986), *The Skyscraper in American Art, 1890–1931*, New York: Da Capo Press.

Schlor, J. (1998), *Nights in the Big City: Paris, Berlin, London, 1840–1930*, trans. P.G. Imhof and D.R. Roberts, ed., J.L. Koerner and S. Bann, London: Reaktion.

Schneider, J. (1980), "Picturing Vision," *Critical Inquiry*, 6, Spring: 499–526.

Schuyler, D. (1986), *The New Urban Landscape: The Redefinition of City Form in Nineteenth-Century America*, Baltimore: Johns Hopkins University Press.

Schuyler, M. (1961), *American Architecture*, 2 vols, (eds) W.H. Jordy and R. Coe, Cambridge MA: Harvard University Press.

Scobey, D.M. (2002), *Empire City: The Making and Meaning of the New York Landscape*, Philadelphia PA: Temple University Press.

Scott, W.B. and Rutkoff, P.M. (1999), *New York Modern: The Arts and the City*, Johns Hopkins University Press.

Sekula, A. (1982), "On the Invention of Photographic Meaning," in V. Burgin (ed.), *Thinking Photography*, Basingstoke: Macmillan.

Sennett, R. (1990), *The Conscience of the Eye: The Design and Social Life of Cities*, London: Faber & Faber.

September 11 Digital Archive, http://911digitalarchive.org.

Shanor, R.R. (1988), *The City that Never Was: Two Hundred Years of Fantastic and Fascinating Plans that Might Have Changed the Face of New York City*, New York: Viking.

Shapiro, M.J. (1983), *A Picture History of the Brooklyn Bridge*, New York: Dover.

Sharpe, W. (1988), "New York, Night and Cultural Mythmaking: The Nocturne in Photography, 1900-1925," *Smithsonian Studies in American Art*, 2 (Fall): 2–21.

Shepp, J.W. and Shepp, D.B. (1893), *Shepp's New York City Illustrated. Scene and Story in the Metropolis of the Western World*, Philadelphia and Chicago: Globe Bible.

Silver, N. (1967), *Lost New York*, Boston: Houghton Mifflin.

Simmons, P. (1999), *Gotham Comes of Age: New York through the Lens of the Byron Company, 1892–1942*, San Francisco: Pomegranate.

Singer, B. (1995), "Modernity, Hyperstimulus, and the Rise of Popular Sensationalism," in L. Charney and V.R. Schwartz (eds), *Cinema and the Invention of Modern Life*, Berkeley: University of California Press.

Sloan, H.F. (ed.), (1978), *John Sloan: New York Etchings (1905–1949)*, ed. H.F. Sloan, New York: Dover.

Smith, C.S. (1984), *Chicago and the Literary Imagination, 1880–1920*, Chicago: University of Chicago Press.

Smith, D. (1990), *Texts, Facts, and Femininity: Exploring the Relations of Ruling*, New York: Routledge.

Smith, F.H. (1912), *Charcoals of New and Old New York*, New York: Doubleday, Page.

Smith, J.S. (1982), *Elsie de Wolfe: A Life in the High Style*, New York: Atheneum.

Sorkin, M. and Zukin, S. (eds) (2002), *After the World Trade Center: Rethinking New York City*, New York: Routledge.

Spann, E.K. (1981), *The New Metropolis: New York City, 1840–1857*, New York: Columbia University Press.

—— (1988), "The Greatest Grid: The New York Plan of 1811," in D. Schaeffer (ed.), *Two Centuries of American Planning*, London: Mansell.

Stange, M. (1989), *Symbols of Ideal Life: Social Documentary Photography in America, 1890–1950*, Cambridge: Cambridge University Press.

Stebbins, T.E. Jr., and Keyes, N.K., Jr. (1987), *Charles Sheeler: The Photographs*, Boston: Museum of Fine Arts.

Stein, G. (1972), *Selected Writings*, ed. C. Van Vechten, New York: Vintage.

—— (1988), *Lectures in America*, London: Virago.

Stein, S. (1983), "Making Connections with the Camera: Photography and Social Mobility in the Career of Jacob Riis," *Afterimage*, 10 (10) (May): 9–16.

Steinberg, L. (1972), *Other Criteria: Confrontations with Twentieth-Century Art*, New York: Oxford University Press.

Stern, R.A.M., Gilmartin, G. and Massengale, J.M. (1983), *New York, 1900: Metropolitan Architecture and Urbanism, 1890–1915*, New York: Rizzoli.

Stern, R.A.M., Gilmartin, G. and Mellins, T. (1987), *New York 1930: Architecture and Urbanism Between the Two World Wars*. New York: Rizzoli.

Stern, R.A.M., Mellins, T. and Fishman, D. (1999), *New York 1880: Architecture and Urbanism in the Gilded Age*, New York: Monacelli.

Stevens, W. (1965), *Selected Poems*, London: Faber & Faber.

Stieglitz, A. (1897), *Picturesque Bits of New York and Other Studies*, New York: R.H. Russell.

—— (1978), *Camera Work: A Pictorial Guide*, ed. M.F. Margolis, New York: Dover.

—— (1989), *Alfred Stieglitz: Aperture Masters of Photography*, New York: Aperture.

Stilgoe, J.R. (1983), *Metropolitan Corridor: Railroads and the American Scene*, New Haven and London: Yale University Press.

Stokes, I.N.P. (1967), *The Iconography of Manhattan Island*, New York: Arno.

Strauss, A.L. (1976), *Images of the American City*, New Brunswick: Transaction.

Sussman, E. with Bloemink, B. J. and Nochlin, L. (1995), *Florine Stettheimer: Manhattan Fantastica*, New York: Whitney Museum of American Art.

Symmes, M, (2004), *Impressions of New York: Prints from the New York Historical Society*, Princeton NJ: Princeton Architectural Press.

Tagg, J. (1988), *The Burden of Representation*, London: Macmillan.

Tafuri, M. (1980), "The Disenchanted Mountain: The Skyscraper and the City" in G. Ciucci, F. Dal Co, M. Manieri-Elia and M. Tafuri (eds), *The American City: From the Civil War to the New Deal*, trans. B. L. La Penta, London: Granada.

Talbot, G. (1976), *At Home: Domestic Life in the Post-Centenial Era, 1876–1920*, State History Society of Wisconsin.

Tallack, D. (2002), "'Waiting, Waiting': The Hotel Lobby in the Modern City" in Leach, N. (ed.), *The Hieroglyphics of Space: Reading and Experiencing the Modern Metropolis*, London: Routledge.

Tashjian, D. (1975), *Skyscraper Primitives: Dada and the American Avant-Garde, 1910–1925*, Middletown CT: Wesleyan University Press.

Tauranac, J. (1979), *Essential New York*, New York, Holt, Rinehart & Winston.

—— (1985), *Elegant New York: The Builders and the Buildings, 1885–1915*, photographed by C. Little, New York: Abbeville Press.

Taylor, W.R. (1992), *In Pursuit of Gotham: Culture and Commerce in New York*, New York: Oxford University Press.

Tester, K. (ed.), (1994), *The Flâneur*, London: Routledge.

Tichi, C. (1987), *Shifting Gears: Technology, Literature, Culture in Modernist America*, Chapel Hill: University of North Carolina Press.

Tissot, R. (1983), "Impressionism, American Style," in M. Chenetier and R. Kroes, (eds), *Impressions of a Gilded Age: The American Fin de Siècle*, Amsterdam: Amerika Instituut.

Trachtenberg, A. (ed.) (1980), *Classic Essays on Photography*, New Haven CT: Leete's Island.

—— (1982), *The Incorporation of America: Culture and Society in the Gilded Age*, New York: Hill & Wang.

—— (1984), "Image and Ideology: New York in the Photographer's Eye," *Journal of Urban History*, 10 (August): 453–64.

Troyen, C. (1998), "The Open Window and the Empty Chair: Charles Sheeler's *View of New York*" in M. Doezema and E. Milroy (eds), *Reading American Art*, New Haven: Yale University Press.

Troyen, C. and Hirshler, E.E. (1987), *Charles Sheeler: Paintings and Drawings*, Boston: Museum of Fine Arts.

Tsujimoto, K. (1982), *Images of America: Precisionist Painting and Modern Photography*, Seattle: University of Washington Press.

Tunnard, C. and Reed, H.H. (1956), *American Skyline: The Growth and Form of our Cities and Towns*, New York: New American Library.

—— (1972), "The Vision Spurned: Classical New York," *Classical America*, 2: 10–19.

Van Dyke, J.C. (1909), *The New New York: A Commentary on the Place and the People*, New York, Macmillan.

Van Hook, L.B. (1990), "Decorative Inmages of American Women: The Aristocratic Aesthetic of the Late 19C," *Smithsonian Studies in American Art*, 4 (Winter): 45–69.

Van Rensselaer, M.G. (1892), "Picturesque New York," *The Century Magazine*, 23: 164–75.

—— (1996), *Accents as Well as Broad Effects: Writings on Architecture, Landscape, and the Environment, 1876–1925*, ed. D. Gebhard, Berkeley: University of California Press.

Veblen, T. (1970), *The Theory of the Leisure Class: An Economic Study of Institutions*, London: Unwin.

Vertov, D. (1984), *Kino-Eye: The Writings of Dziga Vertov*, trans. K. O'Brien, ed. A. Kuhn, Berkeley: University of California Press.

Walsh, J. (2000), "The Attraction of the Flatiron Building: Construction Processes" in M. Balshaw, L. Kennedy, A. Notaro, and D. Tallack (eds), *City Sites: Multimedia Essays on New York and Chicago, 1870s–1930s: An Electronic Book*, Birmingham: Birmingham University Press, http://www.citysites.org.uk.

—— (2005), "A Space and Time Machine: Actuality Cinema in New York City, 1890s to c. 1905," PhD thesis, University of Nottingham.

Ward, D. and Zunz, O. (eds) (1992), *The Landscape of Modernity: Essays on New York City, 1900–1940*, New York: Russell Sage.

Warner, S.B. (1984), "Slums and Skyscrapers: Urban Images, Symbols, and Ideology" in *Cities of the Mind: Images and Themes of the City in the Social Sciences*, ed., L. Rodwin and R.M. Hollister, New York: Plenum.

Wartofsky, M.W. (1984), "The Paradox of Painting: Pictorial Representation and the Dimensionality of Visual Space," *Social Research*, 51 (4) (Winter): 863–83.

Watson, E.B. (1976), *New York Then and Now: 83 Manhatan Sites Photographed in the Past and the Present*, New York: Dover.

Weaver, M. (1986), *Alvin Langdon Coburn, Symbolist Photographer, 1882–1966: Beyond the Craft*, New York: Aperture.

Weber, B. (2001), *Homage to the Square: Picturing Washington Square, 1890–1965*, New York: Berry-Hill Galleries.

Weber, E. (1994), *Alfred Stieglitz*, New York: Crescent Books.

Weinberg, H.B., Bolger, D. and Curry, D.P., with the assistance of N.M. Brennecke, (1994), *American Impressionism and Realism: The Painting of Modern Life, 1885–1915*, New York: The Metropolitan Museum of Art.

Wharton, E. (1974), *The Age of Innocence*, Harmondsworth: Penguin.

—— (1985), *Old New York*, London: Virago.

—— (1995), *The Custom of the Country*, London: Virago.

Wharton, E. and Codman Jr., O. (1975), *The Decoration of Houses*, New York: Arno Press.

White, N. (1987), *New York: A Physical History*, New York: Atheneum.

Williams, J.L. (1900), "The Cross Streets of New York," *Scribner's*, 28 (November): 571–87.

—— (1900), "The Walk Up-Town in New York," *Scribner's*, 27 (January): 44–59.

—— (1902), *New York Sketches*, New York: Charles Scribner's Sons.

Williams, R. (1973), *The Country and the City*, London: Chatto & Windus.

—— (1977), *Marxism and Literature*, Oxford: Oxford University Press.

—— (1989), *The Politics of Modernism: Against the New Conformists*, ed. T. Pinkney, London: Verso.

—— (1992), "The Metropolis and the Emergence of Modernism," in P. Brooker (ed.), *Modernism/Postmodernism*, London: Longman.

Williams, R. and Williams, D. (1993), *Shared Perspectives: The Printmaker and the Photographer in New York, 1900–1950: Prints from the Collection of Reba and Dave Williams, Photographs from the Collection of the Museum of the City of New York*, New York: The Museum of the City of New York.

Williams, R. and Williams, D. (1994), *New York, New York: Prints of the City: 1880s–1990, from the Collection of Reba and Dave Williams*, Oxford: Harperprints.

Williams, W.C. (1976), *Selected Poems*, ed. C. Tomlinson, Harmondsworth: Penguin.

Wilson, E. (1991), *The Sphinx in the City: Urban Life, the Control of Disorder, and Women*, London: Virago.

Wilson, R.G. (1979), *The American Renaissance, 1876-1917*, Brooklyn: Brooklyn Museum.

Wilson, W. (1993), *Stuart Davis' Abstract Argot*, San Francisco: Pomegranate.

Wolff, J. (1990), *Feminine Sentences: Essays on Women and Culture*, Cambridge: Polity.

Yochelson, B. (1994), "What are the Photographs of Jacob Riis?" *Culturefront*, 3 (3) (Fall): 28–38.

Yount, S. (1992), "Consuming Drama: Everett Shinn and the Spectacular City," *American Art*, 6 (Fall): 87–109.

Zeisloft, E.I. (ed.) (1905), *The New Metropolis: Memorable Events of Three Centuries from the Island of Mana-hat-ta to Greater New York at the Close of the Nineteenth Century*, New York: Appleton & Co.

Zigrosser, C. (1942), *The Artist in America*, New York: Knopf.

Zilczer, J.K. (1979), "Antirealism in the Ashcan School," *Artforum*, 17 (March): 44–49.

Zurier, R. (forthcoming), *Picturing the City: Urban Vision and Representation in the Art of the Ashcan School,* Berkeley: University of California Press.

Zurier, R., Snyder, R.W. and Mecklenburg, V.M. (1995), *Metropolitan Lives: The Ashcan Artists and their New York*, New York: National Museum of American Art.

Index